Structure and Style

Structure and Style

Conserving Twentieth Century Buildings

Edited by
Michael Stratton

Centre for Conservation Studies
Institute of Advanced Architectural Studies
The University of York, UK

E & FN SPON
An Imprint of Chapman & Hall

London · Weinheim · New York · Tokyo · Melbourne · Madras

Published by E & FN Spon, an imprint of Chapman & Hall,
2–6 Boundary Row, London SE1 8HN, UK

Chapman & Hall, 2–6 Boundary Row, London SE1 8HN, UK

Chapman & Hall GmbH, Pappelallee 3, 69469 Weinheim, Germany

Chapman & Hall USA, 115 Fifth Avenue, New York, NY 10003, USA

Chapman & Hall Japan, ITP-Japan, Kyowa Building, 3F, 2–2–1 Hirakawacho, Chiyoda-ku, Tokyo 102, Japan

Chapman & Hall Australia, 102 Dodds Street, South Melbourne, Victoria 3205, Australia

Chapman & Hall India, R. Seshadri, 32 Second Main Road, CIT East, Madras 600 035, India

First edition 1997

© 1997 E & FN Spon

Typeset in 10/12 pt Times by Gavin Ward, York
Printed in Great Britain by the Alden Press, Osney Mead, Oxford

ISBN 0 419 21740 1

A catalogue record for this book is available from the British Library

Contents

Part Three
The Evolution of Twentieth Century Building Construction

Part Four
Conservation Options

Contributors

Dr Bill Addis Lecturer in Structural Design, Department of Construction Management & Engineering, University of Reading

Peter Burman Director, Centre for Conservation Studies, Institute of Advanced Architectural Studies, The University of York

David Jenkin Director, DEGW London Ltd

Susan Macdonald Architectural Conservation Branch, English Heritage

Kenneth Powell Consultant Director, The Twentieth Century Society

Peter Ross Associate Director, Ove Arup

Dr Michael Stratton Lecturer in Conservation Studies, Institute of Advanced Architectural Studies, The University of York

Professor Andrew Saint Department of Architecture, University of Cambridge

Professor Philip Steadman Design Discipline, Open University

Robert Thorne Senior Associate, Alan Baxter & Associates

Professor John Worthington Director, Institute of Advanced Architectural Studies, The University of York; and Deputy Chairman, DEGW

Preface and acknowledgements

The twentieth century, with just a few years left to run, seems to be of increasing rather than fading interest. Conservationists, designers and critics are all too keen to express an opinion praising to the skies or utterly condemning relatively recent architecture. Each announcement by English Heritage concerning post-war listing is accompanied by carefully-worded press releases and less-considered journalistic comment. While the preservation establishment is listing key buildings, or in the case of the National Trust, opening Modernist houses to the public, radicals are researching such esoteric themes as the architectural use of plastics, or clamouring for the preservation of diesel locomotive depots.

These initiatives and the underlying conservation principles that support them were considered at a conference held at the Institute of Advanced Architectural Studies, King's Manor, York. The immediate surroundings were more Ancient than Modern, but Sir Bernard Feilden's alterations and additions of the 1960s made the venue more than appropriate. It is improbable that his bold, blunt addition of a two-storey brick and concrete study block over a seventeenth century stone cellar would be acceptable in the 1990s. Yet, one of the key themes to emerge from the conference was that as conservation attitudes are changing so rapidly it is increasingly difficult to define, let alone defend, any absolute rights and wrongs.

This book consists of papers presented at the Institute over 31 October to 1 November 1996, with an introduction that provides a background and draws upon the discussion that enlivened those two days. The volume explores the challenge of evaluating and conserving the building stock that we are inheriting from this century. It shows how debates have shifted from a pre-occupation with icons of the Modern Movement and with naked steel and concrete. Architects, planners and managers of estate are interested, by necessity, in the value – economic, social and visual – of offices, public buildings, housing and factories. Such twentieth century buildings, which dominate the landscape of many towns and cities, have been typically undervalued.

Part in jest, Andrew Saint gave the conference and this book an alternative subtitle: 'DEGW meets SPAB'. Peter Burman, a committee member of the Society for the Protection of Ancient Buildings, lays out an argument for conserving twentieth century buildings in the same way that key figures within

the Arts and Crafts Movement approached Medieval structures – respecting and protecting their form, history and evidence of age, while make necessary repairs in a restrained but honest intervention. Through dialogue and a little banter, it became clear that high quality non-commercial buildings were less likely to be improved by sweeping change than others which could take and benefit from the time-scale of transformation presented by David Jenkin and John Worthington of the consulting firm DEGW. Some twentieth century structures, such as traditionally-built houses and public buildings do mellow over time.

The chapters in the first section of the book progress from evaluating our building stock, in terms of its quantity, nature and significance, to consider issues of adaptation and conservation. Concrete structures, cladding systems and services may all need major attention within a couple of decades, and the conservationist cannot often take the SPAB approach of cautiously undertaking the minimum remedial works. This 'crisis' – of young, expensive buildings discovered to have contracting frames, spalling cladding and useless services – has been used as ammunition to condemn twentieth century or at least 'Modern' architecture. However it emerged that only a minority of buildings are likely to be hit by such a crisis before reaching maturity. Housing and office blocks, dating from the late fifties to early seventies, where experimental structural systems were combined with inflexible forms of plan and services, fail soonest and most catastrophically. Most earlier buildings and also those of more recent date have already proved to be more durable and more flexible.

The section on building fabric highlights the need to differentiate between superficial decay and deep-rooted problems, such as concrete cancer or rusting steelwork. Susan Macdonald captured the tenor of these contributions by arguing that conservationists must be ready to challenge the orthodoxy that twentieth century buildings need sweeping repairs, administered by one or more specialist contractors. Almost every recent research consultancy or conference paper has emphasized the merit of a more cautious approach. Vintage concrete does not have to be re-coated to take an elevation back to some mythical pure white image, as presented by contemporary photography. Patina and streaking, as found on stone ashlar, can be acceptable and even welcomed.

I am indebted to Peter Burman, Robert Thorne and John Worthington for their advice and contacts, drawing together an enthusiastic but very busy group of academics and practitioners. My thanks go to all the contributors in giving so fully of their time and knowledge and for the extra work in turning a lecture into an illustrated final text.

Thanks are due to Gavin Ward of IoAAS for turning the manuscripts into camera-ready copy. Caroline Mallinder and Regina McNulty at E & F N Spon showed enthusiasm for the subject and content of this book from the outset, and helped through every stage of its production. Photographs and drawings were provided by the author of the relevant chapter, except where a specific credit is given.

Michael Stratton
Institute of Advanced Architectural Studies,
The University of York
January 1997

Michael Stratton

Introduction

This book attempts to take a broad look at the building stock of this century. It sidesteps round the famed and generally protected icons – houses by Lutyens, penguin pools and thirties flat-roofed houses – to examine commercial, industrial and public buildings that have to work hard to ensure their survival. In drafting their chapters, the contributors sought to tackle a series of basic questions in relation to the many and diverse buildings erected over a long and turbulent period.[1]

Are the major twentieth century buildings fundamentally different from those of earlier ages? They are frequently categorized as being big, revolutionary in structure and radical in intention and image. Some see them as dinosaurs – indulgent experiments using thinly-researched building materials and social theories. Their designers may be presented as progressives breaking away from redundant philosophies and styles, or arrogant prima donnas dismissive of public taste and social sensibilities.

These generalizations certainly apply to particular groups of buildings and architects. But several of the contributors to this book take a fundamentally different starting point – that the majority of Britain's recent buildings are evolutionary rather than revolutionary in their form. Looking to earlier periods, New Lanark Mills near Motherwell and Albert Dock, Liverpool are large complexes presenting innovative forms of construction and bold unadorned elevations. Such industrial buildings pioneered the structural use of metal and then concrete back in the eighteenth and nineteenth centuries. Most commercial buildings of the twentieth century build on such innovations. They follow Victorian precedent in being hybrid structures, steel or concrete frames clad with traditional brick and stone, or pre-cast panels. Most architects and engineers of this century have been motivated by aims already well entrenched in the Victorian period – to create buildings that worked, that gave a sense of order to complex and often contradictory functions and that contributed to rather than

merely reflected contemporary culture. The whole idea that the twentieth century has a stand-alone character may be a purely British fabrication engendered by two World Wars, and an over-riding sense of failure. American and Australian historians in particular tend to think and write more in terms of evolution than discontinuity.

As the Modernist orthodoxy is broken up, so conservationists appreciate the challenge of identifying and caring for architecture of great quality across a large and rapidly changing map. As Andrew Saint suggests, we need to build on our broadening awareness to understand building types in their geographical and historical context, from Edwardian offices, inter-war semis, and post-war factories to garden cities and shopping centres. The issue is not simply whether buildings are listable, but how they and their related landscapes can be seen and managed as assets rather than increasingly tatty liabilities.

How can conservationists judge the twentieth century commercial and public architecture that dominates the centres of so many British towns and cities? Building types such as offices, multiple stores and shopping centres fail to rouse the zeal of most architectural historians. Commercial or local authority architects are rarely the subject of research monographs or exhibitions. Many of the buildings they designed are large, have already suffered unsympathetic alteration, and have become stigmatized locally as well as nationally as symbols of comprehensive redevelopment or political empire-building. Due to their lack of 'purity' in terms of structure or style most will not even have friends among those fighting to preserve icons of the Modern Movement. Only in the last few years have the principles, publications and casework of the key conservation agencies such as DoCoMoMo (International Working Party for Documentation and Conservation of Buildings, Sites and Neighbourhoods of the Modern Movement) related directly to hard decisions by commercial architects and engineers, or local authority officers. The chapter by Peter Burman highlights the central importance of the principles of the SPAB (Society for the Protection of Ancient Buildings) while Ken Powell shows how the Twentieth Century Society makes a positive and occasionally pragmatic input when difficult decisions have to be made about the future of important buildings.

The whole principle of British conservation, as enshrined in the criteria for listing, assumes that older buildings are scarcer and more precious. This approach makes the preservation of twentieth century buildings more difficult to justify, and selection more problematic. It is clear that some key turn-of-the-century structures, such as early steelworks are already long extinct, while first generation cinemas and multiple stores only exceptionally survive in anything approaching their original form. The make-up of our building stock is only now being properly researched and Steadman's chapter marks a first step in relating such studies to issues of conservation. Even less is known about the dynamics of urban growth and redevelopment – from city centres to suburbs. The sweeping success of urban historians in unravelling the complexity and subtleties of the Victorian city is yet to be achieved for our own age.

Tackling the twentieth century

We suffer from a lack of objective knowledge and of accumulated experience. The twentieth century is too long and too topical to have been studied in a broad, all-embracing manner. Early appraisals were as much critiques as academic history, Goodhart-Rendel's witty *English Architecture since the Regency*[2] presenting a country poles apart from analysis by Nikolaus Pevsner. The latter's *Pioneers of Modern Design* followed a convoluted path from William Morris and early iron-framed buildings to Walter Gropius. Virtually all the other broad-brush histories of twentieth century architecture, such as Curtis, Sharp and Frampton adopt Pevsner's approach of plucking highlights of Modernism to create a story of bold progress.[3] These later surveys refer only infrequently to Britain, so dismissing most of our architecture as being derivative or backward-looking.

A scan through any library's holdings on British twentieth century architecture shows that the subject has been tackled almost decade by decade – from the Edwardian swansong of Empire to the Art Deco twenties, Modernist thirties and the Brutalist sixties. The two World Wars and the supposed gulf between traditional and modern architecture have been seen as unbridgeable divides.

As might be expected, historians started with the most distant and stolid decade, the 1900s – extended and labelled as the Edwardian age. They present it as a grand finale to the scale and optimism of Victorian architecture and a precursor, through the Arts and Crafts, to more overtly modern work to come. Robert Macleod first unravelled the threads of different ideologies, styles and breeds of architect.[4] Two books by Alastair Service explore this territory in fuller detail, the second associating specific styles with domestic, public and ecclesiastical architecture. His study on London focuses on the social and historical flavour of the capital at its zenith.[5] The richly detailed biographical dictionary of key Edwardian architects by Stuart Gray emphasizes the continuity from the Victorian period and the sheer scale of professional activity and of many of the buildings themselves.[6] Meanwhile exhibitions, and most notably that on Edwin Lutyens, have helped to convey the architectural quality of the period to a broader public.[7] Since then there have been specialist monographs on key architects, for example on the classicist Reginald Blomfield by Richard Fellows, and on C.R. Mackintosh by Alan Crawford.[8] The City of Glasgow has generated a whole tourist industry out of 'Mockintosh'. The cult of this semi-tragic figure has cast the remarkable work of his contemporary Scots designers into a deep shadow from which they are only just emerging.[9]

Key advances in twentieth century construction have been analysed in the journal *Construction History*, articles covering the advent of steel and concrete construction. Most recently the Institution of Civil Engineers has published a synthesis of current knowledge of early concrete, from fireproof floors to proprietary reinforcement systems.[10] Richard Fellows has sought to relate new materials to the exuberant façades of many public and commercial buildings.[11] However there is still no all-embracing study of the evolution of building form, and most historians resort to contemporary builders' manuals or specialist volumes such as *Cassell's Reinforced Concrete* of 1913.[12]

Even the inter-war period, lasting only 21 years, has been compartmentalized rather than seen as a whole. One has to turn to social history, such as the pioneering work by C.L. Mowat for a broad appraisal, while J.B. Priestley's *English Journey* published in 1934 provides a crisp insight into these confused and antagonistic years.[13] For too long attention focused on the decorative arts, the fripperies of Art Deco being contrasted with the streamlined forms of the thirties.[14] Meanwhile advocates of International Modernism retained their high moral ground, culminating in an exhibition held at the Hayward Gallery in 1979. Disengenuously titled the *Thirties*, it was more a discourse on the introduction of the Modern Movement into British Architecture and the sister arts.[15] A double issue of *Architectural Design*, entitled 'Britain in the Thirties' was intended as a counter blast; the introduction by Gavin Stamp emphasizes the diversity of inter-war design.[16] The *Scottish Thirties* provides a wide-ranging coverage of architecture north of the border. McKean highlights the importance of buildings erected for recreation, whether pubs, shops, swimming pools or exhibition halls.[17]

Studies of planning rather than architectural history provide the best approach to the post-war period. Lord Esher's *A Broken Wave* examines the impetus to comprehensive redevelopment given by bomb damage and the vision of modern, orderly cities coming from Le Corbusier and the new town movement. Esher's account is best read in conjunction with Marriott's journalistic but influential *The Property Boom*. It rips through the machinations of Harry Hyams and other property developers, so explaining much of the banal development that blights our city centres.[18]

The bright and occasionally naive architecture of the immediate post-war years has received only fragmented attention, partly because much of it lacks the rigour of thirties Modernism or of sixties Brutalism. The commemorative survey, *A Tonic to the Nation*, credits the Festival of Britain 1951, a quarter-century after the event, in encouraging the use of colour, lightweight metal forms and whimsy in architecture and the decorative arts.[19] A review of the bright and open interior designs in this idiom is provided by Lesley Jackson's *'Contemporary' Architecture*.[20] A number of regional studies, for example on the north of England, present a more diverse viewpoint on fifties architecture.[21]

Rather than try and tackle recent decades on a chronological basis, researchers have focused on individual building types. Sadly the densest body of research within this formula, that undertaken by English Heritage to underpin their listing programme, remains unpublished. The listing branch have been able to draw on several excellent studies, on housing for example, the best interweaving social, political and design issues, whether the focus is early International Modernism,[22] the inter-war semi[23] or post-war tower blocks.[24]

Industrial architecture was hailed as the logical outlet for a functionalist Modernism. Brockman argued that industry should be housed in buildings finely tuned to their purpose and made of mass-produced materials.[25] The Twentieth Century Society's special issue on *Industrial Architecture* has explored the images that firms sought to create through their factories, from by-pass factories, pithead baths to the low slung offices – nicknamed prestige pancakes – erected for major companies in the fifties and sixties.[26] Specific industrial building types,

such as power stations[27] and mass-production factories, whether for cars, aircraft or food have all been studied from the viewpoint of the Industrial Archaeologist.[28] A broad synthesis of trends in the design of factories has been presented by Stratton and Trinder.[29]

New commercial and public buildings may have had dramatic impact on our towns and cities but they remain strangely neglected by historians. The crisp middle-of-the-road work of Charles Holden for the London Underground is analysed by Lawrence,[30] while Atwell revels in the explosion of exotic and futuristic designs for cinemas.[31] Office blocks and department stores await full study, but Susan Barson and Andrew Saint explored the flamboyant newspaper headquarters of Fleet Street.[32] Saint's exemplary study of post-war school architecture shows how the reformist zeal of young designers became linked to educational reform and new prefabricated building systems.[33]

The role of the architect has been in flux, even crisis, during this century – compromised by the scale of large practices, local authority departments, and with individual creativity constrained by the complexities of modern design and construction. Perhaps in consequence, there are fewer biographies than for the nineteenth century, where a clutch of monographs – on Burges, Norman Shaw and Waterhouse – provide a key to understanding contemporary architectural practice. It is worth noting Allan on Lubetkin,[34] and Powers on Goodhart-Rendel and on Oliver Hill, whose oeuvre slipped so easily from traditionalism to Modernism and then back again.[35]

Despite many key figures of practice in the fifties and sixties still being alive, we understand little of their intentions, which are likely to be far more subtle and even contradictory than they would have us believe. Were they pre-occupied with the function of the building and new building technologies as most would have us believe? Many figureheads of the Modern Movement pull down a

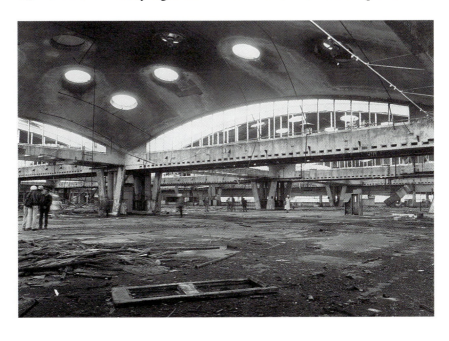

Fig 1.1 Brynmawr Rubber Factory, by the Architects' Co-operative Partnership, 1947-1951. Nine concrete shell domes cover the main production area. This photograph was taken in October 1996, when the future of this works hangs by a thread.

screen, denying any debt to their contemporaries and contemporary culture, let alone the work of older generations. In the form of a sympathetic exposé, Alan Powers has conveyed how the designers within the Architects' Co-operative Partnership were inspired by the character of the Welsh Valleys, welfare initiatives in the United States and inter-war poetry when designing the Brynmawr Rubber Factory, erected as a vision of a better, more egalitarian future during 1947-51.[36]

Criteria for protection

The evaluation of twentieth century architecture has now extended to the work of provincial designers and such offbeat building types as Second World War pillboxes. It is driven primarily by the desire to identify what is listable, and then get the progressive, the typical and the eccentric protected – even though listing may not be the most appropriate conservation measure for the building. This pre-occupation, among both amateurs and professionals, has worked against any broader consideration of the changing form of our urban landscape, and of the future value of the building stock that we are inheriting. The established criteria for listing defined by planning law and circulars have already been extended, but some writers, including Andrew Saint in this book, suggest that the national, academically-defined groundrules will soon be outrun by more popular, and more locally-orientated choices.

Accepting current orthodoxy for the moment, most agree that the challenge is to select the best of any period. But what is the best? Those buildings that were most widely heralded in the fifties and sixties are now often the most reviled and the most problematic in terms of their future. Gavin Stamp accepted that these decades 'saw some terrible mistakes and some should be allowed to go', then countering this argument with the caution that 'one must go for the important whether one likes them or not'.[37] The challenge is to differentiate between buildings that are unsound in terms of their conception, function and impact, and those that are visionary although flawed, and may deserve being retained for their historic significance.

Some of the most progressive structures of the post-war period are so big and inflexible as to be viewed as no-hopers once their original use has been lost. The conference *Preserving our Recent Past*, held in Chicago in April 1995, explored the extent to which preservationists have to be pragmatic, accepting what is deemed worthy by the academic world and working 'within the realm of public sentiment and opinion'. Considering the tourist-related developments at Waikiki, Honolulu, Chapman and Hibbard concluded that 'it is perhaps better to have the chance to preserve the artistically unified, pristine, or exceptional than to go down in flames attempting to save the typical, the representative, or the messy and ugly, however much we might value the latter and appreciate its fine points'.[38] With the benefit of hindsight one would urge British conservationists against such faint-heartedness. Those who have stuck their neck out and argued for buildings considered beyond the bounds of contemporary acceptability have usually been vindicated, as academics and journalists have caught up a decade or more later, whether to praise surviving Art Deco factories or lament the loss of early concrete structures.

Listing and the listable

The concept of listing buildings of architectural and historic merit was established immediately after the Second World War, partly in response to the losses incurred in the Blitz. Few twentieth century buildings were afforded protection as a result of regional surveys undertaken during the fifties and sixties, guidelines imposing extreme selectivity for anything dating after 1914. The key dates for extending the agenda into our century are 1970 and 1980. In the former year, Sir Nikolaus Pevsner put forward a list of fifty prime examples of Modern Movement architecture, including thirties houses and flats, and the Penguin Pool at London Zoo.

A decade later, the Firestone Factory designed by Wallis, Gilbert & Partners and built 1928, was partly demolished over the August Bank Holiday weekend, just as a proposal for listing was pending confirmation. Disgust at the blatant opportunism shown by the developers was accompanied by a strengthened interest in inter-war architectural design. A listing survey with a cut-off date of 1939 was initiated, which resulted in almost 150 buildings gaining protection. For the first time particular attention was given to the distinctive qualities of building types characteristic of the age, such as underground stations and airports.

The next key initiative came in 1987. Bracken House, the headquarters of the *Financial Times* in the City of London and built 1957-9 to designs by Sir Albert Richardson, was threatened with demolition. It was listed, leading to a new ground-rule that buildings at least thirty years old, and in exceptional cases just ten years old, could be considered for listing. English Heritage responded to the 'Thirty Year Rule' by putting forward 70 further cases, drawn from the period 1940-57. Most were rejected, partly because the preservation of council housing was so contentious, but also because there was a lack of published research to clearly define what made individual buildings so distinctive. However the 'Ten Year Rule' did lead to the Willis Faber Building in Ipswich, designed by Foster Associates and built 1973-5 being listed grade I in 1991, in response to proposals to fill in its swimming pool.

A research programme into post-war architecture was launched in 1991, initially focusing on school and university architecture and resulting in 47 educational buildings being listed in March 1993.[39] Further building types have now been tackled, reports and proposals for churches, public buildings and bridges being put out to public consultation in March 1996. Diane Kay, who has led the post-war programme, has summarized the criteria used, drawing upon those defined with earlier periods in mind, while accepting the need for great selectivity. The key pointers are: high architectural quality, innovation in technique or idiom, rarity, and association with persons or events of historical importance.[40]

The acceptability of this approach and the principles which underlay it have been tested to the full by the contentious world of office buildings and high-rise public housing. Some property companies such as MEPC, the owners of Centre Point, designed by Colonel Seifert and built 1961-5, have resisted office blocks being listed, not so much because they want the option of demolishing them, but because they fear that the bureaucracy of listed building consents will inhibit

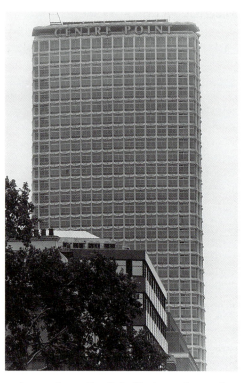

Fig 1.2 Centre Point, by Colonel Seifert, 1961-5: London's prime symbol of sixties property speculation.

their ability to refurbish and upgrade services. English Heritage hope that management agreements and a policy of flexibility will allow change without unduly compromising the character of the design.

In the case of public housing it is the underlying principle of whether buildings, often despised by the very people that live in them and seen as symbols of inhuman planning, should be sanctified through listing. It is an argument that was worked through decades earlier in the South Wales valleys, when local councillors spurned efforts to save physical evidence of the Industrial Revolution – specifically a group of terraced houses called the Triangle – now to the regret of the local community as well as historians. The recommendation that brought this conflict out onto the airwaves was that Park Hill, the dramatic but infamous deck-access estate in Sheffield, should be listed grade II*. Built in 1961 to designs by Lewis Womersley, the 1000 units tower over the city and the moorland beyond. Several local residents became media stars during early September 1996, as they condemned arty academics who never had to suffer the noise, late night vandalism and sheer inconvenience that come with living at Park Hill.

With the most contentious elements of the post-war programme now out in the open, most conservationists hope that professional and media attention can shift from argey-bargey over whether individual buildings should be listed or not, to how our building stock can be best used, maintained and adapted, with appropriate standards of authenticity being applied to listed examples. In concluding this introduction, one or two of the key issues can be introduced.

Materials, services and change

Several chapters in this book, those by Addis, Ross, Stratton and Macdonald, focus on materials. Modernism is often associated with the introduction of new industrial materials and forms, supposedly breaking from the traditions of brick and stone to create crisp, maintenance-free buildings. But there was no clean break – there are steel and concrete structures dating to the nineteenth century and numerous important masonry structures of the twentieth. The chapter by Bill Addis shows how the take-up of steel and concrete in the United Kingdom ran around twenty years behind innovations in mainland Europe and the United States. Furthermore, many British Modern Movement buildings are intriguingly dishonest in their form – white walls of render suggesting a concrete structure, but in reality hiding traditional brickwork.

The concept of a maintenance-free building has proved a dangerous myth, resulting in a lack of care for buildings both new and old. When decay becomes apparent, architects and surveyors may respond by writing off the complete structural or cladding system as an abject failure, and urge drastic intervention or total replacement. One of the key themes to emerge in this volume is that a thorough investigation – progressing from studying the building and its fabric, and understanding its context, to identifying alterations and defining its current significance – is a vital prelude to any specific decisions concerning repair.[41] Such research and careful thought about the proposed future use can usually permit the retention of more of the original fabric with benefits in terms of both integrity and economy.

Building users and managers now expect higher standards from old buildings. Central heating transformed our attitudes to traditional buildings back in the sixties, and we now demand proper climatic control from glass curtain-walled structures. Much of the debate over the refurbishment of the Boots Wet Processes Building at Beeston, Nottingham, designed by Owen Williams and dating to 1932, focused on how a more stable working environment could be

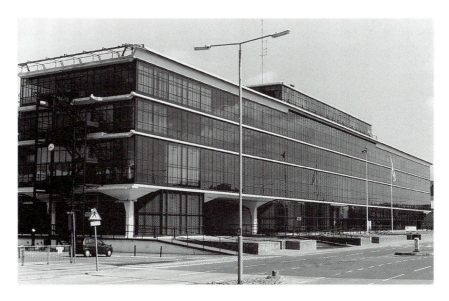

Fig 1.3 Boots Wet Processes Building, Nottingham by O. Williams, 1932, following restoration and showing the effect of installing tinted glass.

achieved without destroying the transparent nature of the glass screen wall.[42] Recent research has illustrated how sophisticated services and information technology can be introduced into historic buildings without destroying their character.[43]

Returning to the issue of tower blocks, the conservationist's agenda of achieving architectural 'authenticity' may appear worlds apart from the need to create a better living environment through refurbishment. In the case of large, unlisted towers of the sixties, most are willing to accept dramatic change. New double glazing and overcladding can transform thermal performance and appearance, while the enclosure of ground floor areas and individual balconies brings added safety and living space. In Hackney, north London, three tower blocks will remain on the Nightingale estate, partly because enough residents wanted to stay in them and also because they were better built than the contemporary towers on the borough's other estates. But where tower blocks are tagged as being of architectural significance, even minor refurbishment may rouse conflict. Plastic-coated aluminium windows were installed in part of Churchill Gardens in Pimlico, London during the early 1980s. English Heritage and residents alike expressed concern at the despoilation of Britain's first visionary rehousing project after the end of the Second World War. In this instance the original architect, Sir Philip Powell was invited to develop less-intrusive designs of replacement window.[44]

Wessel de Jonge put forward a series of basic models of preservation for twentieth century architecture: restore to an original state as monuments, restore but with small technical improvements, and pragmatic conservation where modern methods are honestly used and choices are dominated by the demands of the property market.[45] In deciding between these options, one must reconcile the importance of the original architectural conception and the structure as it now stands. Most alterations of recent years are seen as tawdry and worthless, but they may be sensible responses to fundamental failings in the building and mature into acceptability if not removed.

Martin Pawley would urge a fourth option, of demolition, arguing that some buildings were designed for a short working life and that preserving them denies them their polemic, often radical intention. But conservation is, at its best, a creative process bringing renewed vitality and meaning to buildings.[46] Far more people will appreciate Giles Gilbert Scott's Bankside Power Station when it is open as an art gallery, just as the Edwardian Michelin Building in west London has gained a much stronger identity as a restaurant than as a tyre depot.

Bankside demonstrates how rapidly attitudes, both professional and public, are shifting. On London's South Bank the Festival Hall is now broadly popular while the virtually windowless concrete mass of the Hayward Gallery is becoming seen as a bold monument to Brutalist design. While the Bull Ring shopping centre in Birmingham is poised for total redevelopment the slightly earlier precinct in Coventry is recognized as a key element in the city's character and history. Amidst such flux, the role of conservationists is not to stop change but to manage it. The following chapters all show a need to work towards a consensus – informing and drawing ideas not only from professional colleagues but also from building owners, councillors and the public.

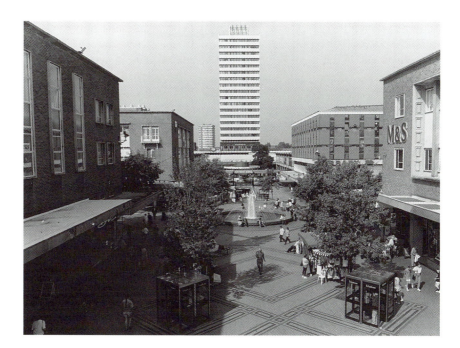

Fig 1.4 Coventry City Centre, by D. Gibson & A. Ling, 1952-64. This view looking towards the west shows the strong axial layout, and, in the distance, the circular Godiva cafe in front of a 22-storey block of flats.

References

1 This book aims to complement a conference that examined philosophical and technical issues in conserving Modern Movement architecture, published as Macdonald, S. (1996) *Modern Matters: Principles and Practice in Conserving Recent Architecture*, Donhead, Shaftesbury; and a conference at York which presented a wide range of building types, materials and styles found in buildings dating from the Edwardian period to the sixties, published as Burman, P., Garner, K. & Schmidt, L. (1996) *The Conservation of Twentieth Century Buildings*, Institute of Advanced Architectural Studies, York.

2 Goodhart-Rendel, H.S. (1953) *English Architecture since the Regency*, Constable, London.

3 Pevsner, N. (1960) *Pioneers of Modern Design*, Penguin, Harmondsworth; Curtis, J.R. (1982) *Modern Architecture since 1900*, Phaidon, London; Sharp, D. (1991) *Twentieth Century Architecture: a Visual History*, Lund Humphries, London; Frampton, K. (1980, 1992) *Modern Architecture: a Critical History*, Thames & Hudson, London.

4 Macleod, R. (1971) *Style and Society: Architectural Ideology in Britain 1835-1914*, RIBA Publications, London.

5 Service, A. (ed.) (1975) *Edwardian Architecture and its Origins*, London; Service, A. (1977) *Edwardian Architecture*, Thames & Hudson, London; Service, A. (1979) *London 1900*, Granada, St Albans.

6 Gray, A. S. (1985) *Edwardian Architecture: a Biographical Dictionary*, Duckworth, London.

7 Amery, C. (1981) *Lutyens: the Work of the English Architect Sir Edwin Lutyens (1869-1944)*, Arts Council, London.

8 Fellows, R.A. (1985) *Sir Reginald Blomfield: an Edwardian Architect,* Zwemmer, London; Crawford, A. (1995) *Charles Rennie Mackintosh*, Thames & Hudson, London.

9 For a study of a neglected Scottish architect see Sloan, A. & Murray, G. (1993) *James Miller*, Rutland Press, Edinburgh.

10 (1996) 'Structures and Buildings: Historic Concrete', *Proceedings of the Institution of Civil Engineers*, **116**, Nos 3 & 4.

11 Fellows, R. (1995) *Edwardian Architecture: Style and Technology*, Lund Humphries, London.

12 Jones, B.E. (1913) *Cassell's Reinforced Concrete*, Waverley, London.

13 Mowat, C.L. (1955) *Britain Between the Wars*, 1955, Methuen, London; Priestley, J.B. (1934) *English Journey*, Heinemann, London.

14 See, for example, Battersby, M., Klein, D., McClelland, N.A., & Haslam, M. (1987) *In the Deco Style*, Thames & Hudson, London.

15 Hawkins, J. & Hollis, M. (1979) *Thirties: British Art and Design before the War*, Arts Council, London.

16 (1979) AD Profile 24: 'Britain in the Thirties', *Architectural Design*, **49**, 1979.

17 McKean, C. (1987) *The Scottish Thirties: an Architectural Introduction*, Scottish Academic Press, Edinburgh.

18 Esher, L. (1981) *A Broken Wave*, Allen Lane, London; Marriott, O. (1967) *The Property Boom*, Pan, London.

19 Banham, M. & Hillier, B. (1976) *A Tonic to the Nation: the Festival of Britain 1951*, Thames & Hudson.

20 Jackson, L. (1994) *'Contemporary' Architecture: Interiors of the 1950s*, Phaidon, London.

21 Allsopp, B. (1969) *Modern Architecture of Northern England*, Oriel, Newcastle upon Tyne.

22 (1996) The Modern Home Revisited, *Twentieth Century Architecture*, **2**.

23 Jackson, A. (1971) *Semi-Detached London*, Allen & Unwin, London; Oliver, P., Davis, I., & Bentley, I. (1981) *Dunroamin: the Suburban Semi and its Enemies*, Barrie & Jenkins, London.

24 Glendinning, M. & Muthesius, S. (1994) *Tower Block: Modern Public Housing in England, Scotland, Wales & Northern Ireland*, Yale, New Haven.

25 Brockman, H.A.N. (1974) *The British Architect in Industry 1841-1940*, Allen & Unwin, London.

26 (1994) Industrial Architecture, *Twentieth Century Architecture*, **1**.

27 Stratton, M. (1994) *Ironbridge and the Electric Revolution*, J. Murray, London.

28 Collins, P. & Stratton, M. (1993) *British Car Factories*, Veloce, Godmanstone.

29 Stratton, M. & Trinder, B. (1997) *Industrial England*, Batsford, London.

30 Lawrence, D. (1994) *Underground Architecture*, Capital Transport, Harrow.

31 Atwell, D. (1980) *Cathedrals of the Movies: A History of British Cinemas and their Audiences*, Architectural Press, London.

32 Barson, S. & Saint, A. (1988) *A Farewell to Fleet Street*, English Heritage, London.

33 Saint, A. (1987) *Towards a Social Architecture: the Role of School-Building in Post-War England*, Yale, New Haven and London.

34 Allan, J. (1992) *Berthold Lubetkin: Architecture and the Tradition of Progress*, RIBA, London.

35 Powers, A. (1987) *H.S. Goodhart-Rendel 1887-1959*, Architectural Association, London; Powers, A, (1989) *Oliver Hill: Architect and Lover of Life*, Mouton, London.

36 Lecture by Alan Powers at DoCoMoMo Conference, Nottingham, July 1996. For a full study on the project see Perry, V. (1994) *Built for a Better Future: the Brynmawr Rubber Factory*, White Cockade, Oxford.

37 Gavin Stamp contributing to an English Heritage Seminar, London, February 1996.

38 Chapman, W. and Hibbard, D. Assessing significance and preservation value in Waikiki, in Slaton, D. and Shiffer, R.A. (1995) *Preserving the Recent Past*, Historic Preservation Foundation, Washington, II-63.

39 English Heritage (1996) *Something Worth Keeping? Post-War Architecture in England*, English Heritage, London, 3-5.

40 Kay, D. The listing of post-1945 buildings, in Burman, P., Garner, K., and Schmidt, L., (1996) *The Conservation of Twentieth Century Historic Buildings*, IoAAS, York, 10-11.

41 This sequence of research is developed more fully in Allan, J., The conservation of modern buildings, in Mills, E.D. (1994) *Building Maintenance and Preservation*, Butterworth Heineman, Oxford, 155-7.

42 See Strike, J. (1996) Careful Medication for a Curtain Wall, *DoCoMoMo Journal*, **15**, 61-4.

43 DEGW ETL (1996) *Heritage and Technology*, DEGW ETL, London.

44 See Harwood, E., The windows of Churchill Gardens, in Macdonald, S. (1996) *Modern Matters*, Donhead, Shaftesbury, 70-77.

45 de Jonge, W., Contemporary requirements and the conservation of typical technology of the Modern Movement, in Henket, H.J., & de Jonge, W. (ed.) (1990) Conference Proceedings, DoCoMoMo, Eindhoven, 84-9.

46 See Powers, A. Conservation and creativity, in Burman, P., Garner, K., and Schmidt, L., (1996) *The Conservation of Twentieth Century Historic Buildings*, IoAAS, York, 4-5.

Part One

Philosophical Issues

Peter Burman

Towards a philosophy for conserving twentieth century buildings

You perhaps fancied that architectural beauty was a very costly thing.
Far from it. It is architectural ugliness that is costly.
Ruskin, J. (1854) *Lectures on Architecture and Painting delivered at
Edinburgh in November, 1853*, London.

Continuity or discontinuity?

Here the starting point is the idea that there is after all a thread of discernible
continuity between buildings of the more distant past and those of the twentieth
century; and consequently, although there are indeed differences of emphasis,
there is more of a thread of continuity – more than has sometimes been imagined,
at any rate – between the philosophies needed for the conservation of 'old work'
(as theorists of around the turn of the century referred to old buildings) and those
needed for the conservation of mainstream twentieth century architecture.

I found it intriguing that, on looking up the word 'mainstream' in the *Shorter
Oxford Dictionary* (for it is often the simplest words that trip us up), one of the
three possibilities on offer was 'a type of jazz based on the 1930s swing style and
consisting especially of solo improvisation on chord sequences', for is not 'solo
improvisation on chord sequences' a passable if ironic description of a great deal
of work carried out to existing buildings where there is no consistency of
philosophical approach and no research (including the indispensable detailed
and painstaking recording) into the precise nature of a building followed by a
careful weighing of its cultural significance? However, the primary definition
given is 'the prevailing trend in opinion, fashion, etc.'; and yet a third definition
is 'the principal current of a river'. Although it is the primary meaning which we
are principally concerned with here I nevertheless particularly like to bear in
mind that third definition as well because it reminds us that – in spite of the
vagaries of fashions and 'movements' – there is arguably a broad river of

architectural continuity between the 1890s and the present day. This has been well put in a recent article in *Country Life* by Alan Powers, who points out that:

> The whole period played a subtle, complicated game with the past and with national identity. To the generation of pupils and admirers of Shaw, including Lutyens, there were subtleties and refinements to be achieved, rather than vast new territories. To another group, admirers of Philip Webb, there was a different sort of inward journey, to discover the essence of architecture. For many, this was exemplified in J. F. Bentley's new Roman Catholic cathedral at Westminster – its vast brick interior transcending issues of nostalgia and nationhood. Much of the 1890s architecture was dross, but young talent found patronage, and many buildings remain to delight us with an open-minded refinement suggesting the possibility of future development. If the same kind of inward journey is becoming evident in some projects today, it may be because the commotion of stylistic conflict can be put at a distance. The 100-year cycle from the 1890s may be more than a coincidence – a sort of recurrent *fin de siècle*.[1]

However, it is clear that a question being asked with increasing urgency in the 1990s – which was certainly not being asked in the 1890s – is 'How can we best *conserve* modernity?' In this question is implicit the idea that modernity must necessarily be something different from tradition, an idea which can easily become exaggerated. Other reasons for this question are complex, and may be said to include the following:

- If we look around the cities and towns of the different regions of the world, from China to Peru, it is obvious that in the past three decades there has been a staggering amount of urban renewal. Go to Adelaide, in South Australia, just to take one example, and you will find a city dominated by commercial skyscrapers which only thirty years ago – to judge by photographic documentation – was a remarkably intact late nineteenth and early twentieth century city, with many handsome classically-inspired façades to the mansions of the rich, and to its financial and other institutions. It was a city which exuded confidence, solidity and strength and moreover much of it was less than one hundred years old.
- Second, if we look back on the *whole* urban landscape of the twentieth century from the standpoint of the approaching millennium, we have the strong and healthy realization that much of what we want to preserve – either because of its intrinsic beauty or interest, or because of its inherent usefulness – is in fact of the twentieth century.
- Perhaps we are also able to accept that there is no longer a requirement to take sides either for or against Modernism. Modernism can now be seen as one of the myriad cross-currents of twentieth century culture, in itself neither good nor bad, though with certain characteristics so far as architecture was concerned which were well expressed in an article by Oliver Hill which appeared in *Architectural Design & Construction* in September 1931: 'I feel we are on the brink of an epoch in domestic architecture and the decorative

arts. These must inevitably reflect our new mode of life, and no longer will the traditional styles of the past, however they be bolstered up and rejuvenated, meet the new conditions. Architecture must conform to the general increase of pace if it is to live. Man's house, as his clothes, his car, plane and speedboat, must be designed to serve his new requirements. Directness, fitness, and economy are the paramount requisites, while simplicity, a maximum of sunlight and such facilities for recreation and exercise, dancing, swimming, and squash, as may be possible, will be large factors to be provided for in the modern house. Their design will need very clear thinking. Traditional motifs being eliminated, their designers will thus be unhampered and free to rely upon proportion, line, form and rhythm, and the selection of material for their effect.'[2]

- A fourth reason for our asking the question 'How best to *conserve* modernity?' with increasing urgency is that traditions of good maintenance and repair, unglamorous but vital activities, seem to have gone out of the window during the late twentieth century except (to take Britain as an example) for such traditional buildings as cathedrals and parish churches, country houses occupied by the more conscientious private owner and by the two National Trusts, and Oxford and Cambridge colleges. The reasons for this may be as much social as architectural, and in Western Europe, at least, the unbearable trauma of the First World War killed off many traditional craftsmen and architects brought up in the Arts and Crafts traditions of skilful repair, as well as creating the intellectual and spiritual environment for the kind of attitude to the past and the present opportunities so well expressed by Oliver Hill. Incidentally, for a substantial part of his life Oliver Hill was the tenant of one of the most magical medieval and seventeenth century houses in England, Daneway, in the parish of Sapperton, Gloucestershire, one of the key rural focuses of the later phase of the Arts and Crafts Movement: while appreciating and respecting it, however, he nevertheless added to it in the way of decoration and works of art describing it to a close friend as 'magic on a scale as never before or since – bizarre, magnificent, crazy, culturally unbelievably rich'.[3]

However, there were alternative ways of looking at things even then; in fact the very same issue of *Architectural Design & Construction* contained the first instalment of a long double article by A. R. Powys, a slightly older contemporary of Oliver Hill, entitled 'Origins of Bad Architecture'. Powys argued that it was 'dependence on reasoned theories' which was the main cause of the present 'unhappy state of architecture', and – as we might expect from someone who spent much of his time as Secretary of the Society for the Protection of Ancient Buildings (from 1911 to 1936) defending vernacular buildings – he distinguished between 'monumental architectures' and 'a lesser architecture that is wholly admirable' and argued that it was digested experience which produced a tradition of good building. He criticized the way in which the SPAB's defence of older buildings had led some to argue for a kind of vernacular revival:

They demand the use of local materials, a use which has become a burden to the man who needs to build; they demand that England shall live in

accord with the catchwords of a few men who do not know that what was once good is now bad, and who, trusting to reason, but omitting in their reasoning many factors, declare that the use of machine-made materials is to be condemned.

He analyses qualities such as *proportional economy* (the idea that an architect or builder can exercise an appropriate degree of elaboration), *traditional experience*, and *cultural experience*:

Today it appears to me that the prevailing urge of cultural experience grows from a natural pride in the newer powers which man has gained over the physical world, and in the manipulation of the materials latent in and produced from the earth. It is in the conscious use of these powers under this cultural urge that a danger to architecture lies; and it is from the natural acceptance of these powers without too conscious a pride in them that I believe the glory of an architecture fitting and harmonious will presently be derived. Indeed, here and there, it is with us today.

And he concluded that:

The chief origin of bad architecture is the consciously laid stress on one or more attributes of architecture which in one or other generation have been theoretically asserted to be essential to the art. A theory has caught the minds of men and has been accepted beyond its merit and other attributes have consequently been neglected – attributes that should have been given proportionate place.[4]

To Powys I shall presently return, as I think there are good reasons for regarding him as a pivotal figure in the development of conservation theory and practice in England at precisely the same moment as the Modern Movement – to which he was by no means unsympathetic – was gaining momentum. But I want first to examine something, at least, of the origins of conservation philosophy in England.

Ideas concerning trusteeship and value

I believe it is particularly important to do this because of the now widely-held view that the main line of conservation philosophy which has come down to us through Ruskin and Morris was applicable – in so far as it was truly applicable, as some would argue – only to old churches and cathedrals, romantic castles, picturesque cottages and farmhouses, and in short to the building types which were prevalent before the Industrial Revolution. I don't subscribe to this view myself because I think there are some over-arching ideas in Ruskin's and Morris's thinking, and in the thinking and practice of their co-workers and disciples, which are almost certainly applicable to *all* buildings or places of value. For example, to my mind, one of the most important bequests Ruskin has left to us is the idea of trusteeship – magnificently expressed in a passage in 'The Lamp of Memory':

The idea of self-denial for the sake of posterity, of practising present economy for the sake of debtors yet unborn, of planting forests that our descendants may live under their shade, or of raising cities for future generations to inhabit, never, I suppose, efficiently takes place among publicly recognized motives of exertion. Yet these are not less our duties; nor is our part fitly sustained upon the earth, unless the range of our intended and deliberate usefulness include, not only the companions but the successors of our pilgrimage. God has lent us the earth for our life; it is a great entail. It belongs as much to those who are to come after us, and whose names are already written in the book of creation, as to us; and we have no right, by any thing that we do or neglect, to involve them in unnecessary penalties, or deprive them of benefits which it was in our power to bequeath[5]

I cannot see that this idea of trusteeship is any less relevant to the buildings or gardens or landscapes of value which have been created in the twentieth century than it is to those of any earlier period; and later on I shall say something about how we assess what is of value, and in precisely what that value lies. What I want to emphasize here is that, from *The Seven Lamps of Architecture* onwards (and it was very widely read, not only in English-speaking countries, and from 1900 even available in French), there was never any excuse for not realizing that there is an over-riding ecological argument for conservation, which we neglect at our peril; in the late twentieth century it is difficult to share Oliver Hill's optimism for the attributes of modern living – we know too much about world poverty, and about the horrific effects of pollution – and we must surely be realizing, if we did not do so before, that any notion of conservation which fails to take into account this idea of trusteeship of the earth's resources must inevitably be a flawed one.

I find myself rather less convinced, though still deeply moved, by Ruskin's idea that the greatest glory of a building '... is in its Age, and in that deep sense of voicefulness, of stern watching, of mysterious sympathy, nay, even of approval or condemnation, which we feel in walls that have long been washed by the passing waves of humanity'; though I recall vividly how I felt three years ago when I entered Walter Gropius's House, near Boston, and found Mrs Gropius's dresses still hanging in the wardrobe, their cutlery and table-linen still in the kitchen drawers, and indeed the whole evidence of their daily culture of living still palpably intact, thanks to the assiduity first of all of their daughter and then of the Society for the Preservation of New England Antiquities. Human associations are indeed *very* important, and the passing of time and the whole dimension of time are important too, but Ruskin perhaps was carried away by his own poetry in giving the 'voicefulness' of age such a key role in the defining of the specialness of a building. Even with twentieth century buildings, which embrace the whole gamut of materials and constructional techniques whether traditional or innovative, it is open to us to value the effects of the gradual softening brought about by years of human use, by the changes and alterations brought about through changing needs and perceptions about the use of space, and by the adventitious effects of weathering and even of pollution.

Indeed, removing the effects of changes and alterations – and even of weathering or pollution – may sometimes be physically harmful; whether it is philosophically desirable may be another matter, and one which can only be judged with sureness if the quality and calibre of our analysis is sufficient for the purpose. What our German colleagues have defined as *Bauforschung*[6] is still lamentably in short supply in many countries; but we shall have little good conservation without it, whatever the date of the building. Buildings do not simply exist as though in a glass case, to be observed by the passer-by; rather they are part and parcel of the continuing life of humanity, touched (as Ruskin argued) by its joys and sorrows, and it is therefore appropriate that they should bear those marks of time. We cannot leave Ruskin without reminding ourselves of certain other key ideas of his which have gone on reverberating ever since in the canon of conservation literature, one being respect for original surface:

> That which I have above insisted upon as the life of the whole, that spirit which is given only by the hand and eye of the workman, never can be recalledAnd as for direct and simple copying, it is palpably impossible. What copying can there be of surfaces that have been worn half an inch down? The whole finish of the work was in the half inch that is gone

Here it will be said by some in relation to twentieth century buildings that much or most of the original surfaces have been produced by machine, rather than by the hand of the craftsman; but I would reply that we must still be discriminating and in two senses. First, in reviewing twentieth century architecture as a whole, it is clear that the craftsman *has* had a role after all; and moreover a role which from time to time has been re-affirmed, and is now once again in the ascendant. Secondly, we must recognize that machines also exist in time and space – and even vary widely in terms of calibre, and in the quality of the products – and there are strict limits to the extent to which a surface produced in, say, the 1930s can be accurately reproduced today; even granted the reproduction to be faithful in appearance, and that has certainly been achieved with panache in some recent restoration projects, the essence still will not be the same. Does that matter? Well, certainly it does if you have any need for or faith in authenticity: if so, is a copy good enough?

Another fundamental point Ruskin makes is to urge the substitution of repair and constant vigilant maintenance for restoration, expressed in words of memorable incantation:

> Take proper care of your monuments, and you will not need to restore them. A few sheets of lead put in time upon the roof, a few dead leaves and sticks swept in time out of a water-course, will save both roof and walls from ruin

and then a little later on comes an idea which I believe the late twentieth century has rebelled against but perhaps for the good reason that it suits less well with the clean lines of the kind of architecture advocated by Oliver Hill and many others, namely:

20

bind it together with iron where it loosens; stay it with timber where it declines; do not care about the unsightliness of the aid: better a crutch than a lost limb

Presently I will describe two contrasting but I believe valid approaches to the conservation of a significant building in the twentieth century, which will illuminate this idea of Ruskin's and a divergence from it. But I want to conclude this rehearsal of Ruskin's principal ideas about conservation with his re-statement of the idea of trusteeship which comes at the very end of 'The Lamp of Memory':

> yet, be it heard or not, I must not leave the truth unstated, that it is again no question of expediency or feeling whether we shall preserve the buildings of past times or not. *We have no right whatever to touch them.* They are not ours. They belong partly to those who built them, and partly to all the generations of mankind who are to follow us. The dead have still their right in them: that which they laboured for, the praise of achievement or the expression of religious feeling, or whatever else it might be which in those buildings they intended to be permanent, we have no right to obliterate.[7]

Again, it will be argued that Ruskin's sentiments cannot possibly apply to twentieth century buildings; yet to whichever point of the compass we turn it is clear that buildings expressive of symbolic or spiritual power have been as much a preoccupation of the twentieth century as of any earlier period. What shall we say, for instance, of the churches of George Pace in Northern England (four of which have been listed), or of Antonio Gaudi's *Sagrada Famila* in Barcelona? What is also fascinating is that buildings conceived in one culture of power have been modified by another, as can be seen in those buildings of the Third Reich in Berlin overlaid by mural paintings in the 1950s to express the radiance of *Socialismus*: in such instances cultural value has been added, not taken away.

Morris and other key thinkers in the circle of the SPAB
There is insufficient space here, and perhaps no need, to rehearse at the same length the principal ideas expounded by William Morris in the foundation documents of the Society for the Protection of Ancient Buildings (SPAB), founded by him, Philip Webb and George Young Wardle in April 1877; yet it is vital that they are not passed by. The most important are three key letters, to *The Athenaeum* on 5 March 1877 concerning the restoration of Tewkesbury Abbey by Sir George Gilbert Scott, that of 15 April 1878 to the Editor of *The Times* concerning the threat to the Wren churches in the City of London, and that of 31 October 1879 to the Editor of the *Daily News* concerning the threatened restoration of St Mark's Venice; the Manifesto of the SPAB drawn up in April 1877; and Morris's speech to the first annual general meeting of the SPAB in 1878. The *Manifesto* is a complex document, which deserves patient exegesis, but suffice it here to say that it contains at least three significant ideas which have influenced much subsequent thinking:

- that 'restorations' mean destruction – here he is repeating Ruskin, who specifically gave his agreement – namely, 'the reckless stripping from a building of some of its most interesting material features';
- that the definition of value can be broadly drawn – Morris says 'If, for the rest, it be asked us to specify what kind of amount of art, style, or other interest in a building, makes it worth protecting, we answer, anything which can be looked on as artistic, picturesque, historical, antique, or substantial: any work in short, over which educated, artistic people would think it worthwhile to argue at all';
- and, again echoing Ruskin, but with the greater cogency perhaps of an essentially practical and creative man, Morris makes a plea for maintenance which has never been bettered in the English language: '.... stave off decay by daily care, to prop a perilous wall or mend a leaky roof by such means as are obviously meant for support or covering, and show no pretence of other art, and otherwise to resist all tampering with either the fabric or ornament of the building as it stands';
- and then comes a clutch of ideas which it would be difficult to sell to the late twentieth century in relation to most buildings of the past, and especially the relatively recent past, when we have become so accustomed to the idea of re-use as the salvation for many otherwise future-less buildings: '.... if it has become inconvenient for its present use, to raise another building rather than alter or enlarge the old one; in fine to treat our ancient buildings as monuments of a bygone art, created by bygone manners, that modern art cannot meddle with without destroying.'[8]

Reflecting on these ideas of Morris, it is curious to speculate how he would have viewed the fact that the concrete and steel structures of the twentieth century decay from the inside out; here the idea of 'antiscrape' is more difficult to apply. However, Morris would surely have inveighed with relish against the twentieth century idea that a new building can be maintenance free. Indeed it is at that very point that we reach a sharp distinction in values between the Morris school and that of the Modern Movement. For Morris, as for the German-speaking and Italian theorists of the late nineteenth and early twentieth centuries, the whole point of 'old work' was that it aged naturally, just like a human being or a more portable work of art such as a sculpture or a painting; by careful maintenance and gentle 'interventions' the life of an old building could be prolonged, but with the marks of aging lovingly respected; for the Modern Movement, however, the ideal was that no weathering should occur but if it did then the intention of repairs or replacement should be to make it 'as good as new'. Here, surely, is a fallacy: why should we not appreciate and enjoy the weathered surface of concrete or accept the fact that a Modern Movement building is now fifty or more years old and may fitfully bear the marks of its age?

I would want to stress that the ideas of Ruskin and Morris are the quintessential *poetry* of conservation, without which we shall scarcely be inspired towards the necessary *prose* of conservation, and that they will sometimes lead us in directions which the original authors could not readily have envisaged; but the vitality and essential validity of their ideas has never been

successfully challenged, which is surely why we continue to ponder and discuss them – but maybe they can also be viewed as a prism or lens through which we should invariably look, when trying to discern what *are* wise conservation decisions in particular cases, in late twentieth century conditions? There is no sense in which they provide a recipe; indeed if we are really looking for a simple recipe, rather than a philosophic basis for our actions, then our search is anyway doomed to failure.

What I believe to be a very creative aspect of the SPAB is that it established right from the beginning a tradition of respect for craftsmanship and for materials; and it is noteworthy that the best of twentieth century architects, even those of the Modern Movement, have shown a respect for materials and the choice of materials and even – though less consistently – for good craftsmanship. No-one saw this more clearly than W. R. Lethaby (1857-1931), first Principal of the Central School of Arts and Crafts and a notable Surveyor to the Fabric of Westminster Abbey from 1906 onwards. Writing in the memorial volume for Ernest Gimson, who had died in 1919, Lethaby said of the SPAB that:

> Dealing as it did with the common facts of traditional building in scores and hundreds of examples, it became under the technical guidance of Philip Webb, the architect, a real school of practical *building* – architecture with all the whims which we usually call 'design' left out. Here we saw that architecture should mean solid realities, not paper promises, names and dreams. Here Gimson's love for old buildings deepened into a passionate reverence, and from this very regard he early came to see that ancient architecture was an essence & reality, not a 'style' which might be resumed in another kind of society at will by a different kind of people. It is a curious fact that this Society, engaged in an intense study of antiquity, became a school of rational builders and modern building. Here Gimson for years was in close contact with Philip Webb, Morris's friend from the Oxford days and for the early years of its existence the architectural member of Morris and Co. – a stern thinker and most able constructor.[9]

Happily, this 'stern thinker and most able constructor', Philip Webb, has left us his whole approach to the conservation and repair of buildings (and also, in his extensive correspondence, his approach to the design of new ones) in a publication put out by the SPAB in 1903 entitled *Notes on the Repair of Ancient Buildings*. Webb had retired from active practice in January 1901, but remained on the SPAB committee; and though it is not certain who actually wrote the text the most likely candidate is the Secretary of the SPAB from 1883 to 1911, Hugh Thackeray Turner (1853-1937), in close consultation with Webb and with Webb's disciple William Weir (1865-1950). This seems to have been the first time the *Manifesto* was published to a wider world, other than being sent in the post to architects and building owners, while the *Introduction* sets out the SPAB's position very clearly. Of course the whole witness of the SPAB (and of similar protest movements in other countries, such as France, Germany, Italy and what is now known as the Czech Republic) has to be seen as a reaction to the restoration mania which had such determined exponents in most European

cultures. One passage in the *Introduction* addresses this question, and will give the flavour of the whole:

> The motive of the first restorers was excellent, but they acted on the false belief that modern work made in imitation of ancient work could take the place of the old without any loss of authenticity or interest as a historical or artistic document. The knowledge they had gained by study they supplemented with theories and prejudices which, if they had gone more deeply into the matter, would have been found to be mistaken[10]

The importance of this 1903 publication is threefold: firstly, it put across not just the philosophical basis of the SPAB's thinking but an approach to actual repair problems which ranged across the whole gamut of what usually went wrong with older buildings and showed that repairs could be carried out without loss of character or integrity; secondly, because it was readily available and amongst the standard works on the shelves of architects' offices for the next two decades or so, it ensured that the Arts and Crafts approach to repair became part of mainstream architectural consciousness amongst those architects, and they were both many and distinguished, who carried on the task of repairing, altering and adding on to houses and churches great and small; and thirdly, it was the prototype for A.R. Powys's great classic *Repair of Ancient Buildings* which was published as a substantial volume in 1929 and has since been twice reprinted, the second time as recently as 1995. Most of the ideas in the 1929 work are already present in that of 1903, buttressed by another quarter of a century of experience, and only the advice on the conservation of mural paintings – a notoriously controversial subject, even now – has failed to stand the test of time until today.

Medieval and modern attitudes to 'old work' and to the more recent past
I now want to look at two contrasting repair or restoration programmes carried out in different parts of England in 1911 and 1994 respectively, to see if they can carry us forward at all in adumbrating a philosophy for twentieth century buildings. The first example is medieval and the second twentieth century, but what is revealing is the different attitudes towards repair or conservation. It is astonishing that the first of these two houses, the Priest's House at Muchelney in Somerset, was recommended for demolition in 1896 and 1901; built around 1400, and altered about a century later, it is one of the happiest survivals of a medieval parsonage house. The reason for the threat of demolition was its parlous condition caused, naturally enough, by prolonged lack of maintenance, and so it presented an apt opportunity for the SPAB to exercise both its philosophical and technical approach. The money for the repairs was raised by Thackeray Turner through a public appeal to which Jane Morris, Thomas Hardy and Bernard Shaw contributed; with money in hand for the repairs the Society was able to persuade the National Trust to purchase it and what then followed was described in *Country Life* by Richard Haslam in September 1994 as:

> a *locus classicus* of twentieth century repair – a point at which the emerging union of the Arts and Crafts and antiquarian tastes of the post-

William Morris generation came together. The Priest's House was lucky to have an architect of the substance of Ernest Barnsley to find the way through. One has the feeling of solutions being found for the first time, and of the forging of a public philosophy which, mercifully, has been firmly taken up since and is widely followed in action today.[11]

In fact, the solutions are those advocated in the SPAB's 1903 publication, to which indeed Barnsley and Gimson (who were close to Philip Webb, and tried to persuade him to retire to live amongst them in Sapperton, near Cirencester) may well have contributed ideas. The most striking thing about the repairs is that they are for the most part *visible*, so honest in that sense, and they have become part of the continuing and developing cultural value of the building. Let me explain further: the north wall was inherently unstable and so the north doorway and the Tudor window above it had to be taken down and rebuilt; but Barnsley felt that the eastern portion, where there had once been a spiral stair, could be strengthened and supported without dismantling. So he proposed a buttress which is a riven slab of blue lias stone, a monolith, which ought surely to be the most famous buttress of the twentieth century; utterly memorable in its visual communication of support, it apparently aroused some anxiety when it was shown in the architect's drawings. Tongue slightly in cheek, one imagines, Barnsley assured Thackeray Turner and the National Trust that it was a local tradition; and all was well. Technically it is of interest in that the weight of the wall is transmitted to the buttress by a new spreader beam of the red tile work which became one of the hallmarks of the tradition of honest and visible repair; at the same time it is arguable that, just as with repairs of the seventeenth and eighteenth centuries where brick was very often used to repair stone buildings, it

Fig. 2.1 The slab buttress by Ernest Barnsley at the Priest's House, Muchelney, Somerset.

Fig. 2.2 Kitchen range added by Ernest Barnsley to the Priest's House.

adds some beauty and variety of colour and texture. Characteristic of the Arts and Crafts approach to adding on to older buildings is the straightforward way in which a kitchen and lavatory have been added, at right angles to the original building, and in materials which are close to the original – stone and thatch – but faced with timber clapboarding.

At the Priest's House, Muchelney, a change of tenancy just over two years ago brought the opportunity for a further programme of repairs, supervised by John Schofield of Architecton. His firm has as one of its tenets (and it is surprising how many architectural practices lately have put down on paper their philosophical approach to repairing and adapting buildings, for example James Simpson of Simpson and Brown, Edinburgh, and Derek Latham, Derby) that 'repair should meet as many of the interests of a building as possible'; this recent work has included renewal of the thatch but, for instance, the sagging timber structure which had become too weak to support the thatch has been left in place but strengthened with steel, both visibly (in which instances it has been painted iron-oxide red) and invisibly (behind a new oak board lining).

At much the same time as John Schofield of Architecton was repairing the Priest's House at Muchelney two years ago John Winter and Associates were working on High Cross House on the Dartington Hall Estate in Devon, built as the headmaster's house of the experimental school established by Leonard and Dorothy Elmhirst in 1931-2, the first essay in the International Modern Style at Dartington, and one of the first in England. It was designed by William Lescaze, a Swiss architect who had settled in America, and it was commissioned from him by the newly appointed headmaster, William Curry, who had previously been headmaster of the progressive Oak Lane County Day School in Philadelphia (1929), the building which had made Lescaze's reputation in America. Dorothy Elmhirst wrote to a friend, Stephen D'Irsay, on 21 March 1935, saying:

Did I tell you that we are building one very modern house here? It was designed in New York by Mr Curry's friend, Lescaze, and it is built up in planes on the slope of a hill, and from every angle I find it clean, stark and beautiful. Certain of the exterior walls are painted blue and, on a day like this, match the sky itself. I wonder whether in a few years we shall regard every other type of architecture stuffy and suffocating, and artificial.[12]

It must be said that the Elmhirsts, Americans themselves, were extraordinarily interesting and enlightened patrons; purchasing the Estate in 1925, they began by restoring the largely derelict medieval buildings, adding new farm buildings and schools as the need arose. The cultural significance of the whole enterprise has been well described by Bridget Cherry in the Buildings of England *Devon* volume (1989):

Dartington is famous for architecture of two periods. The medieval remains are among the most extensive surviving establishments of a great secular magnate; the 1930s buildings include some of the first examples in the country of the newly fledged International Modern style. The preservation and restoration of the first group and the creation of the second arose from the bold and successful reincarnation of Dartington under Leonard and Dorothy Elmhirst as a centre for experiments in rural reconstruction and progressive education Economically the aim of the Dartington Trust was to establish that an estate managed on the latest scientific principles can pay. It started rural industries and a company of builders The buildings for these varied activities, the new housing for the estate workers, and the schools are scattered among the various older hamlets of the parish, to no single coherent plan or design[13]

The important point, to which I shall return, is that the cultural context and significance of Lescaze's *House for Mr Curry* (as it is called in the drawings and specification) are well understood; if it had not been well understood, then it would have been easy enough to discover, as this is a wonderfully well documented house. We not only have the original documentation for the building of the house, and all the complementary records of the Estate, but there is also abundant mention in contemporary literature including a surprisingly sympathetic article in *Country Life* of 11 February 1933 by the *doyen* of country house memorialists, Christopher Hussey. There is an interesting passage in it about colour:

> A more recent development is to direct the eye by means of a graduated tinting of the walls. The natural "chiaroscuro" is emphasized by the walls nearest the windows being painted white or light colour, and the walls farther away progressively darker greys or deeper colour. The device is still experimental, and my own impression from the examples of it in this house is that it works better with colours than with white.[14]

The reinstatement of the colour scheme, inside and out, has been one of the features of the recent restoration work though John Winter claims to have 'used some license' rather than creating Lescaze's scheme exactly. According to an article which appeared in *The Architects' Journal* for 9 February 1995:

> The hallway (with a gleaming chrome handrail to the stairs now re-installed) was painted yellow originally, but that yellow is now carried up on the western wall to the top of the house – with striking results. Lescaze's shades of grey in the living room, intensifying in chiaroscuro fashion, were thought to be too sombre; so the room is now white with a grey-green ceiling. The archive area is an ethereal eau-de-nil; the cafe, a darker green.[15]

Before leaving the original documentation for Mr Curry's house, I cannot resist quoting a couple of sentences by the original occupant:

> To me, serenity, clarity, and a kind of openness are its distinguishing features, and I am disposed to believe that they have important psychological effects upon the occupants. Of this, however, it is too early to speak confidently.[16]

However, there is much that could be said about the rightness or wrongness – or appropriateness or inappropriateness – about what has been done. What is indisputably admirable, it seems to me, is that the house has been put in good order and given admirable new uses, as the archive repository for the Estate and as the setting for the outstanding collection of pots by such artists as Bernard Leach, Lucie Rie, Shoji Hamada, and for the small but choice collection of paintings by Ben and Winifred Nicholson, Cecil Collins and others; but I do question whether, if there had been a really rigorous analysis of the cultural

significance of the house, a concept with which I shall now deal, in the case of a house which is such an important document as this it would have been thought advisable to diverge from something so fundamental as the original and known colour scheme.

The evolution of international ideas about conservation

In an essay entitled 'The Preservation of Ancient Buildings', published posthumously in *From the Ground Up* (1937), A.R. Powys seems to be rehearsing for the contribution he made to the international meeting at Athens in 1931, when he and Sir Cecil Harcourt-Smith were the British representatives; he states that:

> the reproduction of missing parts for academic reasons is harmful, and that aesthetic reasons for such change is suspect – for who, remembering the contradictory opinions as to the "looks" of things which successive generations held, can reasonably suppose his own contemporaries less affected by passing fashion than those which preceded.

He goes on to state that the SPAB 'holds that no prejudices as to the means which may be employed in the repair of an old building should hinder the use of any appropriate material that modern knowledge has provided'[17] and this seems to tally closely with Article IV of the Athens Charter which states:

> The experts heard various communications concerning the use of modern materials for the consolidation of ancient monuments. They approved the judicious use of all the resources at the disposal of modern technique and more especially of reinforced concrete.[18]

I mention this for two reasons. The first is that the conservation, repair and sometimes (as recently at Ludlow Castle) the partial reinstatement of ruins has been a major activity in the twentieth century, and it seems strange that there is such a small literature on the subject. A very wide range of approaches has been adopted. Here in Britain we have an almost exaggerated respect for ruined castles and abbeys, but this very respect can lead to draining away from them the magic which our painters have discerned in them over the centuries. A whole group of twentieth century buildings, including those constructed for military and defence purposes and those associated with the production of atomic energy, are now being valued for their part in evoking the 'memory' of significant phases of twentieth century history. They are often physically damaged or incomplete, and compete with vegetation. Surely their picturesque and emotive qualities are as important to respect or conserve as those of thirteenth century Jervaulx Abbey or fourteenth century Sherriff Hutton Castle? The National Trust clearly thinks so at Orford Ness, on the Suffolk coast.

The other reason for referring to Powys's involvement with the Athens Charter is that it is really the ancestor of the Venice Charter of 1964, with a commendable emphasis on maintenance and repair, though it was the Venice Charter which first promoted the modern idea of 'authenticity', which has ever

Fig. 2.4 One of the concrete 'Pagodas', part of the Cold War defences systems at Orford Ness, Suffolk, now under the care of the National Trust. (The National Trust).

since been notoriously difficult to define. I must say I enjoyed enormously a recent pronouncement by Pascal Mychalysin, the French foreman mason of Gloucester Cathedral, who on being asked whether the renewal of eroded stonework was authentic or not drew himself up to his full height and said: 'Authenticity – it's a myth!' And he may well be right, or he may well be right in owning up to the fact that it cannot always be retained if a building is to be repaired, let alone transformed for another purpose.

However, I here want to declare my conviction that – theorizing apart – the most useful document a practical architectural conservator can have in his hand is the Burra Charter of 1979, with its various revisions and additions of 1981 and 1988. I understand that at the time of writing a revision, or perhaps further additions, is being contemplated; and though that is perhaps as it should be it needs also to be recognized that charters are themselves *documents*, and they therefore exist in the dimension of time like other cultural artefacts, and – this is my own first principle of conservation – nothing of value should be taken away, but perhaps they can be added to, from time to time, and in response to changing needs. We must see what happens. The Venice Charter, I would argue, is too European, and indeed too Latin, in its language and its sentiments to hold a world-wide significance for every culture; and that is probably the reason why the authenticity debate has been raging in recent years, culminating in the Nara Conference in Japan in early November 1994. The declaration which was agreed on there, with some difficulty in the drafting I surmise, respects cultural diversity and therefore 'heritage diversity' (a new concept); it declares that the conservation of cultural heritage is 'rooted in the values attributed to the heritage', and that our ability to understand these values depends on 'the degree to which information sources may be understood as credible or truthful'. It was then found necessary (and indeed helpful) to define 'information sources', namely: 'all monumental, written, oral and figurative sources which make it possible to know the nature, specificities, meaning and history of a property'. The concluding words of the declaration are as follows:

Depending on the nature of the cultural heritage, and its cultural context, authenticity judgments may be linked to the worth of a great variety of sources of information. Aspects of these sources may include form and design, materials and substance, use and function, traditions and techniques, location and setting, and spirit and feeling, and other internal and external aspects of information sources. The use of these sources permits elaboration of the specific artistic, historic, social and scientific dimension of the cultural asset being examined.[19]

Ruskin thou shouldest be living at this hour! Anyone who has ever had to draft a committee document will feel sympathy with the authors of the declaration, but it can hardly be said to inspire. No doubt that is why the debate rumbles on.

What we need, I would suggest, is first of all a philosophy (and I have argued that the ideas of Ruskin and Morris and their co-workers and followers are still relevant and a necessary starting point for a valid conservation philosophy) and secondly a methodology; and, in the absence of anything better, I would again suggest that for methodology the Burra Charter offers as good a basis as any and that it is as applicable to mainstream buildings of the twentieth century as to any earlier epoch; indeed in Australia it has been used chiefly for decision-taking about buildings of the nineteenth and twentieth centuries. The Burra Charter begins with ten definitions of which I will single out three:

- '*Place* means site, area, building or other work, group of buildings or other works together with associated contents and surrounds'
- '*Cultural significance* means aesthetic, historic, scientific or social value for past, present or future generations'
- '*Conservation* means all the processes of looking after a place so as to retain its *cultural significance*. It includes maintenance and may according to circumstances include *preservation*, *restoration*, *reconstruction* and *adaptation* and will be commonly a combination of more than one of these.'

More than at any time in the past we now realize the importance of *context*, and the perils and dangers of taking decisions about significant monuments and buildings in isolation from their physical and social setting; set against such concerns the Burra Charter's focus on *place* rather than monument or building (as in other formulations) is highly significant, and infinitely rich in its implications. Also valuable is the attempt to define *cultural significance*: instead of a lengthy and inevitably restrictive definition the Burra Charter is content to adduce 'aesthetic, historic, scientific or social value' (with which we may compare William Morris's dictum that value resides in 'anything which can be looked on as artistic, picturesque, historical, antique, or substantial: any work, in short, over which educated, artistic people would think it worthwhile to argue at all'), and to guard against fashion by adding 'for past, present or future generations'. At first sight it would seem difficult to improve on the definition of *conservation*, as embracing *all the processes* of looking after a place so as to retain its cultural significance: however, we should perhaps now want to add to this something which would carry the strength of the German term *Bauforschung*

(building research). For, and this is the real point, no competent understanding of a place can be developed without a profound and careful study of it in all its aspects. That having been said, the Burra Charter certainly implies that kind of study in its Conservation Principles, and especially the third which reads that '*Conservation* should make use of all the disciplines which can contribute to the study and safeguarding of a place' and the sixth which declares that 'The conservation policy appropriate to a place must first be determined by an understanding of its *cultural significance*'. Of great importance to the successful use of the Burra Charter are the three sets of *Guidelines* dealing with the concept and establishment of cultural significance (which is virtually another way of advocating *Bauforschung*); the scope, development and implementation of conservation policy; and procedures for undertaking studies and reports which set out all kinds of considerations that, from a certain standpoint, might seem to be obvious but in point of fact are more honoured in the breach than the observance where the Burra Charter or something like it has not been adopted. An exemplary idea is that the report 'should be exhibited and the statement of conservation policy adopted' and that publication of the report is to be encouraged.[20]

An admirable example of doing what you say should be done is given by James Semple Kerr, a leading figure in Australian conservation practice, in the publication of his report on the *Sydney Opera House* described as 'an interim plan for the conservation of the Sydney Opera House and its site'.[21] The great joy of publishing a report such as this, which in sixty-eight pages covers everything advocated by the Burra Charter, is that its recommendations and suggestions can not only be assimilated by the decision-takers (presumably in this case the Sydney Opera House Trust, and the public authorities of New South Wales) but also *debated*. We shall never have a truly responsible regime for conservation, in any country, until those who are responsible for significant buildings, and those who advise and act for them professionally – which should invariably be an inter-disciplinary team – are prepared to make their recommendations and suggestions public, whether through publication or exhibition or both, and to engage in debate about them. It should not be thought that such debate will be hostile (though that will also be a possibility, and sometimes a necessary one), but at the very least it would be well informed.

To sum up: this chapter is necessarily called 'Towards a philosophy for conserving twentieth century buildings' because, clearly, there is a great deal more that might be said and many more examples might well be given of the concepts and modes of repair which are arguably appropriate to buildings which are recognized as having cultural value. At any rate, the first stage is to recognize whether a particular *building* (or *place*) has cultural value; and then to define precisely, by study and close examination, wherein that cultural value lies. Only when that has been done, by pursuing processes similar to those advocated by the tried and tested German notion of *Bauforschung* or those steps advocated by the Burra Charter (which, it has to be said, are remarkably similar), will a reliable course of action emerge. All that a building owner may desire – including additions and modifications, perhaps to suit some new use – may well be possible, and indeed permissible, if the cultural value is not impaired; and that

can only be determined by taking the necessary steps. Undergirding all is the commonly accepted idea that there is such a thing as a *philosophy of conservation*, and that it matters intensely that such a philosophy should be respected; here the teachings of Ruskin and Morris and (I stress it again) their co-workers and followers are still both relevant and inspiring. If a truly European view were to be achieved, and that is certainly desirable, then it would be necessary to consider the writings of other authors, especially in the German-speaking countries and in Italy, where philosophies of conservation have been thought out. But that must await another opportunity, and a broader canvas.

References

1 Powers, A. (1996) 'Pleasure United with Virtue'. *Country Life*, **190**, No 43, 24 October.
2 Hill, O. (1931) 'The Modern Movement', *Architectural Design & Construction*, **I**, No 11, September.
3 Powers, A. (1989) *Oliver Hill (1887-1968): Architect and Lover of Life*, Mouton Publications, London.
4 Powys, A.R. (1931) 'Origins of Bad Architecture', *Architectural Design & Construction*, **I**, No 12.
5 Ruskin, J. (1849) 'Lamp of Memory', in *The Seven Lamps of Architecture*, London.
6 Bauforschung (i.e. 'building research') was a phrase coined by Armin von Gerkan in 1924.
7 Ruskin, J. (1849) 'Lamp of Memory', in *The Seven Lamps of Architecture*, London.
8 Reproduced in full in Kelvin, N. (1984) *The Collected Letters of William Morris*, **Vol 1**, 1848-80, Princeton University Press, Princeton, as sent to Dante Gabriel Rossetti with a letter of 3 April 1877 asking him to join the Committee of the SPAB.
9 Lethaby, W.R., Powell, A., and Griggs, F.L. (1924) *Ernest Gimson, His Life and Work*, Shakespeare Head Press, Stratford on Avon.
10 SPAB Committee (1903) *Notes on the Repair of Ancient Buildings*, Batsford, London.
11 Haslam, R. (1994) 'Priest's House in Muchelney, Somerset', *Country Life*, **188**, No 35, 1 September.
12 Giraud, M. (ed) (1995) *House for Mr Curry*, High Cross House, Dartington Hall Trust, Dartington.
13 Cherry, B. and Pevsner, N. (1989) *The Buildings of England: Devon*, Penguin, London.
14 Hussey, C. (1933) 'High Cross Hill, Dartington, Devon', in *Country Life*, **7**, 11 February. This article preceded others on the repair and conversion of Dartington Hall itself into a 'varied educational centre', and its subtitle declares of High Cross Hill 'Designed by the American architects Howe and Lescaze and recently completed; this is probably one of the most extreme instances in England of the functional type of house associated with the name of Corbusier'.
15 Mead, A. (1995) 'Reviving a fine example of Modernism's blue period', in *The Architects' Journal*, 9 February.
16 Giraud, M. (ed) (1995) *House for Mr Curry*, High Cross House, Dartington Hall Trust, Dartington.
17 Powys, A.R. (1937) 'The Repair of Ancient Buildings', in *From the Ground Up*, Dent, London.
18 International Office of Museums (1933) *Athens Charter*, Institut de Cooperation Intellectuelle, Paris.
19 *Nara Conference on Authenticity* (1995) Proceedings published jointly by UNESCO World Heritage Committee, ICCROM and ICOMOS, Trondheim.
20 ICOMOS (1988) The Australia ICOMOS Charter for the Conservation of Places of Cultural Significance (*The Burra Charter*), 1979 and revised in 1981 and 1988.
21 Kerr, J.S. (1993) *Sydney Opera House*, commissioned by NSW Public Works for the Sydney Opera House Trust, Sydney.

Andrew Saint

A case for reforming architectural values

As the century draws out, it is beginning to dawn on us that our criteria for value in architecture are in the course of fundamental change and subversion. It is a process that is revealing itself most sharply for the architecture of our own turbulent, prolific century – so ubiquitous, so unavoidable. For that reason I shall limit my remarks to the last hundred years, and to Britain alone. But I don't believe we can duck the truth that the whole rickety edifice of architectural value is tottering. A hundred years hence, the way in which people look upon the works of Adam, Ledoux, Michelangelo or Schinkel will have altered utterly. That's more disconcerting, perhaps, than the easier prophecy that the status of such twentieth century titans as Aalto, Lutyens, Mies and Scharoun will have changed in absolute and relative significance. Because it's not just a matter of moaning, as so many English critics have done, that the priorities of modernist architectural orthodoxy have made ordinary people in Britain uncomfortable and must submit to a traditionalist 'makeover'. Rather, the whole concept of educated taste, which may be construed in either traditionalist or avant-garde mode, is slowly eroding in favour of image and immediacy of impact. In the face of that reality, we are beginning to have to think willy-nilly of other ways of operating when we grapple with ways of determining architectural or any other cultural value.

What is architectural value? I shall not attempt a rigorous definition of the thing. Instead, I want to point descriptively to a number of value-systems for architecture current in Britain today. They overlap, shift and confuse; indeed the profound instability of all of them is part of the theme of this chapter. But certain distinguishable attitudes of mind have coloured all assessments of and controversies over architectural value for the past half-century and more. They are:

- The architectural attitude or, more properly, architects' attitude, nurtured in the architectural schools and honed in the architectural press.

- The art-historical attitude, academic by pedigree, connoisseurish by instinct, and wedded to the critical appreciation of the fine arts.
- The archaeological attitude, which grapples less with aesthetic experience than with rarity, technical 'firsts' and the accumulation and docketing of historical evidence.
- The popular attitude, inarticulate, inconsistent and by its nature elusive of definition, but manifest in such phenomena as the irrepressibility of the ornamental instinct in the ordinary dwelling.
- The economic attitude, which looks upon buildings primarily as generators of private or public wealth – a position which often but by no means always aligns itself with:
- The functional attitude, whereby buildings are appraised for the practical efficiency and all-round satisfaction they afford to owners and users.

These last two attitudes do not quite carry the blatant freight of culture with them that my first four attitudes do; I shall be less concerned with them in this paper. But let us not suppose for a moment that the more pragmatic values (or, as the architectural philosophers now call them, 'instrumental' values) attached to buildings can be dismissed as diametrically contrary to true architectural values. The architectural attitude, for instance, has persistently allied itself with instrumentality. Martin Pawley, and others of his ilk, like to argue that the twentieth century needs more throw-away buildings or flexible buildings and that true twentieth century culture is precisely about that quality of impermanence.[1]

In all periods, negotiation takes place between different attitudes and interests of the type I have distinguished in the struggle for cultural consensus. That is what criticism is all about. But a curious feature about architectural criticism over the past fifty years in Britain has been a growing tendency to locate the centre of this negotiation, this ever-shifting argument about value, in the listing process. The listing of historic buildings proffers an official, allegedly objective critical process – a crucible wherein the different cultural ingredients of the different interest groups are systematically refined and resolved. Impurities and irregularities removed, the listing mechanism is supposed to come up with the pure gold of architectural value – the retrospective totality of buildings that the nation should protect, treasure and retain.

Anyone acquainted with the history and day-to-day reality of listing will savour the oddity of this recent stress on it. The mechanism for national listing is not an old one in Britain; it dates back no further than 1944. Nor is day-to-day listing in the hands of an all-wise, disinterested, perfectly informed academy methodically sifting and adjudicating upon the representations of different interest or attitude groups. Instead it is largely delegated to junior staff and now, consultants, working empirically, under great pressure, at speed. There are guidelines and criteria, of course, but the philosophy of listing is still primitive. And yet, in England at least, it is upon this assortment of dedicated but circumscribed individuals that the burden of developing a value-system for twentieth century architecture, particularly for the buildings of the second half of the century, has rested.

How has this emerged, and what have been the consequences? Since the start of listing, the first three of my attitudes, the architectural, art-historical and archaeological points of view, have dominated the process to the exclusion of other views of value. In the days when little was listed after 1840, these attitudes co-existed in tolerable harmony. A timber-framed cottage, for instance, united architectural charm with archaeological rarity-value; an Elizabethan prodigy-house or a Georgian terrace seldom raised conflicts of value between the architectural and the art-historical ideology. With the Victorians, things got harder. Here in the 1960s a head-on clash took place between the rising ambitions of Victorian connoisseurship (abetted in some spheres by industrial archaeology) on the one hand, and architectural progressivism on the other. Architects had worked out their own very selective historical reading of the nineteenth century (devised, as it so happened, by art historians stoking the boilers of the good ship *Modern Movement*). Woe befell any Victorian building that found no place within it! Since then, as we know, professional historians have effectively shooed the architectural fox out of the nineteenth century chicken coop – for reasons that have so much to do with the zeal of enthusiasts, but something perhaps also to do with popular attitudes to architecture. The Midland Grand Hotel lies down in happy harmony now with the St Pancras train shed; both are listed Grade I, and few feel moved any more to commend or condemn the one at the expense of the other.

A similar pattern of events followed for the two inter-war decades, though here the arguments were less aggressive and the process is not yet complete. Progressive buildings were sought out first, then officially protected; conservative buildings (with exceptions – Lutyens tended to be listed very early) have mostly crept into the lists a little later.

Part of the half-articulated philosophy of listing is that the number of protected buildings should be proportionate to their age and rarity – a piece of historical common-sense in which, be it noted, the aesthetic argument plays no part at all. So the closer we come to the present day, the more fiercely the criteria bite. We list less twentieth century buildings because more of them survive. How then do we choose between them? Here the architectural attitude is of help, because it tends to be exacting and exclusive. Few buildings enjoy the highest accolade of architectural criticism. Since the advent of the Modern Movement, with its international frame of reference, the supreme standard of excellence is set higher and remoter and becomes elusive indeed. What hope has Stockport or Stevenage of coming up with a building to vie with the best by Terragni or Asplund or Louis Kahn?

Art history, and the type of architectural history that trundles along in its wake, is a slow-moving thing. It takes years for things to fall entirely into place. We are only now getting the nineteenth century into historical perspective. Yet the practical exigencies of change and the urgencies of the planning process force us to make such mature judgements as we can about the value of buildings dating from the second half of our own century. For this reason also, the modern listing process has been driven largely – to its credit, not exclusively – by the architectural attitude.

Let us now take a closer look at this architectural attitude. The heart of it lies

in the architectural schools and the architectural journals, where a fluid, fugitive dialogue is ever on the move about the nature and value of contemporary architecture. It is fed by fashion, innovation, individualism, ambition, image and – often now – by a hapless degree of esoteric, half-rational theory. It is less concerned with performance in use, user-satisfaction, context, consensus, or the fruits of experience, though homage to these great issues is perfunctorily done in the responsible architectural magazines. The critical model for all this is the concept of the avant-garde, which came to maturity early in this century in art schools, has superficial connections with revolutionary socialism, but is now beginning to show creaking signs of age.

The architectural attitude has changed a good deal over the course of the century. To take just one criterion, that of publication, more buildings were published in 1901 in more magazines than are published today, at greater length and with on the whole a less subjective letterpress; facts mattered then more than opinions. The contents of the architectural press are now altogether more selective and subjective, from the self-conscious cultural criticism of the *Architectural Review* (just getting under way at the start of our century) to the strident 'booming' of the big British stars, the 'signature architects', in *Building Design*. The opinions offered have shifted dramatically, in so far as one can generalize about the matter. One critic, Colin Davies, has argued recently that there is very little candid criticism of contemporary buildings; no one dares to be rude, there is self-censorship, a 'closed system'.[2] That has perhaps often been the case. And yet fashion has changed dramatically. Most buildings favourably published in 1925 would have been scoffed at in 1950 as pompous and conservative, while the efforts of 1950 and even 1975 now all too often look arid and joyless. Unfashionable buildings have often been hard to publish in the detail they deserve. A case in point is the 1950s traditionalist but individualist idiom of architects like Albert Richardson and Donald MacMorran, which failed to get into the smart magazines and were relegated to the unfashionable columns of *The Builder*. Many good buildings were never published at all. Equal but opposite examples of intolerance could doubtless be cited for the 1920s, when the young Danish architect-critic Steen Eiler Rasmussen found our architectural schools (specifically the Architectural Association) dumbfoundingly ignorant of European buildings and languages, and the entire British architectural press shot through with complacency.[3]

The architectural attitude, therefore, is a shaky and inconsistent thing. Objectivity is not to be sought from it. It has the precious qualities of immediacy, availability and the critical habit; it is a first port of call when we're trying to grapple with the vast and confusing legacy of twentieth century architecture. But we need to appreciate also that it is only the mouthpiece of the makers of buildings, indeed of one small sector of the makers of buildings, and of a pressing but by its nature ephemeral concern with the present.

When a building is published in one of the architectural magazines, we have a record, full or concise, of the state of that concern, of current architectural thinking at the time of publication. But of course the architectural attitude is richer than that. In its more sophisticated guises it makes copious use of history and intersects with historical research and criticism in order to further and

reinforce current architectural ideologies. I have already remarked on the men in the boiler-room of the good ship *Modern Movement* – Giedion, Hitchcock and Pevsner chief among them. These three valiant stokers were all art historians, of a kind; and all in the early portions of their careers put history, of an exciting but far from impartial kind, to the uses of architectural ideology. There is nothing wrong in that. History with commitment is history with point and energy; history which is of some use and which enriches the culture and consciousness of some major development in human affairs is the most satisfying and absorbing kind. There is a remarkable amount of history to be found in the architectural magazines nowadays. It is by no means always clear why it is there, but one has the sense that the authors usually suppose, or at least hope, they are stimulating and furthering current architectural thought, even if only by the way of presenting fresh images or re-presenting old ones.

Yet this is not the only kind of practical purpose to which history can be put in relationship with architecture. When it comes to the subject I have in mind, the enterprise of assessing the total legacy of what we have built in the twentieth century, it is clear that this kind of ideological architectural history is not at all the instrument we need. I am talking about the kind of history that offers a fair and judicious retrospective judgement of total national achievement and value in architecture. Both are practical and purposive kinds of history, but they are not at all the same thing.

Both within the listing process and beyond it, this retrospective kind of history is at continuous work on the twentieth century, undermining the ideological certainties of the architectural attitude, substituting complexity for simplicity and a multi-directional sense of purpose and progress for pure linearity. Earlier I distinguished between the art-historical and the archaeological attitudes. Both assist in this process of reassessment. Archaeology, with its traditions of objectivity and its instinct for survey and recording, in principle has the easier task. It seeks out technical 'firsts' or characteristic structures and ensures they can at least be remembered, perhaps even preserved (though the instinct for preservation, the thirst for maintaining direct experience of a building, often comes second in the archaeological attitude).

Critical art history (perhaps I should call it critical history plain and simple) has the harder role. This is partly because the whole slant of twentieth century architectural history has been so bound up with the architectural attitude that the two have become hard to disentangle. But it is also, I think, because aesthetic judgement, the stock-in-trade for the critical art historian, has still to settle down for much of the twentieth century. Such judgement has to be exercised over a huge range of disparate work, a range every whit as eclectic and disorderly as the supposedly ultra-eclectic nineteenth century; and it has to be exercised sternly and sparingly, at least as far as the listing process goes. Aesthetic judgements of a highly subjective kind determine the fate of many twentieth century buildings. In the face of that, it is easiest for historians to connive in and perpetuate the established exclusivisms of the architectural attitude.

My concern is that even this combination of attitudes, exercised with all the intellectual probity in the world, is not giving us a thorough or convincing or representative picture of what matters most about our twentieth century

architecture, is not properly guiding those who have to decide what to look after and cherish. In short, it seems to me inevitable that the listing process will burst apart sooner or later, and with it our whole carefully honed but tenuous structure for evaluating architecture.

I want to go on and illustrate these thoughts by examining just two places of very different type, Welwyn Garden City and Birmingham. I advisedly choose places, not buildings. For our everyday assessments of environmental value do not confine themselves to the limits which are ordinarily insisted upon in architectural judgement.

Welwyn Garden City is the second of the two pioneer planned towns founded by Ebenezer Howard. It dates back no further than 1919, and so is an entirely twentieth century community. It was slow off the mark, though not so slow as its elder sister, the garden city of Letchworth. If the peril of failure ever hung over Welwyn Garden City it has long since blown away; in the early 1990s it boasted the highest domestic rateable values of any British local authority outside London. That is one mark of the town's success – an indicator, if you like, of the economic attitude towards good architecture or planning. Of course we know also that the two English garden cities were internationally influential, mightily affecting planning and domestic architecture in Germany, France, the United States and many other countries. How much built in Britain after 1914 possesses that kind of international significance? The answer is very little. So by two clear criteria, economic popularity and architectural influence, Welwyn Garden City possesses exceptional value. No other twentieth century new town in Britain has achieved that fascinating and desirable convergence – though Milton Keynes may one day do so.

Yet we are hardly conscious in contemporary architectural criticism of more than an occasional and embarrassed genuflection towards the status of Welwyn Garden City. Letchworth, in every way a less mature and successful town, boasts an excellent museum and attracts a modicum of architectural tourists; Welwyn Garden City very few. Letchworth also has a good number of listed buildings, Welwyn almost none. So the official system concurs with the architectural evaluation, as so often. Why is this?

The answer, though familiar to most of us, is quite complex, and I venture to think might puzzle outsiders to the architectural culture. As we know, the listing

Fig. 3.1 Welwyn Garden City, a corner off Handside Lane.

Fig. 3.2 The Quadrangle, Handside Lane, Welwyn Garden City, by H. Clapham Lander, 1920. Unprotected under current legislation.

system deals well with individual buildings in isolation but is less well equipped for assessing and protecting groups of small twentieth century (or for that matter, Victorian) buildings built to a repetitive design, however subtly they may be attuned to their context. Excellence and individualism of architectural design are valued above all; the repetition of a design is held to diminish its significance. Merits of grouping and context demand lesser skills of discrimination and elicit weaker powers of planning control; the job of respecting such qualities is devolved to the instrument of the locally designated conservation area. Even in Letchworth, apart from the pioneering closes and compositions and some individual houses of merit by architects like Parker and Baillie-Scott, most of the early buildings remain unlisted. In Welwyn Garden City, even the subtly changing sequence of frontages and closes along and off Handside Lane is unlisted (and, by the usual rules, increasingly unlistable as the plastic window brigade does its damnedest). Where the local authority is reluctant to designate conservation areas (and Welwyn-Hatfield Council has tended to believe in the connection between property values and freedom from controls), not much can be done about places like these.

The other factors that come into play and discriminate against a popular success like Welwyn Garden City are those of its relative youth and its style. Buildings erected after the First World War are neither as rare nor as old as those built before it, so less of them are listed. Letchworth's early cottages creep under this significant line; those of its sister-foundation, started in 1919, do not. What is more, Letchworth cleaves to the vernacular revival, a style ideologically acceptable to the architectural attitude because it is linked to the progressive creativity of the Arts and Crafts Movement. Much of Welwyn Garden City's domestic architecture (not all) rejects this for neo-Georgianism, a style adopted by its architect-planner Louis de Soissons (following the lead of Abercrombie and Adshead) ironically on the grounds that it was more sophisticated, practical and 'modern' than Parker and Unwin's cottagey, art-and-crafts idiom. Modern, however is just what architectural critics do not see little neo-Georgian houses as being; they stand for the English cul-de-sac – exactly the place where, in the

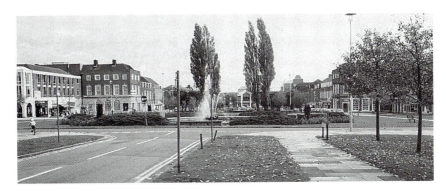

*Fig. 3.3 Howardsgate,
Welwyn Garden City,
looking east across the
axis of The Parkway,
with the Howard Centre
in the distance.*

name of progressivism, British architects should not have been after the First World War but regrettably still were.

This vision is by no means yet dead; and one of the towns we should be proudest of has suffered sorely for it. Slowly, Welwyn Garden City is eroding. The theatre disappeared some years back. Guessens Court, an early essay in communal development, was half-demolished a decade ago. Gravest of all, Howardsgate, the main cross-axis off the proud mall of The Parkway, is now closed by the ponderous prospect of the Howard Centre, replacing a fetching little colonnade in front of the station. This new retailing centre testifies, of course, to the town's success. Something had to be done to make up for the founding fathers' lack of foresight over shopping; nor, to be fair, was Howardsgate the most coherent or untouched of streets. Yet the lack of informed concern, inside or outside Welwyn Garden City, over the integrity of one of modern Europe's greatest success stories in town-making, is surely curious. Are not our priorities wrong somewhere?

*Fig. 3.4
The Howard Centre,
Welwyn Garden City.*

My other example, Birmingham, is rather different. Birmingham is not just a modern city, though it had an energetic post-war bout of trying to convince itself and everybody else that it was exactly that. Nor, notoriously, can it boast the lucid, zoned planning that pervades Welwyn Garden City. Its centre is a patchwork of fragments of all qualities. Here the individualistic approach to value in architecture ought to be valid, if anywhere. Using the kind of 'national criteria' enshrined in the listing process, one ought to be able to pick the good buildings and leave the dross to fend for itself. And that approximately is what has happened. Among twentieth century buildings in Birmingham's city centre, several Edwardian buildings, a few inter-war ones (mostly civic), but so far only one post-war one (the bizarre New Street signal box) have been listed. Which perhaps may seem as it should be.

If however you then ask whether this procedure in any way encapsulates the spirit of the rich and tangled history of Britain's 'second city', I am bound to say that it does not. The anodyne criteria for national architectural excellence skim swiftly over Birmingham, picking up almost nothing of local meaning and character in their net. Can this be right for the second most populous place in the land? A valiant effort to remedy the situation for the post-war period has been attempted by the City of Birmingham's conservation staff, led by Nicola Coxon, whose 'Finding the Fifties' architectural 'trail' draws the rambling wayfarer or resident past a bemusing jumble of structures, some still in neo-classical idiom, other in post-Festival of Britain style with cheerful, tinny curtain-walls.[4]

Fig. 3.5 Grosvenor House, New Street, Birmingham, by Cotton, Ballard and Blow, 1953.

Fig. 3.6 Tube Investment House (former Swallow Hotel), Six Ways, Birmingham, by Cotton, Ballard and Blow, 1957.

At most of these buildings the sophisticated architectural connoisseur will scoff, just as Victorian gin palaces and provincial town halls by borough surveyors used to be scoffed at. No doubt this scoffing will be replaced by a more tolerant attitude in the future. But it is not so much that the scoffing is right or wrong. Rather, it raises the question of the circumstances in which that kind of discrimination is relevant. In central Birmingham it clearly is not. It is a place with a great deal of character, and if we cannot evaluate it in terms of the characteristic, and ask ourselves why Cotton, Ballard and Blow at exactly the same time built here in the neo-Georgian style, there in the Festival of Britain idiom, we will have missed a good deal of the architectural quality and energy of the place. If instead we are bent on remarking how *retardataire* the buildings are, how far behind London and how much further behind New York or Helsinki, we shall have done neither ourselves nor Birmingham any favours. The whole thing becomes an exercise in misconstrued negativity. Ought not some kind of regard to be had to a Birmingham equivalent of 'critical regionalism' (Kenneth Frampton's phrase, but a concept which goes back at least to Lewis Mumford and the liberal, organicist wing of Modern Movement polemics)?

Someone may object that 'if you open the floodgates of taste, let alone listing, to the likes of Cotton, Ballard and Blow, won't that discredit the system?' Indeed it may. Perhaps it should. Let us consider what listing is for. It is not ultimately an objective standard of excellence, however much those who are uncomfortable about living with uncertainty would like it to be. It is a tool of the planning process, a 'marker' which bids everyone sit up and take notice and begin the debate when alteration or transformation of demolition is suggested. There has

Fig. 3.7 Smallbrook Queensway, Birmingham, with sculpture of Hebe, by J.R. Thomas, 1957. The sculpture was commissioned to commemorate the start of Birmingham's Ring Road and the resurrection of the city.

been far too much fuss about listing. It carries an intellectual burden for which it is not fully equipped. The serious decisions about a building should come when change is proposed, not before. One might even be provocative and propose that Birmingham's hated urban motorway – rumoured now to be under prospect of removal – ought with propriety to be listed as the pioneering post-war set of structures most characteristic and most challenging about that car-dependent city. I do not propose for one moment that it should be kept, if Birmingham can find a way of dealing with its transport problems without it. But few with any broad feeling for history could doubt that the Birmingham road system ought to be studied, docketed and recorded by our roving band of consultant archaeologists before it disappears into the scrapheap of time. Which, after all, is what all buildings will eventually do, listed or not. We conservationists really must become more broad-minded, open, modest and amiable about what we think we are doing with buildings.

The two examples I have chosen could be multiplied a hundredfold at all sorts of scales and for many kinds of structures and environments, not forgetting the interaction between buildings and landscape, to illustrate the narrowness of our present criteria for architectural value as represented by the touchstone of the listing system. The cry will go up, of course, that too much is already protected, that the planning process is already hidebound by inertia, and that a stop must be put to the tireless encroachments of the heritage industry. That does not meet my point at all. Of course change must occur to our communities and cities, and that change must often be expeditious. But I am not convinced that the set of criteria with which we operate for demarcating what we value gives fair or balanced expression to the diversity of twentieth century history, society and artistic achievement.

Every baffled newspaper editorial about the listing of ugly concrete buildings, every private sardonic remark about the interpolation of standard panelled doors with fake fanlights into half-privatized blocks of council flats, represents a great deal more than the battle of taste versus ignorance. Behind such ritualistic positions lies a stifled debate about preference, manipulation, dignity and

Fig. 3.8 Signal Box, Navigation Street, Birmingham, by Bicknell and Hamilton, 1966. This eccentric structure alone among Birmingham's post-war monuments has been deemed listable.

personal aspiration in a modern democracy. Our critics and historians are only just beginning to tussle with this without condescension; they have taken a very long time to get there, but they are doing so now. In France (a *dirigiste* culture if ever there was one – it is no accident that the phrase *avant-garde* is French), authors like Pierre Nora have been exploring the concept of popular memory, while François Loyer has started to draw the reluctant authorities into revaluing traditional, regional, twentieth century architectures.[5] Here, the books of Patrick Wright and Raphael Samuel and the controversies between them seem to me especially pressing and pertinent, as they strive to decipher the palimpsest of contemporary British culture and to reveal what exactly people value most about the past and why.[6] Samuel's *Theatres of Memory*, in particular, seems to me a work of prophetic value, because it tries to survey the whole field of popular involvement with the past in the twentieth century, critically yet without snobbery or condescension.

In the end we are obliged to make moral and critical and practical choices and Samuel leaves us few criteria by which to do so. His work is only a beginning. Architecture is a particularly tricky area, because the planning process forces us to make such choices before we have the full maturity of hindsight. These forced early choices are exciting to make; which is why there has been so much of the pioneer spirit of enthusiasm in the post-war listing programme. But until we have gone far further with fresh ways of thinking, our assessments of the cultural value of twentieth century architecture can only be construed as provisional and, very probably, distorted.

References

1 Pawley, M. (1990) *Theory and Design in the Second Machine Age*, Blackwell, Oxford, and other writings.

2 Davies, C. (1997) 'The State of Design Publishing: Editorial Constraints', *Harvard GSD News*, forthcoming.
3 *AA Files*, 20, Autumn 1996, 19 (translation of an article of 1928).
4 (1995) *Finding the Fifties: A 1950s Architectural Trail around Birmingham*, Birmingham City Council, Department of Planning and Architecture and the Ikon Gallery, Birmingham.
5 Nora, P. *Les Lieux de Mémoire*, 7 vols, 1984-1993; François Loyer, 'Le Partrimoine du XXe Siècle en Europe', unpublished paper, c1992.
6 Samuel, R. (1994) *Theatres of Memory*, Verso, London; Wright, P. (1996) *The Village that Died for England*, Vintage, London; (1992) *A Journey through Ruins,* Paladin, London; and (1985) *On Living in an Old Country*, Verso, London.

Part Two

The Building Stock and its Future

Philip Steadman

The non-domestic building stock of England and Wales:
types, numbers, sizes and ages

Introduction

In 1991 the Department of the Environment invited our research group at the Open University to set about building a database of the non-domestic building stock of Great Britain. In the event it has been necessary to leave out Scotland and Northern Ireland, so it is for now just a database for England and Wales. It covers buildings of all types other than houses and flats, and will contain records on an estimated 1 700 000 properties. This is Pevsner's *Buildings of England* in computerized form, if you will, but covering all the bicycle sheds as well as all the cathedrals. Five years on, work for the DoE is still in progress; but the final objective of the project is in view.

This database is not designed to serve the purpose of the conservation of historic buildings. (Its primary use is connected with the conservation of fuel, as will be explained.) It will not contain certain of the items of information which might be important for making policy about the nation's architectural heritage, such as the names of designers or builders, details of style and decoration, or assessments of architectural quality. Indeed in many cases it will not even be possible to identify, from the database, the precise addresses or occupiers of buildings.

On the other hand the database can, because of its comprehensive nature, provide a statistical backcloth against which some strategic issues in conservation can be viewed. It can provide estimates of the numbers and sizes of buildings throughout the country devoted to different uses, or with different structural systems, or with specific wall or roof materials. For the majority of buildings, estimates are available of age and structural condition, and for many the dates at which they were last refurbished. Beyond these raw statistics, the data can offer a picture of the flexibility of various non-domestic building types to accept ranges of different activities. This is, of course, highly suggestive of future possibilities for conversion and re-use.

The national non-domestic building stock (NDBS) database

The work to develop the national non-domestic building stock (NDBS) database is commissioned and funded by the Global Atmosphere Division of the Department of the Environment, as part of its programme of research on climate change.[1] The database will be maintained and used by the Building Research Establishment. The research supports the Government's commitments, made at the Rio 'Earth Summit' and in subsequent international meetings, to reduce the emissions of carbon dioxide and other greenhouse gases which are causing global warming. About half of these emissions, in Britain, are associated with buildings (domestic and non-domestic). They come from burning oil, coal and natural gas, either to heat buildings directly, or to generate the electricity which is consumed in buildings.

So far as houses and flats go, there has for many years been a reasonably good statistical picture available of the numbers and types in the national stock, and of their ages, built forms and heating systems. This picture is provided by the Census, the Department of the Environment's regular House Condition Surveys and other sources. For non-domestic buildings the same has not been true. Knowledge of the composition of the stock has been patchy, especially in the private sector. An absolute prerequisite for testing and setting national policy for fuel conservation in non-domestic buildings is a reliable, comprehensive, statistical overview of what that stock comprises. Once such a database is complete, it may of course prove useful in many other contexts, not only in conservation. The project team has received inquiries over the last few years, for example, to do with disabled access to buildings, property insurance, local air pollution from boilers and factories, and projections of growth in traffic (since non-domestic buildings are the destinations of many trips). No doubt a range of other applications exist, especially in the property and construction industries, and in town planning.

Sources of data: the Valuation Office Agency of the Inland Revenue

The main source of data on which the project depends is the Valuation Office Agency of the Inland Revenue, who make detailed surveys of the majority of non-domestic buildings in order to calculate commercial rates. Only a few types of building are exempt from rates: churches and other religious buildings, agricultural buildings, and all Crown properties including central government offices, Ministry of Defence properties, prisons and courts.

With these exceptions, all rated non-domestic properties appear on the Valuation Office's Rating List. This is a public document, available in both paper and electronic form. The information it gives about each property is rather sparse: just the address, name of the occupier, a brief description of the use of the building ('shop', 'surgery', 'police station') and its rateable value. There are no data in the Rating List about floor areas or other aspects of construction or form. Nevertheless the document provides a complete listing (with the omissions indicated) of over 1.7 million properties (not all of which are buildings), and is useful for obtaining numbers of premises devoted to different activities. Because of its role in taxation, it is unlikely that the List misses many eligible properties, or counts many of them twice.

Fig. 4.1 A commercial building comprising three shops at ground level and two floors of offices above.

So far the terms 'building', 'property' and 'premises' have been used in rather loose and interchangeable ways. In ordinary discussion this is perhaps acceptable, but in any statistical work it is necessary to be more precise. It turns out, perhaps surprisingly, to be a far from trivial question, how to decide what constitutes *one* non-domestic building. The issue has to do essentially with the question of whether a definition is based on architectural and built form criteria, or is based rather on ownership and occupancy.

Consider the kind of combination office and shop buildings which are so common along the high streets of our smaller towns. Imagine a single block, erected all at one time and in a homogeneous style and form of construction, which consists of say three shops at ground level, plus a couple of floors of offices above (Fig. 4.1). All have their own independent access, are separated by party walls or 'party floors', and are owned or rented by different companies. To architects and other building professionals this would be one building. But to anyone counting 'shops', or counting 'offices', and going by ownership or tenancy, it would be four premises or 'buildings' – three shops and one office.

It is the latter kind of definition which is used by the Valuation Office, since it is occupants or owners who are taxed. The rating data are organized by hereditaments: that is, pieces of inheritable or taxable property. The consequence is that what in architectural terms is a single office or mixed-use commercial building will, if shared between several tenants or owners, be split by the Valuation Office into a number of hereditaments. Conversely a single large hereditament, for example the main campus of a university, may comprise many separate buildings. The same could be true for hospitals and larger factories. In what follows, when reference is made to numbers, this will in general be numbers of hereditaments.

The Rating List covers all rated hereditaments, then, but without giving much information on each. There is a second and much more informative database developed by the Valuation Office, to which the NDBS project has privileged access via the Department of the Environment, called the Valuation Support Application or VSA. This covers only a subset of rated premises, which the Valuation Office refers to as the four bulk classes: 'Retail', 'Offices', 'Warehouses' and 'Factories'. Together these account for some 1.4 million hereditaments, or roughly three-quarters of all rated properties by number.

The data contained in this VSA database on each hereditament are, on the other hand, extremely detailed.[2] They include floor area broken down by floor level; some (fairly rudimentary) information about construction including structural system and materials of roof and external walls; and data about services including whether or not the building has central heating, air conditioning, lifts or escalators. Once again, because valuations are based primarily on floor area, one can expect the area data in particular to be quite reliable.

So far as the uses of buildings go, there are several classification schemes. The Valuation Office has its own slightly eccentric system of *primary descriptions* of activities which convey the nature of the business or institution occupying the premises: 'telephone exchange', 'amusement arcade', 'sports centre' and so on. (They are 'primary' descriptions in that they relate to the principal activity of the occupants. Often a single hereditament, with a single occupant, will nevertheless house a combination of uses, such as 'shop and cafe', 'supermarket and petrol station' or 'sports centre and swimming pool'. The primary description picks what is judged to be the more important activity in each case.) The primary descriptions are further qualified by a series of *building use codes* which, despite their name, have less in general to do with activity and more to do with built form characteristics or with the previous uses of premises. For example within the 'Office' bulk class the building use codes distinguish purpose-built offices, offices converted from residential, offices converted from factories or workshops, offices over shops and so on.

A third system by which the occupants and their activities are classified in the VSA is the Standard Industrial Classification (SIC), which distinguishes economic sectors and is very widely used in government statistics to do with production, trade and employment.[3] Thus while a primary description might classify a hereditament as an 'office', the SIC would distinguish whether this was the office say of a building firm, an electronics company or a merchant bank. The SIC is particularly useful in characterizing factories and workshops by industrial sectors.

At an even finer level of detail, the Valuation Office has a further series of classifications for different types of use within a single hereditament – not quite to the room level, but certainly to the level of discrete zones within buildings. Thus the floor area of an 'office' hereditament can be broken down into office space proper, computer rooms, canteens and kitchens, plant rooms and covered parking.

On the ages of hereditaments, the VSA gives both the date of construction and the date of the most recent refurbishment. All dates prior to 1900 are grouped together. From 1900 to 1970, dates are grouped into bands of roughly twenty, then ten, then five years. From 1971 onwards the actual year is specified. The more recent age statistics ought to be especially reliable, since the process of entering buildings into Valuation Office records is triggered in the first place by applications for planning and building regulations permissions. Unfortunately the data about refurbishment in the VSA appear to be incomplete, and are entered for only some 12% of hereditaments. They too are probably more accurate for more recent dates. The Valuation Office allows its surveyors to assess the overall

'quality' of buildings, presumably in terms of structural and decorative condition, on a simple three-point scale, 'poor', 'average' and 'good'. These assessments are not as informative as they might be, since over 80% of hereditaments are classified as being of 'average' quality; but they may be useful all the same.

What is missing from the VSA – at the level of material description of buildings – is any real information about their geometrical forms. There is a field in the database labelled 'built form', but this allows only for a series of codes describing a building's relation to its neighbours: whether it is detached, semi-detached or terraced. This has some value obviously, but the information is difficult to interpret, and perhaps not very meaningful for buildings of any complexity of form. There is no quantitative information in the VSA either about fuel use, which is of course crucial to the Department of the Environment's interests. We will come back to these points.

Up until 1992 all these survey data on non-domestic buildings were held by the Valuation Office in paper files, in a hundred offices scattered across the country. In that year the Inland Revenue took the decision to centralize and computerize the records in the form of the VSA database; and in 1993 the Department of the Environment was fortunate to be able to negotiate access for the purposes of the NDBS project. The rating data remain however strictly confidential at the level of individual hereditaments. In order to preserve this confidentiality the copy of the VSA supplied to the NDBS project has all addresses and names of occupiers removed. Hereditaments can be located only to the nearest postcode.

Some statistics for the
'Office', 'Retail', 'Factory' and 'Warehouse' bulk classes

Recall that the VSA covers the four bulk classes, 'Offices', 'Retail', 'Warehouses' and 'Factories'. Figures 4.2 to 4.4 show some overall statistics to illustrate just a few of the many kinds of analysis which are possible. The pie-chart of Fig. 4.2 shows how the total floor area in the VSA, amounting to some 404 million m^2 (i.e. 404 km^2), is divided between the bulk classes. The

Fig. 4.2 (left) Total floor areas in the Valuation Office's four 'bulk classes' – Office, Retail, Factory and Warehouse – in England and Wales.

Fig. 4.3 (right) Numbers of hereditaments in the Valuation Office's four 'bulk classes' – Office, Retail, Factory and Warehouse – in England and Wales.

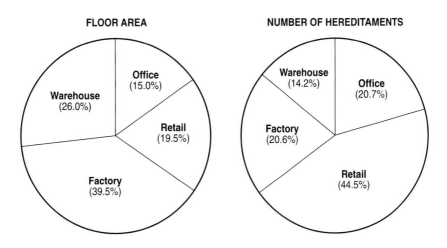

FLOOR AREA

Office (15.0%)
Warehouse (26.0%)
Retail (19.5%)
Factory (39.5%)

NUMBER OF HEREDITAMENTS

Warehouse (14.2%)
Office (20.7%)
Factory (20.6%)
Retail (44.5%)

respective classes are rather broadly defined in terms of uses: 'Offices' comprise both commercial and local government (but not central government) offices; 'Retail' covers a series of commercial services including restaurants and cafes, as well as shops; 'Factories' include workshops plus some miscellaneous industrial premises; and 'Warehouses' include stores. Figure 4.3 shows numbers of hereditaments in the four classes. The larger average sizes of factories and warehouses are clear from a comparison of the two charts.

An analysis of the total floorspace in the VSA across the counties of England and Wales is fruitful. Study of 'Office' hereditaments shows, not surprisingly, the dominance of London and the South-East. 'Retail' floorspace might be expected to be spread roughly in proportion to population right across the country. The Factory and Warehouse bulk classes show heavy concentrations in the North-West, the Midlands and London, with Kent and Hampshire also featuring more strongly than might perhaps be anticipated. Clearly the VSA could be analysed to produce maps for specific building types, and at much finer scales of geographical detail.

Figure 4.4 shows distributions of age of buildings in each of the four bulk classes, by total floor area. In the 'Office' class there is a striking proportion of floor area – some 25% – which dates from before 1900. At the more recent end of the age spectrum, we find that a third of the current stock of 'Office' space has been built in the 1980s and 1990s. In the 'Retail' class nearly 40% of floorspace is from the nineteenth century or older. By contrast, close on half of the 'Warehouse' stock by area has been built since 1970.

FLOOR AREA BY AGE

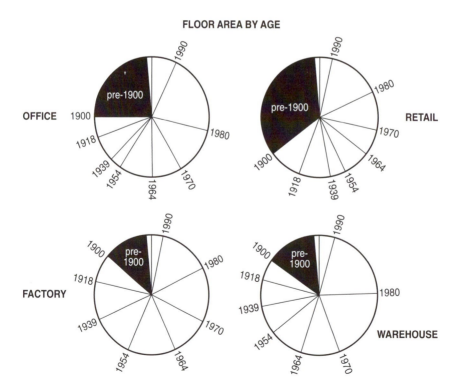

Fig. 4.4 Ages of buildings in the Valuation Office's four 'bulk classes' – Office, Retail, Factory and Warehouse – by total floor areas.

It will be appreciated how all the other information contained in the VSA presents the opportunity for a huge variety of comparable analyses, which can potentially illuminate many questions in building science, using that term in its broadest sense. The results of some such work have been presented in a series of reports to the Department of the Environment.[4] The Building Research Establishment will bring together a digest of these and other data in a forthcoming Non-Domestic Fact File.

Building types outside the VSA database

The VSA, as mentioned, covers only some 70% of all commercially-rated hereditaments however. Indeed the four bulk classes turn out to account for about half of all non-domestic floor area. There are of course many other significant groups of building types besides offices, shops, factories and warehouses. In the private sector there are hotels, pubs, restaurants and cafes; buildings for sports, entertainment and the arts; and buildings associated with transport and communications. In the public sector there are buildings for education, health care, defence and law and order.

For the majority of these types, statistics on numbers of hereditaments can be obtained from the Rating List. Otherwise data on floor areas, and where available on other building characteristics, have been accumulated from a huge variety of sources. These include government departments especially the Department of Health, the Department for Education and Employment and the Department of Trade, the Chartered Institute of Public Finance and Accountancy, British Telecom *Yellow Pages*, market research firms, the English and Welsh Tourist Boards and a whole range of other specialized professional and trade associations.[5] These have yielded an immense mosaic of pieces of information – many of them contradictory – which have been fitted together and reconciled so far as possible, to create a map of all these various 'non-VSA' building types. Many gaps and uncertainties remain; but the diagrams in Figs. 4.5 and 4.6 provide an overview of results to date.

In Fig. 4.5 the area of each rectangle is proportional to the number of hereditaments of each respective type. The overall area represents a total of some 1 685 000 hereditaments (or premises in the case of non-rated types). The four heavier rectangles at the left half of the figure correspond broadly to the four bulk classes of the VSA. (They do not however correspond precisely. There are some types included which lie outside the bulk classes, such as central government offices. Meanwhile there are other types, such as restaurants and cafes, which the Valuation Office counts in the Retail bulk class but which are shown here under Hotels and Catering. For these and other reasons, direct comparison with statistics given for the bulk classes earlier is not possible.) The picture is clearly dominated by shops and offices, while within the Factories and Workshops group it is actually workshops which are in the majority. The Warehouses and Storage group is fairly evenly divided between warehouses and stores (although how the precise boundary is defined between these two types is not entirely clear).

Outside the VSA, hotels, guest houses and pubs account for significant numbers of hereditaments, some 73 000 between them. The 108 000 heredit-

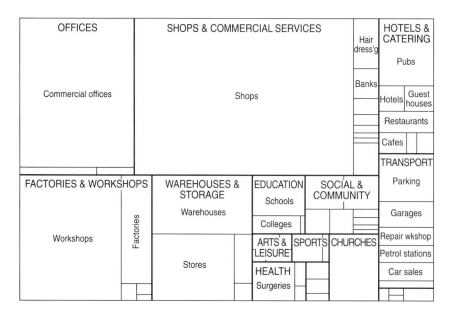

Fig. 4.5 Diagram to represent the entire non-domestic building stock of England and Wales, in terms of numbers of hereditaments or premises. The area of each rectangle is proportional to the number of premises of the given type. The complete diagram represents some 1 685 000 hereditaments/ premises.

aments grouped under 'Communications, transport and the motor trade' are dominated by multi-storey car parks, garages, vehicle repair workshops and petrol stations. (Once again there are problems of definition here. The repair of vehicles, the sale and storage of vehicles and the sale of petrol can be found separately, or in any combination, within a single hereditament. It is a nice question whether to call some of these businesses 'garages', 'car showrooms' or 'filling stations'.)

There are something like 48 000 churches and other places of worship in England and Wales, and around 24 000 surgeries. Certain important building types, like hospitals and universities, are hardly numerous enough to feature in the diagram. There are a few surprises. Buildings for sports, entertainment and the arts might possibly have been expected to feature more prominently. (They account for about 30 000 hereditaments in total.) And few people might guess that there would be 3000 kennels and catteries – more than double the number of nursery schools, or the number of museums and art galleries. Present work on the NDBS project is devoted to getting a clearer picture of how the large undifferentiated masses of shops, offices and workshops can be broken down into sub-types: shops for example into corner shops, supermarkets, department stores, garden centres, takeaway food shops and so on.

Translating these same data into floor areas has some interesting effects in transforming the map (Fig. 4.6). Now each rectangle is proportional in size to the total floor area (on all levels) of the given type. The floor area of the entire non-domestic stock is estimated to be something over 800 km². (Although there remain large uncertainties for many types.[6]) Now shops and offices have shrunk in their relative significance, and factories dominate the industrial building types rather than workshops, because of their larger average area. Schools come to assume importance comparable with shops and offices, accounting as they do for more than 68 km² of floorspace. Both universities (14 km²) and hospitals (25

1 square kilometre ☐

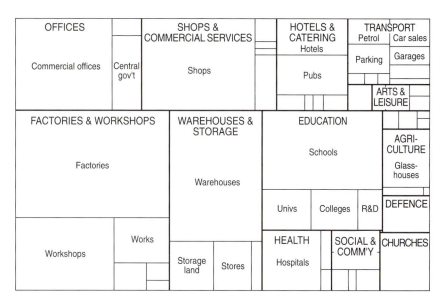

Fig. 4.6 Diagram to represent the entire non-domestic building stock of England and Wales, in terms of floor areas (on all floor levels). The area of each rectangle is proportional to the total floor area of the given type. The complete diagram represents some 800 square kilometres of floor area.

km^2) now make their appearance as very significant types in terms of area. Perhaps the most striking discovery here is the enormous area of horticultural glasshouses: 22 km^2, nearly the same as hospitals. (Although this statistic is doubtless of greater interest to the energy analyst than to the architectural historian.)

It would be possible to carry on indefinitely giving ever more detailed statistics, some curious, many tedious, about the non-domestic stock. Instead let us concentrate on one specific issue, crucial to the preservation of those buildings which are worth keeping: and that is their potential to accept new uses. In order to present some analytical results, it is necessary however to describe another aspect of the project for the Department of the Environment. This work shows, in unprecedented detail, what ranges of activities are presently to be found within different geometrical forms and types of construction. It thus provides quantitative evidence about the flexibility of those forms.

Surveys in four English towns

As mentioned earlier, the VSA database, and some other sources of national data, give little or no information about built form or fuel use. In order to remedy this situation the project team, in collaboration with colleagues at the University of Manchester, have carried out a large-scale programme of specially-targetted surveys in four towns: Manchester, Swindon, Tamworth and Bury St Edmunds.[7] The towns were chosen to be of a graduated range of sizes, spread across the country, and none of them dominated by a single industry. In Manchester the city centre was surveyed. In the other three towns a roughly triangular area was covered, extending from the centre out to the periphery. All non-domestic buildings were surveyed in each case, yielding a total of some 3350 addresses and 4 million m^2 of floorspace.

For every building a whole series of items of information have been collected, many of them equivalent to the Valuation Office records. These include

structural system, materials of roof and external walls, an estimate of the age of the building, and the names and activities of the occupiers. There are however two main differences from the VSA database. The first is that the geometrical forms of buildings are recorded; and the second is that, for a sub-sample of addresses, extremely detailed information has been obtained about building services, all energy-using appliances and equipment, and fuel bills. These data are being collected by a team from Sheffield Hallam University.[8] The energy data are obviously central to the Department of the Environment's interests. But they are not relevant to our present concerns, and will not be described further.

Returning to the question of built form, measurements in plan have been based on 1:1250 Ordnance Survey maps. Every building was photographed from all accessible sides by the surveyors, and storey heights have been estimated from these photographs. Sketches and notes were made on site of roof forms and estimated roof slopes. Thus the external envelopes of buildings have been recorded with reasonable accuracy – although not their detailed internal room arrangements.

All this information has been entered to the *Smallworld* geographical information system (GIS), which combines computer mapping with database facilities. Every building has been broken down into a series of pieces of floorspace, each on a single level, which have been termed *floor polygons*. Figure 4.7 shows how this is done for a large office building in Swindon. Notice how the polygons on different levels allow for overhangs, setbacks, ground-level carriageways and so on. Thus the representation is not just in terms of a prism projected to the appropriate height from the building footprint. A series of attributes are attached to each floor polygon, describing the occupants and their activities, wall and glazing materials, roof type and roof materials where applicable, and so on. Included among these attributes are the floor level on which the polygon is found, and the height of that storey.

Thus although the polygons appear in the GIS simply as two-dimensional shapes on a map, they represent all floor levels overlaid one on another, and so constitute a kind of 'pseudo-3D' model of the building in question. For example it is possible to compute external wall areas automatically, by multiplying perimeter lengths of polygons by storey heights. The forms of pitched roofs are not represented explicitly, but by means of symbolic codes standing for 'monopitch', 'double pitch with gables', 'double pitch with hips' and so on. Because angles of slope are also recorded, the areas of sloping surfaces can be computed.

Inferences about built form in the national stock

These data from the four towns are providing the basis for classifications of built form, and of patterns of energy use, with which it will be possible, using the VSA and other national data, to extrapolate to the level of the country as a whole. To give just one illustration of the kind of approach which is envisaged: the graph of Fig. 4.8 plots total floor area against total exposed wall area for all floorspace surveyed in the four towns. Each data point represents a class of buildings distinguished by activity: all shops, offices, factories and warehouses, according to the Valuation Office's primary descriptions.

Fig. 4.7 A large office building in Swindon, broken down into 'floor polygons' for entry to the Smallworld geographical information system.

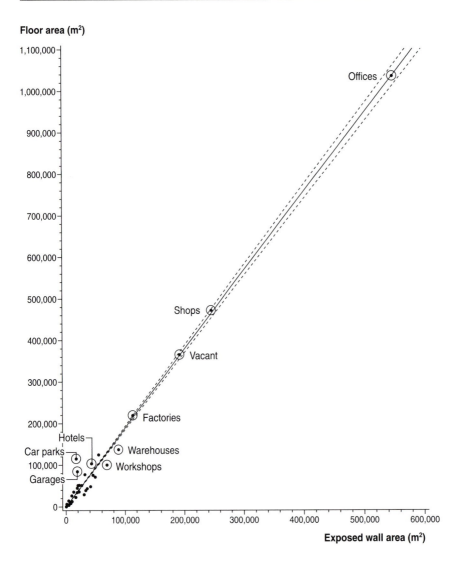

Floor area (m²)

Fig. 4.8 Total floor area (m²) of all buildings surveyed in four English towns for the NDBS project, plotted against their total exposed wall area (m²). Each data point represents all buildings of the given activity type.

Exposed wall area (m²)

 The results are rather remarkable. Many classes of buildings (defined by activities) lie on or very near to the straight line corresponding to a ratio of floor area/wall area close to 0.5. The regularity arises because of the basic constraint which the requirement for sidelighting places on the depth in plan of many major building types. (It occurs also because we are considering large samples of buildings. The single data points conceal considerable variation in the ratio of wall area to floor area within each type.)

 The findings give strong encouragement to the idea that it will be possible to make tolerably secure inferences of exposed wall areas in the national stock, based on a knowledge of floor areas. Indeed it would not be too dangerous to assume as a first approximation that for much of the stock, exposed wall area is half of floor area – although the hope is that much better predictions than this crude global extrapolation will be possible in due course. Notice how building

types with characteristically deeper plans, like multi-storey car parks and garages, rise above the line on which the sidelit types are found. (They have less wall area for given floor area.) There may still be statistical regularities to be discovered for such types, despite the fact that the strict constraints of sidelighting no longer apply.

Flexibility in the relationship of activities to built forms

Such aggregate statistics conceal an enormous variety, of course, at the level of individual buildings. The samples from the four towns provide materials with which to explore the extent of variability of many common types: to embark on a kind of 'natural history' of buildings, an up-to-date version of Durand's *Receuil et Parallèle des Edifices*.[9] Figures 4.9, 4.10 and 4.11 show churches, schools and public houses from the Swindon sample, all to a common scale. To the amateur of architecture, the professional historian, or the conservationist, this richness and heterogeneity are of the essence. To the building scientist wanting to generalize about form, however, they present serious problems of classification. There can, it is true, be a certain consistency in the forms – considered at a more abstract level – of such relatively well-defined types as schools or churches, especially when these are grouped by size and by historical period. But in the non-domestic stock more generally, there are widespread departures from any such well-behaved relationship of form to function.

Consider some examples from Swindon, which are by no means unusual. Figure 4.12 shows a detached suburban villa which, when we look closely, we find is in use as a spiritualist church. Large parts of the so-called 'non-domestic' stock are to be found in former houses or in buildings of equivalent domestic scale and design. Figure 4.13 shows a Victorian primary school building which, when surveyed, was serving as the headquarters of Swindon Silicon Systems. Of all non-domestic activity types it is perhaps offices which are the most heterogeneous. The term 'office building' tends to conjure up in the mind the classic detached, multi-storey, framed-structure block. But in truth a great

Fig. 4.9 Examples of churches from the Swindon sample, all drawn to a common scale.

61

Fig. 4.10 Examples of schools from the Swindon sample, all drawn to a common scale.

Fig. 4.11 Examples of pubs from the Swindon sample, all drawn to a common scale.

number of offices are to be found again in houses; in premises converted from a multitude of other uses; as well as in special-purpose two- or three-storey terraced buildings along high streets, or in low-rise blocks in office parks. As a final example from Swindon, and perhaps the most problematic, Fig. 4.14 shows a complex of sheds which, within the same premises, combine a factory for making doors and window frames, a glass warehouse, some offices and a shop selling garden furniture. Thus this single building goes right across all four of the Valuation Office's bulk classes: 'Retail', 'Office', 'Factory' and 'Warehouse'.

Fig. 4.12 A detached suburban villa in Swindon, used as a spiritualist church.

It becomes very clear that any classification of building types in the existing stock must cope with these very loose relationships between activities and forms: indeed that a clearcut distinction has to be made between the classification of the uses of buildings on the one hand, and the classification of their geometrical properties on the other. An approach to the classification of built forms has been developed for the NDBS project, which is perhaps rather crude and simple-minded in some ways, but at least has the merits of being comprehensive, and of distinguishing certain of the gross properties of form which are likely to affect fuel use in buildings.[10] Certainly this classification does not begin to address many of the complexities and subtleties of form which would interest the critic or the historian. But the ways in which it categorizes forms may still perhaps be of some value in the context of conservation, as well as in other areas of building science besides energy analysis.

Fig. 4.13 A Victorian primary school in Swindon, used as the offices of an electronics firm.

Fig. 4.14 A complex of sheds in Swindon, occupied by a factory, a warehouse, some offices and a shop.

An approach to the classification of built forms

A number of radical simplifications have been made. First, all decoration, surface articulation, attached orders – much indeed of what constitutes the real stuff of detailed external architectural modelling – has been ignored. Second, buildings of complex form are decomposed into simpler component parts. For example the nineteenth century public baths in Swindon shown in Fig. 4.15 can be separated into the halls which house the pools, the cellular office strips around the periphery, the top-lit Turkish baths and so on. Third, a broad distinction is made between what have been termed 'principal forms' and 'parasitic forms'. The principal forms house the main useable spaces in buildings; while the parasites provide for activities which are functionally subservient to, or dependent on, those of the principal forms, and would not exist without them. Examples would include attached circulation towers; ground-level circulation links or covered ways; canopies, porches and portes-cochères; roof-level plant rooms; and small ground-level extensions and lean-tos (Fig. 4.16). Although there are ambiguities in certain cases as to where a principal form ends and a parasite begins, in practice it is not too difficult to set some workable criteria for effecting this separation. The parasitic forms are not ignored in subsequent analysis, but simply treated separately.

Fig. 4.15 The former public baths in Swindon.

Fig. 4.16 Diagrams of 'parasitic' form types.
AC = attached open-sided canopy.
AG = attached glasshouse, conservatory.
AI = monopitch aisle.
AR = covered street or arcade.
AT = atrium.
BA = basement.
BL = balcony.
CB = circulation bridge.
CL = covered enclosed ground-level circulation link.
CT = attached circulation tower.
EX = small single-storey extension.
OR = occupied pitched roof or attic.
PC = porte-cochère.
PO= porch.
PR = roof-level plant room.

Finally we create a separation between shape or configuration on the one hand, and dimensions on the other. Take the simple 'shed' form shown in Fig. 4.17: single-storey, rectangular in plan, double-pitch roof with gables. Its size can be characterized by dimensions of width and length in plan, height to the eaves, and angle of roof slope. By varying these four parameters, sheds of any desired size can be derived. A single generic 'shed' form can stand for all possible dimensioned instances of sheds. Conceptually this is the same as the parametric description of shape which is very common in computer-aided engineering design.

The approach taken to classifying these parameterized forms turns on two essential criteria. The first is whether space is naturally lit or artificially lit. The second has to do with the characteristic sizes of rooms – or perhaps one should rather say, the broad 'texture' of the internal subdivision of the form. A three-way distinction has been drawn here. (Doubtless this could be refined and elaborated.) The first category is *open plan* space, which is self-explanatory. It is conventional to talk of open plan in the context of offices; but here the term is

Fig. 4.17 A generic 'shed' form described by four dimensional parameters.

intended to apply equally to continuous unobstructed space in factories, warehouses, supermarkets and so on. The second is *cellular* space, consisting of a regular subdivision into more or less equal-sized rooms, as in cellular offices, hotel rooms or school classrooms. The third category is what have been termed *halls*, by which is meant large single spaces for assembly or performance. The type would cover not only all theatres, cinemas, lecture halls and auditoria, but also churches, courts of law and television studios.

It will be appreciated that the lighting distinction is of direct importance in the context of any analysis of electricity use. Both the lighting criterion and the spatial subdivision criterion are connected with the characteristic depths of buildings in plan, which in turn affect the ratio of volume to surface area – and so heat loss or heat gain – as well as the possible demand for mechanical ventilation or air conditioning.

By permuting the two lighting criteria with the three criteria having to do with internal subdivision, we obtain six basic types of space: daylit cellular, artificially lit cellular, daylit open plan, artificially lit open plan, daylit hall, artificially lit hall. The typical uses of daylit cellular space include most residential activities – in hotels, pubs and private rooms in hospitals – as well as small corner 'shops' whose forms are equivalent to terrace houses. Toplit cellular space is found on occasion in public baths (cf Fig. 4.15) and in the changing rooms of gymnasia and sports centres. Artificially lit cellular space is rather improbable architecturally, because natural lighting and ventilation are generally considered essential for all smaller 'habitable' rooms, of course. Most office uses are to be found either in daylit cellular or daylit open plan space.

Multi-storey mill-type factory buildings are generally daylit open plan. The category artificially lit open plan is typical of the sales areas of larger shops, some industrial production areas, and many warehouses. All theatres and cinemas are artificially lit halls; while churches, community halls, lawcourts and halls for many sporting activities tend to be daylit halls.

Beyond this simple six-way classification, a series of further distinctions have been introduced for convenience. These have to do for the most part with

whether natural lighting is provided via sidelighting or toplighting (or both); and with numbers of storeys. Multi-storey forms of four storeys or less have been separated from those of five storeys or more, this being the approximate threshold at which passenger lifts become obligatory. Certain categories of single-storey space have been isolated. A category for 'single room forms' has been introduced to cover little buildings such as kiosks or sports pavilions, where the distinction between open plan and cellular becomes meaningless. Finally we have introduced some special versions of forms characterized by their structural properties. For example open plan artificially lit space can be provided in the form of trucking or car parking decks. Both open plan space and halls can be accommodated in 'shed' structures (cf Fig. 4.17). Converted railway arches are given a separate category in their own right.

For much (although not all) of the work on the NDBS project it is sufficient to treat these built forms as if they were separate independent entities. In reality as we know they are often combined into more complex 'composite' forms, through a process which can be imagined as that of placing built form components either beside each other or on top of one another. The constraints in practice on possible combinations have mostly to do with structural limitations, and with natural lighting, whether supplied from the side or the top. The relevant 'lit surfaces' of the form must clearly remain unobstructed. Many composite forms are produced by wrapping single-aspect sidelit space around the outside of artificially lit or toplit forms. For instance sidelit cellular space can be wrapped around toplit halls (cf Fig. 4.15), or around artificially lit open plan space.

Diagrams of all the types of 'principal forms' used in the classification of the four towns' data are given in Fig. 4.18. These include two 'composite' types which occur with sufficient frequency for them to be coded as such. The first is CDO, cellular sidelit around open plan artificially lit space. This is found typically in department stores, in the lower floors of some office and mixed-use commercial blocks, and in the lower floors of many hotels and larger pubs. The second is CDS, cellular sidelit around open plan space within a single shed. This is found where small offices are created along the edges of sheds devoted to factory, warehouse or workshop uses.

The component forms of all buildings at the 3350 addresses in the four towns have been classified according to the schemes indicated in Figs. 4.16 and 4.18. Figure 4.19 shows the relationships, for these buildings collectively, between their principal form types and the activities which are accommodated. The latter are classified according to the Valuation Office's primary descriptions. The numbers give gross floor area (m^2). Thus the entry of 1551 m^2 at the extreme top left of the table shows that this quantity of floorspace is to be found in built forms categorized as CS4 (cellular sidelit on four storeys or less) occupied by petrol filling stations. (These are the office or shop parts of the filling stations. There will also be 'parasitic' canopies, as well as some other built form types.) It should be emphasized that there is by no means a universal one-to-one mapping here of individual institutions or businesses onto single forms. Any large institution is likely to occupy a number of built forms, of similar or different types. Conversely, several enterprises may well share a single built form – as in the example of the combined shop/office building illustrated in Fig. 4.1.

Fig. 4.18 Diagrams of 'principal' form types. Arrows show direction of daylighting.

CS4 Daylit (sidelit) cellular strip, 1- to 4-storeys.

CS5 Daylit (sidelit) cellular strip, 5-storeys or more.

OD4 Daylit (sidelit) open plan strip, 1- to 4-storeys.

OD5 Daylit (sidelit) open plan strip, 5-storeys or more.

CT1 Toplit cellular, single-storey.

HD Daylit hall, either sidelit or toplit (or both).

HA Artificially lit hall. (No diagram is shown for HA 'artificially-lit hall', equivalent to HD in form.

OS Open plan space in a single shed.

OC1 Open plan continuous single-storey space.

OG Open plan car parking or trucking deck.

OA Artificially lit open plan multi-storey space.

SR Single room form.

SSR String of single room forms.

RA Railway arch.

Composite forms:
CDO Daylit (sidelit) cellular strip around some or all edges of artificially or toplit open plan space.

CDS Open plan shed with daylit cellular strip or strips inside, along one or more edges.

Flexibility in the relationship of activity to built form

Figure 4.19 substantiates many of the points made earlier about the flexibility of built form types to accept different activities. In general, any column in the table in which large numbers of entries are found, must correspond to a highly flexible type of form. CS4 and CDO are outstanding examples: practically every activity (in terms of primary descriptions) occurs within both these types. Meanwhile a row in the table with many entries tends to signify that the activity in question is very adaptable, and can take place within any of a great variety of forms. 'Shops' and 'offices' are cases in point.

At the opposite extreme, there are certain cases of highly specific mappings of activity onto built form. Not surprisingly, the great majority of OG floorspace (artificially lit open plan car parking or trucking deck) is occupied by 'garage' and 'car park' activities. (The smaller areas of OG space under 'office' and 'shop' correspond to parking levels within large office buildings and shopping centres respectively.) This is an inflexible type of form.

Some care needs to be taken, certainly, with the interpretation of these results in relation to flexibility; and it would be wrong to encourage over-simplistic conclusions. That 'factories' are to be found in CS4 (sidelit cellular space on four storeys or less) as well as in OC1 (single-storey open plan space, either artificially lit or toplit) is *not* an indicator that the industries in question can be housed as conveniently in the one form as the other. It is a consequence of the obvious fact that factories typically combine a variety of activities within the one set of premises, to which the different forms are suited. The CS4 accommodates the office part of the factory, while the OC1 houses the production and storage areas.

There is a characteristic 'built form recipe', as one might say, by which each individual factory hereditament tends to be made up. To take another example: we find that individual schools are typically composed of a certain proportion of CS4 forms, to accommodate the classrooms and staff offices, a number of daylit halls HD housing the assembly hall, dining hall and gymnasium, as well perhaps as a number of single room forms SR for temporary classrooms, various parasitic forms and so on.

The results in Fig. 4.19 are also to a degree dependent on the specific categories by which activities are grouped in the Valuation Office's classification scheme. For example the description 'shop' is very broad and takes in everything from little corner shops, through 'standard units', to department stores, supermarkets and retail warehouses. If 'shops' were disaggregated into these more specific sub-categories, then the mapping onto built forms would change substantially. The corner shops would all be found within CS4, the supermarkets and retail warehouses within the various single-storey open plan artificially lit types, and so on.

Despite these qualifications however, the overall point remains. There is still an enormous flexibility, of which this summary table provides just a panoramic overview. More work is needed to examine these patterns in detail. Many types of institution or business need to be conceived, as we have seen, in terms of combinations of activities, which demand particular combinations of built forms into 'composite' arrangements. Other characteristics besides the basic form type

Activity	CS4	CS5	OD4	OD5	CDO	CT1	HD
Petrol filling station	1551						
Vehicle repair workshop	5830						
Garage	633				1 079		
Hotel, motel	32 572	7 956			46 758		104
Boarding house	3 445						
Public house	31 934				5 368		119
Wine bar	8 596	503			2 941		
Restaurant	21 355		771		15 093		
Cafe	6 589				3 212		146
Market							
Shop	197 067	1 427	5 845	3 303	141 328		744
Bank	3 356		2 197		4 671		113
Betting shop	1 030				179		
Hairdressing salon	11 522				2 691		146
Kiosk					58		
Launderette	541				137		
Post office	1 530						
Showroom	756						
Office	1 643 643	80 028	6 342	84 373	725 304	75	233
Local government office	38 686	4 173	816		10 665	199	720
Warehouse	18 711				9 359		
Storage depot	1 569						
Store	1 488				675		
Factory	22 225			10 064	3 210		164
Mill	30 233		2 039				
Works	11 205		377				
Workshop	32 445		1 119		34 724		
School	49 870		141		6 670	712	6 854
College	56 726	8 048	1 822		13 925		
Library	13 016		1 684		5 230		2 748
Museum	3 780						
University, polytechnic	5 589				24 864		
Surgery	18 996				3 159		
Health centre	4 195				2 279		
Hospital	36 734		126		7 695		369
Community centre	3 968						1 520
Clubhouse	14 584		785		8 864		1 051
Leisure centre					434		
Hall	175						3 613
Sports centre	1 103				271	383	3 091
Stadium	732						
Cinema	1 519				2 673		
Amusement arcade	1 671				720		
Bingo hall	1 066						
Theatre	7 095				1 908		3 935
Police station	12 188						315
Law court	8 817				1 277		2 730
Church	5 960				2 177		11 571
Telephone exchange			3 372				
Bus station	2 764						
Car park							

Fig. 4.19 Relationship between activities, as classified by Valuation Office 'primary descriptions' (rows) and 'principal form' types (columns), for all relevant floorspace in the four survey towns

HA	OS	CDS	OC1	OG	OA	SR	SSR	RA
	893		63			66		
	15 908	5 829	4 660			322		3 079
	3 752	1 079	588	62 718		136		
	134				1 331	438		
	63					41		
	1 302		572			597	85	378
			92		1 388	12		390
	310		447		1 437	336		234
	73		59		1 265	122	21	
	578					22		
421	10 359	977	20 702	8 445	96 709	3 668	94	582
					1 188	207		
			35			20		
	53		100		529	313		
					66	17		40
	25		46					
	1 102		386		600	35	42	
	1 097	1 666	2 357		821	81	159	
	5 734	9 876	2 772	6 932	9 758	1 424		
					319	582		
	40 712	42 933	32 072		1 364	859	150	
	2 086		21 922			232	93	
	172	498	657			60		
	63 633	22 558	55 880		23 244	1 321	1 001	
	238							
	7 215	3 598	50 764		1 067	2 139		
	31 873	10 728	14 495		44	1 000	119	305
235	776					1 242		
	2 026		1 708			367		
					2 675	115		
		5 449				207		
	3 548					31		
					28	61		
			450			34		
	823					372	119	
						80		
492	461	285	142		1 599	832	175	
	41					140		
	1 282				2 036	46		
						210	109	
6 420						49		
					134			290
1 671			33			11		
4 539								1 995
	753		1 261					
			295			25	14	
1 173	167					302		
					4 236			
	2 161		4 567	2 610				
	746			107 142		121		

See Fig. 4.18 for an explanation of the abbreviations and diagrams of the form types.
Numbers give floor areas (m^2).

71

need to be considered, of which size and number of storeys are just two which come immediately to mind. It may then be possible to use these findings, suitably elaborated, to construct certain larger groupings of types of institutions or businesses – perhaps one might call them 'generic functions' – which can all be accommodated interchangeably within specified types and sizes, or combinations of types and sizes, of forms. This in turn could provide the kind of strategic picture of the flexibility of the existing stock which would be directly useful in framing conservation policy.

References

1 For a general description of the project and its aims, see Steadman, J.P., Bruhns, H.R. and Rickaby, P.A. (1994) *The National Non-Domestic Building Stock Database: An Overview*, Report to the Department of the Environment and the Building Research Establishment, Centre for Configurational Studies, The Open University, Milton Keynes.

2 For a full account see Bruhns, H.R., Steadman, J.P. and Rickaby, P.A. (1994) *The National Non-Domestic Building Stock: Some Preliminary Analyses of the Valuation Support Application (VSA) Database*, Report to the Department of the Environment and the Building Research Establishment, Centre for Configurational Studies, The Open University, Milton Keynes.

3 Central Statistical Office (1981) *Standard Industrial Classification*, Revised 1980, Her Majesty's Stationery Office, London.

4 A list is provided in Steadman, J.P., Bruhns, H.R. and Rickaby, P.A. (1994): see Ref. 1.

5 Steadman, J.P., Rickaby, P.A. and Bruhns, H.R. (1996) *A Classification of Non-Domestic Buildings, and Procedures for Integration and Manipulation of Building Stock Data*, Report to the Department of the Environment and the Building Research Establishment, Centre for Configurational Studies, The Open University, Milton Keynes.

6 One large area of uncertainty concerns the 'Factory' bulk class in the VSA, where comparisons with floorspace statistics produced from Inland Revenue rating data in 1984 appear to show a 50% reduction in factory floorspace over the decade to 1993. Some experts in the field have privately expressed doubts as to whether such a marked decline can actually have occurred.

7 Brown, F.E., Bruhns, H.R., Rickaby, P.A. and Steadman, J.P. (1992) *An Analysis of the Non-Domestic Building Stock of Swindon*, Report to the Department of the Environment and the Building Research Establishment, Centre for Configurational Studies, The Open University, Milton Keynes; and Brown, F.E., Bruhns, H.R., Rickaby, P.A. and Steadman, J.P. (1993) *An Analysis of the Non-Domestic Building Stock of Manchester, Tamworth and Bury St Edmunds*, Report to the Department of the Environment and the Building Research Establishment, Centre for Configurational Studies, The Open University, Milton Keynes.

8 See for example Ashley, A., Mortimer, N.D. and Rix, J.H.R. (1993) *Energy Use in the Non-Domestic Building Stock*, Report to the Department of the Environment, Resources Research Unit, School of Urban and Regional Studies, Sheffield Hallam University, Sheffield.

9 Durand, J-N-L. (1801) *Receuil et Parallèle des Edifices*, Paris.

10 Steadman, J.P., Bruhns, H.R. and Rickaby, P.A. (1994) *Classification of Building Types in the National Non-Domestic Building Stock Database: An Overview*, Report to the Department of the Environment and the Building Research Establishment, Centre for Configurational Studies, The Open University, Milton Keynes; and Steadman, J.P. (1994) 'Built Forms and Building Types: Some Speculations', *Environment and Planning B: Planning and Design*, **21**, s7-s30.

Acknowledgements

The work described here is that of a large team, and many of the analyses and ideas presented are those of my colleagues, in particular Harry Bruhns, Peter Rickaby, Frank Brown, Senino Holtier, Bratislav Gakovic, Mark Smith and Deirdre Bethune. The NDBS project is funded by the Department of the Environment, as described. Additional financial support for the four towns surveys and work with the *Smallworld* GIS has come from the Engineering and Physical Sciences Research Council and The Open University.

Kenneth Powell

Beyond the fringe:

fighting for the appreciation and conservation of twentieth century architecture

Casework is the *raison d'être* of the amenity societies, much as patient care is that of family doctors. Indeed, the buildings we deal with might be seen as our 'patients' – sometimes we lose them. Others recover and find a new lease of life, set to outlive us. We have to make a judgement on priorities. Our resources are limited and the demands on them vast. We have plenty of people who want to tell us how to do our job. It is a matter of judgement – and common sense. Buildings are not, of course, quite like people. Some are expendable. Society changes and old uses fade away. In many cases, buildings can be adapted to meet changing needs: refurbishment is now a major part of the workload of every architectural practice. From where I sit in Clerkenwell, I can see very routine 1950s and 1960s offices and industrial buildings – none of them of special architectural interest – which have been snapped up by developers for conversion into stylish 'loft' style apartments. I can also see the house that Piers Gough built in the 1980s for Janet Street-Porter, a wild, wilful and unforgettable intrusion. But who would want a world without new buildings? The excitement of the best of the new – by Will Alsop, Zaha Hadid, Future Systems, not to forget Rogers and Foster – is equal to that experienced 60 years or more ago when new buildings by Connell, Ward & Lucas, Lubetkin or Wells Coates were unveiled.

A recognition of the worth of inventive new design has to underlie the work of any society claiming the twentieth century as its sphere of interest. Not that we are heedless followers of trends. Our casework committee comprehends a wide range of tastes and approaches. We have an architect who is expert on the work of Lutyens and the inter-war traditionalists, another who worked with James Stirling, enthusiasts for late Gothic Revival and for the New Brutalism. We are an alliance of interests. Some members groan when the Hayward Gallery is discussed. Others see few attractions in Stockbrokers' Tudor, however well done. But we know that the debate on the nature of the twentieth century 'heritage' is far from over and we learn from each other.

The Twentieth Century Society is learning and discovering in much the way that the Victorian Society (and I have been a member of that Society for 25 years) was in the late 1950s and 1960s. The post-war listing programme, in which we have been actively involved, has stimulated research into buildings and architects and produced challenges to established views of the post-war era. Our own walks, tours and conferences – which are much more than a diversion for members – have uncovered a lot more.

Casework is a communal activity in that, without the monthly meetings of the committee, it would be hard to imagine how it could be done at all. But the routine of writing letters, telephoning planning officers, attending site meetings and wading through planning applications is mostly the work of our caseworker, currently Hedwig Saam, though I am involved in a number of the cases (especially those which involve matters of policy or principle and thus impinge on our wider concerns).

The Society's decision to change its name (it was founded as the Thirties Society in 1979) reflects, of course, the growing concern with post-war buildings – though pre-1939 buildings still form a major focus of our casework. In principle, our remit extends up to yesterday. Hence the interest in the 1980s 1 Finsbury Avenue block which seemed to be 'at risk' (see the case-study below). There are those in our own ranks who feel that an interval – maybe 30 years is about right – is needed before the true value of a building can be dispassionately assessed. In practice, we have, as in all cases, exercised our judgement. In recent months, for example, we have been engaged in discussions about alterations to two 1980s buildings by James Stirling, after Lutyens the most influential British architect of this century.

The Society's resources, as I have said, are modest. But our geographical coverage extends across the whole of England and Wales (Scotland is, for most purposes, another country, though our present Chairman resides there). Campaigning far from London is not always easy, but the Society has to be in tune with local issues. One of our most intractable cases, that of the Brynmawr Rubber Factory in Gwent (built 1946-52 and listed II*) has produced a fierce debate in the region, centring on the relevance of this Modern Movement monument to present day needs (notably for more jobs). We cannot ignore this debate, though we can point out that the factory is arguably the only twentieth century building of world interest in all Wales. If it goes – as it may yet do – Wales may come to regret its loss. Moreover, the building seems so usable – yet, despite vast effort, the elusive 'right' use has not appeared. And now there is a valid listed building consent to tear it down.

Few buildings can be monuments, preserved for their own sake (though it is wonderful that the National Trust now owns and opens to the public Goldfinger's house in Hampstead). Twentieth century buildings are neither scarce nor, on the whole, 'special'. When I was a child, the bulk of the built environment was still Victorian. The clearances of the 1960s changed that. Most of our cities are now quite largely post-war in date and there is much about them that we do not love. We are only just beginning to address the issue of conserving entire areas of twentieth century date, as opposed to single buildings. It would be folly to suppose that we can be anything but selective.

Yet the astounding quality of the best work – so much of it – achieved during this century stands out. Increasingly, we can see the themes and ideas which link the modern heritage to that of preceding centuries. The idea that the Modern Movement was an unnatural rupture with the past seems increasingly misguided. The heritage of the recent past is being rediscovered. The Royal Festival Hall, one of our best post-war buildings, is recovering its glamour at the hands of Bob Allies and Graham Morrison, young architects who find active inspiration in the work of Martin and Moro. Alexander Fleming House, Goldfinger's noble but austere Constructivist masterpiece, will soon be restored as apartments, a key element in the renaissance of Elephant & Castle. And Bankside Power Station will be the Pompidou Centre of London, a dynamic merger of the industrial architecture of the past and the sensitive adaptive modernism of the Millennium. These projects will be the markers for the revival of a neglected patrimony.

Pioneer Health Centre, Peckham, London
(Sir Owen Williams, 1933-34; Grade II)

The first of the new health centres of the inter-war years was built at Peckham in south London and was the brainchild of two doctors, husband and wife, working in the area. The 'Peckham experiment' (as it became known) was intended to monitor and steadily improve the health of the local population by offering regular medical check-ups, a place for healthy exercise, and a social venue in one building. The intention was preventative, rather than curative, care. The concept was unique at the time and inspired other such ventures – for example, the Finsbury Health Centre, which opened in 1938.

The engineer Owen Williams (1890-1969) had made his name with his contribution to the 1924 Wembley Empire Exhibition. During the 1930s, he designed the Empire Pool at Wembley and major factory buildings for Boots, Nottingham. At the Pioneer Health Centre, Williams used a reinforced concrete structure of load-bearing columns which allowed the use of large areas of glass in the elevations and strikingly transparent corners of the building.

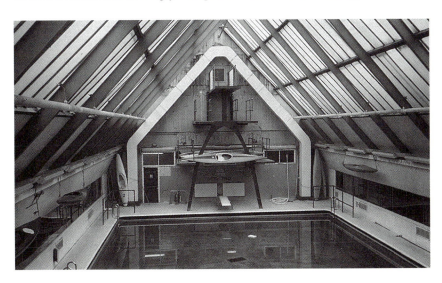

Fig. 5.1 Swimming pool in the Pioneer Health Centre, Peckham, London, by O. Williams, 1933-4.

Visually, the most stunning feature of the Health Centre is the centrally located swimming pool. This feature, however, also played a part in the decision of the present owners to close and sell the building. Southwark College, which has been using the Centre for some years, claimed that it could no longer afford the costs of maintenance, regarded the building as ill-suited to its needs, and found the pool, in particular, a needlessly extravagant amenity.

During the summer of 1996, the building was closed and put up for sale. The Society had a meeting with Southwark College before the building was vacated. At this time, the College was in negotiation with a possible buyer who proposed to turn the Centre into a residential nursing home – the internal spaces would have been seriously compromised by sub-division and the pool covered over. We expressed concern at this possibility and questioned whether the right use had been found for the building. Southwark Council has since reconsidered the future of the Centre and we were encouraged to learn that sports or leisure use is being investigated. In the case of this very important – but relatively little known – building, we were able to encourage an appropriate new use through informal discussion, before any formal planning application was made. We hope for a happy outcome. We also hope that the listing of the building will be reconsidered – it deserves to be II* or even I – in recognition of its great qualities.

1 Finsbury Avenue, London EC2
(Arup Associates – partner in charge, Peter Foggo, 1984; unlisted)

The atrium at Finsbury Avenue was a pioneering structure of its period – the elegantly detailed building set the pattern for the adjacent Broadgate office development, itself partly designed by Arup Associates. Early in 1996, the Society discovered that the occupants of the building, SBC Warburg, wanted to close off and floor-in the atrium at third floor level to create more space for dealing operations. Though recent in date, 1 Finsbury Avenue is a building of exceptional quality. In principle, spotlisting was possible.

SBC Warburg were, in fact, anxious to consult interested parties about their plans – being developed by the original designers, Arup Associates. A high level meeting was arranged. The Society's decision not to oppose the plans was a reflection of our assessment both of the adaptation proposals and of the quality of the interior – impressive but not quite on the level, for example, of Rogers' Lloyd's. The new insertion – in theory, reversible – was elegantly designed. Moreover, Foggo had intended that a building of this kind should be adaptable and flexible. 'Preservation' was inappropriate. The Society did not press for listing and the works received the go-ahead. Whether the Department of National Heritage would ever have agreed to list the building remains uncertain.

Bankside Power Station, London SE1
(Sir Giles Gilbert Scott, with Mott, Hay and Anderson, 1954-60; unlisted)

Bankside has been a Society case for many years – it features prominently on our membership leaflet. When the building first faced closure, we argued for its retention and listing. Though the building was not summarily demolished, a certificate of immunity from listing was issued, leaving its future decidedly uncertain as the operational innards were stripped out.

Gavin Stamp has written that:

> Scott's ability to handle huge, awe-inspiring masses of masonry and his effectiveness at conjuring up the 'sublime' served him well with power stations. His skill at designing Gothic towers of strong profile, gently tapering as they rise, was exploited again when he came to design the great chimney for Bankside...[1]

Scott's masterful use of brickwork probably owes something to the Dutch architect Dudok. The skilful massing and excellent detailing of the building offsets its great bulk.

The salvation of Bankside came about as a consequence of the Tate Gallery's Museum of Modern Art project. After a prolonged examination of possible sites, the Tate opted for the disused power station and launched a design competition for its adaptation. This was won by the Swiss practice, Herzog & de Meuron, a firm known for its sensitive and tactile approach to modern design. Herzog & de Meuron's approach seemed relatively conservationist – other competitors proposed major alterations to the exterior of the building.

Although the power station was (and remains) unlisted, the Tate consulted extensively on its proposals – since they formed the subject of a Lottery application, general support was sought. Meetings with representatives of the Tate, Herzog & de Meuron, and the British executive architects, Sheppard Robson, produced a lively dialogue. We were happy to see the interior of the power station radically adapted, but were less happy with proposals to recast the exterior to the river. The removal of the stepped section adjoining the chimney and the addition of an asymmetrical 'light bridge' extending right across the building would greatly change its image. The Society felt that symmetry was an essential quality of Bankside.

The case for change was argued by Jacques Herzog, who explained that the central stepped section would need to be demolished anyway since it was connected to the structure supporting the turbines – which were to be removed. Was there really an argument for replicating it? In the end, we agreed to the change – the ziggurat-like appearance of the building will be lost. The light beam was more problematic. Though Bankside appeared to be symmetrical, it was so as a result of Scott's slight of hand – one of the end bays is a fake, empty behind the frontage. Herzog & de Meuron declined to pursue this approach. Their determination convinced us that their way had a logic of its own, particularly in terms of the new use. There are those in our ranks who lament the changes to the main elevation of this magnificent building, but our reservations about this aspect of the scheme are probably outweighed by our delight at the power station receiving a new lease of life. This could be one of the world's liveliest cultural centres by the beginning of the next century. The process of discussion and negotiation over the building's adaptation led to an acceptance of what was proposed, but was felt, on both sides, to have been positive and productive. Where large modern buildings are concerned, re-use often implies a dialogue with the leading edge architects and designers of today.

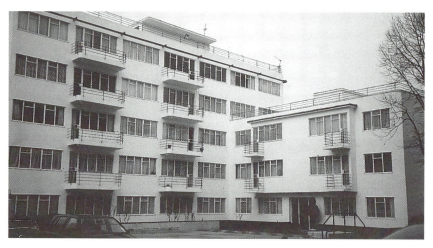

Fig. 5.2 Pullman Court, Streatham, London, by F. Gibberd, 1936.

Pullman Court, Streatham, London
(Frederick Gibberd, 1936; Grade II)

Pullman Court, Gibberd's first important job, is a beautiful and well-preserved example of classic Modern Movement architecture in a rather unassuming area of London. It consists of three blocks of apartments, two parallel lower ranges and one taller building, forming a U-shaped development. The two lower blocks house small one- or two-bedroom flats, while the tall block contains three-bedroom apartments.

At the time of its opening, Pullman Court offered the most up-to-date amenities – a swimming pool, for instance, and rooftop gardens. There was built-in furniture, so that tenants could move in without the clutter of typical middle-class life. The principle of *existenz minimum* attracted artists, musicians and others looking for truly modern surroundings. The flats make the best use of their orientation. The blocks were well set back from the road, with living rooms in each facing south.

Sixty years on, the need for refurbishment is not in dispute. Like many other buildings of this era, Pullman Court suffers from cracking and spalling concrete, the result of steel reinforcing rods being set too close to the surface. During a routine check, the engineers involved in the refurbishment discovered that the long access walkways were never properly constructed and could face imminent collapse. They proposed a complex steel support structure for the walkways and replacement of the existing concrete parapets with a lightweight material. The Society viewed these proposals with alarm: they would utterly compromise the streamlined look of the blocks.

Our approach, working with English Heritage, the residents and their consultants, was to look for alternative solutions to what appeared to be a serious problem. We were, of course, challenging a professional judgement and there was some resistance to our involvement. After an initial meeting on-site, we put forward the idea of retaining the existing walkways, replacing their present surface with a strengthening screed and epoxy mixture – a technique successfully applied elsewhere. The retention and repair of the existing parapets has also been accepted. There is now a presumption towards repair rather than

reconstruction. This approach could be cheaper than what was originally proposed and will probably not require listed building consent. More to the point, the appearance of Pullman Court will not change. The solution initially proposed would have destroyed its appearance and probably reduced the sale value of the flats. This case demonstrates the need for the Society to have expert technical back-up and to be able to produce alternative strategies of repair.

Pimlico School, London SW1
(GLC Architects – John Bancroft, project architect – 1967-71; unlisted)

Pimlico School was built for 1725 pupils on an exceptionally tight site, which dictated the layout of the building. The school is arranged in a single block around a long spine and is partially below street level, exploiting the deep basements of the Victorian terraces formerly on the site. The grounds that surround the school are also below street level and are surrounded by a concrete enclosing wall. There is a rigorous logic to the scheme which inspires admiration, despite the gritty character of the building. It represents a stern reaction to the picturesque tendencies which had hitherto dominated school design in post-war Britain. In order to fit all the rooms into a very tight, long range, the architect designed deep rooms, well supplied with daylight. Bancroft tilted and glazed the outside walls to maximize light, giving the school a dramatic form. On the top floor, rooms are top-lit. There has long been a problem of solar gain and over-heating, not helped by the failure of the air cooling system. The insertion of a series of louvres has not entirely resolved this shortcoming.

The school – which is generally in sound condition, internally and externally – is a seminal work of architecture, especially notable for its circulation diagram and a benchmark for other designers working in the field. Unfortunately, its future is, at the time of writing, uncertain. The recently-launched Private Finance Initiative (PFI) is being used to promote a redevelopment of the site, which would house both a new school and an enabling development. The Society has been arguing for the listing of the building. Since it is less than 30 years old, however, and would need to be listed Grade II* (as outstanding) there was disagreement in our own ranks as to whether this claim could be upheld. English Heritage seemed equally divided on the issue and did not take a strong line. The Society has since pressed the case for II* listing, and the matter rests with the Department of National Heritage. In view of the political overtones of the case – PFI projects have been heavily promoted by the present government – a decision is awaited with some interest.

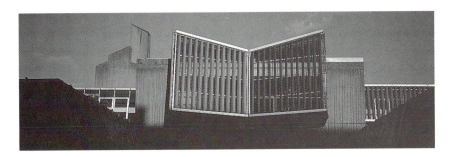

Fig. 5.3 Pimlico School, London, by J. Bancroft, 1967-71.

Holly Frindle, Whipsnade, Bucks
(Berthold Lubetkin, 1933-36; Grade II)

Holly Frindle (or 'Bungalow B' as it was once prosaically known) is close to the larger Whipsnade house built for Lubetkin's own occupation (he lived there for only a short time, in fact).

The importance of Lubetkin's work lies in its marriage of innovative technical solutions and a concern for the social context of architecture. Lubetkin built many mass housing projects, but only two villas of the Whipsnade type. The latter are technically important as an experimental use of the 'frame and fill' approach later used at the Finsbury Health Centre.

Fig. 5.4 Holly Frindle, Whipsnade, by B. Lubetkin, 1933-6.

After years of neglect which left the building in a serious state of disrepair, Holly Frindle has now found a new owner who intends to restore it. But he and his architect face considerable problems, many of them related to Lubetkin's use of new materials and techniques. In the case of the reinforced concrete, the reinforcing rods are too close to the surface, so that the surface has spalled. The steel-framed Thermolux windows of the front elevation were, at some later date, partly filled in with concrete, reducing the effect of transparency. Resolving these defects requires an expert approach. The Society has been concerned therefore to monitor the work on the building, while seeking its upgrading to II*.

The Slipper Chapel, Walsingham, Norfolk
(Fourteenth century, restored after 1904; Grade I)

The exquisite medieval Slipper Chapel has been the Roman Catholic shrine at Walsingham since 1934 and contains fittings, many of them of excellent quality, of this century. The east window is a fine work by Comper's pupil, Geoffrey Webb, which is in tune with the other sanctuary fittings. (This was, in fact, Webb's last work – he died in 1955).

The proposal to remove Webb's glass and replace it with a new window (in a weak, sub-historicist style) seemed to us incredibly destructive. The Society objected strongly and the Historic Churches Committee for the diocese of East Anglia subsequently resolved to refuse consent. The Webb glass is to stay *in situ*, with the new window adapted to fit the west window (currently plain). The swift resolution of the case averted a re-run of the bitter dispute over A.W.N. Pugin's 1850s window at Sherborne Abbey, Dorset, removed – despite strong opposition – in favour of an unremarkable new design.

Former Hartnell Salon, Bruton Street, London W1
(Gerald Lacoste, 1934 and later; Grade II)

Norman Hartnell (1901-79), 'the Royal dressmaker', moved his salon into 26 Bruton Street in 1934. The interiors, set within a typical Mayfair Georgian house, were designed by Gerald Lacoste, who used up-to-date materials, glass in particular, to create an ensemble more obviously at home in Paris. The salon can be claimed as one of the most notable decorative schemes of the era, and is remarkably intact.

Since the winding-up of the Hartnell business, the salon has been empty. The owners of the (listed) building see Lacoste's interiors as a mere impediment to office use. It was suggested that they might be reconstructed in a museum – always a last-resort solution. The Society believes that there are potential users for the building as it stands and has strongly objected to consent being given to strip it out – a stance which has found support with English Heritage and Westminster Council.

Fig. 5.5 Hartnell Salon, Bruton Street, London, by G. Lacoste, 1934.

81

Fig. 5.6 D90 Office Block,
Boots, Nottingham,
by Skidmore, Owings &
Merrill with YRM, 1967-8.

D90 Block, Boots, Nottingham
(Skidmore, Owings & Merrill with YRM, 1967-68; Grade II*)

The Boots site at Nottingham, a vast industrial campus on the edge of the city, contains a number of significant buildings, not least the inter-war factory blocks by Owen Williams. The D90 building was designed as head offices for the company, nearly 500 ft (152.4 m) long and single-storey, a Miesian pavilion (with a central courtyard) squatting in the flat Midlands landscape. The architects, SOM, were the principal heirs of the Mies tradition in the USA and the Boots office block has obvious links with, for example, Mies's Berlin National Gallery. The interiors, principally the work of YRM, are exquisite, extravagantly fitted out in oak on a rigorous grid. Indeed, the quality of the interior explains the II* listing.

It is ironic, therefore, that the owners are now seeking a major revamp of the interior and the removal of much of the fitted furniture, including the partition screens (seen as 'oppressive'). A major refurbishment of the listed building is proposed, together with the construction of a substantial extension, to provide state-of-the-art open plan offices, on a newly-constructed raised floor.

The loss of much of the interior of a Grade II* listed building is a matter for concern. But it needs to be seen in the context of changing approaches to office technology. The Society felt that it could not simply oppose the proposals in principle, but argued for particular care with the treatment of the new raised floor and for the retention of at least a sample area of the office 'carrels'. Amicable discussions continue with Boots and their architects, but the likelihood is that the arguments for radical change will prevail. Our best hope is to ensure that they are reflected in high-quality new design.

Hallfield School, London W2
(Drake & Lasdun, 1955; Grade II*)

Hallfield School is the star feature of the Hallfield estate, which was planned by Tecton and executed by two of its former members. Indeed, the school is the natural hub of the estate, 'a place of excitement, discovery and development for children' as Trevor Dannatt described it in 1959. The site was formerly occupied

by large Victorian villas in extensive gardens and many fine trees were incorporated into the development. The sinuous outline of the school and its highly expressive forms are as far removed as can be imagined from 'functionalism' and are a premonition of some of the leading-edge architectural themes of the 1980s and 1990s. This is a highly-enoyable, much-liked building which has coped well with intensive use over 40 years.

Hallfield School is now, however, too small for the community it serves. For some years, some of its pupils have had to be taught in temporary cabins. The school governors were determined to replace these accretions with a well-designed extension to see Hallfield into the next century. They organized a design competition for new classrooms and brought in Sir Denys Lasdun and Lord (Richard) Rogers as judges. Four distinguished practices participated, but the clear winner was Future Systems, the partnership of Jan Kaplicky and Amanda Levete, with a proposal which takes its cue from Lasdun's original idea of 'leaves on a branch' and refigures it in a contemporary way. Future Systems propose circular pods containing classrooms off a winding circulation route. The pods would be prefabricated and built of metal and glass. They could be added in more than one phase and disruption on site would be much less than that resulting from conventional building works. Both Lasdun and Rogers firmly backed this scheme, as did the Society (which was brought in immediately after the judging to comment). We hope that it can be funded and built. As is so often the case, a completely contemporary solution is seen as the best way of adding to an historic complex.

Conclusion

The Twentieth Century Society is sometimes asked whether it has a developed philosophy of conservation – should it even agree a formal statement of its principles in the spirit of the SPAB Manifesto? To my mind, the SPAB Manifesto has been something of a burden to our oldest amenity society, a form of holy writ which can be invoked by would-be defenders of the true faith. (So we get the absurdity of SPAB refusing to countenance a faithful reconstruction of the bomb-damaged City church of St Ethelburga on the grounds that it would constitute a 'sham'.) It would be particularly inappropriate for the Twentieth Century Society to embalm its approach to historic buildings in this way. Although the Society's concern is not solely with buildings which stem from the tradition of the Modern Movement – as should be clear from the account of our casework – the twentieth century has been, for better or worse, a century of dynamic change. Relatively few twentieth century buildings call for preservation in the strict, archaeological sense. Moreover, given the sheer scale of the twentieth century heritage, there is the need to accommodate – sometimes encourage – new design and the work of contemporary architects and designers. The stimulus of new use is vital in this respect.

The Twentieth Century Society, English Heritage and the other agencies concerned with the protection and repair of modern buildings are still hampered by inadequate knowledge about the constructional techniques and materials used in those buildings. As we learn more, we shall be better able to form a consistent approach to repair which reflects both fidelity to the original and the need to

ensure high performance in the future. As an illustration of the best practice in this respect, the recent restoration of Lubetkin's penthouse at Highpoint 2, in Highgate, north London might be cited – the principle here has been close but not dogmatic attention to the original, with the spirit of Lubetkin's work always clearly in sight.

Of course, we hope that more buildings of our century will be preserved in the way that Goldfinger's Willow Road is being preserved by the National Trust. But most buildings need to earn their keep, to adapt to a changing society. For us, more than for other amenity societies, I believe, conservation really is a matter of managing and controlling change, not trying to prevent it.

References
1 Stamp, G. (1980) 'Battersea Power Station', *The Thirties Society Journal*, **1**, 4.

David Jenkin and John Worthington

Making the recent past fit for the future:
change in the commercial world

Perceptions of the role of conservation have changed and matured over the last fifty years. The fear that conservation would completely freeze the present to save the past has not been fulfilled. Today there is a recognition that adaptation and development can support the wider goals of using what already exists to provide for a sustainable future.[1]

The conservation charters reflect a swing in attitudes from the preservation and restoration of monuments, as encapsulated in the Athens Charter of 1931, to a concern for environments and placemaking conveyed by the Burra Charter dating to 1979.[2] The first part of this chapter focuses on redefining the role of conservation in approaching the mainstream, everyday architecture of the twentieth century: the houses, factories, schools and the commercial buildings that comprise the bulk of our late twentieth century constructed landscape. Three quarters of the British office stock has been built since 1900 with over 30% completed since 1972. Four issues need to be addressed. Firstly what characterizes the bulk of the twentieth century building stock? Secondly what might be worthy of retention and what is the role of conservation? Thirdly what skills may be required? Lastly will the conservation of relatively recent buildings require a change in approach by planners, architects, conservation officers, building owners and investors? The second half of the chapter considers a major strand of our recent building stock – post-war office buildings – highlighting the need to respond and plan for change and the importance of sustainability in an age of uncertainty.

Change is central
The twentieth century perhaps above all else is characterized by the increasing speed of change. While the agrarian economy lasted more than a thousand years, the industrial economy lasted no more than two hundred and fifty years, before being superseded by the service economy which has had a life span of sixty to

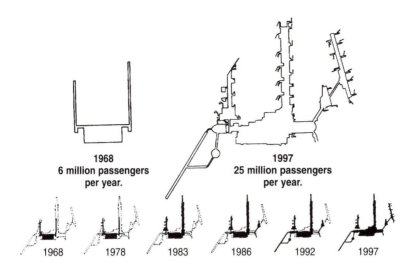

1968
6 million passengers
per year.

1997
25 million passengers
per year.

1968 1978 1983 1986 1992 1997

Fig. 6.1 The growth of Terminal One at London's Heathrow airport from 1968-97.

eighty years before being overtaken by our current knowledge economy. This arguably may have a lifespan of no more than fifty years, before the next economic wave emerges founded on the bio-sciences.[3] Today the average life of business is no more than forty years.[4] Computer giants, such as Digital Equipment Corporation founded in 1954, grew to be major global businesses by the early 1980s, yet ten years later they are struggling for survival. With the average product life cycle of computer equipment being less than three years, change is endemic and irreversible. The key driver of change is technology. Advances in transportation have reduced travel times and facilitated movement, while the miniaturization, mobility and increase of power to cost ratio of computers has changed our way of working. Telecommunications have allowed companies to function globally, while customizing products through flexible manufacturing to local markets.

Buildings have have to respond to similar pressures for change. Since 1968 Terminal One at Heathrow airport has grown from its original capacity of 6 million passengers a year to 25 million by 1996 (Fig. 6.1). The greater the speed of change and the more that products, services and companies become global in their spread the greater will be the demand for local differentiation, continuity and a sense of place. The challenge is to understand and re-use sensitively what we have already, so as to provide continuity, the comfort of a familiar context, and the capacity to adapt and hence secure the future.

New parameters
Towns of the past are predictable, ordered and readable. The fabric is composed of the background grain of everyday vernacular housing, commerce and workspaces, punctuated in the foreground by monuments imbued with civil or religious meaning. The unique and the everyday were clearly understood, each finding its rightful expression (Fig. 6.2). The Modern Movement in architecture broke with the continuity of the past. The modern city fabric was fragmented (Fig. 6.3) with the clarity of foreground and background becoming blurred.

*Figs. 6.2 & 6.3
Maps comparing the form
of the traditional and
'modern' city.*

Housing blocks, such as Le Corbusier's Unité at Marseilles, stand proudly in the foreground as icons to the new social order, and the office towers become the cathedrals to commerce. The architectural profession expanded from less than 11 000 members in 1900 to over 19 000 ARCUK members by 1960. The continuity of vernacular architecture designed and built by craftsmen within well established traditions was largely dissolved by the rise to dominance of the design professions. By 1981 architects in private practice certified 45% of all non-housing private new build, invariably using innovative technologies and new methods of construction.[5]

The Modern Movement deliberately broke with the past, in its approach to space and construction.[6] Traditional concepts of space as being static, sequential and closed were superseded by a desire to create spaces that were fluid, variable and open. In pursuit of the desire to absorb change and allow space to flow, construction became that of the column, beam and slab, fleshed out with infill components. Prefabricated buildings, tower blocks and many offices were conceived to be rapid to construct and easy to adapt over a limited life expectancy. In designing his proposed fun palace in the 1960s, Cedric Price saw buildings as no more than a 'rig' to accommodate continuous adaptation and change. The 'blue jean' concept of buildings that mature and improve through use was recognized by Herman Hertzberger's offices for Centraal Beheer in the Netherlands, dating to the 1960s, which celebrated change and recognized that buildings matured and improved the more users adapted and decorated them.

The building stock of the latter half of the twentieth century does not fit easily within the conservation principles traditionally applied to other periods. Buildings were designed to have limited life-span, be adapted, absorb change, and separate out the different component systems each with their own life cycle (Fig. 6.4). The Modern Movement set out to contrast rather than provide continuity with the past, all to accentuate *The Shock of the New*.[7]

Conservation for the twenty-first century

The post-war building boom for housing, education, health, commerce and retailing transformed the landscape of most British cities. Reconstruction spurred on by war damage and the slum conditions of the Victorian building stock was comprehensive. Large swathes of inner cities were cleared and rebuilt in the modern idiom. Thirty years later much of this relatively young stock is drab, technologically outdated, unloved and even vandalized. What should be

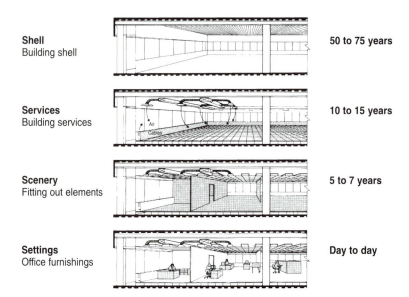

Shell Building shell		**50 to 75 years**
Services Building services		**10 to 15 years**
Scenery Fitting out elements		**5 to 7 years**
Settings Office furnishings		**Day to day**

Fig. 6.4 The four S's and their implication for strategic briefing.

retained and what demolished? In contrast to attitudes prevailing in the 1960s most would accept that it makes sense to recycle rather than dispose. Three criteria are proposed in assessing the merits of retention. Firstly has the bare building shell the capacity to adapt to a variety of alternative functions and is the basic structure sound? Secondly is the location accessible or are the buildings marooned by changing communications and economic circumstances? Finally does the building have intrinsic cultural or historic value? Is it loved and recognized by the community? Except in exceptional circumstances, if the building does not meet the first two criteria, to retain structures purely for their historic value could strangle the community with expensive millstones around its neck.

The role of conservation is to become the moderator of change, working within a spectrum of opportunities. The options range from doing nothing by consolidating what already exists to demolition of selected parts of a building complex to allow the whole to breathe and flourish. The conservationist becomes the arbiter of value, appraising historical and cultural qualities in parallel with utility, ease of adaptation and robustness of structure. The role is both to cherish the fabric and conserve the spirit of the building by selecting and supporting appropriate uses. Conservation requires an understanding of both the building and the most appropriate range of future uses.

Placemaking

Placemaking is at the heart of conservation. The concept reflects the need to both conserve the fabric and revive the spirit of an area. Successful re-use depends on an understanding of the attributes of a building's form and image and matches them to the appropriate organization and economic use. Spaces become places when they are enlivened by activity. Stuart Brand in his book *How Buildings*

Learn[8] takes DEGW's[9] analysis of component life cycles, to describe how buildings are enlivened by their continuous adaptation and reordering of the furniture, fittings and services within. The perceptive conservationist designs with time in mind.

Sharpened awareness

Making best use of our massive portfolio of twentieth century buildings will require:

- A recognition that many buildings may best be demolished if they are poorly located, inflexible and difficult to adapt. A rigorous assessment should be made of the capacity to accommodate new services, if the configuration will allow for alternative layouts, and the degree of flexibility given by construction and site.
- An understanding of building characteristics and user needs, to guide the choice of development strategies and future uses.
- A recognition of the value of the past in facilitating new patterns of use for example, the Art Deco heritage of Miami has advanced from being a maintenance nightmare to become a desirable focus for discerning residents and visitors.
- An understanding of the particular problems of repairing and maintaining modern construction technology.

Post-war commercial architecture

Post-war commercial buildings need users to achieve sustainability, and the users in turn need *the buildings* to help make their businesses work. The principle of whether to refurbish or rebuild is therefore about pragmatism and practicality; how viable is it? Is it cost effective? Will it provide the support the users need to carry out their business? These issues not only concern an increasing number of twentieth century listed buildings, but also the significant accumulation of good, solid, useful building stock that tends to be ignored, mostly through ill-formed prejudice.

Britain is full of tired concrete and steel-framed commercial buildings built since the Second World War but now in various states of disrepair. The inconsistent quality of their design and construction has created prejudices which make it difficult to be objective about their usefulness or cultural value for the future.

Most 1950s, 60s and 70s buildings need major works, particularly relating to their services, but often also to their cladding and sometimes their structure. The buildings of the 1980s were more generous in sectional height and cladding specifications. Although statutory requirements for energy control and safety have been increased, many different problems have been stored up through poorly shaped floor plates and low grade and ill-conceived installations for services.

The IT boom of the 1980s (which continues today) signed the death warrant for many of the early post-war buildings. During this period, DEGW carried out a number of studies which looked at the impact of IT on office buildings. These

studies predicted the redundancy of many post-war buildings, and indeed started a revolution in the type of space that was to be provided through new build and refurbishment..

The ability to allow for *change over time* must always be of high importance in considering the future of any building. It has taken a long time for this to become recognized. Most design decisions are still made from a 'snap-shot in time' and little or no regard is given to the user's need to adapt the building to support their business needs and help them in their inevitable adoption of new work methods and their consequential need for different types of space in the future.

During the 1970s, leading edge companies such as IBM and DEC were continually rethinking how they could get the most out of their people and how their accommodation could help them to increase their business. They both have a long history of developing their own office buildings and investing heavily in innovative types of space to promote future efficiency. In 1990, IBM was one of the first organizations in Britain to experiment with address-free working environments at Bedfont Lakes near Heathrow. Address-free working is a response to the fact that sales and support staff spend a great deal of time away from the office, resulting in the wastage of expensive space and equipment. The solution was to intensify space use through shared facilities and a greater reliance on mobile office technology. This has made a major impact on not only the *type* of space they require, but also the *amount* of space. This shift is being taken-up by many other organizations, and will change the way we value and measure buildings.

The re-use of high quality building stock has always been worthwhile, and the Georgian House model continues to perform as a home, or often now as office, school, hotel and doctor's surgery. It is only perhaps the wholesale massacre of buildings after the War in search of a new, brighter, more efficient and technological future that has clouded our instincts for adaptation.

Sustainable buildings embrace the principles of *structure, skin, services, scenery*; which take account of the relative need to fix certain elements and allow for different levels of change over time. Structure is clearly the longest lasting at approximately 70 years with skin at 30-40 years. Services will change due to demand, but can be expected to last 15-20 years. Scenery, such as the arrangement of desks and partitions, responds to changing organizational needs, and can last 5-7 years.

The recession of the 1990s and further changes in technology gave a breathing space in development and encouraged a realization that the balance of refurbishment versus redevelopment is worth investigating without prejudice. It is sadly still common for old structures to be dismissed as incapable of dealing with the requirements of a modern commercial user, today and in the future. On the other hand, there are many new buildings promoted as being intended for 'modern' users, but where, on examining the end result, it is difficult to understand how the brief was developed and who they are meant to serve best ... the user, the developer, the planner, or the architect? In many ways little has changed, and we are still producing poor buildings that, when assessed against user needs, are redundant before they are even built.

New buildings have just the same requirement to respond to their potential users as existing stock. To understand what is useful about older buildings, we need to look forward and try to assess the needs of future occupants. Perhaps of greater importance is the need to improve the quality of the building stock through the next generation by learning from the successes and failures of the past, and its performance over time.

What are the keys to long-term resilience? These can be summarized in three basic principles:

- The *capacity* particularly in sectional height and potential risers, to handle a number of different types of environmental, electrical and data services.
- *Simple plan forms* with minimum of columns, reasonably clear open floors, and a variety of spaces to allow a rich mix of settings to meet a range of organizational demands.
- The separation of building components into clearly definable parts - *structure, skin, services, scenery* - to allow for future replacement. These range from hard parts to soft areas, and reflect the difficulty, time and cost required to make changes.

The Broadgate development at Liverpool Street Station, London was the first new development to incorporate the need for change in a major way. The buildings were designed not only for a particular market sector (the growth in financial institutions), but also to allow for adaptation in the future as tenant profiles and needs changed. The way the space supports that organizational change must also be allowed to change. We would call this *futureproofing*. The fact that these offices were often over-designed to meet the perceived needs of ever-hungry IT (cooling, voids, risers) will prove to be a great asset in the future as they will be able to be easily adapted and refurbished. Broadgate is the best example of generous floor-to-floor dimensions, and a principle of *reversibility* that will enable the whole building to be reconfigured in the future. The cladding panels can be replaced, upgraded, or simply adapted for new uses. The voids (or atria) filled-in and opened up again as the requirement for larger floorplates or daylight and aspect changes. Only the structural frame need remain, and at Broadgate it carries enough spare capacity to allow for a significant amount of

Fig. 6.5 Plan of typical building at Broadgate, by Arup Associates, showing even-depth space around cores and atria.

adaptation to support this inevitable change in need. It will be interesting to look back at the complex in 20 years to see how this group of offices has changed and whether the investment in infrastructure has paid off.

The key has to be *adaptability*. Georgian houses and warehouses have demonstrated that the best buildings have many lives. Their forms are, by their very nature, undemanding of their occupant yet sufficiently adaptable to suit a wide range of requirements. Some buildings emerge with new uses: industrial to lofts, hospitals to residential, houses to offices and educational use.

Organizational change

A look at the last 50 years shows that the importance of change applies not only to the suppliers of the building stock, but also to the owner-occupier. Change will occur both in the general market place (the demand will be different in each cycle) and within the organizations themselves. Organizational change is now moving at a considerable pace and almost every organization is rethinking its ways of doing business. But even this must be allowed to revert: mergers, demergers, new work practices, rightsizing, teamwork and all the unknowns of the future will have to be catered for.[10]

For a developing business, property demands are therefore focused simultaneously *internally* at the owned or leased stock of space, and *externally* towards the providers of space. Headquarters buildings designed to be entirely specific for their corporate commissioner are a long-term real estate nightmare. They are the most difficult properties to find new owners for, and their image and complexity works against them. However, it is easy for straightforwardly designed 'back offices' intended for an owner-occupier, to be sold or sub-let to another organization, or often a collection of smaller businesses, and in these circumstances, the simple, predictable, non-threatening, economic plan form will succeed. Meanwhile, the redundant corporate headquarters will take time to find new users, and in the meantime gain a reputation for lack of flexibility. The rule has to be: the simpler the shape the better.

New ways of working

DEGW's recent work has looked at the ways people work in offices, and broadly categorized them as follows:

- *Cell*: individual, enclosed, static workplaces.
- *Hive*: busy, dense, open, process orientated.
- *Den*: group work, project based.
- *Club*: high level, varied task, interactive.

Work practices are changing, and there is a trend towards greater interactive, more specialist, and less individual workplace-based activity. The 'Club' provides the ultimate in shared facilities, image and a number of different worksettings, allowing a variety of tasks to be carried out in the appropriate local environment. Most organizations have bits of all four of these, but the companies that are largely only one of them need to be very careful in selecting their building to suit their business needs. Telephone sales operations are largely

'Hive' (and need simple, clear, deeper space); solicitors tend to be 'Cell' (although this is changing); designers work in project teams in 'Dens'; and the 'Club' space can even be a public space such as a hotel, reception, or airport lounge.

New technology

Changes in the development of information technology are rapidly affecting the impact the building has on the performance of the organization. The ubiquitous provision of raised floors for the single use of cable distribution is now under question, and the imminent introduction (and acceptance) of wireless technology will make the choice of building yet again broader.

Together with English Heritage and Lucent Technologies, DEGW ETL have recently completed a study, *Heritage and Technology*, which sets out to look at how historic buildings can be brought into beneficial use to protect their future. Without new users, and with a continued reduction in government sponsorship, the long-term prospects for many important buildings will be increasingly bleak.

For the purposes of this study, we modelled four types of building that were considered and tested:
1 eighteenth/nineteenth century mansion.
2 eighteenth/nineteenth century terraced house.
3 nineteenth century industrial/warehouse.
4 twentieth century steel- or concrete-framed building.

A measurable methodology has been devised to help assess the requirements of different types of potential commercial users, to determine how important and fixed the building elements are, and how well the buildings could accommodate potential user's requirements. For the user profiles, we incorporated our earlier work (cell, den, hive, club) and tested the historic buildings against them.

Although clearly only building type 4 (twentieth century steel- or concrete-framed building) is the period of the buildings that are the subject of this book, the broad lessons are valuable, and the impact on the way we reconsider and occupy our existing buildings could be significant.

In DEGW's own warehouse-conversion offices for example, wireless technology is being tested for data on PCs, CAD workstations, and printers, and the results to date have been good (although at the expense of some speed, most noticeable on printers). It is early days, and may take five years for the right systems to be developed, and to be affordable and perhaps most importantly acceptable. When this happens, the specifications for buildings will be radically different and, above all, more liberal, enabling old building stock to be reconsidered positively once again.[11]

Environmental control

New ideas about the provision of services may make an important input when considering the re-use of a building. The rise in popularity of low energy, user controlled, naturally ventilated 'green' systems is changing the way we look at the depth and sectional height requirements. Add to this the 'liberating' force of new IT, and dogmatic, static specifications will need dramatic reconsideration.

93

What are the main issues?

There are many areas that need to be addressed both before a decision is made to refurbish, and/or during the design process to ensure that an appropriate end product is achieved.

Quality of space

- How good will the end product really be, and will it suit the user's needs properly? Even if it meets current and foreseeable requirements, how easily can it be adapted in the future to accommodate unknown change?
- Can good sized spaces be created with the minimum of columns which compromise office layouts?
- Can a ceiling height be achieved that meets standard developers' requirements i.e. about 8 ft 10 in (2.7 m)? This is often not possible, and not always as important as tenants are led to believe. It depends on the depth of floor plate and the area of fenestration. The aspect, and depth and volume of space are the main contributors to the quality of daylight.

At the Dti's (Department of Trade and Industry) new headquarters in Victoria Street, London, DEGW have transformed an early large 1960s office building into a facility fit for at least another 20-25 years. It has been totally refurbished to provide space to meet the demands of a modern but changing organization, and given a new image by the addition of a glazed entrance to highlight cultural changes and create space for security, visitor reception and disabled access.

The major achievement was to create a ceiling height of 8 ft 10 in (2.7 m) in the office areas, made possible by the installation of a very shallow raised floor for cable distribution and fresh air supply, combined with a shallow suspended ceiling incorporating chilled ceiling panels. This is standard technology in many parts of Europe, but new to Britain in this type of situation and on this scale. Without the adoption of such a low-technology solution, the building would have remained low-ceilinged, and been perceived as a redundant shell.

The Dti also has a policy (as in much of main-land Europe) of locating staff close to the windows. The shallow plan form at Victoria Street allowed for this,

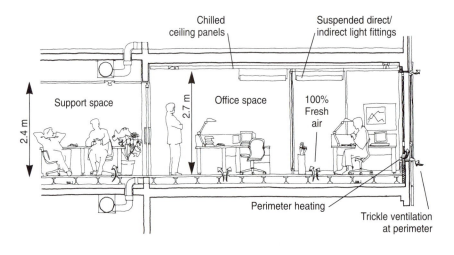

Fig. 6.6 Section through the perimeter office space at the Dti's new headquarters in Victoria Street by DEGW, 1995, showing shallow floor void for air distribution and cabling, and shallow ceiling void for chilled ceiling panels.

and permitted the high degree of cellularization needed in some of their departments. However, this plan form would not work well for organizations such as insurance companies or telesales operations that need large uninterrupted open areas.

Ultimately, any successful refurbishment will always have to *match* the supply of space (what the building can offer) and the demand of what the organization needs both now and in the future. A key measure is going to be the ability of any building structure to *adapt over time* to meet new challenges.

The environment
• What are the environmental options? Can natural ventilation be considered?

The cost-plans of most developers and quantity surveyors are based on the use of a fan-coil system, and proving that there is a cheaper alternative in capital terms can be difficult. At the Dti, the initial cost-analysis for chilled ceilings did not compare favourably with the fan-coil solution (which would only have permitted a 2.4 m ceiling). However, for this project the timing was opportune because there was a keenness for manufacturers of chilled panels to break into the British market and very competitive rates were received.

Image
• What is it that is important to the organization about the image projected by its accommodation? Is it most critical in relation to the customers, or the staff? Is its presence needed at street level, or as a distant symbol?
• What is the message the entrance and building form should give to staff and visitors? This is often the most difficult area to define clearly, yet critical for achieving a successful refurbishment.

All building skins deteriorate and need maintenance. The questions must be asked: is it good enough and do parts, or all of the skin need replacing? In addition, the issue of style versus practicality needs addressing.

Fig. 6.7 Dti's refurbished headquarters, Victoria Street, London, has been given a new image by the addition of a new reception building.

Fig. 6.8 The entrance to Boots The Chemists new, expanded office facility in Nottingham, by DEGW, 1995-98, provides a focus for over 2000 staff occupying a refurbished listed building and a new office building of about the same size.

The refurbishment of the Dti's headquarters provided the opportunity to extend and re-image the organization through the new entrance. This gave the Dti its new public face and is now frequently used as a back-drop for television interviews.

At Berkshire House, High Holborn, London the life of this sixties office block was extended by recladding but, perhaps more importantly, it was totally re-imaged by a new sky profile and enlarged entrance.

At the Boots offices and factory on the edge of Nottingham, their new entrance provides the important link between the new and the sixties block by SOM, creating a single facility for over 2000 staff. Its new image and physical connections provide the integration and identity the organization needs to help it develop its business over the next 25 years.

Approvals

- In the current planning climate, will the planners allow a new building to be of the same height or density as the one it replaces? With more post-war structures being listed, how easy is redevelopment going to be?

The Boots D90 1967 head office building at Nottingham is a good example of a protected, but adapted and considerably enlarged building. A management agreement is being devised with English Heritage and the planners to protect the important parts of the Grade II* listed building, while recognising that for Boots to carry out their business, they must be allowed to change and adapt the building at regular intervals. Like many users, Boots have a history of producing good quality buildings of note, and it would be foolhardy to straightjacket them through conservation legislation. With listing being extended to an increasing number of commercial buildings dating to the twentieth century, firms may resort to a pre-emptive demolition of unwanted stock, as has occured recently with a number of Lancashire cotton mills.

Time

- How much longer will it take to obtain a new planning permission, demolish the existing building, and build a new one, compared to refurbishing a standing structure? From many studies, it is clear that adapting a building, making new additions if necessary, achieving improvements in circulation, services and possibly providinga new entrance could be substantially quicker than building from new, particularly in sensitive areas.

Change of use
* This of course is the solution for many 'redundant' buildings. There has been a phenomenal expansion in the number of commercial buildings being converted to other uses, mainly residential, and this is always an option that should be considered.

What gains can be made?
* Are there possibilities for gains in space through more efficient planning within the shell? Can plant and risers be made more efficient or relocated outside the shell? Are there opportunities for extensions?

Technical issues
These are many, and cannot be covered totally in this section. However, there are a number of important issues that need exploring at the outset as they can have a major impact on the viability of refurbishment.

Floor levels
There are two issues here:
* Can a simple, single floor level be achieved? Many buildings have ramps and steps because of the introduction of raised floors, and because buildings with different floor levels have been joined together.
* Can disabled access be provided easily? In many buildings, the ground floor is raised to allow the lower ground floor to receive some light, and to give a sense of arrival and importance as the visitor climbs the stairs. This is nearly always difficult to deal with. Chair lifts are one solution, but are not very satisfactory, particularly on listed buildings. Some buildings do, however, provide opportunities as the space is available to incorporate ramps which do not appear as add-ons and can be generous enough to be used by everyone.

Fire escapes: are there enough and are they located in the correct places? Do the stair widths, fireman's lifts, and protected routes and shafts comply with the current regulations?

Energy efficiency: can it be improved to meet modern standards?

Floor loadings: are they adequate for the planned purposes, and do they comply with the institutional values? Is the structure safe?

Deleterious materials: does the building contain any noxious materials likely to harm its occupants or the environment?

Maintenance: will it be viable to run the building to a satisfactory level over time? Maintenance costs can be prohibitively high for older buildings.

Perhaps the most important technical issue to be considered is *procurement*. Traditional ways of contracting out the construction are wholly inappropriate for major refurbishment projects, particularly when listed buildings are involved.

Work on existing buildings can never be fully defined, and such 'fixed-price' or 'lump-sum' contracts will always contain a risk of additional costs from variations to their scope of work. Moreover, in this highly competitive market contractor's bids tend to be low, on the basis that there will be changes in the contract from which they can recoup their costs and make a worthwhile profit.

There are a number of proven procurement routes that can restrain the costs and protect the quality of the product. Primarily they must be set up to be non-adversarial; that is, it must be clear how the contractor and his trade contractors price the work and get paid for any alterations. They must allow for the scope and detailed programme to change and additional costs and savings to be easily assessed. It must be in the client's, design team's and contractor's interest to work closely together towards a successful project that is profitable and creditworthy for everyone.

The way ahead

Many refurbished buildings can perform as well for their occupiers as new ones. The existing stock of commercial space is enormous and of great value; it must be well utilized rather than wasted. The selection of the right building for the right organization will ultimately sustain existing structures, extending the life of simple robust buildings and high quality, possibly more complex, listed ones.

The key to long-term success for our future building stock is to look at the best survivors and learn from them. Our work in the Heritage & Technology study showed that of the four generic types we studied, the nineteenth century industrial warehouse was the most adaptable over time. This is because it is robust; it is not precious; it is strong; it is efficient with simple floor plates and stairs at the extremities; and tends to be of reasonably generous proportions. Buildings of this century tend to be more precious, with beautifully crafted stair-cases, reception areas and cores sited centrally to minimize walking distances. For the refurbishable buildings of the future, we should look back to those multi-floored, industrial sheds and learn from them. The differentiation of *structure*, *skin*, *services*, *scenery* must be considered in the design of new buildings.

A good example of sustainability is the boardroom at the Prudential headquarters in Holborn Bars, London, which has survived major organizational,

Fig. 6.9 (left) Prudential's boardroom, refitted by DEGW, 1993, to harness new technology.

Fig. 6.10 The original Lloyds Corporation trading room, re-engineered by DEGW, 1990, to produce simple office space that can be easily re-configured and adapted in the future.

cultural and technological change to emerge as a truly interactive setting for the board to carry out its business, whilst retaining the extraordinary environment the Prudential built for itself almost 100 years ago. This is a symbol of the successful meeting of heritage and technology.

Those that have succeeded over time have the ability to easily adapt to new requirements demanded of them. In the 1958 Building of the Corporation of Lloyds, DEGW in effect changed its use after the main trading space (The Room) became redundant. This became 'normal' office space, but respecting the high quality of the surroundings. The interventions were treated as large pieces of furniture; they are large, but removable, making it a reversible design that will allow for other types of change in the future.

The buildings at both Stockley Park and Broadgate were developed with change in mind, and BT have tested two of the Stockley Park buildings at Heathrow with a 'second generation' fit out and shown them to be rational and easily adaptable. It may only be five years on, but the approach BT takes in occupying its space has changed so radically during that time that the buildings had to be completely refitted. Their simple, clear, robust and non-fussy design has enabled this change to take place easily, without challenging the basic fabric of the original buildings or necessitating major structural works.

One that got away, but I believe could have been adapted to work well, was Petershill near St Paul's Cathedral. This classic large 1960s development was tired, with all the inherent problems of these buildings; it had complex floor levels, low ceilings with downstand beams, failing cladding and a huge image problem. The initial proposal in the late 1980s was for total redevelopment, but an alternative proposal by DEGW was also produced to show how well the basic infrastructure could be re-used to provide good quality space and a hugely improved image. This proposal proved to be the most viable at the time, and was well received by the city planners. However, the economic climate again changed and the refurbishment or regeneration proposal was superseded by a new build solution.

Fig. 6.11 BT's 'Workstyle 2000' offices at Stockley Park, by DEGW, 1996: a radical approach to occupying a simple flexible office building. 1150 worksettings have been provided that will initially accommodate 1500 staff, rising to over 2000.

Fig. 6.12 (left) Concept plan for new laboratories, Great Ormond Street Hospital (GOSH) showing simple zoning layout for easily adaptable space.

Fig. 6.13 The laboratory spaces at GOSH, by DEGW, 1985, are planned within a simple, repetitive framework governed by the structural grid and service risers, allowing alterations to be made quickly and economically for its initially intended use and for other future uses.

To allow for the unknown is not always entirely practical, but, by not designing too tightly, some flexibility can be provided to *futureproof* and sustain our building stock for the next generation of users. DEGW's new pathology laboratories for The Hospital for Sick Children at Great Ormond Street (GOSH) London, are highly serviced, special facilities, but have been designed with *change* in mind. It is classic shell and core, and fit out; with the separation of the hard (long life) from the soft (relocatable) elements. During the outline design process it was tested for other uses (hotel, office) to survive beyond its current requirements. No one knows the requirements of the next users, particularly in government funded institutions. This facility could be sold off or become redundant in the face of increasing commercial pressure. Given such a scenario, it is paramount that major investments such as this have a life beyond that originally briefed, and this building will survive because it has been designed to allow for future change. It has been *futureproofed*. This is the approach we should be taking to creating a building stock in the late twentieth century.

References

1 This chapter integrates two papers given at the conference, with John Worthington writing the first half and David Jenkin the second on commercial architecture.
2 International Office of Museums (1933) *Athens Charter* (1931), Institut de Cooperation Intellectuelle, Paris; ICOMOS (1988) The Australian ICOMOS Charter for the Conservation of Places of Cultural Significance (The Burra Charter), 1979 and revised in 1981 and 1988.
3 Worthington, J. 'Supporting the Science Based Industries' in Sommer, D. (1995) *Industriebau Radikale Umstrukturierung*, Praxis Report, Birkhauser, Basel.
4 Davis, S. & Davidson, B. (1991) *2020 Vision*, Business Books, London.
5 Hillebrandt, P. (1984) *Analysis of the British Construction Industry*, Macmillan, London, 90-1.
6 Giedion, S. (1954) *Space, Time and Architecture*, Oxford University Press, London.
7 Hughes, R. (1980) *The Shock of the New*, Thames & Hudson, London.
8 Brand, S, (1994) *How Buildings Learn*, Viking Penguin, New York.
9 Duffy, F., Cave, C. & Worthington, J. (1976) *Planning Office Space*, Architectural Press, London.
10 Worthington, J. (1997) *Reinventing the Workplace*, Butterworth-Heinemann, Oxford.
11 DEGW ETL (1996) *Heritage and Technology*, DEGW ETL, London.

Part Three

The Evolution of Twentieth Century Building Construction

Bill Addis

Concrete and steel in twentieth century construction:

from experimentation to mainstream usage

Introduction

The first part of this chapter is an outline of the story of steel and concrete construction in Britain during the twentieth century. This will serve to illuminate the two main engineering questions in building conservation which are addressed in the later parts, namely:

- identifying the events of historical significance that can inform the debate as to which buildings are worth conserving and the engineering historical arguments for doing so; and
- preparing the client, architect or engineer, faced with the task of conserving any building, by presenting some of the many types of construction that may lurk beneath the carpets of a twentieth century building, and some guidance on where to gather more detailed information about twentieth century construction and how to proceed with the structural appraisal of a building.

Both steel and concrete were, and are, alternative means of achieving the same type of building structure – a frame building with non-loadbearing walls. This idea had been established for many centuries in timber-framed buildings but these were inevitably modest in scale and seldom more than three or four storeys high.

Steel and steel-reinforced concrete were both new materials which reached maturity at about the same time at the end of the nineteenth century. This is not a coincidence since a reinforced-concrete building needs steel just as much as a steel one does. A pre-requisite of both new construction materials was, then, high quality, cheap steel available in appropriate sizes. This moment arrived, more or less exactly, in the late 1880s. Hitherto steel would only be considered for large prestige projects, such as the Forth Rail Bridge and the Galerie des Machines at the 1889 Paris exhibition, where steel's extra strength (about 20% greater than

wrought-iron) was worth the cost premium. The first all-steel frame building was the 1889-90 Rand McNally Building, Chicago; the first concrete frame building in the USA, by Ernest Ransome, was in 1889 and the first Hennebique concrete frame was his 1895 spinning mill in Tourcoing, France.

Steel and concrete buildings are nearly always discussed separately, especially by engineers who use a different Design Code of Practice for each. In fact, their use right up to the present day is rather more symbiotic than is usually acknowledged; the term 'composite construction' is a modern term for a very old practice. From the earliest days, iron and steel members were afforded fire protection by being encased in concrete, and concrete was made structurally more useful by the inclusion of wrought-iron or steel sections in a wide variety of shapes. Floor structures, in particular, depended upon the fire resistance of concrete and the tensile strength of steel combined in many hundreds of different configurations, both patented and not. In nearly all these instances, both deliberately and not, the steel and concrete shared the loads on the structure to some extent, in the manner of modern composite construction.

A comprehensive history of steel and reinforced-concrete construction and the modern structural frame has yet to been written, though some of the story can be found in a few key sources.[1] There are many separate, though intricately interwoven, lines of development to follow, including:

- the technology of the structural materials: their properties, manufacture and durability; construction methods and site assembly to make whole structures.
- protection of structural elements against fire: floor systems and fireproof construction.
- design procedures for ensuring the structural stability and safety of buildings, and establishing appropriate sizes of structural members and components.
- current building regulations, both local and national.
- new types of non-loadbearing façades to suspend from the frame which would fulfil the many environmental functions of the building envelope, as well as convey wind loads to the frame.
- history of new functions of buildings, new building types and demands of 'modern' architecture.
- new ways of achieving the desired internal environment in buildings, including integrating the structure and façade with the increasing numbers of building services (especially air conditioning and vertical access by means of stairs, lifts and escalators) and using a building's fabric (structure and façade) to moderate its thermal performance.
- the economics of construction: costs of raw materials, labour, plant, *in situ* costs, procurement methods and project financing.
- the story of the development of all of the above, first in their countries of origin (seldom Britain) and then as they were introduced into Britain, mainly in the face of considerable reluctance.

The rest of this chapter will touch a little upon all of these, but will concentrate mainly on the first two and will consider only the British part of the story. It is also worth mentioning at the outset that most of the innovations in steel and

concrete construction did not occur in mainstream architecture. Rather it occurred on projects that were not steered by architects – civil engineering, bridges and industrial buildings. Furthermore, during all but the last two decades, the most innovative engineers all worked for contractors during the early years of their careers. Ove Arup, for example, was not a design engineer in the modern sense, and he formed the firm that now bears his name in his fifties after most of a lifetime in contracting.

The legacy of the nineteenth century

Framed construction in steel and modern reinforced concrete were both imports into Britain during the last decade of the nineteenth century – steel from the USA and Germany; concrete from France and Germany and, later, also from Denmark and the USA. This may be a little surprising given Britain's pioneering contributions to the development of iron, steel and concrete well before 1900.

Cast-iron columns and beams were in widespread use throughout Britain from the beginning of the nineteenth century, some 40 years before any other country. The world's first major structures in wrought-iron (Britannia Bridge, Menai Straits, 1845-49; Saltash Bridge, Plymouth, 1859) and in steel (Forth Rail Bridge, Queensferry, 1882-90) were all British. Paxton's ideas for the Crystal Palace were realized with engineering input from William Barlow, Robert Stephenson, and the contractors Fox and Henderson. It was conceived as a pure frame building – cast-iron columns and girders of both cast- and wrought-iron, rigidly connected. In the building as built, wind bracing was provided by diagonal cross-bracing rods of wrought-iron. Just a few years later the first genuine frame building was constructed at Sheerness dockyard, Kent, a three-storey boat store with cast-iron columns and beams of cast-iron and of wrought-iron. Completed in 1860 it still stands, even after the gales of 1987.

Un-reinforced concrete was widely used in foundations and major civil engineering projects throughout the nineteenth century and, from the 1870s, some concrete bridges were built. During this time, too, a wide variety of fireproof flooring systems had been developed beginning, around 1800, with brick jack-arches between parallel cast-iron beams. Later developments included, in the 1830s, cast-iron joists embedded in concrete, a system patented by Henry Fox in 1844 and, from 1848, known widely as the Fox and Barrett floor. The earliest patent for reinforcing concrete (using disused cables from coal mines) to make a beam or floor was in 1854 by W.B. Wilkinson, a plasterer and manufacturer of cement and 'artificial stone' products from Newcastle-upon-Tyne. During the following 40 years many similar patents were filed. In 1877 Thaddeus Hyatt, an American working in Britain, published privately the results of extensive experiments he had undertaken on concrete beams reinforced with iron and which had been tested at Kirkaldy's materials testing laboratory in London. A building designed in 1886 using Hyatt's system of reinforcing concrete survives to this day at 63 Lincoln's Inn Fields in London.

Many architects had embraced developments in using un-reinforced concrete. It had been used for walls in domestic buildings in the 1850s; by 1870 this was quite common and one warehouse reached a height of 60 ft (18.3 m). Various inventors had devised patented 'concrete-building apparatuses' for use by house-

builders and these were well reported in the press and, apparently, quite widely used. At this time it was usual to support concrete floors by wrought-iron beams in one of many types of fire proof floor system (see below). However, it is alarming now to learn of the bold use of wholly un-reinforced concrete. One such floor was reported in 1876 as being 40 ft by 16 ft (12.2 m by 4.9 m) and $4^1/2$ in (115 mm) thick at the crown and 11 in (280 mm) thick at the springing. Another example was a balcony projecting 4 ft (1.22 m) from the wall supported on cantilevers, cast *in situ* tapering from 11 in to 3 in (280 mm to 75 mm). The only means adopted for fixing was a cemented butt joint between the cantilevers and house wall. Twelve days after casting the balcony was successfully tested by three men running along it. It is worth mentioning here because it is more than likely that some of these remain, yet to be discovered by unsuspecting architects and engineers.

Nearly all the pioneering British use of iron and steel on a large scale had been related to transport and industrial buildings, hardly any of which had involved architects. Despite British expertise in iron, we built relatively few commercial or public buildings to match those by James Bogardus in New York from 1850 onwards (his patents for cast-iron frame buildings were based entirely on what he saw on his visit to England), or the exposed wrought-iron façades appearing on the continent from the 1880s. Generally, however, even in the late 1890s, the British architectural press included little mention of iron or steel except in fireproof floors.

The main application of wrought-iron and, from the mid-1880s, steel was as beams or girders used in conjunction with concrete for various types of fireproof floors, as was evident from advertisements in the architectural press – Measures Brothers' 'Siemens-Martin and Bessemer steel joists – the best and cheapest in the market'; Potters Patent fireproof flooring, a composite iron and concrete system; W.B. Wilkinson 'Est.1841. Concrete workers. Designers and constructors of concrete staircases and fireproof floors of all descriptions, with as little iron as possible, and that wholly in tension, thereby preventing waste'; 'Homan's fireproof floors' from Homan and Rodgers, Engineers, who also offered 'constructional steel and ironwork, roofs, piers, bridges, joists and girders and concrete fireproof floors (used in nearly 2000 buildings)' and, from 1897, 'constructional steel skeleton buildings (American System)'.

Despite these many early, but modest uses of steel and concrete, the first large frame buildings were not built in Britain until the last few years of the century, in fact, probably in the same year, 1896-97. The steel frame of Robinson's Emporium, a furniture warehouse in West Hartlepool was built of steel from Redpath Brown and Company. The reinforced concrete frame of Weaver's Mill in Swansea was constructed by Hennebique who, during this project, selected Mouchel to be the General Agent for his patented system of reinforced concrete construction in Britain. For this first major project in Britain Hennebique took no chances; the cement, sand, aggregate and steel were all imported from France.

To put the following chronological outline in context, the British construction industry has, from the end of the nineteenth century until the 1960s, generally lagged about 20 years behind events in continental Europe and the USA.

1900-1920

By the end of the first decade of the new century, framed construction in steel or concrete had become the norm for large buildings. This change was one of the most rapid and dramatic ever experienced by the British construction industry and was due entirely to foreign firms penetrating the British market, apparently with considerable ease. There seems to have been a remarkable lack of business acumen and commercial initiative with which to challenge the French and Americans who, between them, snapped up most of the projects for major framed buildings before the First World War and dominated the contracting field.

In principle, there was no excuse for British ignorance of the principles of framed construction. Steel and reinforced-concrete construction practice had been brought to the notice of both engineers and architects in many papers delivered in London and the provinces, e.g.:

- frequent pieces in the technical press from 1896.
- a paper in 1897 at the Institution of Civil Engineers on steel skeleton construction in Chicago.[2]
- Hennebique's system described in 1902 (*Builders' Journal*).
- Mouchel presented a paper at the RIBA in 1904.[3]

British contractors, and those architects and engineers who might have influenced the contractor's choice of structure, seem to have had a typically small-minded and conservative attitude to the new materials and remained firmly stuck in the nineteenth century. They saw steel as a material for internal columns and, with concrete, for floor structures. This was but a minor development of the mills we had developed 100 years earlier. Indeed, some factory owners persisted in demanding cast-iron columns right up to the First World War. Our skill in using steel certainly lagged behind Germany and the USA. According to one American engineer working with Bylander (see below), British builders circa 1905 'simply piled one piece on top of another, stuck a few bolts in and called it constructional steelwork'.[4]

Histories of this period record the first uses of steel and concrete in 1896 or so, but little else until the famous examples of the Ritz Hotel, London, and other large buildings from 1904 onwards. There must be much more yet to discover about these early days but it can be safely assumed that there was a growing use of both steel and concrete for industrial buildings during this gap. The Ritz Hotel is significant in our story for several reasons – it was a non-industrial building; it was in London; and it exposed the existing building regulations (especially in London) for not permitting frame buildings (in either concrete or steel) with non-loadbearing walls. The construction of the Ritz could not be ignored in any corner of the country as its progress was reported week by week from September 1904 in *The Builders' Journal and Architectural Record* (which later became our *Architects' Journal*). This represented a dramatic change of content for what had hitherto been a rather conservative periodical, and things did not stop there – in May 1906 it changed its name to *The Builders' Journal and Architectural Engineer* and published the first issue of its new monthly *Concrete and Steel Supplement*.

The generally slow uptake of steel and concrete was also, of course, rooted in the attitudes of British clients and architects. Again, foreigners were able to exploit the vacuum. Michelin House, by F. Espinasse, 1905-11, not surprisingly perhaps, had a French architect and employed a Hennebique frame of 'ferro-concrete' (the English phrase for the parent firm's *béton armé*) built by Mouchel & Partners. The Ritz was designed by Mewès and Davis (respectively French and English) who had studied together in Paris. Selfridge was a Chicago businessman opening a new department store in London – he already knew the benefits that a steel frame would bring to his building (and his business) and brought in an American architect and contractor to build it. White, the engineering partner of the contracting firm, was an American who had worked in Australia and had launched a London branch of his firm in 1900.

Just as is the case today, the major buildings of this first decade involved a small number of key individuals and firms – clients, architects, engineers and contractors – with preferences for working together and building up their joint experience, success breeding success.

The designer of three of the earliest steel frame buildings in London was the Swedish engineer Sven Bylander who worked for the Waring White Building Company and had previously built steel frame buildings in both Germany and the USA. These were the Ritz Hotel, London, by Mewès & Davis, 1904-06; Selfridges Department Store, London, initially by Daniel H. Burnham of Burnham & Root fame, 1904-06, then Frank Atkinson (Sir John Burnet, too, had some input); and the RAC Club, London, by Mewès & Davis, 1908-11. Frank Atkinson went on to design the steel-framed Adelphi Hotel, 1912-13, in his home town of Liverpool where he ingeniously emphasized the thinness of the cladding to the frame by bringing the windows forward to the outer surface of the building. (If the experience of domestic buildings is anything to go by, this probably reduced the life of the windows, which were subject to greater exposure to wind and rain.)

It is particularly interesting to learn just what it was about the so-called American methods that was so new on the Ritz Hotel project. The use of 360° cranes for steel erection was one innovation. Another was the drawings for the building which were fully dimensioned and incorporated many standard details. This enabled the German steelworks (the steel for the Ritz came from Germany) to minimize errors and to undertake the work without needing to make templates, which was still the practice in Britain, and so to reduce the price.

One of the earliest buildings to express its frame structure (of steel) in the façade is the magnificent Tower Buildings at Pier Head in Liverpool, by Walter Thomas, 1906. The same architect went on to design the Royal Liver Building in Liverpool, 1908-1911, with a Hennebique ferro-concrete frame, engineered by E. Nuttall & Co. from Manchester. It had 15 storeys and, with the additional superstructure reached a height of 310 ft (94 m), which was then the tallest concrete building in the world, an achievement not overlooked in the Hennebique firm's publicity. The Cunard Building, by Willink & Thicknesse and Mewès & Davis, 1913-16, which is adjacent to the Liver Building, was built by the Trussed Concrete Steel Company using the Kahn system of concrete reinforcement.

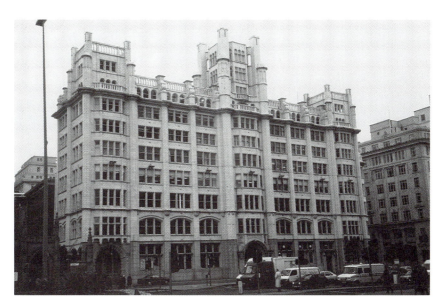

Fig. 7.1 Tower Buildings at Pier Head, Liverpool, by Walter Thomas, 1906. (Bob Lamb)

Another significant building in ferro-concrete (the Kahn system) from this period was the seven-storey YMCA building in Manchester, by Woodhouse, Corbett & Dean, designed 1908 and recently refurbished. There is some virtuoso structural engineering in its two blocks – one incorporates a 60 by 20 ft (18.4 by 6.2 m) swimming pool on the fifth floor and the other a two-storey hall on the second/third floor and gymnasium on the fifth, both with 89 by 53 ft (27.2 by 16.1 m) column-free areas. The fourth floor contains five steel trusses 11 ft (3.35 m) deep between which are classrooms.

The major engineering significance of all these buildings is that they lay outside the scope of current building regulations and required considerable persuasive skills by their engineers to get them accepted by the regulatory authorities. Frames were deemed not to be suitable in façades because of fears that thermal expansion of the frame would cause cracking of the façade. Reinforced concrete had the additional difficulty that there was little guidance on design calculations. The RIBA addressed this in 1905 by setting up a Reinforced Concrete Committee under the chairmanship of Sir Henry Tanner, chief architect

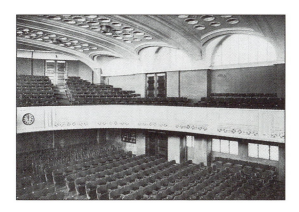

Fig. 7.2 Large Hall on 3rd floor of the YMCA Building, Manchester, by Messrs Woodhouse, Corbett & Dean, engineer Trussed Concrete Steel Co., 1908-11. (Concrete & Constructional Engineering, 6, 1911, 370)

109

to the Office of Works and a concrete aficionado. Sir Henry's choice of Hennebique's ferro-concrete, engineered by Mouchel, for the new General Post Office buildings in the City of London, 1907-09, was to lend a certain official backing for this new construction material (and was, by the way, only possible because Crown buildings were exempt from building control). Although the Committee was boycotted by the Institution of Civil Engineers, its report in 1907 contained useful design procedures for engineers.

Following this, in 1908, at a room in the new Ritz Hotel (chance or irony?) Sir Henry was invited to become Vice-President of the newly formed Concrete Institute, with Edwin Sachs as its Executive Chairman. Sachs had formed the British Fire Prevention Committee in 1897 and for some years had campaigned to end the restrictive marketing of proprietary concrete systems in favour of enabling any competent person to use his engineering knowledge to design structures in reinforced concrete. One of the first undertakings by the Institute's executive committee was to advise the chief architect to the London County Council who was preparing the new issue of the London Building Act which appeared in 1909. This advice, together with the pressure from Bylander, the engineer at the Ritz and Selfridges, led to the removal of the need for a building façade to be fully load bearing and finally the way for frame buildings was open. In 1912 the Concrete Institute extended its name to include 'an Institution of Structural Engineers, Architects, etc.' and in 1922 changed its name to 'The Institution of Structural Engineers'.

From an architectural point of view, London was rather conservative and it was not until the second decade of the century that a building clearly expressed the new found freedom inherent in non-loadbearing façades. Kodak House, in Kingsway, London, by Sir John Burnet, 1911, is an excellent example among the first. The frame, which might have been made of either material, was, in fact, of steel. Blackfriars House, London, by F.W. Troup, 1913, with a steel frame by Bylander, is another good example.

An excellent example of industrial building in concrete from this same period was the Gramophone and Typewriter Company (later HMV, then EMI) building

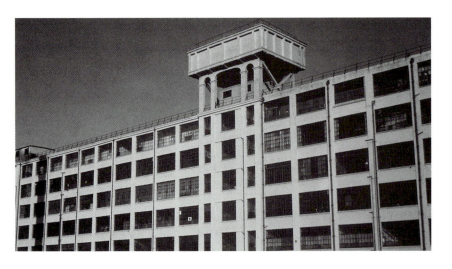

Fig. 7.3 EMI Building at Hayes, Middlesex, engineer Trussed Concrete Steel Co., 1912-13. Both Owen Williams and Oscar Faber worked on this building. The original building comprised the water tower and the section to its left.

at Hayes in Middlesex, completed in 1913. The exposed concrete frame, built by the Trussed Concrete Steel Company (formerly the Indented Bar Company and later known as Truscon) with large metal-frame windows, presaged an honesty in the façade that only found its way into non-industrial buildings a decade or more later. It is also notable for two of the team who worked on it – project engineer Oscar Faber (then aged 27) and design engineer Owen Williams (aged 23). Between them these two men would do more than any others to shape British concrete construction during the following quarter of a century. Even by 1912 Faber had clearly gained considerable experience with concrete for, in that year, he wrote one of the first British manuals on concrete construction.

By the end of the First World War the final major innovation in concrete construction had reached Britain from the USA, Switzerland (the work of Robert Maillart) and Germany – the flat slab. This system avoided the downstand beams that were characteristic of many earlier systems. In addition to the obvious benefit of reducing the overall height of multi-storey buildings, flat slabs clearly made an enormous impression on some architects who saw them. Hitherto the undersides of floors had always been visually cluttered by beams and jack-arches; the architectural clarity and honesty of a single 'sheet' of structure caught the imagination of Le Corbusier and Rietveld and became the hallmark of much domestic architecture in the Modern style during the 1920s and 1930s, especially on the Continent. One of the earliest known examples in Britain is the elegant Bryant and May match factory in Liverpool dating from 1919. The consulting engineer was Sven Bylander who, some fifteen years earlier, had engineered the steel-framed Ritz and Selfridges buildings in London.

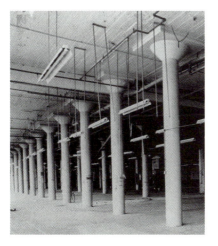

Fig. 7.4 Interior of the Bryant & May factory, Liverpool, engineer Sven Bylander, 1919. (Institution of Civil Engineers)

Fig. 7.5 Steel reinforcement for a mushroom slab. (Concrete Engineers' Pocketbook 1911, International Correspondence Schools, London [issued by the American branch of ICS])

1920s and 1930s

In major public buildings steel frames continued to dominate the British market until well into the 1930s. From the start they had three important advantages over both traditional construction and concrete frames:

• high strength allowed wider spans between columns.
• simplicity of construction enabled speedy erection.

- it was easy to attach fixtures and machinery to steel frames, and to adapt the building as its use changed.

But there were also three serious disadvantages:

- structural steel needed considerable fire protection which, to begin with, was usually achieved by embedding the steel in concrete.
- an all-steel building would use more steel than one in reinforced concrete, a key issue in the post-war shortages of the early 1920s and 1950s.
- there was nothing inherent in the use of steel that encouraged its expression as an architectural material in its own right; steelwork was generally hidden beneath fire-protection, and building façades were usually of stone or brick.

It was into this context that concrete began to emerge as a material with characteristics that would appeal to architects. Concrete could offer four utterly new opportunities:

- curved lines and surfaces.
- solid three-dimensional form.
- cantilevers.
- thin structural 'sheets' (flat slabs, deep beams, shear walls, curved shells).

All these had first been used by 1918 in a wide variety of non-architectural applications – factories, warehouses, maritime structures, airship hangars, even reinforced concrete boats. Sporadically they were discovered or reinvented by architects, mainly on the Continent, who gradually explored their potential. During the 1920s the several constituents began to combine and by 1930 finally coalesced to became the principal characteristics of the International Style.

Relatively little of note was executed in Britain during the 1920s: rather the decade was a pregnant pause waiting for the next to begin. Some rare hints of what was to come were the Royal Horticultural Society Hall, London, by J.M. Easton & H. Robertson, eng. Oscar Faber, 1923-26; the Palaces of Engineering and Industry for the British Empire Exhibition at Wembley, by Owen Williams,

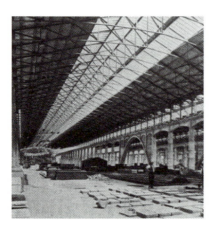 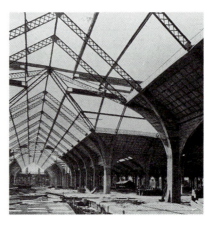

Figs. 7.6 & 7.7 The Machinery Hall (later known as Palace of Industry), and (right) Palace of Engineering, British Empire Exhibition, Wembley, Middlesex, during construction by Maxwell Ayrton, engineer Owen Williams, 1924. (Concrete & Constructional Engineering, 18, 1923, 638-9)

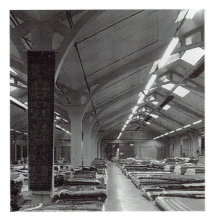

Fig. 7.8 The Palace of Industry is currently used as a carpet warehouse. (English Heritage)

Fig. 7.9 Church of St John, Rochdale, by Bower Norris, engineer Burnard Green, 1925. (Concrete & Constructional Engineering, **20**, *1925, 540)*

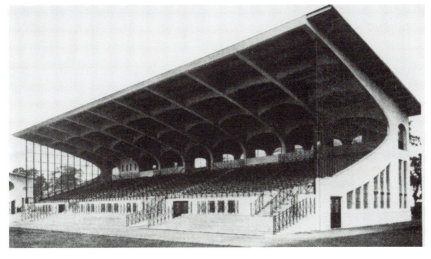

Fig. 7.10 Stand at Northolt Park race track, engineer Oscar Faber, 1929. (Concrete & Constructional Engineering, **24**, *1929, 392 & 742-4)*

1924; an early reinforced concrete shell 8 in (200 mm) thick, spanning 54 ft (16.5 m) forming the dome of the Church of St John in Rochdale; and the wonderful grandstand at Northolt Park race track.

When the new decade did come it arrived with an astonishing, almost *fin de siècle* vitality, even in Britain, and the architectural results are well enough known. Among the first commercial buildings with exposed concrete structure were the offices of W.S. Crawfords in High Holborn, London (1930) by Frederick Etchells who had translated Corbusier's *Vers une architecture* (1923) into English (1927). The new International Style inspired domestic architects, and many houses of reinforced concrete were built during the 1930s. However, in Britain, concrete was less common as the choice for larger buildings. An exception was made when the building was seen especially as needing to express a modern image, such as cinemas, rail and underground stations, bus stations, and a relatively new invention, the airport building.

During this era of architectural adventure many engineers, too, were stimulated to innovate, not only in technical matters but also in changing their very role and the contribution they might make to buildings. They sought to

concern themselves with far more than the structure of buildings and to embrace the whole of building engineering and construction technology – building services and methods of manufacture and site assembly – as well as seeking to make a direct contribution to the finished product, the architecture itself, by working in close collaboration with architects in the conception of buildings. For the first time they began to see themselves as designers of buildings.

Three stand out for their innovation and the degree to which they have influenced the following half century – Owen Williams, Felix Samuely and Ove Arup. Owen Williams was without doubt the greatest British engineer of the twentieth century.[5] He worked predominantly in concrete and, indeed, made the rare move from eminent engineer to eminent architect. Among his many contributions to the art of total building design were:

- the expression of the function of structural members by shaping them to reflect the stresses and bending they were carrying: e.g. the columns and floors of the Daily Express building, London, 1929-31; roofs in BOAC maintenance headquarters building, Heathrow Airport, London, 1950-55.
- the integration of services into his concrete structures: e.g. the main columns of his Dorchester Hotel scheme, London, 1929-30 (completed by other architects) were a cluster of four columns with a central void to carry vertical service runs; Pioneer Health Centre, Peckham, 1933-35.
- the curtain wall: e.g. the Daily Express building, London, Boots 'Wets' building, Nottingham, 1930-32 (see Fig. 1.3).
- sheer structural boldness and ingenuity; e.g. one roof in the Boots 'Drys' building, 1935-36, has 9 ft (2.75 m) deep valley beams spanning 215 ft (65.6 m) on just two columns, suspended from an adjacent building at one end and with a 48 ft (14.6 m) cantilever at the other, far greater than ever before.

The use of the curtain wall (which had first been used by Walter Gropius in 1925) was, of course, the one development that led to the most dramatic change in the appearance of frame buildings: the load bearing structure could now be entirely separate from and independent of the façade and, if necessary, invisible. This final stage of realizing the dream expressed in Corbusier's Dom-Ino House of 1914 was, in Britain, largely made possible by the development of cheaper fire-protection for steel such as plasterboard. Apart from Williams' many

Fig. 7.11 Roof detail of the BOAC maintenance headquarters, Heathrow Airport, by Owen Williams, 1950-55.

buildings curtain walling was also used to considerable acclaim in Peter Jones department store in London, by W. Crabtree, 1936-38. However its widespread use did not come until after the war.

Felix Samuely came to England in 1933 after working for eight years in Germany and two in Moscow on both concrete and welded steel structures, mainly in industrial contexts.[6] He effectively brought welding to Britain in Simpsons Store, Piccadilly, by Joseph Emberton, 1934-35 and the de la Warr Pavilion at Bexhill, by Eric Mendelsohn & Serge Chermayeff, 1935-37, which was Britain's first all-welded-steel building (see Fig. 9.8). As Bylander had encountered 30 years earlier, the regulatory authorities lagged behind the engineers. Samuely's proposal for Simpsons, that the entire street façade be supported on a single, welded steel Vierendeel girder, was rejected. He lost this battle (forced to abandon the Vierendeel and add three unnecessary 80 ft (24.4 m) beams which doubled the weight of steel in the façade), but won the war, for the LCC bylaws were soon revised to incorporate portal frame structures.

Fig. 7.12 Simpsons store, No. 26 Piccadilly, London, during construction by Joseph Emberton, engineer Helsby, Hamman and Samuely, 1933-35. (F.J. Samuely & Partners)

Fig. 7.13 Simpsons store, comparison of the structure as proposed by Samuely using a Vierendeel Girder and as modified by LCC. (Architects' Journal, 21 May 1936, 777)

Fig. 7.14 Simpsons store, exterior view (F.J. Samuely & Partners)

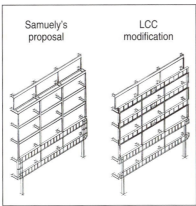

Samuely's proposal

LCC modification

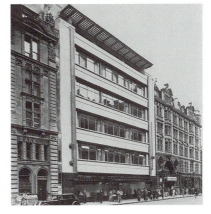

Faced with designing a building directly above an underground railway in London, Samuely designed one of the first vibration absorbing foundations. The seven-storey reinforced concrete office block, originally for vintners W.A. Gilbey, Camden, London, by Chermayeff, 1937, was built on a 4 in (100 mm) raft of cork. Further to reduce vibration and noise ingress, the structures for the office and services sections of the building were separated by cork joints and the building was air conditioned.

Samuely was always concerned to reduce costs by reducing the weight of structures and improving their buildability. He developed many ultra lightweight structures by welding combinations of flat strip, rods, profiled steel-strip sections and tubes; one such factory structure used half the weight of steel as a structure with conventional steelwork. He also devised prefabricated glazing assemblies and lattice trusses in welded-steel, descendants of which became so popular for schools in the 1950s.

Samuely saw his job as enabling architects to achieve what they wanted most effectively. He worked again and again with Chermayeff and was frequently chosen by architects and clients because of his reputation for close collaboration. He worked unceasingly to pass this philosophy on to others through his long-standing links with the Architectural Association and many lectures and articles.

Arup's contribution to progress in construction has tended to overshadow that of Williams and Samuely, who were of equal, or even greater importance; this is due mainly to the subsequent activity and fame of the firm that carries his name. Arup worked for Christiani & Nielsen, Danish contractors and acknowledged experts in concrete, who were expanding their activities in Britain, mainly in civil and industrial and maritime applications.[7] Arup saw the benefits that his knowledge of construction could bring to architects, especially by adapting for use in buildings the rapid casting of concrete using highly simplified concrete profiles amenable to the use of climbing formwork that his firm had developed for grain silos. He first did this, working closely with Lubetkin and Tecton, on the Gorilla House, 1933, and the Penguin Pool, 1934, at London Zoo, and then Highpoint in north London, 1935. In this last project Arup, like others before him, came up against the regulations. He proposed doing away with many of the columns which Lubetkin had originally included by thickening the walls sufficiently to carry all the vertical loads. Eventually, with some additional (unnecessary) reinforcement added as a compromise, his idea went through, but only because Highgate lay outside the jurisdiction of the London County Council.

The pioneering work of these men helped define the modern role of the consulting engineer. They always sought to approach problems from first principles rather than blindly following codes and regulations and they put their minds to work on the design and construction of the entire building.

The immediate pre-war period saw an increasing pre-occupation with speedy construction and experiments in prefabrication of steel and concrete – later known as 'industrialized building' – which became quite common. One figure of particular note was the French engineer Eugène Mopin who, in 1934, used his ingenious structure for multi-storey buildings. It had a light steel spot-welded frame (just strong enough to carry deadloads) and pre-cast concrete elements

which were grouted together to work as a composite structure. He successfully exported the system to Britain where it was used in one of the largest projects in the country – Quarry Hill flats in Leeds, 1938-40. The Mopin system enabled the project to be completed 25% quicker and using 50% less material than conventional methods.

1945-1965

The construction environment in Britain in the immediate post-war period was dominated by a tremendous need for new buildings (especially, housing and schools) and a shortage of steel. These two factors encouraged the use of concrete and the search for high-speed construction methods.

Ove Arup realized the potential of the simplified concrete construction methods he had devised with Tecton before the war. In a report written in 1944 he outlined the options for a variety of two-storey buildings using what he called the box frame idea. This same idea was expanded many times in a number of blocks of flats, for example in Hallfield Estate, Paddington, London, 1946-54, and Spa Green Estate in Rosebery Avenue, London, 1949-50, both with Tecton as architects. This system came to be known as egg-box or crosswall construction.

Fig. 7.15 Cutaway isometric of Spa Green Estate, Finsbury, London, by Tecton, engineers Ove Arup & Partners, 1949. Note the reinforced concrete structure of continuous walls and floors without columns or beams. (Ove Arup & Partners)

Le Corbusier was a dominant influence on the young architects of the late 1940s and 1950s and to them an obvious solution to our housing needs was to build upwards. Unfortunately their architectural ideals were rather lost in the rush to build as much and as quickly as possible. All the major contractors developed their own systems for high-rise flats and

Fig. 7.16 The completed building at Spa Green Estate. (Sydney Newbery, by courtesy of Ove Arup & Partners)

other building types. A survey in the 1960s reported no less than 170 proprietary building systems, mostly non-British, many of which were used in Britain under license.

As is always the case with a new type of construction implemented in haste, too little time was spent on the design and planning of many of these systems and, especially in Britain, a host of problems arose – condensation, 'penetration' (i.e. water leaking from flat roofs), mould, faulty lifts, spalling concrete, detached claddings of tile or brick, social problems associated with young children living high up and, most famously, disproportionate collapse should a lower building element be removed, for instance by a small gas explosion, as occurred at Ronan Point, London in 1968. For a variety of reasons, many of these blocks have been demolished. A greater number, however, are now being rehabilitated to a more luxurious standard.

But not all industrialized building was bad. The war had left Britain with a shortage of schools as well as housing and in the late 1940s Hertfordshire County Council Architects developed a kit of standardized parts, mainly in steel, to build an almost infinite variety of primary and secondary schools. This idea led to the launch of the Consortium of Local Authorities Special Programme in 1955 and a great many schools and, indeed, the halls of residence at York University, were built using the CLASP system well into the 1960s.

The relative cost of steel frames had gradually increased during the 1930s so that by the end of the decade concrete became the most usual choice for building. This situation was exaggerated after the war with the shortage of steel, and so began the heyday of concrete construction in Britain which continued until the end of the 1970s. Not only were there a great many building systems using pre-cast elements, this period also saw the rise (and fall) of using concrete shells and folded plate structures.

The concrete shell is undoubtedly the most dramatic type of new structure that this century has seen (until, perhaps, the tensile cable net and membrane structures of the late 1960s). As with many ideas it began modestly and rather earlier than usually realized. On the continent shells appeared in the late 1920s

and Eduardo Torroja was an early exponent in Spain during the 1930s. In Britain there had been some thin shells before the War, e.g. Church of St. John, Rochdale (Fig. 7.9), Doncaster aerodrome and Chessington railway station, but these were on an altogether different scale to what came after the war.

The first major shell roof was the Brynmawr rubber factory in South Wales by arch. Architects Co-Partnership, eng. Ove Arup & Ptnrs, 1947-50. At the time of writing this is the subject of a debate about its possible rehabilitation and reuse, but it is noteworthy that, from the structural point of view, the building has been given a clean bill of health.

Other notable shells during this period were the bus garages at Bournemouth, 1951, by Jackson & Greenen, and Stockwell, London, 1954, by Adie Button & Partners, and the Bank of England printing works at Debden, by arch. J.M. Easton & H. Robertson,[8] eng. Ove Arup & Ptnrs, 1953; Smithfield Market, by arch. T.P. Bennett, eng. Ove Arup & Ptnrs, 1962-63; and the roof of the Commonwealth Institute in London, 1962, one of the few large hyperbolic paraboloid roofs in Britain by archs. Robert Matthew and Johnson-Marshall & Ptnrs, eng. A.J. & J.D. Harris.

More likely to find reuse are the smaller shell roofs that cover many hundreds of markets and factory buildings constructed up and down the land during the 1950s and early 1960s. They were usually constructed by specialist contractors who often offered to construct the rest of the building as well. Many of them have lasted well even in our moist climate; as with other reinforced-concrete buildings their life depends mainly on the quality of the site personnel and the care with which they placed the reinforcement and made and poured the concrete.

Fig. 7.17 Exterior view of The Pannier Market, Plymouth, Devon, by Herbert Walls and Paul Pearn, engineers British Reinforced Concrete Engineering Co., 1960.

Like many of the small curved shell roofs, folded plate structures in concrete were used in small local authority, commercial and factory buildings and, in general, have gone unremarked. One charming example is a garage in Plymouth, by arch. Roseveare, eng. Felix Samuely & Ptnrs, 1960.

A further technical development in concrete construction spread comparatively quickly during the 1950s, albeit much later than on the Continent. This was the use of pre-stressed concrete. By tensioning the steel reinforcement, concrete beams could carry much larger loads. This could lead to both lighter and cheaper structures or to greater spans with the same amount of material. As with other technical developments, a few individuals were prominent. Samuely, a particularly ingenious engineer, used pre-stressing in both steel (e.g. in the Skylon at the Festival of Britain, London, 1951) and concrete (e.g. Malago

Fig. 7.18 Car showroom, Turnbull's Garage, Plymouth, by Roseveare, Engineer Felix Samuely & Partners, 1960. The folded plate roof is supported on 10 columns beneath the valley points. The adjacent flat circular roof covered the first self-service filling station in Britain.

factory, Bristol, 1948; see Figs. 7.23 & 7.24) and spread his ideas widely. Alan Harris (later of Harris & Sutherland) had worked in Freyssinet's firm in France immediately after the war and brought pre-stressed concrete back with him, for instance at the BEA hanger at Heathrow Airport, 1951, and the Spekelands Road Freight Depot (Liverpool). Pre-stressed concrete was given particular (and uncharacteristic) encouragement by the government during the late 1940s and early 1950s. As its use enabled steel to be used more efficiently, steel used in pre-stressed concrete was not subject to the same rationing that restricted the use of steel in conventional reinforced-concrete and steel structures.

The rising cost of steel buildings in the 1930s had prompted the steel industry to look carefully at the use of steel to see if it could be used more economically. The Steel Structures Research Committee was formed in 1933 to evaluate current design methods which, to some people, seemed unnecessarily conservative. The result was one of the rare revolutions that have occurred in building design. It had long been known that steel had a reserve of strength beyond the point when the material yielded and deformed permanently in a plastic way. The current design methods, however, took no account of this. Professor John Baker had steered much of the research before the war and took the opportunity to construct a full-size test when his engineering department at Cambridge needed a new building. Constructed in 1952, its behaviour was

Fig. 7.19 Spekelands Road Freight Depot, Liverpool, eng. A.J. & J.D. Harris. The inverted T-beams each comprise eleven precast concrete elements, post-tensioned with four cables. They are 6 ft (1.83 m) wide and vary in depth from 5 ft 5 in (1.65 m) at the haunches to 10 in (0.25 m) at mid-span. The two-pin portal frame spans 102 ft 6 in (31.2 m).

monitored to check the predictions and assumptions that had been made using the new 'plastic' design procedure. The first 'architectural' use of this approach to designing steelwork was at Hunstanton School, Norfolk, by arch. Alison & Peter Smithson, eng. Ove Arup & Ptnrs, in 1955 (see Fig. 8.7).

In general, steel was not used widely during the 1950s, due largely to its rationing, cost and, it has to be said, the militancy of the steel industry's trades unions. Strikes that interrupted the manufacture, delivery and erection of steel were common and catastrophic to many projects until well into the 1960s.

This period is also notable for an important sub-plot in the story of twentieth century frame construction – the impact on the structure of buildings of the building services. These need special mention because the history of building services engineering is even less well charted and cared about than that of structural engineering. Old services installations were usually removed at the end of their useful life and built-in services such as ducts are usually even less visible than structural elements. Almost inevitably, hardly any aspect of the original servicing of a building will meet modern needs.

The conscious use of the building structure and fabric (especially concrete) to assist with the moderation of the internal environmental conditions of a building is now becoming quite popular and is often assumed to be a new idea. It is not: the Roman hypocaust is ample evidence. The early days of modern domestic concrete construction provide another example from 1870:

> The building is heated by air, warmed by contact with earthenware, conducted mainly through flues formed in the body of the concrete walls and admitted by sliding valvular gratings in the skirtings of several rooms. Ventilation is provided for in every room by distinct flues, formed in the concrete, and entered by apertures near the ceiling.[9]

As the buildings that pioneered modern servicing philosophies (from the late 1930s onwards) come to be conserved and rehabilitated for reuse, so it will be necessary to investigate most carefully how the buildings were originally conceived to work in order to ensure that proposed alterations do not disturb a thermal or acoustic function of a piece of structure or fabric. An elementary example is the cracking caused by central heating drying out the building fabric too much; another is the over-enthusiastic prevention of draughts which then causes condensation.

1965-1997

Developments in construction during the last thirty years have been rather fewer and generally less easy to see in finished buildings than progress in the 1930s and 1950s. In the context of the present volume it is also perhaps too soon to be concerned with the conservation of buildings from this period.

The greatest change has been in the servicing of buildings. First came the rationalization of how to introduce modern services, especially air conditioning, into the frame building. The multi-disciplinary firm of Arup Associates deserves special mention. It was formed by a group of structural and services engineers with architect Philip Dowson, all working at Ove Arup and Partners. They sought

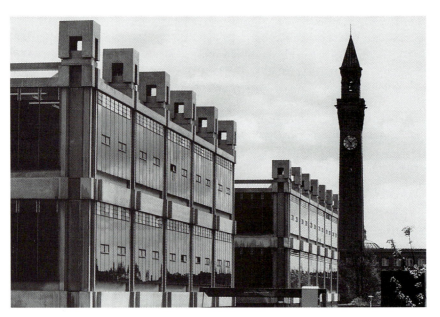

Fig. 7.20 Exterior view of the Mining and Metallurgy Building, Birmingham University, by Arup Associates, 1964-65. (Arup Associates)

to put into operation the philosophy of 'total architecture' that Arup himself had advocated and set up Arup Associates to achieve this particular aim. They began in the 1960s with a number of laboratory buildings, notably the Mining and Metallurgy Building at Birmingham University, for the expanding university sector, followed by buildings for accommodation and offices. The result was a large number of highly-acclaimed buildings which, step by step, developed more and more sophisticated ways of integrating all the engineering aspects of buildings to create a unified whole. The firm also pioneered low energy and naturally-ventilated buildings long before it became fashionable to do so.

The other significant development in the last few decades has been the progress made in what is now known as *fire engineering*. In pre-war days the frames of steel buildings had to be encased to afford adequate fire protection – columns by brick or blockwork, beams in the concrete of the floor structure. This always placed steel at a severe disadvantage to concrete (although this did not seem to persuade as many people as one might expect to choose concrete in 1920s and 1930s Britain[10]). On the other hand steel had the advantage of familiarity to both architects and contractors and was faster to erect on site.

The advent of board protection in the post-war period and fire-sprays in the 1960s gradually made steel more economic although still resulted in the frame being hidden from view. The 1970s brought a dramatic step forward with the development of intumescent paint which would expand to provide an insulating layer only when it was heated in a fire. Nevertheless it can be quite a costly solution. More radical was to approach the entire problem in a new way (see fire engineering, below).

Finally a word about 'fast-track' building which is often hailed as a recent 'invention'. It is not. Many buildings in the 1930s were put up just as quickly as those in the 1980s office boom. And the Crystal Palace, covering some 18 acres of Hyde Park, was erected in just 26 weeks in 1850-51.

Historical summary

In the realm of steel and concrete construction up to the 1970s Britain was a follower rather than a leader, although the country was a fertile ground for foreign contracting firms as well as individual architects and engineers. The pattern of penetration through the industry by nearly all innovations was, indeed, still is, similar – from bridge and civil engineering projects to industrial buildings, to major commercial buildings and finally to (most of) the rest of the industry. The industry is generally very conservative – clients, architects, engineers and contractors alike, though with occasional exceptions among each group.

It is symptomatic of such attitudes in the British construction industry that the most common current research towards improvement consists of 'benchmarking' and studies to identify 'best practice' – in other words to try to catch up with the rest of the world rather than to lead it. This is a far cry from the confidence that underlay the attitude of the eminent Victorian engineers such as William Fairbairn and I.K. Brunel, who undertook to build unprecedented structures of great size and originality.

The technology of steel

The major developments in steel technology and the use of steel in frame buildings can be found in some general books on materials and steel construction.[11] The following is a summary that, *inter alia*, will help to date buildings and inform the investigator what materials and construction may be found in a building of a known date.

Structural properties

Ordinary 'mild steel' is both a strong and a stiff material. These properties are unaffected by age. Components made of steel may lose strength, however, if the metal has corroded, since rust has no strength. All steels have approximately the same stiffness but their strength varies considerably according to the constituents making up the steel alloy. Nowadays the strengths can be controlled very precisely but this was not the case earlier in the century. Another important property is the yield strength – the stress which causes the steel to deform (long before it fractures). This property does not have a constant value and varies according to how the steel and the component were made. Despite its importance in our eyes today, it was seldom measured or quoted by manufacturers until the late 1940s as it had no place in any of the design procedures used until this time (see below).

The main difference between old and new steels is the variability of the strengths, even between pieces in the same building. This was inherent in the manufacturing process and depends on the quality control – a piece of steel can be of poor quality in just the same way as concrete or brickwork can. The consequence of this is that it is not possible to be precise about the yield or ultimate strengths, or brittleness of the steel in an old building without testing a piece (preferably several pieces) to find out.

The heat involved in the welding process can make normally ductile steel brittle and it can then fracture like stone or cast-iron. This situation is aggravated when there is a crack in the metal (caused by corrosion or metal fatigue, perhaps)

which leads to a stress concentration. Welded-steel assemblies can thus fail at surprisingly low loads and many failures of steel structures have resulted from these circumstances. It is, therefore, especially important to inspect crucial welds in old steel structures.

Corrosion

Steel rusts in the presence of oxygen and water and, especially, when also in intimate contact with certain other metals. While this has long been known, ignoring it or giving it inadequate attention is by far the main reason why the structures of old buildings, both in concrete and steel, have deteriorated even to the point of collapse.

Protection is usually by painting with a rust-inhibiting paint but this can be damaged and needs regular reapplication. Small steel components, such as window frames, can be galvanized with zinc which gives them some electrochemical protection. This too can be damaged.

Two particular steels (i.e. alloys of iron) have been developed which include other metals to prevent the iron corroding. Stainless steel (developed in 1913, but widely used only in the last twenty years) contains chromium which forms a protective coating of oxide that inhibits further corrosion. However, stainless steel does corrode in some environments and is now becoming a maintenance liability in some of those buildings where it was used in exposed places.

The other corrosion resistant steels are 'weathering' steels. These contain copper and have been available since the 1930s. Their problem is that the corrosion product (copper oxide) is washed away and stains lower parts of the buildings (especially concrete). The most famous of these in Britain was Cor-ten which had a period of popularity in the 1960s and some excellent buildings survive, e.g. Headquarters Building for W.D. & H.O. Wills at Bristol by arch. SOM with YRM, eng. F.J. Samuely & Partners, 1975).

Manufacture

Steel was widely available from the mid 1880s in various flat, L-, T-, U- and I-sections rolled in a few standard sizes suited to their structural duty. The precise sizes varied from manufacturer to manufacturer and country to country and tables were always provided giving cross-section geometry, structural properties and, sometimes, safe loads for typical beams. In these early days it was still possible to have steel sections rolled to order. Standardization of sections was adopted in Britain in 1904 (rather later than in USA and Germany).

The I-sections were assumed to be used as beams and so were rather deeper than wide. From 1902 'Broad Flange Beams, Grey Process' (Henry Grey was an Englishman) were produced, first of all in Luxembourg and two years later in the Bethlehem Works (USA). They generally had 12 in (300 mm) flanges and were available up to 40 in (1.01 m) deep. In symmetrical format they resemble what we call Universal Column sections and this was their primary use. However in other sections they were widely used as heavy duty beams in buildings to achieve more headroom, for crane runways, railway bridges and, in lengths of up to 80 ft (24 m), as piles. Grey sections were available until the 1940s and the modern Universal Beam and Column sections first appeared in the late 1950s.

Circular hollow sections were available during the entire 100 years of using cast-iron columns in buildings. While hollow sections could be made by riveting plates of wrought-iron (Saltash Bridge) or steel (Forth Bridge) this was rare. Riveted circular hollow steel columns ('Phoenix columns') are found in early twentieth century buildings but died out in favour of simpler sections built up from flats, channels and angles.

Although a structural catalogue of 1902 advertised roof trusses of tubular steel, hollow steel sections were not generally used until the mid-1930s when Stewart and Lloyds' continuous-weld tubes were first produced at Corby. The technology of their use was largely developed for special structures such as cranes and maritime structures, and most recently, oil rigs. The use of tubes (CHS – circular hollow sections) has always been constrained by the geometry of connections and welding was virtually a pre-requisite of their widespread use. Their widespread use in architecture is relatively recent following buildings such as the Pompidou Centre, Paris, 1973-76. The rectangular hollow section (RHS) was developed to simplify the geometry of connections, and to make elements better suited to resist bending as well as tension and compression.

Solid round columns in steel are a lot older and more common than generally realized. In some buildings between 1900 and 1910 they have been found with diameters from 4 in (100 mm) up to 12 in (305 mm) in one eight-storey building. They were generally connected to other structural elements using steel end plates, which were fitted onto the ends of the columns when hot and allowed to cool and shrink. Their main advantage is excellent resistance to fire and small area of cross-section, so offering more floor space. Marks and Spencer required the use of 6 in (150 mm) solid round columns in their stores until the mid-1960s.

Connections

Riveting

At the turn of the century the variety of steel sections was quite limited, especially for larger dimensions. It was common, as it had been with wrought-iron since the 1840s, to build up larger cross-sections by riveting together several flat- and L-sections. This technique can be seen (usually in wrought-iron rather than steel) in most Victorian railways stations and bridges. The rivets were heated red hot and placed in position before being closed using portable hydraulic machines (first developed by William Fairbairn in the 1840s). As the hot rivets cooled they pulled the sections tightly together which served both to prevent the ingress of dirt and water and also to increase friction between the two surfaces.

Riveting was used in two ways. It was the means by which large structural sections could be built up from smaller flat, L-, T-, I- or channel sections – a technique easily visible in early railway bridges. This prefabrication could be done at ground level or even off-site. The other use of riveting was fixing the columns, beams and girders *in situ*. This process was usually more difficult (and dangerous) and kept to a minimum by ingenious use of prefabrication and cranes. Riveting was used until well after the Second World War when it was gradually replaced by bolting and welding. Riveting survives now as a small part of the heritage construction industry and gives a visual appearance that cannot

be achieved using bolts (see the unattractive results at Paddington Station, London, where rivets could have been, but were not, specified in a recent refurbishment).

Welding

As a means of joining steel sections electric arc welding was developed early in the century in the USA and Germany where it was widely used during the 1920s in ships, bridges and buildings. The first British welded ship was launched in 1920 and welding's first use in a major bridge was not until 1934. Its use in buildings spread during the 1930s via the influence of immigrant continental engineers, especially Felix Samuely (Simpsons, London 1935; de la Warr Pavilion, Bexhill, 1938) but it was not widely used until the mid-1950s.

The reliability of welding has improved steadily, both as equipment and technique have improved and as a result of more effective quality checking using X-rays and ultrasonics. Since the mid-1980s it has been possible to control cutting, drilling and welding machinery directly from a computer. This has generally improved accuracy and repeatability, and has facilitated the fabrication of geometrically complex two- and three-dimensional assemblies.

A particular offshoot of cutting and welding technology has been the castellated beam – an I-beam cut along its length in zig-zag fashion and rewelded as a deeper beam with hexagonal holes along the length. Its fore-runner, the Boyd beam, was patented in 1939.

Although not of structural significance, perhaps the greatest influence of welding on twentieth century architecture was the widespread use of the metal window frame which almost became one of the hallmarks of British buildings in the International Style. Blacksmith (hand) welding of metal frames was an old art but expensive; nineteenth century wrought-iron and steel windows usually had tenon joints. In the early years of this century Crittall Windows developed their own machinery to make flash butt welds at the frame corners and many such frames pre-date the First World War. The welding technology was improved considerably after the war and became available to other window manufacturers in the mid-1920s.

Bolting

The bolting together of steel elements has been common throughout the century, usually mixed with riveted construction. This technology enjoyed a sudden growth in the early 1950s with the development of high strength, friction grip (HSFG) bolts. By doing these up very tightly, they pull the steel sections together and increase the frictional force between them, in the same way that hot rivets did. Although originally developed in the USA and Germany for use in bridges, their use in steel-framed buildings soon followed as they needed much less labour to install than rivets.

Cast alloys of iron

The classic grey cast-iron, ubiquitous in the mills and warehouses of the Victorian era, was an extremely brittle material and relatively weak in tension (about six times less than its strength in compression). Its structural use in

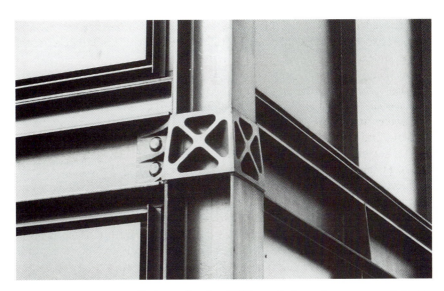

Fig. 7.21 Close up of cast-steel node on the IBM Headquarters, Bedfont Lakes, Middlesex, by Michael Hopkins and Partners, engineer Buro Happold, 1993.

buildings for beams died out in the 1850s and for columns around 1900. Nevertheless, it survives to this day for decorative and 'architectural' purposes.

Since 1946 we have had *ductile cast-iron*. Because of its micro-structure it is also called *spheroidal graphite (or SG) cast-iron*. It has mechanical properties more like those of steel than traditional cast-iron. Its use is still rare, for instance in the Menil Collection Museum, Houston, by arch. Renzo Piano, eng. Ove Arup & Ptnrs., 1981; and the Schlumberger Building, Cambridge[12], by arch. Michael Hopkins, eng. Buro Happold, 1993.

Mild steel can also be cast and has been used since the early 1970s in some spectacularly large structural connections. It is more viscous to cast that ductile cast-iron but has the advantage that it can be welded to other mild steel components. Again its use is quite rare – Pompidou Centre, by arch. Piano & Rogers, eng. Ove Arup & Ptnrs, 1973; Renault Building, by arch. Foster Associates, eng. Ove Arup & Ptnrs., 1984; Bedfont Lakes, Middlesex, by arch. Michael Hopkins, eng. Buro Happold, 1993; Ponds Forge swimming pool, Sheffield, by arch. FaulknerBrowns, eng. Ove Arup & Ptnrs, 1993.[13]

Cast stainless steel has similar structural properties to mild steel and a good resistance to corrosion and is widely used for fittings on boats. For some 20 years now it has been used in buildings, especially for small-scale connections such as those used in glass façades.

Design procedures

The Board of Trade first gave official permission for the use of steel in bridge construction in 1877 but its use in building frames was not recognized by official regulations (the London Building Act) until 1909, five years after its first major use in London in the Ritz Hotel. There was, therefore, up to that time, no agreed design procedure for engineers to follow: each would use his experience and adapt the existing procedures for cast-iron by using different values of working stress and ultimate strength provided by the steel manufacturers. In practice many designers followed the ancient practice of using tables that gave safe loads,

according to span, for the different sections a manufacturer sold. At this time there was no agreed floor loadings in buildings either. The London Act set down design principles, loadings and allowable stresses for beams and columns of both cast-iron and steel. It was used widely for more than twenty years until the first edition of a British Standard code of design practice (BS 449) appeared in 1932.

However, already in the late 1920s many engineers were coming to feel that the principles and figures in the 1909 Act (and BS 449) were both over-conservative and, worse, irrational. In 1929 the British Steelwork Association set up the Steel Structures Research Committee to address these concerns. One result, in 1948, was a more rational, but more complex code (CP 113). This code was effectively ignored by the profession who continued to use BS 449, a new edition of which appeared in 1959 incorporating much of CP 113. This was used until 1985 when a new code appeared, BS 5950. (Loads on buildings, previously incorporated in BS 449, were given their own code in 1952 – CP3 Chapter V.) To this day it is allowable (though uncommon) to use the BS 449 codes. This rather curious (and rather English) story means it is not possible to establish from the date of a building what design code was used, nor what floor and other loadings were assumed. However it is essential to be familiar with these various design codes in order to understand how the original designer might have conceived how the building should work.

The Steel Structures Research Committee also produced a more radical outcome. Under the guidance of Professor John Baker at Cambridge University, a more rational design approach was developed to deal with the ultimate strength of steel structures. It became known as the plastic design method and was first used on a complete building in 1952. The philosophy underlying these procedures has brought about a major design revolution which has influenced all subsequent design codes, for concrete and timber as well as for steel.[14]

The technology of reinforced concrete

It is no exaggeration to say that, in Britain, generally speaking, reinforced concrete has consistently met with resistance from indigenous clients, architects, engineers and contractors. Apart from the work of Oscar Faber and the Building Research Station on shrinkage and creep in the 1920s, all concrete technology has been imported into Britain rather than developed here. More accurately, it has been brought in by foreign clients, architects, engineers and contractors choosing to work in Britain.[15] Nevertheless, once it had arrived there have been, and continue to be, excellent examples of its use to match any in the world.

Structural properties

Reinforced concrete is a more complex material than steel. Its potential depends on both the tensile strength of the steel reinforcement and the strength in compression of the concrete. It also depends upon the strength of the bond between the reinforcement and the concrete since the two can work compositely only if there is a means for stresses in one material to be transferred to the other. Finally the concrete changes its dimensions with time both due to shrinkage associated with the chemical reaction by which concrete is formed and, when subject to continuous loading, due to creep.

The strength of the reinforcement depended on the type of steel specified and its quality. Until the late 1930s mild steel was generally used; after the Second World War 'high tensile' steel was permitted with a strength about 25% higher than mild steel.

Concrete is a composite material. It is the product of a chemical reaction between Portland cement and water to form a matrix in which is embedded the aggregate (usually a mixture of sand and gravel). The strength of the concrete depends on the strengths of the cement mortar and of the rock from which the aggregate is made and also on the strength of the bond between the cement and aggregate. Looked at another way, the strength of concrete varies with the proportions of the ingredients mixed together and the ambient conditions in which the chemical reaction takes place (temperature and humidity) and, as with all chemical reactions, time.

A complete understanding of these issues did not arrive into the world fully-formed. Despite widespread use of concrete during the second half of the nineteenth century, many people using it still did not realize the importance of the mix design in achieving a desired strength nor the chemical nature of the hardening of liquid concrete (it was often assumed to be like mud drying out). Unlike its use as mass concrete in foundations and thick walls, in order to be used in columns and beams the strength of concrete had to be guaranteed; given the variability of the manufacturing process, the minimum guaranteed strength was, in the early years of the century, much less than it was possible to obtain. Only as the reliability of site supervision improved could the guaranteed strength be increased. Before the First World War crushing (cube) strengths of between 11 and 15 N/mm^2 were allowed, depending on the mix; by the 1930s this had risen to 15-20 N/mm^2 and, since the 1950s, to 20-30 N/mm^2. Since the 1930s it has been possible, using special mixes, to make higher grade concretes with strengths of up to perhaps twice that of ordinary grade concrete.

The need for a good bond between the concrete and reinforcement seems not to have been obvious to all the early users of concrete, and many reinforcing systems employed only straight round bars. Any bond that did develop was more or less incidental, enhanced by the layer of rust on the surface of the bar and by the straps and wires used to fix the bars prior to pouring the concrete. Several systems soon employed the idea of bending over the ends of the bars or twisting or crimping the bars (e.g. the Indented Bar Company) to deliberately create a key between bar and concrete which could carry the shear forces so vital to the working of reinforced-concrete beams.

These matters are of great importance for building conservation. Firstly, the material is so young that only now are we finding reinforced-concrete buildings reaching the end of their first life and being considered for rehabilitation. Secondly, the quality of the materials and their use in any concrete building can be expected to be both unpredictable and variable, especially in buildings before about 1930. Thirdly, while it is very likely that the concrete structure of an old building will be satisfactory for modern reuse, it will require a skilled engineer with relevant experience to investigate and understand how a particular structure is (probably) working and to be able to demonstrate that it can carry modern floor and wind loadings.

Systems of reinforcing concrete

The history of reinforced concrete divides reasonably neatly into four stages: up to about 1920; between 1920 and about 1940; between 1940 and the late 1960s; and after 1965.

Before 1920 concrete construction was dominated by various systems of reinforcement patented by their manufacturers. Often these firms were also the contractors who not only provided the steel but also carried out the construction on site. In fact this approach was the key to the early success of the Hennebique firm; it not only patented the method of placing the steel in the concrete but also trained the staff in its own firm and the firms who bought the Hennebique franchise (e.g. Mouchel) to ensure the correct use of the reinforcement on the construction site and the quality of the concrete itself, including the raw ingredients (even the sand was imported from France for Weaver's Mill in Swansea).

The earliest patents for reinforcement date back to the 1850s but none was widely used until the 1890s. By 1910 there were about a dozen proprietary systems in common use in Britain, most of them foreign. The best known are those of Hennebique, Coignet, Considère, Indented bar and Kahn. The Cottincin and Monier systems, better known on the Continent, were also used.

Some independent consulting engineers working in Britain were unhappy about the invasion by these new technologies, but rather than work with contractors to compete they adopted a different approach. They sought to challenge the validity of the various patents, arguing that the idea of using steel to reinforce concrete was commonplace and the many systems all worked in roughly the same way and were based on the same engineering principles. Whilst none of the many patents was ever invalidated the *de facto* result was the same. By the end of the First World War the earliest patents were starting to lapse and no new ones were being granted. By the early 1920s reinforced concrete had effectively passed into the public domain.

Among the many dozens of these early proprietary systems can be found virtually every type of concrete construction known today. For instance, both

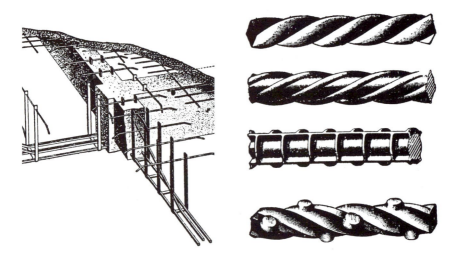

Fig. 7.22 A reinforcing system used around 1910, and examples of reinforcing rods. (Concrete Engineers' Pocketbook 1911, International Correspondence Schools, London [issued by the American branch of ICS])

ribbed slabs and coffered ('waffle') slabs were patented by E.H. Ransome in the USA in the 1880s; and flat slabs were developed both in the USA and by Robert Maillart in Switzerland in the first decade of this century.

During the second period (1920-1940) the various firms continued to use and develop their patented systems until, by the end of this era, they were all virtually indistinguishable. This harmonization was to lead to another outbreak of proprietary systems which dominated the third period, the two decades or so following the Second World War – and came to be know as 'system building'. This was led by contractors rather than reinforcement firms and was their way of breaking into and finally dominating the field. One study logged no less than 170 different systems in use in Britain during this time.[16] This time the patentable idea was usually based on the use of pre-cast structural elements which were assembled and 'stitched together' *in situ*. The similarity with the first two decades of the century is striking; the systems were developed entirely for commercial benefit and involved virtually no significant innovation. Since the collapse of the system-built block of flats at Ronan Point, East London in 1968, proprietary systems have again died out and concrete construction is, generally, again in the public domain.

To summarize these developments it is, perhaps, enough to emphasize how important it is when investigating an old concrete building to find out the date of its construction and which contractor built it. This will instantly point to the type of reinforcement likely to be beneath the surface of the concrete and may also give an indication of the likely quality of the concrete itself.

Formwork and plant

It is striking to find in the records of concrete construction just how early most of the methods of construction were. The following are probably not the earliest examples of their use (even in Britain) but do present a brief overview:

- pre-cast concrete blocks 1830s.
- continuous concrete manufacture 1860s.
- larger pre-cast concrete elements 1870s.
- permanent metal shuttering 1900.
- reusable, 'universal' metal shuttering 1905.
- cranes with 360° delivery arc 1905.
- slip forming (formwork movable without dismantling) 1910.
- batching and mixing plant 1925.
- concrete pumping 1927.
- ready mixed concrete 1930.
- continuous slip forming (grain silos) 1940s.
- ferro-cement 1947.
- 'tilt-up' construction 1952.

Pre-stressed concrete

The first suggestion that pre-stressing might overcome the problem of concrete cracking under the slightest tension loads was made in Germany before the First World War, but no practical means was devised for introducing the pre-stress and also overcoming the inevitable movement caused by creep and shrinkage in the

concrete. Eugène Freyssinet solved this problem and patented his system in 1928. The early use of pre-stressing was in bridges and structures in contact with water, since the pre-stressing would also close up any cracks and keep moisture away from steel reinforcement. A further essential ingredient that made pre-stressing a viable option was the development of high-yield steel wire in the late 1930s. High-tensile steel had been available for some time but it had not been possible to control accurately the stress at which it began to deform permanently (the elastic limit or yield point). This was essential to ensure that the level of pre-stress could be guaranteed.

Pre-stressed concrete had two particular advantages over ordinary reinforced concrete. By pre-compressing the concrete, the imposed load needed to cause tension stresses in a beam is increased. Conversely, for a given load, the depth of a beam can be reduced. Not only does this have a visual benefit but it also means less material is needed. This latter fact was appreciated by the government in post-war Britain when pre-stressed concrete was not subject to the same rationing that applied to steel and conventional reinforced concrete. This undoubtedly partly explains the outbreak of pre-stressing in the early 1950s, particularly by engineers Felix Samuely and Alan Harris. It should be added, however, that there were personal reasons too: Samuely liked pre-stressing in general and used it for structures incorporating timber and steel too (e.g. the Skylon at the Festival of Britain, 1951); and Alan Harris had worked with Freyssinet in France at the end of the war.

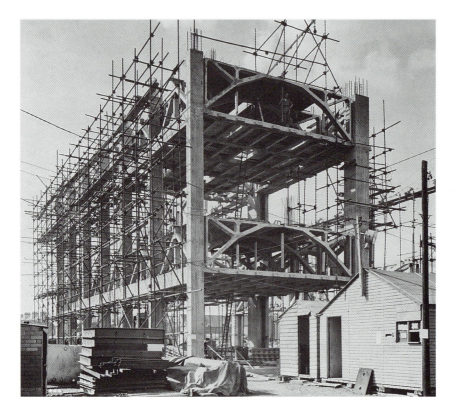

Fig. 7.23 Construction of the Factory at Malago, Bristol, by John E, Collins, engineer Felix Samuely, 1949-51. (F.J. Samuely & Partners)

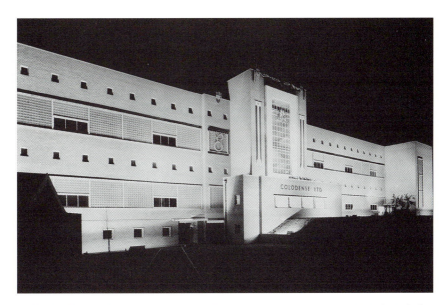

In the 1960s there were a variety of pre-stressing systems available in Britain, much as there had been many reinforcing systems 60 years earlier. Each used different sizes and numbers of cables and patented devices for applying the pre-stress to the cables and locking this in with a cement grout.[17]

Everything that has been said about appraising and reusing reinforced-concrete buildings applies doubly to pre-stressed concrete. Creep and shrinkage of concrete mean it is necessary to periodically check the level of pre-stressing in the steel cables. A loss of tension itself will probably not lead to collapse but may lead to cracking of the concrete. This, in turn, can allow water to reach the reinforcement and cause corrosion.

Design procedures

Reinforced concrete is a very much more difficult material to model mathematically than steel, and the full story of the development of ways of designing various building elements is too complex to treat here.[18] Suffice it to say that the growth in the use of reinforced concrete during the 1920s and 1930s was directly linked to the establishment of the independent consulting engineer who is nowadays so familiar. Hitherto most of the design work had been undertaken by the specialist contractors, a practice that lingers in some specialist areas and with much detailing of steel reinforcement.

The first regulations covering the design of reinforced concrete had been signalled by the 1909 London Building Act for steel, although did not appear until 1915 under the name of the LCC Reinforced Concrete Regulations. The first Code of Design Practice did not appear until 1934. This was augmented (but, as with steel Codes, not legally replaced by) later codes – CP 114 in 1948, CP 110 in 1972 and BS 8110 in 1985. A knowledge of these codes and how they influenced the choice and placement of reinforcement and concrete mix design, is vital to understanding the thought processes that are likely to have gone into conceiving an old concrete structure.

Protection against fire and fireproof floor systems

Steel is weakened to the point of becoming structurally inadequate when heated above 550°C, a temperature which is quickly reached in most fires. Before steel, cast- and wrought-iron were known to suffer similar weakening. The fireproof building had been a goal in building construction for many centuries, and had been accelerated in Britain from the 1780s onwards with the concentration of plant, materials and people in multi-storey factory buildings. This had been the drive behind the introduction of cast-iron columns and, a few years later, beams in the mills. In the nineteenth century most of these buildings had load bearing masonry walls and the columns were, in general, left exposed. So too were the underside of cast- and, later, wrought-iron beams; however the bulk of the beam was encased in the brickwork or concrete of the floor structure and this afforded adequate protection of the metal in a fire.

When the all-steel frame building arrived the columns needed full fire protection and this was effected by encasing them in concrete, within block or brickwork, or with plaster after the appearance of expanded metal products (e.g. 'Expamet' in Britain) which provided an excellent key, at around the turn of the century. In the inter-war period fireboard products such as plasterboard began to replace the wet-trade methods but introduced a new problem – the creation of air gaps between the fire protection and the steel which could allow hot gases to flow through the building and help spread the fire. This problem was the primary drive behind the development of spray-on fireproofing products in the mid-1950s. Unfortunately asbestos fibres were an ingredient of some (but not all) of these sprays until 1975.

Floor structures are generally more vulnerable to fire damage than columns because they are usually more exposed. The development of a fireproof flooring system has probably been the area of most fertile invention in building design over the last 200 years; there have been literally thousands of patented and non-patented systems. The main consequence of this fact is that it is impossible, without proper investigation, to know what holds up the floors of most buildings.

There are several generic types of floor to be found in twentieth century buildings. The jack-arch, either in brickwork with a concrete fill and topping, or mass concrete or hollow clay blocks spanning between parallel steel beams, is an inheritance from the nineteenth century. These contain – sometimes exposed, sometimes embedded – a steel tie rod to locate the beams during construction and to carry the thrust of the arch should the adjacent arch be (or become) absent. They must not be removed during any repair works. A simpler version of this idea is found in filler joist construction in which the full depth between two I-beams is filled with concrete and works as a flat arch. In some systems hollow clay pots are used instead of concrete. By the early days of the century many of these floor systems had effectively become reinforced-concrete floors using a wide variety of steel sections to act partly as beams and partly as tension reinforcement and these systems prevailed until the introduction of metal decking floors after the Second World War.

The first use of corrugated iron and concrete in floors had been in the USA around 1890, but the concrete acted only as a hard-wearing surface and vibration damper. True composite-action metal decking floors were developed in the USA

only in the mid-1950s despite the fact that composite action between beams and concrete had been known and used during much of the nineteenth century. The widespread adoption of these floors depended entirely on the development of effective and cheap spray-on fire protection.

The disadvantage of all these methods of giving steel the fire protection it needed is that they prevent the steel being seen. A breakthrough came with the development of intumescent paints in the 1960s. These foam and bake hard when heated and entrap air which provides excellent insulation. They are used only on large structural members (not metal decking) as they rely for their effectiveness on the large metal section to conduct the heat away. This treatment can also, of course, be applied to the metal structure of existing buildings and has already proved itself a Godsend to those engaged in conserving exposed cast- and wrought-iron in buildings.

Until very recently the fire protection of buildings was treated as a largely qualitative matter. From the early 1950s the notion of a 'fire rating' began to be used and was specified as a time for which a building element must survive a fire. Initially these were empirical figures based on conservative estimates and depended on the position of the element in the building and the building's size and likely occupancy.

The conservative British attitudes to fire probably explain why so few commercial and public buildings in Britain have had iron or steel visible in their façades. The Brussels Department Store and other buildings by Victor Horta, and the buildings in the *rue Réaumur* in Paris, all around the turn of the century, would have been unthinkable in London.

A more scientific approach to fires had begun around the turn of the century when various forms of construction were tested in controlled fires. By the 1930s most countries had fire research institutes, and such experimentation helped to establish temperatures experienced in real fires. Soon after the war the concept of a 'fire load' was proposed. This is, in many ways, analogous to a gravity or wind load acting on a building. It was measured in $BThU/ft^2$ or, for convenience, the weight of timber equivalent to the fire load of the combustible material.

In parallel with these developments, both on the continent and in the USA, the argument gradually came to be accepted that, if the structure was effectively outside the building, it would be adequately protected from an internal fire. A classic example was Mies van der Rohe's pioneering Farnsworth House (albeit single-storey) nearly 50 years ago. The first example of this approach in a multi-storey building in Britain was the Headquarters building for W.D. and H.O. Wills in Bristol (1975, arch. Skidmore, Owings & Merrill (SOM) and Yorke, Rosenberg and Mardall (YRM), eng. Felix Samuely & Partners).

The same rational argument was used by Ove Arup and Partners in the Pompidou Centre, in the early 1970s. In fact, they used a two-pronged approach to ensure that the dramatic steel structure could be fully exposed. They successfully argued[19] that the external steel would not be threatened by an internal fire and also the circular stainless steel columns in the building are filled with water. In the event of a fire, water is pumped around a circuit to remove heat from the steel subjected to the source of heat, rather like the water that cools a car engine. The idea is effective but expensive and has been used only very

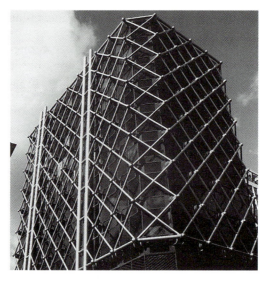

Fig. 7.25 Bush Lane House, London, by Arup Associates, 1976.

rarely in Britain, for instance in the lattice exo-skeleton of stainless steel tubes at Bush Lane House, London by Arup Associates, 1976.

Since about 1985 the concept of the fire load has enabled engineers to model the behaviour of fires mathematically and thus understand and predict the behaviour of buildings during fires. Using computer modelling it is now possible to study the flow of hot gases in fires using Computational Fluid Dynamics (CFD) and even the flow of people escaping from fires. These various modelling techniques, together with a full risk analysis of a fire situation, are now collectively called Fire Engineering and represent the most recent revolution in our approach to fire safety in buildings. This development has been directly responsible for the rapid spread of exposed steelwork in British architecture during the last decade.

The engineering case for retaining an existing building

The clear distinction between the professions of structural engineer and architect has come about largely as a result of the development, during the last 100 years or so, of the structural frame as the armature of a building. Unfortunately this has encouraged people to think separately about the structure of a building and its architecture.

This is hardly surprising since the structural frame is virtually invisible and can be conveniently ignored. At the other extreme the structure is extremely visible, as with many railway stations, sports stadia and tensile membrane structures, for example. In such cases the engineering is again often rendered invisible by being talked about as architecture. Most twentieth century buildings inhabit the middle ground – some of the structure is visible, either where it meets the façade or as columns and cores (around lift, stair or services cores) within the building.

In all these cases the structure and façade directly affect both the appearance of the building, from outside and within, and how it functions as a series of linked volumes and intersecting lines and planes. This has important

consequences when conserving and refurbishing buildings (see the following chapter by Peter Ross, pp143-163).

The general guidance from the Departments of Environment and National Heritage[20] summarizes the main criteria which the Secretary of State applies as appropriate in deciding which buildings to include in the statutory lists. Of relevance to the engineering of buildings are the following:

> *Architectural interest*: ... buildings which are of importance to the nation for the interest of their ... craftsmanship; also important examples of particular building types and techniques (e.g. buildings displaying technological innovation or virtuosity).
> *Historic interest*: ... buildings which illustrate important aspects of the nation's social, economic, cultural or military history.
> *Close historical association*: with nationally important people or events.

Several phrases mentioned in the criteria for deciding are amplified and elucidated. The only mention of factors that specifically touch on engineering comes under the heading Aesthetic Merits:

> The external appearance of a building ... is a key consideration in judging listing proposals, but the special interest of a building will not always be reflected in obvious visual quality. Buildings which are important for reasons of technological innovation ... may well have little external visual quality.

Despite these mentions of engineering among the criteria it is rare indeed for buildings to be listed *primarily* for reasons of engineering interest. The Boat Store at Sheerness, 1858, is an example.[21] There is often also a subconscious linking of engineering history with civil engineering or industrial artefacts such as bridges, factories, mills, pumping stations and waterwheels. This is to deny the engineering content of non-engineering artefacts such as office buildings and cinemas.

Part of the reason for this situation is the rarity of engineers with sufficient enthusiasm for, and knowledge of, the history of building engineering. It usually takes an experienced engineer to identify the quality of a particular example of engineering design and it takes an engineer with a good knowledge of engineering history to judge its significance. Unfortunately, there are not many of the first and even fewer of the second. It cannot be overstated that engineering history has to be created by such people – no one else will. Engineers will have to learn to put their case for listing and preservation as cogently and forcefully as is common among those interested in architectural history. Hitherto this has happened only rarely and not always successfully (the recent case of the Thames Tunnel, East London by Marc Brunel is an example).

The examples of material, structural and constructional innovation given above give an indication of some of the engineering reasons why a building may be significant. A few names of significant engineers have also been given. However their significance depends upon their work being known and

appreciated. There are surely many significant engineers whose contribution to engineering and building history is not yet recognized – Sven Bylander (of Ritz and Selfridges fame) is one example.

Perhaps the most important action that must be undertaken when any existing building is investigated is that an acknowledged expert on that type of building and period of history be consulted. (The Institutions of Structural Engineers and Civil Engineers can usually put architects and clients in touch with appropriate experts.) As with an archaeological find there are six important reasons for this:

- to ensure an appropriate survey is done to establish what is there.
- to establish whether what is found can be identified as an example of a known type of construction or, if not, to record the hitherto unknown construction.
- to identify engineers and architects associated with the project.
- to advise, based on experience of similar known buildings, on aspects of structural appraisal that should be heeded and types of repair, restoration or rehabilitation that may be undertaken.
- to advise on the historical significance of what is found.
- to record what is found, so that its existence is preserved for posterity even if the building is lost.

The structural appraisal of existing buildings

From a client's point of view, the practicality of conserving or refurbishing an existing building made from steel or concrete is identical to a building made from any other material. During the last few years much good guidance has been published but is not yet widely known by all engineers.[22] Nevertheless, the most important activity is to learn as much as possible about the actual building and its state of decay.

The chief difficulty with the structure of a building is that it is generally hidden from view. Indeed, in the case of reinforced concrete, the steel, which is the all-important load bearing material, *ought* to be hidden. The appraisal of any structural element is, therefore, best undertaken by an engineer with experience of historic construction who will know what they are likely to find and will be able to recognize anything that is out of the ordinary. The appraisal will probably require minor intervention but this will be minimal if it can be guided by previous experience, a good knowledge of former techniques of building construction, and as much information as possible about the building and its history. If at all possible the original drawings for the building should be consulted. If these are lost, there may be drawings produced after previous surveys of the building, for instance on the occasion of alterations or major refurbishments. However, such drawings can never be relied upon, for they are unlikely to represent the building as found: all they can do is inform and guide the appraiser.

In general, it is impossible to find out exactly how a building structure is *actually* working. It is not possible to measure how much load is being carried by different elements of the building even under dead-loading, let alone wind and other live loads. For this reason the structural assessment of an existing building is subjective and dependent on an engineer's experience and skill.

Consulting original or other existing drawings will help the engineer appraising the structure in two vital ways:

- to understand as well as possible how the structure of the building is working and how it carries the dead and imposed loads along identifiable load paths down to the foundations; and
- to raise the overall level of confidence in the results of the appraisal.

Failure to do this has, on more than one occasion, led to a false diagnosis of distress in an old building and to unnecessary remedial work or demolition. At the very least, such an outcome is expensive for the owner and developer of an old building.

The following proposals, or similar ones appropriate to other construction systems, can be taken for the main structure of any existing building. Of over-riding importance are general English Heritage guidelines that *a structure should be conserved as found* and that *intervention should, if at all possible, be reversible*. The following suggestions are presented in the order of their degree of intervention.

Outline design stage
- Consider carefully the proposed new use for the building – could heavily-loaded areas be moved to the ground floor or another building, or be restricted to only part of a floor area?
- Would the original or previous uses of the building, the original design loadings, material properties and design methods lead you to believe the building, as new, would have been able to perform the proposed new use? (If not it may be unwise and/or expensive to continue). The first quantitative analysis should begin by using simple mathematical models and conservative working stresses; these will help establish how near (or far) a building may be from being capable of reuse.
- Since some structural intervention and/or new structure is almost inevitable (lifts, services risers and fire escapes) look for ways of exploiting these to introduce new, useful load paths, both for floor loading and wind loading.
- Undertake an accurate, full structural survey of the building including hidden reinforcement if possible. It will be necessary to remove claddings and some concrete cover to achieve this satisfactorily. With care, take samples of the load bearing materials from columns, beams, floors and roofs; these can be tested to provide *actual* values of stiffness, hardness and strengths. These will be crucial to assessing structural safety and stability.
- Most important of all is for the engineer to understand how the building is (probably) working to carry the loads that it carries, and has carried in the past. This is frequently different from first impressions.

Structural appraisal stage
- Check the proposed design scheme using simple versions of the key models first of all:
 - mathematical models of dead and imposed loads.

- mathematical models of all materials.
- mathematical models of the structure and its elements.
 It is not uncommon to find at this stage that the building should not be standing. If so, you can be confident that it is the models that are incorrect, not the building.
- If the behaviour model 'fails', investigate and question ALL the assumptions behind the mathematical models, for example:
 - the proposed floor loadings – is 4 or 5 kN/m² necessary? A strong case might be made for using 2.5 kN/m². This immediately makes the problem a lot easier. Alternatively, it may be argued that only some of the floor area would need to carry 4 (e.g. heavy equipment) while the rest would need to carry 2.5 – i.e. only parts of the floor may need strengthening.[23]
 - perform statistical analysis of test results on material samples to increase confidence in material property values used in modelling.
 - the type and nature of any proposed essential structural interventions.
 - end fixity/effective length of columns and beams.
 - eccentricity of loads on columns.
 - composite action between steel and brick, rubble or concrete.
 - are there 'non-structural' elements in the building which are, in fact, carrying loads and/or adding stiffness to the structure, e.g. in-plane stiffening action of floors, roofs and claddings.
- Only if the behaviour model still 'fails' will some structural intervention be needed. By this stage the purpose of any intervention will be precisely understood. According to need, consider reducing dead loads by removing some screed, rubble or concrete and/or replacing it by less material, or a less dense material.
- If necessary, increase the size (cross-section and/or I-value) of beams, columns and floors by adding new, appropriate material in appropriate ways
 - bolting, welding, clamping, gluing or casting.

Up to this point relatively minor invasion of the existing building is involved. In practice, most twentieth century buildings in reasonable repair can be reused using the approaches given so far.

- Finally, and only if all else fails, consider providing new structure. This may be done in three ways, of increasing irreversibility:
 - new structure in addition to the existing structure, making sure loads are correctly shared between new and old.
 - make the existing structure redundant by providing new load paths. In this case the existing structure may be retained or removed.
 - replace existing structural element(s) with new ones.

The last and best piece of advice to clients and architects is to choose your structural engineer carefully. Many wonderful buildings have been demolished or irreparably damaged because the chosen engineers have had inadequate experience of old buildings or certain types of construction (but what engineer would admit inadequate experience and thereby lose a job?). In general,

demolishing a structure and rebuilding a new one will always be the most expensive solution, and you should be suspicious of any engineer who tells you that a solid-looking old building is unsuited for modern occupation.

References

1 The best non-technical history of the period is without doubt Bowley, M. (1966) *The British Building Industry: Four Studies in Response and Resistance to Change*, Cambridge University Press.

The best sources of technical information are old text books and back copies of periodicals. Periodicals of especial relevance include *The Architects' Journal* (1895-present), *The Structural Engineer* (1921-present), *Concrete and Construction Engineer* (monthly, 1908-66), *The Builder* (1845-present as Building Magazine), *Proceedings of the Institution of Civil Engineers* (1837-present).

One of the few books clearly written with structure and conservation in mind, albeit in an American context is Friedman, D. (1995) *Historical Building Construction – Design Materials and Technology*, Norton, New York & London.

The following give good general pictures of engineering history: Balcombe, G. (1985) *History of Building – Styles, Methods and Materials*, Batsford, London; Collins, A.R. (ed.) (1983) *Structural Engineering – Two Centuries of British Achievement*, Tarot, London; Mainstone, R.J. (1975) *Developments in Structural Form*, Allen Lane, London; Strike, J. (1991) *Construction into Design: the Influence of New Methods of Construction on Architectural Design 1690-1990*, Butterworth-Heinemann, Oxford.

2 Shankland E.C. (1897) 'Steel skeleton construction in Chicago', *Min.Proc.Instn.Civ.Engrs*, **128**, 1-22. Reprinted in *Thames Tunnel to Channel Tunnel: 150 years of civil engineering* Ed. by Will Howie & Mike Chrimes, Thomas Telford, London 1987, 151-178.

3 Cusack, P., (1987) 'Agents of change: Hennebique, Mouchel and ferro-concrete in Britain 1897-1908', *Construction History*, **3**, 61-74.

4 See Lawrence, J.C. (1990) 'Steel frame architecture versus the London Building Regulations: Selfridges, the Ritz and American technology', *Construction History*, **6**, 23-46.

5 See Cottam, D. (1986) *Sir Owen Williams*, Architectural Association, London.

6 See Higgs, M. and Samuely F.J. (1960) *Architectural Association Journal*, **76** No 843, 2-31.

7 As yet there is no biography of Ove Arup. A short tribute was published to accompany a small exhibition marking the centenary of his birth: *Ove Arup (1895-1988)*, Institution of Civil Engineers, London.

8 This firm had also been the architects of the outstanding Royal Horticultural Society Hall, London in 1924-26 with engineer Oscar Faber.

9 Fenlands Villa, Chertsey. See *The Builder*, 12th February 1870, 125.

10 See Bowley (1966) in Ref. 1 *passim*.

11 A good general guide is Doran, D.K. (ed.) (1992) *Construction Materials Reference Book* Butterworth Heinemann, Oxford. The chapters on cast-iron and wrought-iron are especially useful. The following books contain historical introductions and feature many case-studies: Blanc, A., McEvoy, M. and Plank, R. (eds) (1993) *Architecture and Construction in Steel*, E & FN Spon, London; Hart, F., Henn, W. and Sonntag, H. (1985) (English edition ed. by Godfrey, G.B.) *Multi-storey Steel Framed Buildings*, Collins, London.

12 See Addis, W. (1994) *The Art of the Structural Engineer*, Artemis, London.

13 See Addis, W. (1994) *The Art of the Structural Engineer*, Artemis, London.

14 The full story of the 'plastic design revolution' is told in Addis, W. (1990) *Structural Engineering – the Nature of Theory and Design*, Ellis Horwood, Chichester.

15 Recently an entire volume of the Proceedings of the Institution of Civil Engineers has been given over to the history of concrete construction in Britain. It contains fourteen papers each of which features a large number of references: (1996) 'Historic Concrete', *Proc.Instn Civ.Engrs Structs & Bldgs*, Aug/Nov, **116**, 255-480.

An earlier work is still of enormous value: Hamilton, S.B. (1956) *A Note of the History of Reinforced Concrete in Buildings*. National Buildings Studies Special Report No.24. HMSO, London.

16 See the three-volume work: Diamant, R.M.E. (1964) *Industrialised Building – 50 International Methods*, Iliffe Books, London; (1965) *Industrialised Building (Second series) – 50 International Methods*; (1968) *Industrialised Building (Third series) – 70 International Methods*.

17 See (1985) *Post-tensioning Systems in the UK: 1940-1985*, Report 106, CIRIA, London.

18 For full details, see the volume cited in Ref. 15, above.

19 In fact, the argument was not wholly successful with the French authorities who insisted some of the trusses be encased to provide fire-protection and clad in aluminium to mimic the appearance of the steel beneath. During the current rehabilitation of the building the effectiveness of the original argument has been accepted and this fire protection has been removed with the result that the elegance and slenderness of the steel trusses are now revealed as originally intended.

20 See Planning Policy Guidance: Planning and the Historic Environment, (PPG 15), Departments of Environment and National Heritage, HMSO, Sept. 1994, 15.

21 See Skempton, A.W. (1959/60) 'The Boat Store, Sheerness (1858-1860) and its Place in Structural History', *Transactions of the Newcomen Society*, **32**, 57-78.

22 A bibliography of the most useful published works has been collected in Mildren, K., and Hicks, P. (eds.) (1996) *Information sources in engineering*, 3rd Edn. Bowker Saur, London. The two chapters devoted to construction and structural engineering (by Addis, W. and Bussell, M.) contain sections on technical information and guidance on structural appraisal and conservation of existing structures. They also contain the addresses of research institutes, trade associations, etc. who can provide useful information and guidance, e.g. British Cement Association, Building Research Establishment, Concrete Society, English Heritage, Steel Construction Institute.

The following are the key general works: BRE Digest 366 (1991) *Structural Appraisal of Existing Buildings for Change of Use*, Building Research Establishment, Garston; CIRIA Report 111, (1994) *Structural Renovation of Traditional Buildings*, Revised Edition, Construction Industry Research and Information Association, London; IStructE (1991) *Guide to Surveys and Inspections of Buildings and Similar Structures*, Institution of Structural Engineers, London; IStructE (1996) *Appraisal of Existing Structures*, 2nd Ed. Institution of Structural Engineers, London; Guidance Note G58 (1990) *Evaluation and Inspection of Buildings and Structures by the Health and Safety Executive*, HMSO, London

The following books give valuable practical advice and many case-studies: Beckmann, P. (1995) *Structural Aspects of Building Conservation*, McGraw-Hill; Brereton, C. (1991) *The Repair of Historic Buildings: Advice on Principles and Methods*, English Heritage; Highfield, D. (1991) *The Construction of New Buildings behind Historic Façades*, E & FN Spon; Holland, R., Montgomery-Smith, B.E. and Moore, J.F.A. (1992) *Appraisal & Repair of Building Structures*, Thomas Telford, London; Robson, P. (1991) *Structural Appraisal of Traditional Buildings*, Gower Technical.

For more specific information relating to steel see Bussell, M., *Appraisal of Existing Iron and Steel Structures* (1997) Steel Construction Institute, Ascot; Bates, W. (1984) *Historical Structural Steelwork Handbook*, British Constructional Steelwork Association (BCSA), London. For more specific information relating to concrete see ACI 201R-68 (1984) *Guide for Making a Condition Survey of Concrete in Service*, American Concrete Institute; Kay, T. (1992) *Assessment and Renovation of Concrete Structures*, Longman Higher Education.

23 *Office floor loading in historic buildings*. English Heritage 1994 (4pp). English Heritage publish many other leaflets giving advice on the appraisal and rehabilitation of existing building structures.

Peter Ross

The relationship between building structure and architectural expression:
implications for conservation and refurbishment

Pre-twentieth century construction

Before we begin to look at the history of the twentieth century, it is useful to consider briefly (Fig. 8.1) the 'traditional' vocabulary of structural form which had developed over the previous four centuries: load-bearing solid masonry walls, with infill floors and pitched roofs of timber, covered in the main with tiles or slates. The building was heated by burning coal in fireplaces distributed throughout the property, and the associated chimneys ensured a trickle ventilation of air which refreshed the internal spaces. Part of the secret of the success of traditional construction was that it allowed a strategy of repair, where

Roof space
Timber trusses above ceiling.

Floors
Timber, plaster below. Floor heights graded, piano nobile to attic. Domestic loading.

Heating
Open fires generally. (Later: coal boilers and radiators).

Ventilation
'Draw-through' of chimney – stack effect.

Basements
Often permeable construction.

Roof
Medium pitch, slates, parapet with gutter, cornice.

Walls
Masonry. Thick solid construction. Vocabulary of style (Classic or Gothic).

Windows
Sash, often with interior shutters.

Occasional **Flat Roofs** in lead.

Fig. 8.1 Cross-section showing traditional construction.

elements could be renewed or replaced as necessary. Indeed, with some modifications, traditional structures have continued to be built into the twentieth century, particularly in the domestic field, but the focus of attention now shifts to the larger structures with innovative forms and finishes, which could be regarded as the 'mainstream' of twentieth century construction.

Structure and style in the twentieth century
1900-1945

By 1900, as a previous paper has shown, the steel frame was established as a means of creating taller buildings with larger internal spans. The perimeter beams and stanchions were built into a solid external wall which generally had a facing of masonry or terracotta with a brick backing. Overhanging cornices, stabilised in the past by large corbelled stones, were now assisted by secondary steelwork; this was particularly necessary for terracotta, as the 'stones' were simply hollow shells. Thus the structural frame of steel, and later of concrete, existed within façades which still appeared to be load-bearing, although with a gradually reducing scale of decoration in post-Edwardian times.

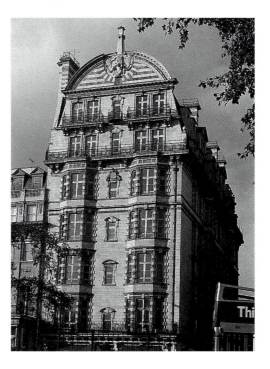

Fig. 8.2 Gloucester House, Piccadilly, London, by Collcutt & Hamp, 1904, showing its cladding of faience.

Somewhere around the turn of the century, the bitumen-based damp-proof course, followed later by the cavity wall, were introduced as ways of economically providing increased resistance to moisture penetration. The outer leaf of the cavity wall was generally only a half-a-brick thick (i.e. around 100 mm), and introduced the idea of the 'thin' external wall, linked to the more solid interior structure by the minimum number of ties which were necessary to ensure its stability.

144

Figs. 8.3 Sketch by Le Corbusier showing use of pilotis.

Modernism, or the International style, was largely of continental origin. Within the scope of this paper I have chosen to present its ideas simply with reference to a single sketch by Le Corbusier (left). The main principles are:

- the building structure is divorced from its cladding.
- the cladding can now be lightened, or made transparent.
- the flat roof (the 'fifth façade') is usable space.
- the ground area has been regained, as the building is lifted up on columns (pilotis).

If we add that form should follow function, and that therefore ornament will no longer be necessary, we have the bones of the style. As a worked example, we can look at Corbusier's Villa Savoye, just outside Paris, of 1929. As a sculptured object it is marvellous, but ten years later Madame Savoye was still to complain that 'it is raining in the dining room, it is raining in the hall'. In this case, prophetically perhaps, the style had outrun the technology. In England, very few Modernist buildings were erected, apart from the familiar icons, before the Second World War put an end to most building activities.

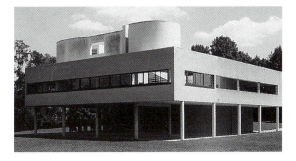

Figs. 8.4 & 8.5 Exterior and stairway of the Villa Savoye, Paris, by Le Corbusier, 1929.

1945-1970

After the War, the Royal Festival Hall, designed for the London County Council by Matthew, Martin, Williams, Moro, 1951, was perhaps the first building to bring Modernism to the eye of the public at large. There is an obvious debt to Corbusier, but the team wisely hedged their bets by using some traditional materials, and finding a distinctive decorative style. The building is undoubtedly a masterpiece, admired by the profession and the public alike. Why then was the story of modern architecture from this point on not one of unalloyed joy? Read on.

Hunstanton School, the Smithsons, 1954, uses steel with a spare elegance which made it a classic of its time, and the completion photographs have been used in countless books and articles. These same photos cannot be retaken today. Putting aside the car parks and the later, unlovely outbuildings, the sea air was

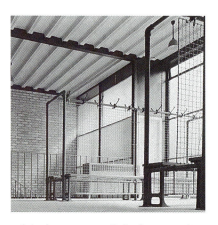

Fig. 8.6 (left) Stairway of the Royal Festival Hall, London, by Matthew, Martin, Williams, Moro, 1951.

Fig. 8.7 Interior of Hunstanton School, by P. & A. Smithson, 1954.

not kind to the thin metal window frames, and the large areas of glazing, together with the slow response of the underfloor electric heating, created 'freeze or fry' areas – problems common to many buildings which had a lightweight envelope with a correspondingly low insulation value.

Around this time, concrete shell roofs enjoyed a brief spell of popularity. Made possible by the engineers' ability to analyse the curved shapes (or more particularly the boundary conditions), they were the essence of Modernism in their expression of structure, and they used a relatively small amount of reinforcement, which was often on extended delivery in the period after the War. However, they were difficult to handle architecturally, and the rising cost of curved formwork and associated falsework eventually made them uneconomic to build. Sadly, the largest shell-roofed factory in Britain, at Brynmawr, Architects Co-Partnership, 1947-51, sits empty despite its Grade II* listing, being too large and too remotely situated to have a viable reuse, but the roofs of the Bank of England Printing Works, at Debden, and Smithfield Market in London, continue in service.

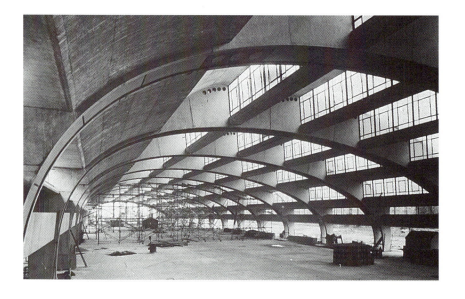

Fig. 8.8 Bank of England Printing Works, Debden, Essex, by Easton & Robertson, 1953-6.

146

In the field of multi-storey housing, concrete was also used extensively. Floors and walls became structural elements in themselves ('crosswall construction') and there was no need for a separate 'frame'. Corbusier's original sketches showed tall blocks surrounded by landscaped parks, on the land made available by stacking the dwellings vertically. The nearest approach to this *urbs in rure* ideal in England can probably be seen at the Roehampton Estate, Richmond, since the site was originally parkland. Again, the model was a Corbusier project, this time the Unité d'Habitation in Marseilles, 1952. However, many tower blocks around the country sat forlornly on bare sites created by the demolition of Victorian housing.

Early blocks were designed individually for specific sites, but the repetitive nature of the brief prompted contractors to explore systems assembled from standard elements, mainly in pre-cast concrete with a variety of finishes, and in panels which were joined together at the edges on assembly. Individual fireplaces were, of course, abandoned, and dwellings were centrally heated. In the early days some underfloor electric heating systems were installed, but on grounds of cost this technology was later replaced by oil or gas systems. Tower blocks as a housing form gradually fell into disfavour for a variety of reasons, but the partial collapse of Ronan Point in 1968 heralded the winding up of the high-rise housing programme in the early seventies.

The tall block *per se* was part of Modernism, but this concept was found to add to building costs in proportion to the height. Apart from housing, its use was in the main confined to corporate office buildings, from the 22-storey Shell Centre, on the South Bank, 1956, to the 43-storey Nat-West Tower in the City of London, 1981. Possibly the most successful, in appearing to be 'tall', is Centre Point by Seifert, 1971. Many other blocks of twenty storeys or so were built in various regional centres, not all proving successful as townscape.

Reinforced concrete had become popular as a framing material in the post-War period, due in part to the shortages in the supply of structural steel sections, but also because concrete allowed a greater flexibility of form. Like the steel frame, it too was initially covered with finishes of different kinds, but, led by the 'truthful form' tenet of Modernism, the material was sometimes exposed as 'fair-face' on frame edges and exterior walls. Architects originally saw fair-face concrete as a pure surface, with no mark or texture; a material which could finally make an 'honest' Villa Savoye (since the original consisted of blockwork within a frame, all rendered over). This was, however, easier said than done, for the concrete face is moulded by the formwork, and shows up the joints between the individual face panels, and the daywork joints, with an embarrassing clarity.

At Marseilles, Corbusier had exploited this by using deliberately roughsawn boards in chequerboard patterns to texture concrete surfaces (*'béton brut'*), and this idea was then used in Britain. The technique was still fraught with difficulty, as these 'rough' boards had to be very well fitted at the edges to prevent the grout losses which disfigure any finish, but some good examples exist. The more usual approach was to use some form of vertical ribbing, with plain bands at horizontal construction joints. The concrete, once cast, could be further textured with a variety of techniques such as sandblasting, or bush hammering, which to varying degrees revealed the aggregate. Ribbed concrete could even be physically

Fig. 8.9 (left) Rhino and Elephant Pavilion, London Zoo, by Casson & Conder, 1964.

Fig. 8.10 Hammered concrete finish at the Rhino and Elephant Pavilion.

attacked with hammers by knocking off the rib edges, a technique used most appropriately for the Rhino and Elephant Pavilion in the London Zoo, by Casson and Conder, 1964. Since these techniques could be better controlled under factory conditions, much use was also made of pre-cast concrete cladding panels, mechanically fixed to the frame, and weather sealed with gaskets or mastic.

The cavity wall in brick had already proved effective as a weather resistant form of domestic construction, and so it was now applied to many multi-storey structures, initially as a panel infill to the edge beams and columns of the frame (Fig. 8.11a). This arrangement was difficult to waterproof at the base of the panel and was rather 'boxy' in appearance. The next step was to move the whole wall outward, so that the outer leaf now ran past the columns, and was supported on a concrete nib projecting from the edge beam (Fig. 8.11b). Only the inner leaf was now built into the frame, and the outer leaf relied entirely for lateral support against wind load on the brick ties built into the beds of the two leaves. The columns were now concealed, and the nib could also be concealed by slip bricks, but this was often an unreliable detail, depending only on mortar adhesion (Fig. 8.11c). The final detail, still in use, was a metal angle with forms of adjustable fixing to the edge beam of the frame (Fig. 8.11d).

The outer leaf was now completely unrestrained in its own plane, and would expand and contract as the ambient temperature changed. Cumulative movements would damage and crack the leaf, since brickwork is relatively stiff but weak in tension. Thus the movements had to be kept below acceptable limits by, in effect, cutting the leaf at regular intervals in both directions to form movement joints, the characteristic feature of the 'thin wall'. To prevent water penetration, the joints needed filling with a material which would accommodate the movements. In response to this a range of mastic sealants was developed, generally applied by 'gun', and possessing the required elasticity when set.

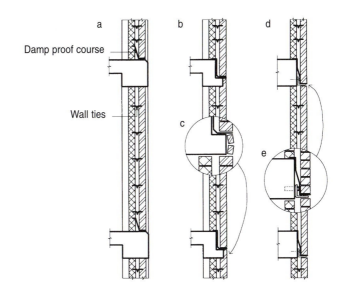

Fig. 8.11 Cavity wall development showing: (a) both leaves within the frame; (b) the outer leaf supported on a nib concealed by slip bricks; and (d) the outer leaf supported on a steel angle.

Although it was clear that these masonry walls were not load-bearing, the expression of the external envelope as a cladding only was made complete by the development of the curtain wall. One or two pre-war examples exist, such as the Peter Jones store in Sloane Square, and the Daily Express building in Fleet Street, but the first 'tight skin' construction, embodying the idea of the grid – repetitive details in both directions – was Lever House in New York, by SOM, 1952. Following this, the first British essay in the field was Castrol House, Euston Road, by GMW, 1967 – aluminium framing with glass infill, and clearly a relatively low degree of thermal insulation.

Fig. 8.12 The external cladding of Castrol House, Euston Road, London, by Gollins Melvin Ward (GMW), 1967.

Roofs in general became flat, although in most cases simply for reasons of appearance. The potential for access or planting was rarely exploited; perhaps the British weather played a part in this. The flat roof did, however, allow the architect a free hand with the plan form, particularly for large buildings. Corbusier's example was again followed, and many performed badly, especially those on a lightweight deck.

With Modernism on all sides, the speculative house builder stayed firmly with traditional construction. A few had dared to experiment before the Second World War with rounded bay windows, but found that flat roofs made the property unmortgageable, and continued with tiles, which were now often pressed out of concrete. The one major innovation was the trussed rafter, eagerly embraced for its cheapness. Combined with the fashion for lower pitches, a generation of houses lost all potential for a loft conversion. For house walls, brickwork remained the firm favourite for the outer leaf – again the influence of the building societies. Blockwork was used in the main for the inner leaf, although a gradually increasing share of the market was taken by the timber frame.

Stylistic innovation in the low-rise housing field was seen mainly in the public sector, in the various generations of New Towns created after the War. Timber flat roofs and curtain façades both had a high percentage of failures in terms of rot and water penetration, since preservation treatments were not mandatory. Sand-lime bricks, which, as the name suggests, are really coloured concrete, performed as concrete, and walls built from them were prone to shrinkage cracking.

1970 to the present

Many of the buildings which date from the two decades after the War had relatively low levels of insulation, as a result of thin walls, flat roofs and large window areas. These levels were accepted, since the Byelaws (and after 1965 the Regulations) were quite modest in their requirements for dwellings, and no minimum standards at all were laid down for other purpose groups, such as offices. The various fuels needed to heat these buildings were relatively cheap, and, it was said, would get cheaper as nuclear power came on stream. However, in 1967, the conflicts in the Middle East came to a head in the Six Days War, which closed the Suez Canal and resulted in a dramatic rise in oil prices. This led, in turn, to the 'energy crisis' of 1973-4, and the successive raising of insulation requirements from this time on in revisions of the Building Regulations. These energy saving measures were given an additional incentive in the early nineties with the rising concerns for global warming allegedly caused by CO_2 emissions.

In order to understand the degree of change, it is necessary to look at a few figures. In 1976, the maximum allowable value of thermal transmittance (U-value) for dwelling walls was 1.0 W/m^2°C (with an overall limit which allowed a generous window area), and for roofs, 0.6 W/m^2°C. In 1978, the provisions were extended to cover all buildings, and the limit for external walls was reduced to 0.6 W/m^2°C, with an allowable single glazed window area of only 25-30% of the total wall area. The current Regulations are complex and allow alternative methods of appraisal, but the limit for walls as elements is reduced to 0.45 W/m^2°C and for roofs to 0.2 W/m^2°C. It is probably true to say that any further

tightening of the Regulations would be of little effect, since heat loss is now dominated by air changes for ventilation purposes, and natural leakage. These are, of course, selective figures, but they serve to illustrate the magnitude of the changes over only two decades. Their effect on the design of the external envelope, while not named as a style, has been as dramatic as the original impact of Modernism.

After the enormous building spree of the sixties, incidentally involving the demolition of many buildings which would today undoubtedly have been listed, the 1970s saw the public's growing disaffection with 'modern architecture'. A full consideration of the causes is outside the scope of this paper, but among the list of complaints related to fabric would undoubtedly have been appearance, since ornament had largely been eschewed, and poor performance in terms of water penetration and internal climate control.

As a response, new buildings which, at least superficially, looked like old buildings became more popular, and the eighties saw the rise of the neo-vernacular style introduced with a fanfare of trumpets at Hillingdon Civic Centre, by RMJM, 1977. Elevations were dominated by brick, with tile-clad pitched roofs over them, and architects painfully rediscovered the discipline which they imposed on the plan. Atria, becoming more popular, still exposed roof structures of timber or steel (since there were no requirements for a period of fire resistance) but all concrete was tucked carefully away out of sight. The style was especially popular with clients who needed to court the public, such as supermarket chains, (with the honourable exception of Sainsbury's) who applied a vaguely medieval face to a building which was in essence a steel frame with a central flat roof.

In parallel, a late development of Modernism produced a small number of 'Hightech' buildings, in which the structural frame and its *modus operandi* were put on display with the crafted enthusiasm reminiscent of nineteenth century engineering works. The first major building to display this structural bravura abroad was probably the Pompidou Centre, in Paris, by Piano and Rogers, 1977, where the structural system, and means of access, were placed outside the building, to provide clear spans inside. Indeed, the services were also put on view (see Fig. 8.13), a technique previously explored at the Hunstanton School, but here they were also on the outside of the building. The principle of exposing services in a major way, however, has rarely been attempted since then; the Lloyds Building, London, by Richard Rogers, 1986, is more or less the sole example. Pompidou is sometimes claimed as an example of English Hightech, a line which begins with the temporary Reliance Controls building, Foster and Rogers, 1967, now dismantled and the Willis Faber Dumas building, Ipswich, by Norman Foster, 1975. In retrospect, this strand of modern design can be seen to have evolved overseas as well as in Britain. Too well-known to need further description, these buildings have a vocabulary which is predominantly metal and glass.

Most mainstream work continued in various versions of Post-Modernism, which in essence relied on motifs from past styles, together with a few full-blown essays in the classical style, but these were all essentially surface decoration, applied to modern frames, which by now were more often steel than

Fig. 8.13 Detail of the Pompidou Centre, Paris, by Piano & Rogers, 1977.

concrete. Tall buildings were generally put aside in favour of wider, lower office developments as at Broadgate, London, Arup Associates *et al*, with the buildings in Docklands an exception to this trend. Facing materials in the main were brick and stone, the latter undergoing something of a revival as techniques of applying thinner slabs were developed, together with metal panelling (mainly coated aluminium) used in conjunction with the glazed wall.

Light industrial buildings had generally been framed in steel since the beginning of the century, with sheet metal cladding, and perhaps brickwork at low level. The metal originally used was, of course, galvanised corrugated iron, followed by corrugated asbestos, but these were gradually replaced by profiled steel of thinner gauge. The sheets were still zinc protected, but pre-finished with a factory applied paint. Early problems of blistering were solved, and the material was regarded as maintenance-free. In the long term, there was inevitably some fading of strong colours, and rusting of cut edges and fasteners, but overall the vocabulary of profiled metal on a steel frame proved the most economic way of covering space, and was used almost exclusively for the later rash of DIY stores of the eighties and nineties. Insulation to meet the Regulations of the time was provided in quilt or board form below the sheeting.

The speculative house builders, vindicated in their adherence to traditional construction, celebrated with an orgy of vernacular detail – steeper pitches, dormers, even, in some cases, rendered elevations, and each house in some way different from its neighbour – encouraged by local authority planning guidelines, such as those produced by Essex County Council.

The timber frame's share of the housing market was approaching 30%, until in 1983 a Granada 'World in Action' programme implied that they were prone to decay. Sales plummeted to around 5%, and the Building Research Establishment (BRE) were commissioned to carry out a survey. After ten years they issued their final report – there wasn't a problem. Meanwhile, the block industry was having

to produce inner leaf units with ever improving insulation values in order to meet the escalating requirements of the Regulations, a factor which has belatedly revived the fortunes of the timber frame. The most retrogressive effect of the latest Regulations has, however, been to permit the filling of the cavity with insulation in masonry buildings generally, and thus compromise the original purpose of the detail.

I have already mentioned the destruction of many historically significant buildings in the sixties. Although amenity societies such as the Civic Trust and the Victorian Society were formed in the late fifties, their influence was limited, because there was no statutory protection for buildings, other than the very few which were listed at that time. However, a start was made on further survey work in 1970. Some ten years later, the Firestone Factory in west London was being considered for listing, when it was suddenly demolished during the August Bank Holiday weekend of 1980. This acted as a trigger for an accelerated resurvey, now supported by a tide of public opinion, and today the number of listed buildings approaches half a million. As a consequence, the eighties and nineties saw the repair and adaptive reuse of many buildings which might formerly have been demolished.

In parallel with this conservation work, the last two decades have seen the extensive refurbishment of some less illustrious post-war buildings, which in some cases has involved the addition of rain screens or pitched over-roofs to leaking fabric, together with an improved standard of insulation. Others have undergone more invasive surgery, or had their curtain walls (often prone to air leakage) removed in their entirety, and replaced by modern panel units. A few, including some of the most unpopular blocks of high-rise flats have, after a 30-year life, even been demolished.

Conservation issues of twentieth century construction
The clad steel frame
The steel frames of the early twentieth century were either unpainted, or were given a single coat of red lead or cement wash. In the long term, the perimeter stanchions and beams depend on the integrity of the wall fabric for protection from contact with water, and eventual corrosion. Since most stones and terracotta blocks are relatively impervious, the resistance to water penetration depends mainly on the adequacy of the mortar fill to the beds and perpends. The most vulnerable areas are horizontal surfaces, such as the tops of the copings and cornices, where the natural flow of the water finds more readily any weaknesses in the mortar fill to the joints.

The product of corrosion action is rust, which is in the main ferric oxide, and many times the volume of the original steel. If the member is solidly built into the masonry (which is not always the case) the build-up of rust may cause a bursting action, which could either fracture the stones, or open up the joints. In general, damage due to corrosion is very slow to develop, and the loss of section of the structural members is rarely sufficient to warrant strengthening measures. Remedial work generally takes the form of preventing further ingress of water, either by the use of sealants, or by covering surfaces with an impervious layer, such as lead sheet.

The external fabric of these and other buildings was, as we have seen, largely of traditional construction, and was maintained using the traditional techniques of repair.

The post-war scene

In the post-war years, construction recommenced, and gradually increased to an all-time high in the mid-sixties. The quality of the new buildings was however, variable, and a disproportionately large number of defects quickly became obvious, which could be grouped under the following headings:

* durability of the external fabric
* water penetration
* internal environmental control.

The reasons for all this defective work are complex, and cannot simply be attributed to particular sectors of the industry. Initially, there were shortages of many common building materials following the War. There was also intense pressure, particularly in the field of local authority housing, to produce buildings at a greater rate than ever before. There was a decline in the craft tradition of the contractors paralleled by a rise in Trade Union militancy, but the principal reason is probably the use of new materials and forms of construction without an adequate evaluation of their performance in the long term.

Spalling of exposed concrete

Reinforced concrete had long been regarded as a very durable material, with many examples (primarily in the field of civil engineering) still in good condition after 50 years or more of exposure. The poor performance of some external concrete cast in the fifties and early sixties was therefore initially unexpected, and a more detailed look at the mechanism of corrosion is needed to see what went wrong.

The reinforcement in concrete is, of course, included principally to take tensile forces, and additionally to control cracking (see Fig. 8.14). The steel reinforcement bars are not separately protected, since the setting process of

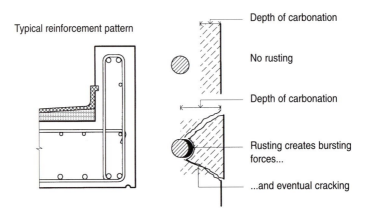

Fig. 8.14 The mechanism of concrete spalling.

Portland cement produces a highly alkaline environment (pH 12 to 13). At this pH, embedded steel remains in a passive state, even though oxygen and moisture, the elements necessary for corrosion to occur, can reach the steel.

On exposure to the atmosphere, carbon dioxide diffuses inwards a certain distance from the concrete surface, and as it proceeds, reacts with the hydroxyl ions in the hardened concrete in a process (referred to as carbonation) which significantly reduces the alkalinity of the concrete. The strength of the concrete is unaffected, but if the carbonation depth exceeds the cover to the reinforcement, corrosion is no longer inhibited. The products of corrosion, as mentioned before, are oxides of iron, whose volume is much greater than that of the original steel. The effect is to create bursting forces, which may initially crack the concrete, and then cause small pieces to spall off. This mechanism was well known, and the reinforcement cover to external concrete had long been set at $1^1/_2$ in (40 mm), which was well in excess of the carbonation depths found in pre-War concrete. This depth, however, depended on several factors, one of which was the actual amount of cement in the mix.

From the fifties on, cement manufacturers had competed on the capability of their material to gain strength rapidly. This could be done most efficiently by finer grinds of the powder, which in effect increased the surface area of the cement particles and speeded up the setting process. The net result was that the actual cement content of mixes generally was reduced, and the lower strength mixes might not always have had enough cement in them to prevent carbonation reaching the steel. Initially the Code of Practice for Concrete Design (CP114) did not specifically address this issue. However, in the 1965 revision, the minimum strength of concrete for external conditions was specified as 25 N/mm^2, and today we would consider 35 N/mm^2 the minimum strength for external work.

Even if the concrete is satisfactory, local problems can still occur if the reinforcement cage has moved out of position towards the face, reducing the concrete cover. A particularly troublesome detail has been the pre-cast concrete window surround, a familiar motif of the fifties and sixties. This is not, of course, a structural element, and the reinforcement was included only for handling purposes. Elegantly thin, they resulted in a cover to the steel which was almost always substandard, and the obvious precaution, galvanising the reinforcement, rarely specified.

The repair of spalled concrete, as with any element which has no applied finish, is difficult, and many owners adopt the 'live-with' approach as long as they feel able. For an individual building, a survey is needed to find out whether the cover is locally substandard, or whether there is a more general problem of carbonation. Local repairs of spalling are generally carried out by cutting back to the steel and either removing it, if this is structurally acceptable, or cleaning it and applying some form of corrosion protection. It is very difficult to 'recast' the concrete, and so it is generally made out to the original profile with mortar. Inevitably, the repaired areas 'read' on the surface, and if the final appearance is unacceptable, many architects will take a deep breath and specify a paint treatment. A substantial paint build-up can of itself be a remedial treatment, if there is a general, but relatively minor, problem of water penetration, although the appearance of the surface is radically altered.

The integrity of multi-storey concrete panel construction

Much of the system-built high-rise housing blocks were, as previously noted, based on pre-cast concrete panels joined together along the edges by *in situ* concrete 'stitches' cast around projecting reinforcement. The structural design of all multi-storey blocks included a check for stability under self-weight and applied loads, chiefly those arising from occupancy and wind forces. There was, however, no regulation requiring these buildings, or indeed any domestic building, to be assessed for the effects of explosive forces – the reason being that the predominant form, the two-storey brick and timber house, simply cannot be designed to resist an explosion of any magnitude.

At 5.45 in the morning of May 16, 1968, a Miss Hodge struck a match to light her gas ring. She lived on the eighteenth floor of Ronan Point, a 22-storey East London block of flats built using the Larsen-Neilson system of pre-cast panels. An explosion occurred, and as a result, some corner wall panels were blown out, in turn bringing about the collapse of that whole corner of the building. The cause of the explosion was found to be a gas leak from the flexible connection to her cooker. Miss Hodge survived, but four people were killed. The number might have been higher, but for the early hour.

The subsequent investigation showed that, for this particular system, the panel joints could cope with the specified wind loads, but that the effects of an explosion (being more than twenty times wind pressure) would result in joint failure. An assessment was made of the jointing methods of the other proprietary systems, and it was found that designers had varied in the degree of 'robustness' which they had provided in the connections. A nationwide check was then made on the total stock, to determine which blocks could not satisfactorily withstand explosion forces. They were either strengthened with steel angles bolted over the joints (see Fig. 8.15) or, if this was not feasible, disconnected from the gas supply. Ronan Point itself was initially repaired and strengthened, but was eventually subject to controlled dismantling in 1986. The legacy of Ronan Point remains in the Regulations – specifically Requirement A3 – under which designers must, for buildings over five storeys, consider the way in which the elements are joined together to avoid a disproportionate collapse of the whole structure following an accident such as an explosion.

The collapse of Ronan Point was a singular event, and the remedial works which followed have long been completed. I have included it because it is so

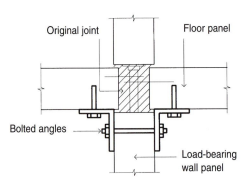

Fig. 8.15 Strengthening high-rise construction using steel angles bolted to the concrete.

well known, and because in a sense this notoriety indicates the rarity of structural failure – and indeed this is as it should be. All but a handful of buildings completed in the post-war period still stand. Even the storm of 1987 over the south-east of England produced no major structural collapse – a few lightweight garage roofs were lifted off, but damage was in the main related to elements of cladding and finishes, such as tiles and glazing. The problems of post-war structures related in the main to serviceability issues, such as the effect of movement joints on the overlying fabric, and the visual problems of exposed concrete already discussed.

Frame movement

As larger buildings were constructed using reinforced concrete, the residual movements of the material after casting became more significant. Apart from a response to ambient temperature, shared to some degree by all materials, concrete will exhibit a drying shrinkage as the initial water from the mix gradually permeates away from the surfaces, and a certain amount of creep deflection under sustained load.

In order to avoid a build-up of shrinkage movement which would produce unacceptable distortions of the structure, large frames were generally divided into sections of 160 ft (50 m) or so by movement joints, which were quite simply breaks in the structure. Since the movement due to shrinkage, typically around $1/2$ in (12 mm), would be concentrated here, the elements of fabric which covered the joint would also have to be jointed, as, for instance, in a flat roof (see Fig. 8.16a). A concrete ground floor also needed regular joints, which in turn required joints in any bonded finish, such as terrazzo tiles (Fig. 8.16b). As a generality, joints are often a particular source of defects, needing careful design and construction, and, for instance in the case of floor joints, undergoing additional impact loads in service.

The creep deflection of larger span slabs also means that brittle partitions of blockwork might need a flexible joint at the head (Fig. 8.16c) and may be susceptible to cracking if built across the slab span (Fig. 8.16d). Thus partitions of cementious materials in their turn also needed movement joints.

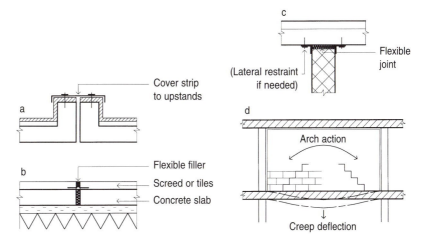

Fig. 8.16
Frame movements.

The thin brick wall

As noted previously, the domestic cavity wall had proved itself in low-rise construction. However, when lifted ten or so storeys into the air it was subject to considerably increased wind loads and driving rain. The method of construction attempted to solve simultaneously the potential problems of instability, movement stresses and water penetration. The principal difficulty is that the solution to each single problem tends to run counter to one of the others. Thus, the joints in the outer leaf necessary to accommodate movement, weaken it. The ties and angles (necessary to support the outer leaf) bridge the cavity and are points of risk of water ingress. And the cavity trays provided to prevent water ingress tend to weaken the assembly, particularly in the parapet zone. It was not therefore surprising that problems of water penetration were common until designers became more familiar with the details, which were eventually published in Codes as design guidance. More seriously, there were occasional problems of local instability of brick panels, due to incorrect installation or corrosion of the wall ties.

Repairs to prevent water penetration, if needing more than a liberal application of sealant, are difficult to achieve. An internal lining leaves the basic problem unsolved, but local dismantling of the wall may be needed to determine the actual cause. General incidence of water penetration may justify the complete removal and replacement of the outer skin, which is obviously very expensive. Overcladding, which minimises tenant disruption and allows additional insulation to be added easily, has been used on quite a few blocks, but radically alters the building's appearance.

The flat roof

Although traditional construction relied largely on the pitched roof, the flat roof was also used in a minor role, for example, to link areas between adjacent pitches. In the late nineteenth century the waterproofing layer was generally asphalt, with bituminous felt (regarded as a relatively short-life material) as the cheaper industrial equivalent. They had in part replaced the older shallow-pitched roofs of copper and lead, which, in limited applications, continued to be used throughout the twentieth century. The roof of the Royal Festival Hall, for instance, is a shallow barrel covered with copper, with asphalt on the surrounding flats.

The principle of the flat roof, which relies on the perfect continuity of a single waterproof membrane, is very different to that of the traditional roofs, which make up for the potential weakness of joints between the elements by a combination of overlap and pitch.

The key elements of a flat roof (see Fig. 8.17a) are:

- the membrane material.
- perimeter details.
- drainage falls.
- insulation.
- vapour control membrane.
- the substrate.

158

a) Warm deck roof

Substrate
Vapour control membrane
Insulation
Membrane

c) Single ply membrane on profiled metal

b) Inverted roof

Vapour control membrane
Insulation
Ballast (slabs or gravel)

Deck
(e.g. profiled
metal)

Membrane
strips
adhesed
together

Insulation
boards

Mechanical
fastener

Fig. 8.17
Flat roof configurations.

The membrane materials used in the sixties and seventies were still in the main asphalt and felt. Both had the potential to perform, but possessed little tensile strength, and tended to embrittle with age.

Perimeter details, such as upstands and outlets, have to be as 'perfect' as the membrane, often in less than perfect situations.

Drainage falls are not in theory necessary, but they do minimise ponding, which has the effect of prolonging any leaks, and causing damage to the membrane in freezing conditions by the formation of ice.

Insulation, in some measure needed for all flat roofs, was generally inserted above the structure and below the membrane. The effect of the insulation is to increase the range of thermal cycling on the membrane, and to give it a less solid support. Lightweight screeds performed satisfactorily, but materials such as fibreboard crushed easily, and once wet, lost strength altogether. Moisture could result either from a leak, or from condensation (see below).

The vapour control membrane was necessary to prevent warm moist air from the building moving through the insulation to the colder layers and condensing. The mechanism of interstitial condensation was probably the least understood aspect of the design of flat roofs, and was responsible for many premature failures.

The substrate was required to provide firm and rigid support. Reinforced concrete slabs were generally satisfactory, but some lightweight decks such as profiled metal were prone to movement, and contained many joint lines. Those which were also moisture susceptible, such as compressed strawboard or chipboard, would lose strength and even fail if any leaks occurred, requiring major remedial work.

Thus, when flat roofs were first used more generally after the War, their performance was variable, and depended very much on the designer's understanding of the principles, and the quality of the contractor's workmanship.

The position has gradually improved, however, due to an increasing understanding on the part of designers, and technical developments in the industry. In the late seventies, 'high performance' felts, with increased elasticity and tensile strength, became available. Some use was made of the 'inverted roof', in which the insulation is placed above the waterproof layer, protecting it and reducing its ambient temperature range (see Fig. 8.17b). Further protection was of course needed for the insulation, and generally provided in the form of concrete slabs or a gravel layer. More efficient insulating materials were developed to meet the demands of the Regulations, among them polystyrene and polyurethane panels, which were impervious to the effects of moisture.

The most recent developments, the 'single ply' membranes formed from synthetic polymers, are mechanically fastened down through the insulation, rather than bonded to it, thus accommodating small movements of the substrate (see Fig. 8.17c).

Roofs which have in the past failed significantly are most likely to have been repaired or even replaced within a relatively short period. Since most flat roofs are out of sight, they are, at least by most pragmatic designers, considered as less significant from the point of view of conservation, and (within the site constraints) may be covered with a lightweight pitched roof, or altered to improve waterproofing and insulation properties. A visitor to the Villa Savoye today will see roof details which are of the nineties rather than the thirties; we cannot conserve a building by repeating substandard details.

Internal environmental control

The aim of the building fabric could be described in a general sense as 'protection' from, among other things, the effects of the weather. In the introduction to this chapter I referred briefly to the traditional domestic building at the beginning of this century. The thermal mass of the thick masonry walls, the modestly sized opening windows, and the generous ceiling heights, all mitigated the peaks of summer temperature. Winter conditions would have been bleak, however, without the open fire for 'comfort', the general aim of the building services.

Although the coal fire has a unique charisma, it does in fact rely on a supply of fresh (cold) air, with the consequence of a large temperature gradient in the room from the source of heat to the draughty perimeter. Between the Wars, the principal of 'central' heating was increasingly adopted for larger domestic and commercial properties. A coal-fired boiler, generally in the basement, heated water which circulated to cast-iron radiators around the property (although fireplaces were often retained) and allowed a more general comfort level to be attained, although temperature levels generally might still have required some warm clothing.

In the post-war period, as we have seen, Modernism produced an external envelope of very different properties. Flat roofs and thin walls, with lower mass and relatively low insulation values, together with much larger window areas

(not all openable) and a loss of much of the trickle ventilation afforded by fireplace chimneys, resulted in large temperature swings between day and night. Adjustable blinds were limited in their ability to absorb solar radiant heat gain, and opening windows were only effective at the building perimeter. Larger, deeper buildings therefore needed at least some form of mechanical extraction, and a high capacity heating system to deal with the summer and winter extremes.

Winters of the sixties and seventies produced a rash of problems in new buildings relating to condensation. Condensation occurs when warm, moist air meets a cold surface. It was often found in the high-rise flats, where walls of concrete (not a good insulator) enclosed relatively small dwellings with no inbuilt ventilation, and where cooking for a family was carried out. Ventilation would have improved matters, but might, in terms of heat loss, have been regarded as an expensive option for those on modest incomes. 'Tenant lifestyle' was an official explanation, implying that the occupants should give up cooking, or perhaps breathing, but the problem really lay in the lack of environmental design. As I have previously noted, it is difficult to change the basic characteristics of an external wall, but better thermal performance could be achieved with an internal lining which included insulation, making sure that there was a vapour control membrane on the 'warm' side, to prevent further problems of interstitial condensation.

Inside the larger buildings, such as the department stores, the main problem was generally heat build-up. The installation of fans mitigated the problem, but the solution really lay in changing the air on a regular basis. This required ducts of significant size, and plant-rooms to accommodate the fans necessary to achieve the air movement, since stack effect alone would be insufficient. Full air conditioning, which would imply control of both temperature and humidity of the internal air, was only rarely installed, and in these cases the low insulation values of the external fabric resulted in very high running costs.

The gradual improvement in the insulation values of the external envelope during the seventies and eighties, together with more sophisticated design techniques in terms of heat recovery from the expelled air and overall system control, made air conditioning more feasible in economic terms, and it was on the way to becoming the norm for the 'prestige' office construction in the late eighties. Service zones both above and below the occupied areas (see Fig. 8.18) provided the necessary space for air ducting, as well as the burgeoning IT

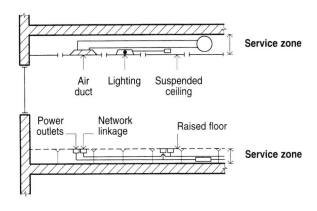

Fig. 8.18
Office service zones.

Fig. 8.19 The flat roof of a late 1980s office block in London, covered with air conditioning equipment and perimeter tracks for a window cleaning gantry (in the distance).

linkages. Simultaneously, full, or more often partial, air conditioning was often introduced in the refurbishment of earlier buildings, finally justifying their flat roofs by locating all the heat exchanger plant there (although generally to the detriment of the waterproofing membrane). A further advantage of closing the windows in our urban centres and relying on mechanical ventilation is that the air can be cleaned of all the dust and dirt by filtration. It is for this reason, as much as for control of the environmental conditions, that institutions such as the major museums and art galleries have, where possible, moved to some level of internal environmental control.

Postscript

Inevitably, a brief review of this kind presents a simplified picture, and individual exceptions will be found to each general trend. There are also other factors which have not been mentioned but which contribute to the broader scene, such as the growth of car ownership (foreseen by Corbusier, who nevertheless overlooked the parking problem), and the sensitivity of the construction industry to the overall level of economic activity. More depressingly, there is the continuing British tendency to regard initial costs as the prime yardstick of value, rather than to consider the long-term savings which might accrue from a higher quality of construction. This view-point was to prove responsible for much of the repair work which became necessary in the seventies and eighties. We always had, for instance, techniques for constructing flat roofs of a reasonable standard, but often chose the cheaper options.

As the century draws to a close, Environmental issues (this time with a capital E) have emerged as a world concern. In a limited sense, these originated in the seventies, identifying materials which, although excellent for their application, were potentially lethal in particular forms (such as lead paints and fibrous asbestos), and then moving to a more general view of building material

properties and their credentials in relation to the ideas of sustainability and the conservation of resources.

This is a history of fabric form, and not of architectural quality. It is possible that out of the total stock of twentieth century buildings a relatively small number will ultimately be regarded as of 'special significance'; smaller in proportion, perhaps, than previous centuries. In the meantime, repair and refurbishment work, particularly of the early Modernist buildings, continues apace.

The best of the past is a difficult act to follow. However, those that pass all the tests (assuming that they are, or can be made to be, durable) will add radically different and exciting forms to the corpus of historic buildings.

Select bibliography

Warland, E.G. (1929 reprinted 1953) *Modern Practical Masonry*. Isaac Pitman, London.

Perry, Victoria (1994) *Built for a Better Future: the Brynmawr Rubber Factory*. White Cockade Publishing, Oxford.

William J. Curtis (1982) *Modern Architecture since 1900*. Phaidon, London.

Esher, Lionel (1981) *A Broken Wave. The Rebuilding of England 1940-1980*. Allen Lane, London.

Sharp, Dennis (1982) *20th Century Architecture: A visual history*. Phaidon, London.

Webb, Michael (1969) *Architecture in Britain Today*. Country Life, London.

Acknowledgements

The Author would like to thank his colleagues in Arup Research and Development for their help in preparation of this chapter, including Barry Austin, Michael Bussell, Bill Monks and John Moss, together with Orla Caffrey (text) and Zoe Rushby (graphics).

Michael Stratton

Clad is bad?

The relationship between structural and ceramic facing materials

Introduction: conserving hybrid structures

The vast majority of commercial buildings of the twentieth century are hybrid structures – framed with steel or concrete and clad with brick, stone veneer, tile or faience. Most historians and conservationists like their architecture to be pure – whether purely traditional and in brick or stone, or purely modern, hence exposed concrete, steel and glass. This gulf between built reality and academic idealism leaves much of our recent building stock stranded without passionate advocates and a philosophy for their conservation. Neither the principles of the Society for the Protection of Ancient Buildings or the work of DoCoMoMo provide a clear framework for hard decisions by commercial architects and engineers or local authority officers.

This chapter will look at the way in which a group of particular cladding materials – architectural ceramics – was applied to both traditional masonry and steel- and concrete-framed structures in the twentieth century. It will show how the fabric of commercial buildings can be properly evaluated and conserved rather than being left to whatever fate refurbishment deals out to them – typically piecemeal re-working, radical smartening-up or replacement. More specifically, a series of case-studies will consider the extent to which conservationists are moving away from replacing whole façades to keep as much of the original fabric as possible – through consolidation or piece-by-piece substitution – and hence maintaining the integrity of the original structure and composition.[1]

Tiling and large glazed blocks or slabs, termed faience, were widely used as a means of creating colourful, durable and washable surfaces, but have been denigrated for being made in factories, for the repetition of standardized forms and for a lavatorial image. In addition to the aesthetic merit of many schemes, they are of particular interest for raising issues about the relationship between structural and cladding materials, about collaboration between designers, builders and material manufacturers, and concerning standardization and prefabrication in architecture.

In conservation terms, tiles and faience have suffered from their industrial origins and their robust appearance. It is still considered acceptable to cut out large areas of original terracotta (unglazed blocks), tile and faience and harshly clean the rest with acids or abrasive jets in a way that would be condemned with stonework or even hand-moulded brick. Glazed ceramics are also at a disadvantage through being used widely on large commercial and public projects – from Odeon cinemas to the sixties railway stations such as London Euston – that often roused controversy when first executed and remain contentious. It will take time for academic and public taste to allow a more objective appraisal of the twentieth century architecture of our towns and cities.[2]

Victorian precursors

Architectural ceramics have long been seen as an economical and durable means of applying decoration to buildings. Victorian tile manufacturers established some of the key principles of mass production in the architectural sphere: the precise replication of forms, repeated decorative patterns, and differentiation between structural and facing materials. Critics came to condemn wall tiles and terracotta for their visual harshness and their failure to mellow with age. Reactions were most vociferous in the early years of the new century when buildings erected in the 1870s and 1880s started to become dingy and tatty as they accumulated layers of sulphurous soot.[3] Now, almost a century later, we tend to favour the mellow appeal of weathered stone more than the brighter image of pollution-resisting and more readily cleanable materials, despite the fact that stonework discolours and decays so rapidly in an urban setting.

The major terracotta firms sought to give their product a new image through the use of glazes. As a parallel development, Minton, Maw and the other manufacturers of tile started to produce large panels of faience for the frontages of public houses. Burmantofts cast huge slabs of faience for lining the walls and ceilings of banks, clubs and offices. The issues relating to the conservation of glazed tiling and early forms of faience have been considered in other publications. It is worth noting that they were frequently overpainted or hacked away, until a small number of tile historians and conservators campaigned to promote awareness of their qualities and to develop new techniques of conservation. Cleaning is now undertaken carefully by hand to prevent damage to raised tube lining. Nevertheless some very fine tile schemes remain unlisted and can only be saved, when threatened, by careful removal. In such situations the most notable innovation has been to use diamond-tipped circular saws to release cement-fixed tiles.[4]

Ceramic skyscrapers

Early skyscrapers, in particular those erected in Chicago at the turn of the century, demonstrated the use of a lightweight ceramic cladding, to protect the steel frame from both water and fire. Terracotta blockwork was soon supplanted by glazed faience, while manufacturers turned to extrusion to mass produce window and cornice mouldings repeated over tall elevations. In conserving their finest steel-framed and ceramic-clad buildings, Americans have been largely content to preserve the distant visual image of the building – using tin and glass

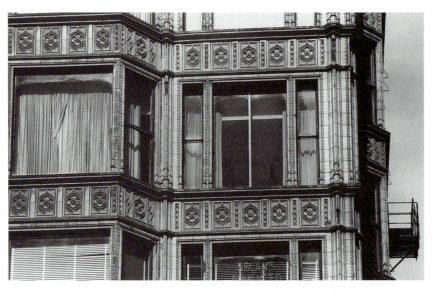

Fig. 9.1 Reliance Building, Chicago, by Burnham and Atwood, 1895, photographed before restoration.

fibre as replacements, rather than insisting on the retention of original material or replication of like-by-like. The first tower block to be clad in faience, and perhaps the earliest to exploit the potential of steel framing to create a thin non-structural envelope is the Reliance Building in Chicago. It was designed by Burnham and Atwood and completed in 1895. This National Historic Landmark, seen as critical in the evolution of the modern skyscraper, was restored during 1995 by the McClier Preservation Group. This project provides a valuable insight into challenges of conserving faience as applied to a steel frame. Many of the cracks and other failures were due to a build-up of compression forces. The faience had been designed as a non-structural skin to the steel frame, some of the blocks being directly supported by steel shelf angles at each floor level. However these angle brackets were not continuous and weight loads ended up being carried down through the floor levels by the ceramic blocks themselves.

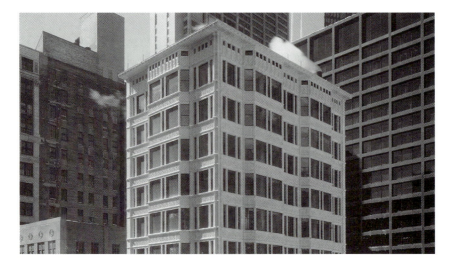

Fig. 9.2 Reliance Building following cleaning, insertion of new blocks and a new cornice in cast aluminium. (McClier Preservation Group)

The joints were very narrow with mortar space being typically no more than an eighth of an inch. The accumulation of forces resulted in blocks cracking; it also led to a particular problem during conservation works. When a damaged block was removed, the in-tact adjoining piece might crack as it took on the stress. To avoid such damage, relief joints had to be cut at each floor level. The cracks had allowed water to penetrate and cause corrosion of the steel anchors and hence further cracking. Approximately 2 000 out of the 14 000 blocks across the elevations had to be replaced.

As in many steel-framed buildings the structure was not badly corroded – only a couple of shelf angles in the most exposed attic area had to be replaced. The dramatic projecting cornice had been removed in the late 1940s, a fate suffered by many turn-of-the-century skyscrapers, in response to fears over falling blockwork if angle brackets did rust severely and fail. It was agreed that the cornice should be re-instated. Sadly terracotta was not specified, due to the cost involved, maintenance implications and doubts as to its durability. Glass fibre reinforced concrete was also rejected. Cast aluminium was chosen for the level of detail and quality of colour match that could be achieved.[5]

One of the finest of Chicago's inter-war skyscrapers, the Wrigley Building by Graham, Anderson, Probst and White, 1920-4, illustrates the dangers of too readily adopting substitute materials. Various details, in particular cornice balustrading and finials, were replaced during the eighties in a resin-based material, called Micro-Cotta. The finials quickly discoloured to a buttery colour and have had to be replaced with terracotta, made, incidentally, in England by Ibstock-Hathernware.

Fig. 9.3 Wrigley Building, Chicago, by Graham, Anderson, Probst and White, 1920-4, showing cornice details in Micro-Cotta.

A new century and a new material

At the turn of the century British architects and manufacturers also took up glazed faience in preference to unglazed terracotta. It was better able to carry polychromatic decoration or imitate the effect of Italian marble, and to resist polluted atmospheres.

This shift broadly coincided with the introduction of steel-framed construction. Architects and manufacturers appreciated the logicality of using hollow ceramic blocks to wrap round, and hence protect, structural members. Furthermore the size and grid-like plans and elevations of most Edwardian commercial buildings offered potential for a greater standardization of forms. However, standardization did not mean mass production. Faience was still made in plaster moulds which could not be stored and re-used from one project to the next. Many designers and their clients were more interested in the potential of clay for being moulded into Baroque or French Renaissance detail than in maximizing economies through repetition and even off-the-shelf forms. Meanwhile town and city surveyors tended to insist on traditional load-bearing walls of brick, so denying the possible economies in terms of weight and expense that could be achieved by closely relating framed construction and ceramic cladding. In Manchester, the steel-framed warehouses designed by Harry Fairhurst and Son in Whitworth Street have façades of weighty and lush matt-glazed faience. It was the rear elevations that were conceived as simple grids, each bay being filled with a large metal-framed window surrounded by plain brickwork.

There is scarcely any more standardization in the way that turn-of-the-century ceramic architecture is being repaired and conserved. Buildings rated as being of lesser importance are likely to be treated in a fundamentally different way to listed examples. The contrasts can be highlighted by a few examples from across the country, working from non-authentic replication to careful research and retention of as much of the original fabric as possible. In the case of the Classic Cinema in Glasgow, the complete façade was replaced by glass-reinforced concrete, after a fire resulted in the brick and faience becoming detached from the steel frame. The city council had to first counter an application for complete demolition; their efforts to promote a more authentic repair foundered since the insurance company demanded a new front in a cheaper, substitute material.

The YMCA Building in Manchester is of particular interest for its innovative combination of faience and concrete. Blocks and slabs were fixed directly to reinforced concrete which was used for both the frame and the walls. The design by Woodhouse, Corbett and Dean, executed 1910-11, reflects the density of the concrete structure. When the building was refurbished to form St George's House by Austin, Strazala and Lord, many blocks with distinctive spirals of fruit and vegetation were lost, as the contractors cut through to expose and treat any rusted reinforcement. More positively, the remakes by Shaws of Darwen match the original Burmantofts work in terms of colour and sheen. The distinctive pattern of fenestration, reflecting the form of the underlying concrete, has been completely retained.

A highly progressive use of faience, in terms of standardization and a close relationship with structural steelwork, was achieved with London's tube stations.

Fig. 9.4 YMCA Building, Manchester by Woodhouse, Corbett and Dean, 1910-11, with Burmantofts terracotta set into a reinforced concrete structure.

The architect for Underground Electric Railways Company had to design more than fifty stations in a period of five years, between 1903-8. Leslie Green overlaid a simple steel grid with pilasters and cornices of blood-red faience, creating a fireproof structure strong enough to carry extra floors for offices or apartments above. The conservation of these stations, almost as characteristic of London as double-decker buses or black taxis, highlights the fact that these buildings have only just become appreciated let alone understood in terms of their materials and appropriate policies for cleaning and repair. Many of the frontages have been cleaned with hydrofluoric acid. Surfaces have been etched or destroyed, resulting in confusion between fully-glazed finishes made by Burmantofts for many of the West End stations on the Piccadilly line, and the duller effect of the vitreous faience supplied by Hathern, at Earl's Court for example. Cleaning firms and manufacturers have had to develop appropriate measures on a station-by-station basis, lacking any clear policy as to whether further cleaning should be undertaken or avoided, and in what circumstances new blocks should be inserted.

At Baron's Court Station, London Underground are confronted with a deep buff and chocolate coloured frontage that has been harshly cleaned and hence lost most of its glazed finish. Their architects are having difficulty in determining the colour and finish of the original surface, and whether the sheen represents an original glaze or a later barrier coating. They are then faced with creating a patchwork effect whereby the new-glazed blocks will glisten out in contrast to the abraded originals, while also having to find a way of protecting the damaged faience from graffiti attack.

Gloucester Road Station, with its *sang de boeuf* faience, provides an example of a steel-framed and faience-clad building that has been the subject of careful assessment as a prelude to conservation. Investigation by a team embracing architects, engineers, conservation specialists and a metallurgist explored any alternative to the highly expensive and destructive approach of removing all fractured blocks, shot-blasting the rusted areas of frame and replacing much of the original brick and terracotta. They started by examining the causes of the cracking of the faience blocks. Careful study of archival drawings showed the

Fig. 9.5 Gloucester Road Underground Station, London, by L. Green, 1905-6, with ox-blood coloured faience.

form of each beam and stanchion. Internal examination was undertaken where the faience blocks were so badly damaged that they would have to have been cut out anyway. The steel frame had rusted due to water coming in from the parapet, cornice and blocked internal pipework. It was recommended that new pipes, lead flashing and mastic would solve these problems. The rusted steelwork could then be stabilized by cathodic protection – applying an electric current to the frame so it would act as a non-corroding cathode. Only a small number of blocks should need to be re-made, so reducing costs and resulting in retention of a greater proportion of the original fabric. Options for cleaning the frontage were assessed on site and in a laboratory. A failed polyurethane coating will be removed by organic solvents, but no harsh overall cleaning undertaken.[6]

A conservationist rather than highly interventionist approach is especially appropriate where the façades have intricately moulded and hand-painted

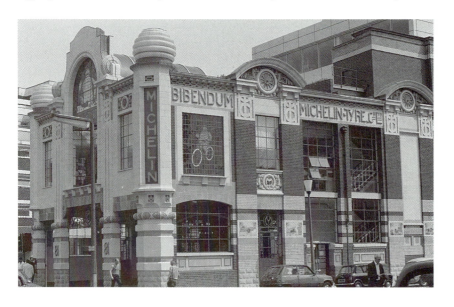

Fig. 9.6 Michelin Building, London, by F. Espinasse, 1911, with tile panels and Burmantofts faience over a concrete frame.

170

decoration. The Michelin Building, also in West London, is renowned as an eccentric Art Nouveau-inspired design with tile panels portraying cars at full speed. The building was designed by François Espinasse and opened in 1911. A frame and walls of reinforced concrete were clad in Marmo faience made by Burmantofts of Leeds, with white, blue, yellow and green colours complementing the tile murals. In their refurbishment, completed in 1987, Yorke, Rosenberg & Mardall (YRM) and Conran Roche took care to retain every possible block and slab, partly because of their historical importance but also to minimize damage to the structure as a whole. Chipped or cracked blocks were repaired with pigmented epoxy filler, which was then given a UV stable coating. Epoxies were specified, rather than cementitious fillers, because the treatment would be reversible if better techniques emerged in the future, and because the colouring agents are less likely to fade. In some cases just a part of a block was remade by Hathernware and carefully set into a void where badly decayed material had been cut out.[7]

Progression and conservatism in the inter-war period

During the inter-war period manufacturers found that they could cast and extrude large slabs of faience, drawing upon the success of experiments undertaken back in the 1890s by Burmantofts of Leeds. Architects for retail stores and cinemas appreciated the potential of faience for providing a bright and washable façade that could be applied to buildings after the shell had been erected and as fitting out was taking place. Whereas many Edwardian ceramic buildings were designed to imitate stone, a new, more innovative aesthetic now came to the fore.

Flat frontages of faience, polished stone, metal or glass were designed to be crisp, clean and modern – and stay that way despite being located in cloudy and polluted environments. During the inter-war period many commercial architects

Fig. 9.7 Cementing faience slabs to brickwork, using fixing rods. (Shaws of Darwen)

progressed, by degrees, from using a stripped-classicism in their designs, with simple, low relief mouldings to create façades of flat, shiny surfaces. Similarly for much of the period, ceramic façades incorporated both hand-made blocks and standardized slabs, the latter being available from Hathern, Shaw and other firms from around 1935.

Architectural ceramics became used almost universally for commercial and public architecture where its popular appeal, colour, and washable and hygienic properties were of particular value. Shops, offices, cinemas, libraries, swimming pools and bus stations have rarely been top priorieties to historians and conservationists. They are typically work-a-day buildings, but they make up a key element of the fabric of our provincial towns and cities. Just for these reasons, being provincial and being a little worn, they are often dismissed by critics and conservationists pre-occupied with whatever artistic movements, architects or fashionable building types are currently in vogue. There is a further problem of architectural credibility, in that critics have difficulty in accepting that many twentieth century designs are not the creation purely of an individual architect but need to be comprehended as a joint effort, involving engineers, or draughtsmen and a modeller in a factory.[8]

Investment in mass production

The terracotta firms made piecemeal improvements to their factories, to accommodate the production of faience by casting from slip or extrusion through metal dies. Shaws, established at Darwen in Lancashire in 1897, had moved to nearby Waterside in 1908. The firm's own patent design of tunnel kiln was installed and major extensions were undertaken in the mid-twenties as employment rose to around 400. A major fire in 1929 prompted further re-investment.[9]

The capability of the firms supplying architectural faience depended as much on entrepreneurship as technology and industrial investment. In the period 1921-5 Hathern was just ahead of the Burmantofts section of Leeds Fireclay as the largest manufacturer of terracotta and faience in the country. Much of this growth can be credited to the efforts of G.A. Hodson who developed a particular enthusiasm for architectural work. The son of the founder of the firm, George Hodson, he directed the business from 1899 to 1938 with a dogged determination and an unwavering belief in the value of terracotta and faience. He succeeded in giving Hathern a more commercial and therefore more flexible outlook than the longer-established firms.

G.A. Hodson believed that it was essential to be able to respond to the varying demands of architects. His modellers and draughtsmen, most of whom were trained within the office as school-leavers, were expected to produce whatever detailed designs were asked of them. The head artists might have been trained at the Royal College of Art, the successor to the training school developed within the Victoria and Albert Museum. They may have studied modelling under Edouard Lanteri, whose teaching developed the principles of the new Sculpture Movement, emphasizing the link between statuary and three-dimensional decorative design. Students or staff from the RCA were most likely to become involved in designing architectural ceramics through working for companies

renowned primarily for their pottery or tiling. Carter, Doulton and Maw had to maintain proper design departments. Hathern or Shaw had little need for inventive artists, as they expected to develop decoration from sketches or even detailed design drawings supplied by architects.

Architects were able to realize their own tastes in the use of architectural ceramics, constrained only by the capabilities of the staff and production process at Hathern. The members of the profession who regularly gave contracts to the Company took differing approaches to the development of their designs and the delegation of responsibility. Some initially impressed upon the designers and modellers exactly how they wished their meeting hall, railway buildings or shop-fronts to appear and only supplied one-eighth inch scale drawings for subsequent schemes. Many were glad to delegate the production of full-scale and shrinkage drawings and the design of decorative detailing. With shops and dairies it was theoretically possible just to introduce a house-style, leaving staff in the draughtsmen's office at Hathern or Shaws to adapt the designs to suit the site and layout of each branch.

However most of the major architects retained very tight control over the design of terracotta and faience by supplying full details themselves, or demanding alterations when the works' drawings were submitted to them for approval. Even with cinemas, where it was more important to achieve a striking visual impact than any stylistic purity, architects usually demanded to be consulted over the decorative details. George Coles, the leading figure amongst all the inter-war cinema architects, was known to be so autocratic and particular, that many of the draughtsmen's drawings would be rejected as a matter of course. Even for a simple streamlined design such as the Odeon in Lough-borough, built 1935-6, he demanded alterations to the mouldings around the entrance and in the use of colour in the faience recesses for the neon lighting.[10]

Meanwhile figureheads within the RIBA, academics and critics condemned the way that faience was being used in the twenties. While some simply associated it 'with the blatant exteriors of public houses', more considered judgements, such as from Professor Charles Reilly and H.S. Goodhart-Rendel, claimed that the material was being developed along entirely the wrong lines. They considered that smooth surfaces with rounded edges were the most logical expression for a plastic material, with decoration being provided through colour and modern sculptural forms.[11]

To both the architects and the manufacturers, slab faience was a logical outcome of the taste for plain and unbroken surfaces. Introduced largely for reasons of economy it did not immediately result in standardization or mass production. As G.N. Hodson emphasized, architects frequently required special sizes, textures and colours and there could be problems in matching cast or extruded slabs with the moulded blocks used to form ribbing, stepped forms or other detailing and corners. Even the size of the blocks or slabs was subject to the tastes of individual architects; typically a compromise had to be reached, with the managers of pressing shops being reluctant to produce forms over two square feet in surface area.[12]

A wide range of standard colours was available but most firms offered to match any colour samples that were supplied, returning fired trials for approval.

Faience could be supplied in a range of glazed finishes, from high-gloss through egg-shell to rough textured.

The terracotta business

A full understanding of the forms of faience used in British architecture requires an examination not only of art movements and attitudes, but also, briefly, of economics and technology.

Hathern's fully glazed faience, marketed as Hathernware, was introduced in 1910, 22 years after Doulton had introduced their Carraraware. The Leicestershire firm never rivalled the subtleties of glazed effects achieved by Burmantofts, Doulton or Carter. These older-established companies had adapted glaze formulae developed for tiles and art pottery to architectural faience. More mundanely, they had found a cheap source of material for the most common greens and browns, by mixing the waste glaze made up for finer wares. Hodson ensured that stocks were held of 'Hathernware' glaze, presumably in the white colour which was most commonly specified; but as with all the aspects of production he deferred to the taste of the architect and client; the management offered 'our best advice on this matter as regards colours available and combinations'.[13]

The Cinema House in Sheffield, by Hickton and Farmer of 1912 was the first major contract to use Hathernware; within a year the material was being specified for over a third of their contracts, and after the First World War faience completely dominated production.

The competitive balance between the long-established firms was disrupted when Shaws of Darwen emerged as a major producer. This relative newcomer into the market appears to have executed only 28 contracts from 1914 to 1923. Seventeen were supplied in the following year alone, and their production increased progressively during the rest of the twenties. Most of the demand was for their fully glazed 'Marmola' faience which they were selling in 1924-5 for around 13s per cubic foot. Shaws' Darwen works was located by reserves of clays ideally suited for large but simply modelled forms of faience, and was equipped with efficient gas-fired kilns.[14]

Shaw combined unrivalled efficiency with a slightly devious entrepreneurship. The firm had few qualms over circumventing the rules of the price regulating body, the Terra Cotta Association. From 1930 the company concentrated on making faience in small sizes, so that it was classified as tiling and therefore beyond the control of the Association; up to three-quarters of the ceramics used on some of their schemes was exempted from price regulation and inclusion in their quarterly return of production.[15]

During the twenties the prices charged by all three companies dropped slightly. Due to the system of grading and compensation imposed by the Association, it was the least successful firms that took contracts at the lowest rates in 1929, just as a serious slump started to affect the industry. The differentials imposed by the TCA, and their failure to stop Hathern and Shaw dominating the market, confirms G.A. Hodson's belief that price was a less important factor in gaining contracts than were a reputation for efficiency and contacts with the appropriate architects and clients. In the late twenties, Shaw

benefited from close ties with the architectural practices of L.G. Ekins and W. & T.R. Milburn, which brought them numerous orders for Co-operative stores in London and for commercial premises in the north-east of England.[16] The early thirties saw a dramatic decline in Hathern's sales of faience and prices fell accordingly. The decline prompted a price war.

Firms retained a regional emphasis in their market, Shaws being strongest in Lancashire, Hathern in the Midlands, and Doulton in London. The links with particular architects are reflected in the pattern of geographical distribution of the terracotta and faience contracts supplied by Hathern and Shaw. Several concentrations of orders in particular parts of the country represent one or more local architects using architectural ceramics supplied by one firm for a series of buildings, increasingly of a particular building type. Shaw gained numerous contracts from the north-east in the twenties, the majority coming from only three architects. During the following decade Hathern captured most of the market for faience in northern Ireland. Such strong regional markets were partly built up through the efforts of particular sales representatives or agents. Many orders came from major industrial towns and cities, and seaside resorts, particularly those settlements nearest to one of the works. Since the manufacturers had to cover the cost of delivery, they were able to offer lower prices or higher discounts for relatively local work. Hathern supplied much of the architectural ceramics used in Derby, Leicester and Birmingham while Shaw dominated in Lancashire and Carter along the south coast.

Architects did not veer from one manufacturer to another to achieve the keenest price or to take advantage of new developments in manufacturing and glazing; their allegiance to a particular, and typically the most local manufacturer appears to have been at least as strong as in the Victorian period. Those with an eye for the subtle differences in modelling and glaze colour between the output of different firms can see an element of a regional vernacular from Shaws' work in Lancashire, to Hathern in the Midlands and Carter of Poole in the Channel resorts.

Slab faience
Faience slabs, large tiles faced on one surface with a glaze, were widely adopted in the thirties as a 'weather-resistant artistic veneer', light in weight and relatively cheap. Slabs were of further practical value as they reduced the density of joint lines, in contrast to glazed tiles, so achieving greater light reflection and reducing the labour costs in fixing. The major firms had tested out the potential for making and fixing slabwork with the use of tiling for interior work. The Winter Gardens in Blackpool for example, developed from 1929 to designs by J.C. Derham, were faced with blocks on the external façades, and faience tiling inside, all supplied by Shaws.

Many orders in the late thirties included slab faience measured by the square yard. Shaw had introduced exterior slabwork as early as 1931, charging 22s per square yard for Gillingham Station, by G. Ellison. Hathern followed four years later. Despite being near standardized in form, and simple to produce and fix, they did not transform the economics of using architectural ceramics. Slabs were almost always combined with moulded work, for corners, cornices and door and

window reveals. The size of order for the firms remained similar, despite the cost per square foot for a given wall area being lower, simply because commercial buildings became larger. Thirties cinemas were, on average, much bigger than earlier examples; Odeon façades dating to 1937-8 cost in the range of £1000 to £2000 while most of the independent cinemas of the late twenties and early thirties had involved orders in the region of £500 to £1000.

Neither manufacturers nor architects had the motivation to ensure that they brought about any revolution in the practicalities of architectural ceramics. Architects frequently required special sizes, textures or colours and there could be problems in matching cast or extruded slabs with the moulded blocks used to form ribbing, stepped forms or other detailing and corners. Even the size of blocks or slabs was subject to the tastes of individual architects; typically a compromise had to be reached with the manufacturing shop at Hathern who were reluctant to produce forms over two square feet in surface area. Firms retained particular pride in achieving special effects in terms of exotic colours and special forms. They introduced the expensive option of machining pieces to achieve 'marble' joints and then introduced a tile 2 ft by 1 ft without warpage. It was fired at the higher temperature of 1220°C as opposed to 900°C used for soft-glazed tiles.

A particular feature of the inter-war period was that faience was used to reface old town centre buildings, to give an up-to-the-minute corporate identity for Burtons or Co-operative Societies. Conservationists, both in Britain and North America, have decried such 'defacing' of high streets or main streets, and few have regretted the re-working or clearance of these chain stores; hence virtually no early multiple shopfronts are protected and hardly a complete store with its internal furnishings survives. The W.H. Smiths at Newtown, Powys is a notable exception, with Carters tiles set into the wood fascia now preserved as a period showpiece by the newsagents.[17]

Conserving slab faience
Several if not scores of inter-war buildings with part of their main elevations covered in slab faience are now listed, so serious attention is being given to conserving these oversized tiles. A wide diversity of approaches is apparent.

A sweeping approach to the refurbishment of a faience building was adopted in the case of Ibex House in the Minories, the City of London. This vast, six-storey office building, by Fuller, Hall & Foulsham, 1937, is clad in cream coloured slabs, standard except for those wrapping around the ends of each tower. The north tower, comprising a third of the building has recently been restored. Many of the slabs were crazed and some had suffered frost damage. They were all stripped for complete elevations of new slabwork. The major Amercian supplier, Gladding McBean of California, won this large and potentially highly profitable contract, due to their long experience in extruding large sections of clayware.

In most projects a more pragmatic formula is adopted, retaining and cleaning the majority of slabs and blocks, while replacing those that are badly cracked or those that have had to be cut away to expose and treat rusted steelwork. In some cases the cost of remaking faience slabs and blocks is eased if the manufacturer

can gain a profit on associated new work. The pavilion at Torquay, by H.A. Garett was recently both refurbished and extended. Shaws of Darwen are currently engaged on a major project at Fenwick's store, Newcastle-upon-Tyne, where £750 000 of faience will be supplied for new work, in addition to material needed to restore the original façades.

Slabs came into use on cinema façades from 1936, giving them a fashionable streamlined image. Harry Weedon designed a series of Odeons with part of their main elevations covered in 2 ft by 1 ft slabs, faience blockwork being used for the cornice, corners and door and window reveals. They have worn surprisingly well given that maintenance has been minimal during the last couple of decades when most have been shut or used for bingo. The listed Odeon in Scarborough, by Harry Weedon, 1936, has recently been refurbished and converted into the Stephen Joseph Theatre on the initiative of Alan Aykbourn. Shepherd Design and Build replaced the minimum number of slabs, while consolidating those that were just slightly damaged.

The use of tiling and faience on the Hoover Building, Perivale, west London, by Wallis, Gilbert and Partners, 1931-5, is modest in area but vivid in impact, dashes of orange and green giving a zest to the otherwise simple façade. Most of the original faience supplied by Carters was retained during the recent refurbishment, some consolidation being undertaken especially where pieces had been damaged by a bomb blast during the Second World War.

The De La Warr Pavilion at Bexhill-on-Sea, designed by Eric Mendelsohn and Serge Chermayeff and built 1934-5, is a great icon of inter-war Modernism with its crisp elevations and south elevation largely of glass. The columns along the balconies facing the sea were built of steel, encased in concrete and clad in

Fig. 9.8 De La Warr Pavilion, Bexhill-on-Sea, by Eric Mendelsohn and Serge Chermayeff, 1934-5, and conserved by Troughton MacAslan with new tiles set into the balcony columns.

Fig. 9.9 Finsbury Health Centre, London by B. Lubetkin and the Tecton Group, 1938, and conserved by Avanti Architects, with areas of new tiling.

12 in by 3 in buff-glazed tiles. By the time that Troughton MacAslan had been appointed conservation architects in 1991, corrosion had caused the concrete to force off the tiles, mosaic being applied as a makeshift repair. Once the steel had been exposed, cleaned and protected, a new cementitious base was built up for fixing replacement tiles, designed to match the originals. Corrosion-inhibiting paint and a low-permeability render were used to give greater protection to the steel box stanchions without having to compromise the slender outlines of the thin columns with their rounded face.[18]

Another key Modern Movement building with a partial cladding of ceramics is also undergoing a phased programme of conservation works. The walls of the Finsbury Health Centre, on the edge of the City of London, present an amazing variety of finishes: concrete, insulated panel, glass brick and square faience slabs. The centre was designed by Berthold Lubetkin and the Tecton group and opened in October 1938. The cream wall tiles were part of a subtle colour scheme, largely lost under layers of grime and white paint. In their conservation report Avanti concluded that the original tiles had suffered too heavily through frost failure and cracking due to the lack of expansion joints to be worth retaining. The conservation architects sought to recreate the same colour, the same 'depth' of glaze and the non-mechanical finish of the originals. After a long search and trials with samples being made by Shaws of Darwen, they resorted to using tiles glazed in northern France. Expansion joints had to be introduced to ensure that the tiles could expand and contract. The joints were set wherever possible in hidden locations, such as where the profile changed. Any expansion joints across a plain wall surface were disguised by colouring them to match the tile for part of their width.[19]

Despite such meticulous attention, the new tiles are a far from perfect match – they are blander in surface finish and devoid of variation, and those forming the bottom of the wall lack the rounded edges of the originals. It might be hoped that those thirties tiles that are still in sound condition are spared during subsequent stages of the current conservation works, at least so that future generations can appreciate the originals, if only to achieve a better match if and when they need to be replaced.

The Second World War and the post-war period

The demand for architectural ceramics virtually disappeared at the outbreak of the Second World War, as projects for commercial buildings were cancelled or postponed. Twenty schemes being undertaken in Weedon's office for Odeon cinemas were abandoned, two where building work was already in progress.[20] The entertainment and retailing industries, whose architecture made such extensive use of faience, did not revive their building programmes until the early fifties by which time several manufacturers such as Gibbs and Canning had shut down. Some firms, while concentrating on the manufacture of chemical ware as part of the 'War effort', managed to keep their architectural departments active by producing funerary vases and slabs.

Gibbs and Canning re-advertised faience in the autumn of 1945 but do not appear ever to have resumed production.[21] Doulton closed their architectural department for good at the outset of the War. Hathern, Shaw, Carter and Burmantofts, having supplied utilitarian products in chemical, sanitary or tableware during the forties, returned to supplying architectural ceramics, initially with small contracts for repair work to bomb damage. The capabilities of the firms remained restricted until the following decade as a result of the requisitioning of workshops and the loss of skilled workers.

In the discussions concerning the rebuilding of bomb-damaged city centres, the merits of architectural ceramics were expounded in by now familiar terms, highlighting their durability and the potential for colour and moulded decoration. It was recommended that faience appeared at its best in flat surfaces, relying for added effect on discreetly contrasting colours, any moulded decoration being kept in low relief.[22]

In response to promotion by the Terra Cotta Association, the Ministry of Works replied that it would be willing to contemplate the use of terracotta rather than Portland stone for rebuilding schemes in London, if the industry could supply a material of a quality comparable to that of late eighteenth century Coade stone.[23] Little came of these plans and the post-war period saw considerable criticism of architectural ceramics, most of the blame being laid on the faulty manufacture of faience slabs. The industry argued that architects were failing to use the material appropriately. Slabs had been fitted to backings without damp-proof membranes, fixed to long concrete beams and slabs without expansion joints, and applied directly to lightweight and potentially unstable concrete.[24]

The collaborative ideal between architect and art manufacturer was left to wither away. Shortages of materials and the need to control costs went hand-in-hand with growing enthusiasm for standardization and abstract decoration. Tiles and faience became most widely used in building types where durable and easily cleaned surfaces were of great value, such as in schools, food-processing factories and power stations. The key markets for Shaws were industrial and commercial buildings in London and the north west of England. Their order book for 1955 includes part of Sheffield University, the Odeon in Middlesborough, Truro bus station and a café at Boscombe.[25] A specialization that ran through into the seventies was supplying both the linings and exteriors of swimming pools. About two-thirds of the output of faience from Burmantofts

appears to have gone to Europe and the ex-colonies, primarily for municipal and industrial buildings.[26] Hathern provided standard-size slabs for numerous shop-fronts and several garages and blocks of flats, Belfast becoming a particularly strong market.

The juxtaposition of different materials and colours, and of plain and decorative surfaces was popular during the fifties. Patterning and the incorporation of pale red, yellow and blue colours were encouraged by the example of the Festival of Britain held in 1951. The Festival Pattern group promoted crystalline and other abstract motifs as forming the basis of a truly contemporary decoration.[27] Such designs were rapidly adopted by Carter for printed tiles. Simpler repeat patterns such as diamonds, circles and wave shapes were moulded into relief tiles and faience. Non-rectangular blocks and slabs, sometimes hexagonal or octagonal in shape, became used for sections of building façades. For the Palace Theatre, Manchester by Messrs Wilfrid, Thorpe and Hirst Smith, façades in Shaws 'sunshine' mottled faience were given a rich variety of ribbing and other surface patterning.[28]

Most of the major examples of post-war faience date to around 1960, in what amounted to a minor revival. During the late fifties faience slabs were presented in the columns of architectural magazines as a functional adjunct to structural steel and reinforced concrete. Meanwhile manufacturers were encouraging architects to introduce decorative effects – 'soft pastel tints (which) can lend dignity as well as prominence' – and to choose from a wide variety of surface textures – full gloss to matt and special 'stone' finishes and special shapes and finishes.[29] By promoting such a plethora of options, the industry undermined the economic and practical advantages of large rectangular slabs, so successfully made and marketed in the late thirties.

It was widely recognized that the ideal form of faience was a slab size of no more than 2 ft square. The most typical shapes for slabs were 24 in by 12 in and 18 in by 12 in, and yet the main firms could not resist promoting non-rectangular slabs – elongated hexagons and octagons being the favourites. Other forms briefly came into vogue, including curved or specially twisted slabs and even a 'random' patterning similar to Kentish ragstone, achieved by arranging up to a dozen different shapes of slab across a façade.

A honey-combed frontage of hexagonal blocks was provided by the now combined group of Shaw-Hathernware for Lewis' department store in Blackpool, designed by Duke and Simpson and dating to 1962-4. Facetted faience slabs were used on the other three elevations. For many commercial buildings Shaw-Hathernware supplied simple motif slabs, in the form of a flame for British Gas and of a barrel for Walker's Brewery, to create appropriate corporate symbols.

Such designs soon passed out of fashion as architectural tastes moved towards starker surfaces that expressed more directly the underlying structure of a building or the coarse texture of unfinished concrete. Large faience slabs had not been proven as an economical cladding material for structural concrete and steel. They were still usually hand-made and relatively heavy and expensive.

Norfolk County Hall, Norwich, designed by Uren and Levy and completed 1968, was to be the swan-song for traditional faience. Set in parkland to the south of the city, low ranges surround a central tower block. The composition was built

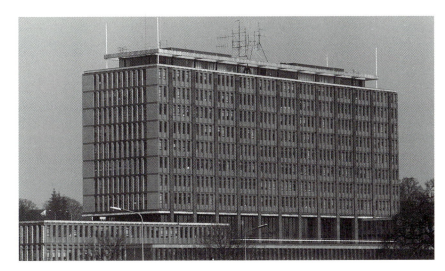

Fig. 9.10 Norfolk County Hall, Norwich, by Uren and Levy, 1968, with faience slabs by Shaw-Hathernware.

up out of a modular layout with structural bays 20 ft 10 in square, the reinforced concrete frame being sheathed with mellow red brick and russet faience slabs supplied by Hathernware. There is no contrived ornamentation. Vigorous projection and recession of the differing materials and the contrast between the eight-storey administrative block and lower two- and three-storey wings projecting asymmetrically, created a picturesque quality far removed from contemporary Brutalist architecture.[30]

Twintiles and prefabrication

Advocates of faience had long argued that it could be used as a facing formwork, directly backed up with concrete and so dispensing with the need for wooden shuttering. This approach was rarely adopted, since the ceramic slabs were vulnerable to damage as the concrete was rammed in place, and because it was so difficult to achieve precise joint lines and to allow for differential expansion. An alternative approach, fixing faience to concrete to form prefabricated panels was only taken up slowly, partly because such panels were so heavy that they were difficult to manage, until tower cranes were readily available.

The Americans had perfected techniques of casting concrete directly onto the back of faience in the thirties.[31] It was only in the sixties that prefabrication and the mass production of ceramics came together in Britain. A number of firms, led by Shaws of Darwen, invested in plant for the mass production of glazed tiles, designed so they could be set into concrete to make up large slabs for rapid on-site erection. During the 1960s they concentrated their architectural production on 9 in by 3 in Twintiles. They were designed to be extruded in pairs with a keyed back which would adhere to concrete, whether prefabricated or set *in situ*. Twintiles became extremely widely used, first for swimming pools, then for hospitals, railway stations and culminating in huge shopping centres. Such mass-produced ceramics necessitated new production facilities and new attitudes at factories dating back to the Victorian and Edwardian periods. The transformation was to prove fraught and ultimately almost catastrophically unsuccessful.

Fig. 9.11 Making pre-cast panels faced with Shaws Twintiles. (Shaw-Hathernware)

To generate funds for investment, Shaws merged with their arch rival Hathernware in 1961 to form Shaw-Hathernware. Many said that it was a shotgun marriage, and that the separate firms never gelled together into one unified organization. In the following year, a start was made on updating the works at Darwen. The industrial railway shut down, the final steam engine going to a salt mine at Sandbach, while the lines and sleepers were relaid at the Tramway Museum at Crich. Production lines from extruders to glaze sprayers and tunnel kilns were laid out to enable vast numbers of Twintiles to be produced. Over the next 20 years Shaw-Hathernware made further incremental investments in the name of mass production.[32]

Twintiles appealed to prestigious architectural practices, far more than the range of faience slabs on offer in the previous decade. Progressive designers accepted the reduction in size and colour variation, for the image of crisp modernity. They were following in the footsteps of their modernist mentor Le Corbusier who had used white tiles on the Armée de Salut in Paris. Traditional door, window and cornice detailing was rejected for smooth surfaces that gave a bold contrast with large areas of recessed glass. A key project in marking the adoption of tile as a cladding for concrete was the Engineering Building at the University of Leicester, designed by Stirling and Gowan and built 1963. It was lauded by Rayner Banham as 'an architectural jewel ... compelling in its massing and contrasts of its forms'.[33] Prestigious contracts gave a focus to marketing efforts by Shaw-Hathernware: they gained much mileage from supplying the elegant Royal Commonwealth Pool, Edinburgh by Robert Matthew, Johnson-Marshall & Partners, 1967, which was lined with gloss white Twintiles, the racing channels being marked out in black tiling.

Yorke, Rosenberg & Mardall made white Twintiles a hallmark of their work in the late sixties and early seventies, from their own London offices to universities, hospitals and airports. Eugene Rosenberg, drawing inspiration from work by Havlicek and Honzik in Prague, advocated tiling as creating a crisp modernist style better suited to the British climate than exposed and quickly discoloured concrete. He experimented on the practice's new London office,

erected in Greystoke Place in 1961.[34] When invited to design the library for the University of Warwick in 1963, YRM recommended the use of white tile cladding over a perfectly plain, rectangular grid of projecting piers and spandrels. Through further commissions for the campus, such as the Science Buildings and the Rootes Hall of Residence, white tiles were to create a coherent visual identity whether the building was erected in reinforced concrete, load-bearing brick or blockwork. An RIBA award was given in 1967 for the library, praised for being 'rectangular, classically proportioned and clad in pristine white tiles'.[35] As will be discussed below, the campus at Warwick, planned as a showcase for tile-clad architecture, sadly became the prime test-case for debates and litigation as the tiles started to fall away, within almost a year of completion. Another flagship project for YRM, St Thomas' Hospital in London was also largely tile-clad. For stage two of the hospital, built 1967-76 and focusing on a large ward block by the River Thames, special off-white glazed tiles were fixed to reinforced render over concrete. The practice also used Twintiles on their lower, more sprawling buildings for the John Radcliffe Hospital in Oxford built 1968-72, the terminal building at Newcastle-upon-Tyne Airport opened in 1967, and Manchester Magistrates Court completed in 1971. Other key orders gained by Shaw-Hathernware were the new railway termini at Manchester Piccadilly and London Euston. Even the pools in Trafalgar Square were lined in Twintiles.

Twintiles were widely used as a facing for pre-cast concrete panels. One of the first examples dates to 1965, when the local authority in Edmonton, north London used cast panels set with Twintiles on a high-rise housing scheme, the

Fig. 9.12 Blackburn Shopping Centre, by Building Design Partnership, 1966-c1970, faced with Twintiles. Photographed in 1996, just before recladding.

project being monitored by the Building Research Establishment. This constructional system became closely associated with a major new building type: the air conditioned shopping centre. These complexes were heralded as bringing an element of modern America into outworn British towns. The redevelopment of the centre of smoky Blackburn, first with a new market in 1964, and then with several phases of comprehensive redevelopment commencing in 1966 was trumpeted as transforming 'virtually all the town centre as grandfather knew it'. 'What Blackburn needed was a firm hand, to sweep away decrepit old buildings'.[36] Half a million tiles were used in the designs by the Building Design Partnership, white and bronze coloured tiling also being used on the slender clock tower which became the focus in the new open square. The tiles were fixed off-site to panels, weighing up to two tons. Up to sixteen of these panels were fixed in a day making for rapid on-site assembly. The much vaunted strength of the bond between concrete and tile was tested and confirmed when the Central Shopping Centre was gutted by fire in December 1972.

Runcorn Shopping City, designed by the Department of Architecture and Planning of the Development Corporation involved 50 000 sq yards of mottled white Twintiles fixed directly to concrete. The culmination and, to some, the architectural nadir of this run of huge projects, was the Arndale Centre, Manchester designed by Hugh Wilson & Lewis Womersley in the early seventies. The tower and the external walls of the shops were faced with pre-cast panels faced with Shaws Twintiles code T1980 – a deep buff colour.

This apparent success story turned sour in terms of both economics and architecture. Even when Twintiles were in strong demand – sales of around £200 000 per annum being projected in the late sixties – Shaw-Hathernware

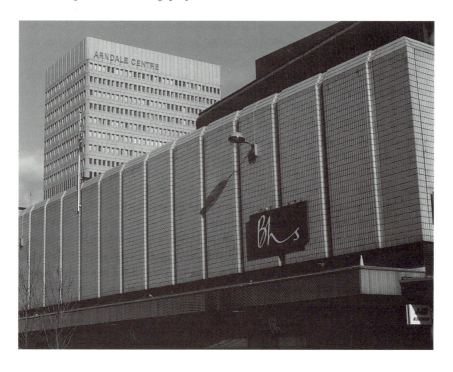

Fig. 9.13 Arndale Centre, Manchester, by Hugh Wilson & Lewis Womersley, c1972, clad with buff Twintiles.

were not making a profit due to holding excessive unsold stocks.[37] Meanwhile the demand for faience had collapsed with the result that the fixing department had to be almost shut down.[38]

In the mid-seventies Shaw-Hathernware was busy supplying the Arndale Centre in Manchester and export orders as far afield as Australia, Tenerife, Camaroons and Mauritius.[39] In the following January a new product, Supertiles, was launched. They were half the weight of Twintiles and designed to be applied to exterior or interior surfaces by adhesives. They necessitated major investment, the expenditure of £100 000 on a new clay preparation plant imposing a major strain on cash resources. As Twintiles fell out of demand in the late seventies, the financial crisis deepened, the company drifting £1 million into the red. The workforce had been cut from 200 to just 80 when a receiver was brought in in February 1980.[40] Shaw and Hathern were demerged, the assets of Shaws of Darwen being bought by the Concrete Masonry Group. After a troubled decade, and a further change of ownership, Shaws re-emerged as a highly successful firm hand-making products with which it had originally been associated – traditional sanitary ware such as Belfast sinks and terracotta and faience blocks and slabs primarily for conservation work. The brief amour with the modern world of mass production, prefabrication and rapid erection had patently failed.

Building failures

Twintiles became associated both with commercial losses and on-site failures. Architects and contractors had successfully resolved practical issues of off-site fabrication, safe delivery and handling. However, research papers and building codes had not tackled such fundamentals as weather resistance, durability, ease of maintenance, and sound and thermal insulation. During the sixties the construction industry was faced with an incredibly diverse range of materials, including concretes, metals, timber, glass and plastics, as well as ceramics in the form of brick, mosaic and tile.[41] There was little in the way of either standardization or standards. The relevant Contruction Industry Board code gave scant guidance on the use of tiling in relation to concrete, focusing on the use of traditional 6 in by 6 in tiles.[42] The new code published in 1966 did not warn about the dangers resulting from the contraction of concrete in its early life, and of water accumulating in voids behind tile cladding.[43]

Cladding systems became a major source of concern in the early 1970s. The fixing of marble slabs, the failure of panel-post connections on tower blocks, and peeling away of tiles roused the greatest concern.[44] Yorke, Rosenberg & Mardall's buildings at the University of Warwick were soon to provide the *cause célèbre* in relation to tile cladding.[45] The first phase at Warwick was completed in 1968. In February of the following year, the University's Building Surveyor noted that an area of Twintiling was bowing out on part of the Rootes Hall of Residence. Concern turned to crisis two weeks later when a larger slab of tile and its backing fell from the south-east side of the library. A survey across the new campus showed that numerous areas of tiling were bulging out. On the award-winning library, the render used to even up the face of the concrete had lifted away from the face of the concrete itself, resulting in the detachment of slabs up to two inches thick. In the case of the brick-walled residences, equally heavy

Fig. 9.14 Tile failure on the Rootes Halls of Residence, University of Warwick, by Yorke, Rosenberg & Mardall, 1968. (University of Warwick)

slabs were peeling away to expose the raw Fletton brickwork. A survey undertaken over the spring of 1969 suggested that several factors could be the cause of such catastrophic failure: excessive thickness of the render applied to build up a flat surface for the tiles, structural movement, thermal movement and in the case of the residential blocks, sulphates emerging out of the Fletton brickwork.

Remedial works were delayed by disputes over liability and legal proceedings. Meanwhile, failure became more widespread, caused primarily by water penetration through the sills and plain cornices. A key aspect of YRM's design was that plain tiles were used for window soffits and sills. These surfaces proved vulnerable to water accumulation and frost damage, while the joints at the corners were liable to be opened by even minor structural or thermal movement. As wranglings between architect, contractor and client continued, the detailing of any parts of the campus under construction was altered to prevent such rapid deterioration. The Physics Building, completed in June 1969, was given aluminium copings. An improved specification for fixing the tiling, using stainless steel mesh, was adopted for the Arts Building completed in December 1970 and the Computer Centre finished in March 1971.

The issue of remedial works took longer to resolve. Sulphate attack through the brickwork of the residential blocks continued. During 1972-4, these buildings were completely covered over to reduce the ingress of water and prevent loose tiling being a safety hazard. The Benefactors Hall, with its hybrid concrete and masonry structure was also overclad. Initial works on the concrete-framed buildings, such as the Library and the Science Block, involved the

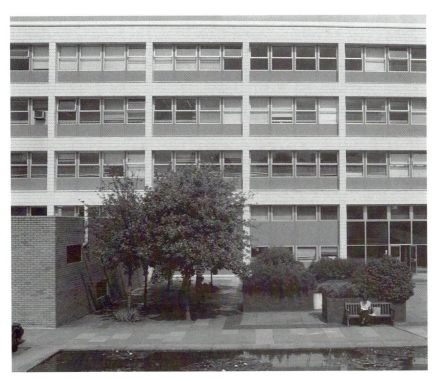

Fig. 9.15
Shaw-Hathernware
Twintiles fixed with
a revised specification
and detailing, Physics
Building, University of
Warwick, 1969.

removal of loose tiling, fixing a mesh to the concrete and then re-applying new tiles. Over 1972-3, metal fixings with circular tie-plates were used to pin vulnerable areas of tiling to the concrete frame at approximately 3 m intervals.

Some areas of tiles that had been refixed started to peel away again. Meanwhile YRM were still anxious to retain their architectural conception of a white tiled grid. In 1974 the practice suggested that epoxy resins should be injected into any voids to re-create a bond; this work was undertaken over the following year. With the exception of where the backing was of brick or blockwork, the resins appeared to perform well until 1980 when the estates officer noted that the glaze was exfoliating in some areas where the resins had been injected. It transpired that the epoxies were absorbing moisture and expanding against the tiles and their fixing cement.

Following court cases over 1973-4, and again in 1988 when the contractor for the resin injection was also involved, the University had to cover the cost of most of the remedial works. In an attempt to find a long-term solution to this desperate saga a major programme of overcladding took place during 1987-8 for the Library, the Rootes Social Building and the Science Block. Only the ground floor columns and stairways were left with their tiling exposed. The stairs of the Science Building can be inspected to witness the deterioration caused by water ingress in terms of salt encrustation, cracking and exfoliation. Meanwhile the near pristine tiled façades of the Humanities Building and the Physics Building demonstrate the crispness of YRM's design and the high performance of the Twintiles, given an appropriate fixing specification and special attention to prevent water ingress.

Problems were being experienced with Twintiles and other cladding systems across the country. Surveyors, architects, structural engineering consultants and the Building Research Establishment scurried from Newcastle Airport to the University of Liverpool and on to St Thomas' Hospital in London. In the case of St Thomas' a stronger bond was achieved between the concrete structure and the render by setting horizontal lines of rope into the formwork for the concrete. A report by the Building Research Establishment published in 1972 confirmed that the main point of failure was not the bond between the keyed tiles and their backing but the interface between the render and the concrete or brick structure. The greater shrinkage of the rendering and bedding mortars than the tiles was one critical factor. Compression in the tiling, caused by creep in the concrete structure, was exacerbated by expansion of the tiles themselves as they absorbed moisture. The use of thick render coats to create a flat surface for applying tiles increased the likelihood of failure.[46] Probably the only design weakness of the Twintile system itself was the wide mortar joint, constituting around 10% of the wall surface. It created a bold pattern but encouraged water ingress, even if a Chromalith 'waterproof' cement mix was specified. A final post mortem on tile-clad architecture was published in 1987. It confirmed that tiling and mosaic finishes inevitably trapped moisture through capillary action and wind suction, and that any form of cladding would be more sensitive to temperature changes than the more stable structural core.[47]

Tile and mosaic cladding remain largely out of fashion and out of production, and several schemes have been removed or overclad. During 1996 the tile facing of Blackburn Shopping Centre was cut away and refaced in coloured cement, partly in response to safety fears as rusting of reinforcement caused some of the Twintiles to fall away. The bomb explosion in central Manchester, on Saturday 15 June 1996, has resulted in debates over the reconstruction of the central shopping district. Not a single voice has been heard appealing in favour of the repair, rather than demolition, of the damaged portion of the Twintiled Arndale Centre.

Conservation issues
In reviewing the conservation of ceramic-clad buildings – from the Reliance and Michelin Buildings to the Finsbury Health Centre and Blackburn's Shopping Centre – standards clearly vary, depending on the country, the date of the structure and its broad status in terms of architectural history and protection by listing or landmarking. All too few projects seem to start with a broad, objective appraisal in terms of history, architectural qualities and condition. Such a study should be seen as an essential prelude to any decision over consolidation, replacement and cleaning.

There is a fundamental challenge in promoting the principle of authenticity – retaining as much of the original fabric as possible or using new materials that are as authentic as possible. All too many professionals and organizations accept that cladding materials are best stripped way. This allows a simple contract for their replacement and can be justified by the belief that twentieth century buildings should, more than their brick and stone forebears, be restored to some loosely conceived pristine state.

The critical factor concerning faience and most cladding materials is not the performance of the slabs or panels themselves. Conservationists need to focus on the relationship with the underlying concrete or steel structure, the form of fixing and the means for handling moisture and expansion and contraction. Failures typically result from a lack of expansion joints, water ingress caused by poor maintenance and moisture working its way through the building in ways that are little understood. Early installations have failed simply because there was not adequate fixing of the cladding back to the frame, resulting in the elevations carrying loads that they were never designed for. In most cases the cause and the damage can be tackled without drastic and destructive intervention. It may be that timely repairs, cutting expansion joints into existing façades and revisions to detailing to ensure better water run-off present the keys to the conservation of ceramic architecture dating to this century.[48]

There is a prevalent attitude that curtain walling is a sacrificial element of a building, to be replaced along with internal fittings and services. This may be fine for the commerical refurbishment of unlisted buildings, offering a path towards upgrading performance and making unpopular architecture more appealing. But there is little evidence that buildings were designed in expectation or such a re-working. High quality, listed architecture should only be reclad as a last resort, especially if the faience, mosaic or glass is a central rather than a minor aspect of the design. Historians and conservationists must recognize that factory-made materials may be as important historically as those worked by craftsmen, perhaps all the more so because they provide evidence of technologies that may be already lost and difficult to replicate.

The use of tiles for cladding in the sixties and seventies was to achieve a bright, permanently attractive finish. The lessons from Warwick are that architects, structural engineers and sub-contractors did not think through the risks of applying a new design of tiling with wide joints that would become water-absorbing once cracks had developed, so drawing in moisture by capillary action to become dispersed through any voids behind the bedding mortar. They blithely dispensed with such traditional details as sills and copings, developed through centuries of experience of building in a wet and frosty climate. Rapidly fabricated concrete had no time to deflect and contract before the tiles were applied. Many architects saw expansion joints as a solution, but mastic seals could simply become a shear line to allow slabs of cement and tile to fall away.

The issue as to whether a conservationist faced with having to replicate damaged material should copy the original forms or restore any defects in the original design is more difficult, and can only be determined in individual cases. However it is clear from this modest survey that, in the case of architectural ceramics, it is rarely the block, slab or tile itself that is at fault. Historic buildings that retain faience and tile cladding are likely either to have been well-designed and built or to have had any faults remedied, recent decay being most probably due to lack of maintenance or simply a fair reflection of the age of the fabric. This brief investigation of the most catastrophic failures to affect ceramic clad buildings shows that there is enormous merit in conservation-led studies to remind the building profession of lessons painfully learnt by contemporary architects, surveyors and contractors.

Every effort should be made to match the original material not just in terms of its visual appearance but also the nature of the clay body or glaze. The major manufacturers are promoting standardized clay bodies which they then colour with slips and glazes to achieve a colour match. Some give-and-take may be necessary if only because leadless glazes are now unavailable and illegal, but the starting point should always be the original specification not a modern standard. Clearly conservationists have a responsibility to upgrade the provision of fixings and expansion joints where necessary, but in most cases changes are normally only necessary at such critical locations as cornices and across large, unbroken areas of ashlar.[49]

In this as in many strands of building technology, twentieth century architecture is best seen as evolving out of established traditions. Faience was still specified for the same reasons of colour, economy and durability as Victorian terracotta. Many of the conservation challenges are the same, and the same criteria for determining conservation policies in relation to consolidation, replacement and cleaning also largely apply. One innovation characteristic of the new century was that building technology evolved through ideas and technologies crossing the Atlantic and the English Channel. Historians need to study the development of cladding systems and of steel and concrete framing on an international basis. Conservationists must also look overseas in developing an appropriate conservation philosophy and in choosing specific treatments and replacement materials. American consultants have wider experience of tackling problems with stress cracking on curtain walls. Experts in San Francisco have been grappling with the problems caused by moisture build-up, as the sea mists roll in each afternoon from the Pacific.

This study highlights the importance of commercial and public buildings in the evolution of twentieth century architectural design. The thematic and post-war listing programmes of English Heritage have brought greater attention to such building types as offices, schools, swimming pools and cinemas. This broad range of urban architecture is of great historical significance in demonstrating a flexible and popular approach to modern design that is still neglected in terms of historical study, conservation philosophy and challenges relating to particular materials and constructional forms. There is a need for a fuller understanding of the rich mixture of materials and decorative effects achieved by many British designers, in league with the material supply and construction industries, all in the cause of creating an effective and appropriate modern architecture.

References

1 This philosophy is promoted in Jester, T.C. (1995) *Twentieth Century Building Materials: History and Conservation*, McGraw-Hill, New York, 43.

2 A valuable summary of the broad issues and prejudices affecting the conservation of twentieth century architecture was presented by Andrew Saint in his lecture: 'Philosophical Issues' in the conference: *Modern Matters: Principles and Practice in Conserving Recent Architecture*, 31 October-1 November 1995.

3 For examples see Stratton, M.J. (1993) *The Terracotta Revival*, Gollancz, London, 99.

4 The newsletter of the Tiles and Architectural Ceramics Society carries numerous articles outlining progress in the conservation of tiling. For a thorough historical overview see Herbert, T. and Huggins, K. (1995) *The Decorative Tile*, Phaidon, London.

5 I am grateful for information on the refurbishment of the Reliance Building from Gunny Harboe, McClier Preservation Group, Chicago. Wiss, Janney, Elstner Associates tackled many of the technical issues relating to this project.

6 Duffy, D. & Wrightson, D. (1996) 'Conservation Goes Underground'. *Context*, **49**, 6-8.

7 Simpson, J. (1988) 'Nunc est Bibendum'. *Building Refurbishment*, January, 29-35.

8 These issues of trying to appraise the representative and the provincial were considered at the Chicago conference. See *Preserving the Recent Past* 11-63, III-3 (Ref. 17 below).

9 *Blackburn Weekly Telegraph* (1904) 9 January; *Darwen News* (1929) 15 June.

10 Odeon Cinema, Loughborough, Hathern Drawings, 1936.

11 (1927) *British Clayworker* **36**, 199-201.

12 Hodson, G.N. (1935-6) Architectural Terracotta and Faience, *Transactions of the Ceramic Society*, 35, 43-51 (49).

13 Hathern Station Brick and Terracotta (n.d.) *Modern Practice in Architectural Terracotta*, Hathern, Loughborough, 18.

14 Shaws of Darwen, (1921) *The Shaws Gas Kiln: Development of Gas Firing as Applied to the Ceramic Arts*, unpaged.

15 Hathern, Letter from G.N. Hodson to W. Facon, Derby, 28 October 1930.

16 Hathern and Shaw Order Books 1926-1931.

17 Luce, W.R. (1995) Kent State, White Castles and Subdivisions: Evaluating the Recent Past, in *Preserving the Recent Past* (eds D. Slaton and R.A. Shiffer), Historic Preservation Foundation, Washington, II-16.

18 Powell, K. Schollar, T. (1994) 'Restoring a Milestone of Modernism'. *Architects' Journal*, **199**, No 7, 35-44.

19 Avanti Architects Ltd (1995) *Finsbury Health Centre Ltd: Review and Progress Report*, Avanti, London.

20 Atwell, D. (1980) *Cathedrals of the Movies*, Architectural Press, London, 158.

21 Gibbs and Canning, Directors Meeting, 10 October 1945.

22 (1994-5) *British Clayworker*, **43**, 76-7.

23 Hamilton, D. (1980) *Crafts*, July-August 1980, 17-24 (17-18).

24 Johnson, N. (1962) *Builder*, **203**, 1962, 279-281.

25 Shaws of Darwen (1955) Faience Sales Book.

26 Leeds Fireclay (1956) Annual Report.

27 Banham, M. & Hillier, B. (1976) *A Tonic to the Nation: the Festival of Britain 1951*, Thames and Hudson, London, 51.

28 Shaws of Darwen (1950s) *Faience by Shaws*, Shaws, Darwen.

29 Johnson, N. (1962) *Builder*, **203**, 1962, 279-281.

30 (1968) *Building*, **215**, 20 September, 113-8.

31 (1957) *British Clayworker* **66**, 52-8.

32 Shaws invested further in mass production of tiles over the next twenty years, a £70 000 sorting machine and a glazing machine costing £40 000 being installed in 1981. (1981) *Darwen Advertiser*, 10 June.

33 Banham, R. (1975) *Age of the Masters*, Architectural Press, London, 108.

34 Powers, A. (1992) *In the Line of Development: F.R.S. Yorke, E. Rosenberg and C.S. Mardall to YRM, 1930-1992*, RIBA, London, 53-61.

35 (1967) *Building*, **212**, 5 May, 98; (1975) *Building*, **229**, 17 October, 80.

36 (1967) *Lancashire Evening Telegraph*, 25 January.

37 Minutes of Directors' Meeting, Shaws of Darwen, 29 May 1968.

38 Minutes of Diectors' Meeting, Shaws of Darwen, 15 May 1970.

39 Report of Chairman to the Shareholders, Shaw-Hathernware, 28 April 1975.

40 Letter from DWF Roberts, Secretary, Shaw-Hathernware, 29 February 1980.

41 (1971) *RIBA Journal*, **78**, May, 200-205.

42 (1970) *RIBA Journal*, **77**, August, 353-359.

43 BSI (1966) Wall Tilings: External Ceramic Wall Tiling and Mosaics; CP212, Part 2 (BSI).

44 (1973) *Building*, **225**, 10 August, 74.

45 I am most grateful for help from Colin Ferguson, Estates Officer who explained the failures at Warwick and the variety of remedial measures employed.

46 Suzanne Woodman of the library at the Building Research Establishment provided assistance. See (1972) 'External Wall Tiling with Cement: Sand Bedding', *DOE Construction*, **4**, 14-17, and (1973) 'External Wall Tiling with Adhesives', *DOE Construction*, **5**, 7-9.

47 Ridout, R. (1987) 'Tell Tile Signs', *Building*, **43**, 50-1.

48 On the conservation of curtain walling see section V in Slaton, D. and Shiffer, R.A. (Eds.) (1995) *Preserving the Recent Past*, Historic Preservation Foundation, Washington.

49 The issue of restoring building defects is debated by De Jonge, W. (1995) 'Early Modern Architecture: How to Prolong a Limited Lifespan?', in Slaton, D. and Shiffer, R.A. (eds.) (1995) *Preserving the Recent Past*, Historic Preservation Foundation, Washington, IV-3-9.

Part Four

Conservation Options

Robert Thorne

Quality, longevity and listing

The reason why the debate about the conservation of modern buildings is so important is that it challenges our fundamental assumptions about how buildings are evaluated. This is not yet widely understood because the debate has followed too narrow an agenda, with a tendency to treat the subject on the same terms as the debates about conserving buildings of earlier periods. The main intention of this contribution is to highlight the radically different issues which occur when modern (especially post-war) buildings are being dealt with, and to examine some of the possible ways of resolving these issues.

Generally speaking the way the debate has been reported so far suggests that the conservation of modern buildings represents a shift in fashion that was bound to occur sooner or later. It was inevitable, the argument runs, that the threshold of appreciation would eventually reach the modern period and that the conservation movement would turn its attention to the recent past. At the turn of the century, when the cause of building conservation first began to attract widespread support, the focus was mainly on medieval and early modern (pre-1700) buildings. Between the two World Wars eighteenth century architecture became the centre of attention and then in the 1950s and 1960s Victorian architecture, once vehemently despised, experienced a dramatic change of fortune. In 1970 it was the turn of inter-war architecture to be officially recognized, and then finally in 1987 the first post-war building was listed. Thus there has been a progressive shortening of focus as to what constitutes buildings worthy of conservation. As Gavin Stamp puts it, 'the wheel of fortune is revolving more and more quickly, and the interval between creation and revival is diminishing.'[1]

In the eyes of many commentators the inevitability of this sequence has been reinforced by changing attitudes to the past which have manifested themselves across a much wider front. In the last few decades the general perception of what is historic has changed dramatically as a result of the commercialization and

popularization of the way history is presented. In everything from local museums and attractions to the music and fashion industries, history is being recycled in a freewheeling and undiscriminatory way, using in particular the artifacts of the recent past. In films, books, clothes and music, as well as in the more obvious repositories of history, the conscious revival of the immediate past has become an everyday experience.[2] The changing attitude to modern buildings can be regarded as just another facet of this all-embracing movement.

Thus the conservation of modern buildings has been presented as both an inevitable episode in a continuing process and as a by-product of an increasingly popular movement. But that leaves unanswered the question of how modern buildings are going to be dealt with when the decision to retain them is taken. On that issue what is frequently said is that the problems will be taken care of as they arise, just as they have been with earlier generations of buildings. Victorian terraced houses, once condemned as jerry-built, are now the bread and butter of many conservation firms, and warehouses, once regarded as beyond redemption, are now being intelligently converted to new uses. Materials once thought unrepairable are now nothing to be afraid of. The inference from what has happened previously is that, given time, the technical and other problems involved in the conservation of modern buildings will be sorted out.[3] Once again what is being suggested is that nothing fundamentally new is occurring, just a variation on what has happened before.

How buildings are assessed

In reviewing these issues the best starting-point is to go back to first principles. Two primary justifications for conserving historic buildings, as embodied in the listing process, are their age and their rarity.[4] The older a building is, the more likely it is to be treasured, and if it is known that it is a rare or unique example of its kind it stands an even higher chance of being singled out for listing. With modern (especially post-war) buildings age and rarity are unlikely to be major considerations. Not much is known about the age profile of our building stock (other than housing) which is why Philip Steadman's contribution to this volume is so helpful. However common sense tells us that there are few modern buildings types which have suffered such attrition that few examples survive: only prefabs are on the endangered species list (Fig. 10.1). Age is also not a key factor, though the foreshortening of history that has taken place in recent years means that historic importance is being attributed to buildings at an increasingly early phase in their existence. But even so they are still too young to be regarded as historic in the sense of carrying the patina of age and long association with past events.

Whether or not they apply to modern buildings, these questions of age and rarity raise the more fundamental issue of why buildings survive. Of course the listing process, and the care of buildings which it promotes, only deals with survivors, and it would be regarded as a waste of time if conservationists devoted their energies to studying buildings which no longer exist. Architectural historians are more inclined to take an interest in buildings which have long ago been demolished, but more with the aim of establishing what they looked like than of analysing why they were discarded. However when it comes to looking

Fig. 10.1 A Phoenix prefab in Wake Green Road, Birmingham. Built in 1945, and recommended for listing by English Heritage in 1996. (English Heritage)

at modern buildings the broad issue of what survives and what does not, and how buildings are evaluated, becomes much more relevant. As the threshold of what is considered historic moves closer and closer to the present day, buildings are being singled out for listing, and thus for conservation, before they have passed through the wider assessment which all buildings are subject to in their first decades. Buildings of earlier periods which get listed have stood the test of time, and that is part of their appeal. Modern buildings are being regarded as conservable before they have faced that test.

This is such a fundamental difference that it is worth setting out in more detail what is meant by 'the test of time' before coming to the more specific issue of how modern buildings are assessed. Different parts of buildings change at different speeds and are assessed accordingly. In his studies of office architecture Frank Duffy distinguishes between the shell, which may last up to 50 years, services which have a life expectancy of 15 years, and scenery (desks, carpets, partitions) which seldom survive for more than 5 years between changes.[5] The chronology which he has outlined relates to a building type in which change is particularly endemic, but the categories he refers to can usefully be expanded to cover buildings of any type or age. Broadly speaking all buildings can be assessed under four headings:

- *Function*: how well the building accommodates the use for which it was designed, and how adaptable to new uses it is. Functional obsolescence can occur for a wide range of reasons, from a failure to meet the requirements of a precise operation to a general change in public taste.
- *Structure*: how well the original design, materials and construction have performed.
- *Services*: how reliant the building is on its mechanical and other services, and how frequently those services have to be replaced.
- *Site and location*: changes in the setting of a building may have a more radical effect on its life expectancy than factors relating directly to the building itself.

197

CONDITION

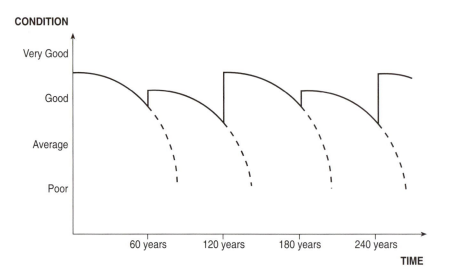

Fig. 10.2 The typical cycle of repair for traditionally built structures.

Itemizing headings in this manner implies that the evaluation of buildings has achieved a state of scientific precision. For the followers of Frank Duffy's dicta that may be so, but historically most assessments have been at an informal if not subconscious level and have produced few records except the evidence of what has happened to the building.

A building which scores badly under two or more of the above headings will instinctively be defined as low quality, and stands less chance of being adapted or upgraded than buildings that have performed well on every count. A low quality building will be onerous to maintain, and will require more frequent overhaul to keep it in reasonable condition.

For traditionally built structures the typical rule-of-thumb is that they require a medium level refurbishment every 50-60 years and a major refurbishment every 100-120 years (Fig. 10.2). At both break-points a decision has to be made as to whether the building is of sufficient quality to merit refurbishment. Historically it seems that these refurbishment cycles have long held true. Even with medieval timber-frame buildings, which had long been thought to have a low life expectancy, there is now evidence that many survived for 100 years or more.[6] With brick and stone buildings of later periods more is known about the life cycle, especially for towns where the leasehold system of tenure gave legal force to the idea of building overhaul at 80-99 year intervals. Against the background of this general pattern, the forces of change and misfortune, or simply an accelerating pace of change, have always played their part. Fire caught many buildings early in their life, or they became functionally obsolescent well before their structural deterioration was a problem.[7] At one extreme, late medieval depopulation accelerated the loss of buildings which might have survived for longer; at another, the fervent years of industrialization in the early nineteenth century led to buildings such as railway stations being replaced within a decade or less of their completion. The profligacy of one generation could shorten the life of a building when the next generation decided to retrench, as when Canons House in Middlesex was demolished after less than 30 years; or

Fig. 10.3 Bankside Power Station, Southwark. Completed in 1960 to the designs of Mott, Hay and Anderson and Sir Giles Scott, this power station was taken out of commission in about 1980. It is now being converted to house the Tate Gallery's collection of modern art. (Greater London Record Office)

affluence could transform a building well before the time of its first overhaul was due, as with the Prince Regent's constant transformations of his Marine Pavilion at Brighton. But if a building could survive these and other short-term changes the times when it was assessed followed a well-established pattern.

The assessment of modern buildings

These historical examples are a reminder of how buildings traditionally have been evaluated. Turning to modern buildings, there are once again many examples of how arbitrary forces of attrition can affect a building when it is still comparatively young. Unforeseen changes can still cut short a building's intended use: Bankside Power Station (Fig. 10.3) was only fully functional for 20 years and Chichester Theological College, celebrated when new as a model of ecclesiastical modernism, has run out of ordinands for training after only 30 years. As in every previous era buildings can be the victim of over-ambitious decisions by one generation, immediately regretted by their successors: many would argue that such has been the fate of the Brynmawr Rubber Factory.[8] And it still remains true that transformations can overtake a building well before its first general overhaul is due.

In these and other respects there is nothing new in what has happened to modern buildings. What is much more significant has been the underlying trend in the pattern of building performance. For many modern buildings the time for a first overhaul occurs much sooner than with traditional buildings – after 25-30 years rather than 50-60 years – and at that stage many are being judged as being of too low quality to be worth refurbishment.[9] Many are fundamentally flawed from the outset and so are unrepairable. This foreshortening of the first

199

probationary period for buildings, often accompanied by an early decision not to retain them, presents a radically different context for building conservation.

Why many modern buildings have become due for their first overhaul while still comparatively young, and why they are found wanting at that stage, are questions touched on by a number of contributors to this book. They also underlie the flurry of attention that recent architecture has received in the refurbishment journals. For the argument presented in this paper, what needs to be spelt out is how modern buildings perform when matched against the tests which conventionally have been applied to buildings of all ages. Of course, not all modern buildings follow the same tendencies. Many have been put together in a traditional way using familiar materials, and they are likely to experience the same repair cycle as traditionally built examples from earlier centuries. But these do not catch the limelight to the same degree as buildings conceived and constructed in a more innovatory mode. For both conservationists and those with a general responsibility for the building stock it is the buildings representing a break with the past that are the main cause for concern.

Using the categories for assessment which have already been outlined, the most prominent issue concerns the structural deterioration of modern buildings: the familiar litany of spalling and corroding materials, problematic claddings, reliance on mastics to seal difficult details, and inadequate connections between building components. To understand these problems means recalling how buildings were conceived and built, especially in the quarter-century after 1945. Wartime experience unleashed an enthusiasm for new technologies which had been latent in the architectural thinking of the inter-war years. The boffin mentality, having proved itself in conflict, was easily translated to addressing the demands of post-war reconstruction. Shortages of building materials (especially steel), and of skilled labour, helped justify the continuance of this experimental outlook, a tendency which architects and engineers, swept along by the same mood, did nothing to resist. The emphasis on achieving as much as possible from the least materials accorded well with the urge to produce a type of architecture suited to the new kind of society that was emerging. In these circumstances it is easy to understand how the lessons of building performance inherited from previous generations were set aside, without the opportunity to test the longer term performance of the methods that replaced them.[10] That is not to say that insufficient thought was put into design, for it was a period of radical creativity the like of which had not been experienced for at least 100 years. On the contrary, it can be argued that too much effort was put into exploring new materials and techniques, at the expense of thinking about the lessons of durability and the integration of materials as embodied in earlier buildings.

In the excitement born of necessity the material which was relied on most of all was reinforced concrete. After the war, steel was in short supply and official licensing favoured its use for reinforcement and pre-stressing. Architects who had grown up admiring pioneering examples of concrete construction such as Highpoint One were more than ready to adopt the new idiom, whether in the exotic shapes of shell and dome construction or the straightforward concrete frame. One of the advantages claimed for concrete was that the frame produced its own finish and required no additional covering or treatment.[11] What we realize

*Fig. 10.4 Newbury Park
Bus Station, Redbridge,
by O. Hill. Built in 1949,
this exposed concrete
structure required
patching and overcoating
55 years later.
(English Heritage)*

with hindsight is that amidst this excitement too little consideration was given to maintenance and durability, particularly of exposed concrete surfaces; that poor workmanship was too willingly overlooked; and that the use of cements such as high alumina cement (available from 1923, but not widely used until after the War) was too readily adopted without a clear knowledge of their long-term performance. The durability of exposed concrete is particularly dependent on the quality of the original design, detailing and construction. High quality concrete work may last for many decades before the first repairs are needed; low quality may need patching after only 15-20 years, and further attention at roughly the same intervals thereafter. These timescales were seldom understood or made explicit when the buildings involved were new.

These points hardly need rehearsing for anyone who has been following the debate about the conservation of modern buildings, so two examples will suffice. At Newbury Park in East London a remarkable bus stand was built in 1949 to serve the underground station, a hangar-like structure consisting of a series of reinforced concrete arches carrying a curved concrete slab roof (Fig. 10.4). Moderate quality concrete, inadequate cover to the reinforcement and conditions conducive to concrete carbonation had led, by the 1980s, to the corrosion of the reinforcement in the exposed parts of the structure and the spalling of concrete finishes. Extensive patching and overcoating of the exposed concrete was finally carried out in 1993-4. The Department of the Environment's Marsham Street blocks are a much younger example of concrete construction, built in 1963-71 on the tower and podium pattern that was in vogue at the time (Fig. 10.5). Government enthusiasm for building systems led to the use of a combination of pre-cast and *in situ* concrete, with on-site fabrication of the pre-cast units.[12] The appearance of the blocks was widely disliked from the time they were finished, but it was less for that reason than because of the deterioration of their exposed concrete elements and other causes that the decision was taken in 1992 that they should be demolished. The blocks have had a lifespan of less than 30 years.

The cladding of concrete in other materials, or the substitution of alternative materials closer to a machine aesthetic in appearance, has generated a further set of problems, highlighted by a series of well-known cases: for instance the failure

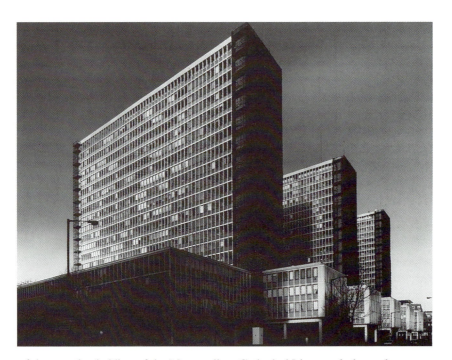

Fig. 10.5 The Department of the Environment Marsham Street blocks. This typical slab-on-podium scheme, built in 1963-71, was proposed for demolition in 1992.

of the mosaic cladding of the Metropolitan Cathedral Liverpool, the replacement of the anodized aluminium external panels of the Sainsbury Centre after only 15 years, and the degradation of plastic and GRP units within a short time of their installation. These have attracted attention because they involve external finishes and therefore are visible, but as the corrosion of reinforcement suggests it is the performance of invisible components which can be even more critical. The quest for solutions involving the minimum number of easily assembled materials generated new combinations of structure and finish, and new forms of joint and fixing, in which the crucial parts were difficult to inspect during construction and impossible to see thereafter. Traditional building incorporates a clear hierarchy between structure and finish in which the elements that are likely to require repair or replacement in the short term are open to inspection and renewal: the innovations of the post-war period often subverted that hierarchy without consideration for how the elements would interact in the long term.

These issues relating to the way in which buildings are put together have come to the fore most often in the use of pre-cast panel systems; either in the way systems have been assembled, with inadequate or badly executed connections, or in the quality of the panels themselves which cannot be repaired without replacing the whole unit. A small scale but typical example of the consequences of ill-designed connections has occurred at the Cakehouse in St James's Park (Figs. 10.6 and 10.7). This modest structure, built in 1969, was meant to seem like a light-hearted garden pavilion but was built in heavyweight materials – a series of pre-cast concrete roof panels spanning radially from a central wall to perimeter steel beams and columns. Glazing spans between the panels to form rooflights.[13] The problem here has been that insufficient tolerance was provided between the components. The joints between the panels, plus the fixing of the

Fig. 10.6 The Cakehouse, St James's Park 1969-70, showing one of the roof slabs being lifted into place. (RCHME: National Monuments Record)

glazing to the panels, has relied on a mastic sealant which has failed to keep the rain out. The attempted simplification of structure and finish has resulted in a fundamentally inadequate solution.

Frank Duffy's methodology for the examination of buildings suggests that structural deterioration (problems affecting the shell) will be preceded by functional changes and changes in building services, both of which are typically on a much shorter timescale. In practice with many modern buildings, especially office blocks, all these coincide because they are locked together in the same highly tuned design (Fig. 10.8). The ease with which services can be replaced is dictated by the building structure (above all its layout and floor heights), and if services cannot be replaced the functional capacity of the building is downgraded. If, as is often the case, the realization that a building is capable of only moderate adaption coincides with the appearance of the first structural problems, then it is unlikely to be thought worthwhile to carry out a first overhaul. The disappearance of so many of the 1960s generation of office buildings in the City is testimony to the fact that they have failed their

Fig. 10.7 The Cakehouse, St James's Park 1969-70, showing the completed tent-like structure. (RCHME: National Monuments Record)

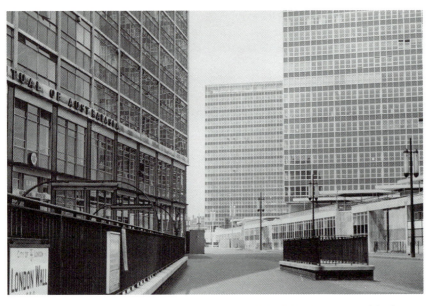

Fig. 10.8 London Wall, City of London, in 1962. Lee House, the furthest building in this view, was rebuilt 1987-92. (Greater London Record Office)

probationary period on more than one count, and the Marsham Street blocks are due to go for much the same reason. The lack of a capacity for adaptation is a prime explanation for the short life expectancy of many modern buildings.

Finally there is the question of location and how a building relates to its setting. Site is perhaps the most powerful determinant of whether a building will succeed or not; economically because a building is valued as a commodity on a particular site, geographically and socially because how a building is seen and used relates directly to where it is. As already suggested, many modern buildings have suffered from changes affecting their location just as many of their predecessors have done. Where the experience of the post-war years differs from what has gone before is in the way layout and siting have been regarded. The separation of functions, and the segregation of streets and buildings often in complex arrangements of layout and levels, has flouted the conventions of how buildings relate to each other and to the street. Nowhere is this more obvious than in the large estates in inner London and elsewhere, most of them completed in the public sector housing boom of the 1960s. The fact that so many of these estates are already being dismantled, to be replaced by housing layouts of a more familiar kind, has many causes; but not the least of them is that such estates were developed with disregard for the traditions of their location.

What should be conserved?

It has always been insisted that the condition of a building should not be allowed to influence the decision whether or not to list it. The principal reason for disregarding building condition and performance is that if they were taken into account building owners would be tempted to let their buildings deteriorate so as to prevent the threat of listing. Claims of expediency would be allowed to compromise the disinterested assessment of a building's importance. But there are also other reasons why the issue of building condition is not normally taken into consideration when the question of what to conserve is being debated. One

is that building conservation has generally dealt with traditionally constructed buildings, so whatever their condition there has been a large fund of knowledge and experience that could be drawn upon in their repair and maintenance. The problems and solutions have long been well understood. And until recently buildings which have been earmarked for conservation have, by virtue of their age, already passed the first test of building condition. They have proved themselves to be sufficiently robust and adaptable to stand the test of time.

The fact that history is catching up with us means that the selection of buildings for conservation has to be dealt with in a new manner. So far, the procedures for selection which were established in the 1940s with traditionally constructed buildings in mind have now been applied in the selection of modern buildings for listing. This change has occurred without due consideration for its overall significance. Buildings are being singled out as worthy of conservation before they have passed through their probationary period, and before it has been demonstrated that it is feasible to conserve them in the long-term. The listing process, which administratively has always been kept separate from the practical issues of building care, has continued down its particular track regardless of the consequence of the decisions that are being made.

The paradox in what is occurring has been given partial recognition in the recent Department of National Heritage paper, *Protecting our Heritage*, published in May 1996. There it is suggested that modern buildings which are listed should be given an additional designation (by the use of the suffix 'M', presumably meaning modern) which would signify that after 50 years the case would be reconsidered; at that stage the listing grade of a building could be altered, or it could be removed from the list if it was no longer regarded as being of special interest.[14] The justification for this proposal says nothing about the broader issues of building assessment which confront those who have to deal with modern buildings. When the consultation paper refers to 'the quality of recent buildings' it means quality in the narrow sense that has traditionally been used in the listing process: an attribution of architectural (i.e. aesthetic) and historic importance, rather than a definition of quality based on the long-term performance of a building and its adaptability to change. The paper reflects a dawning recognition that a problem does exist, but little understanding of the real issues involved.

The idea of the 'M' suffix does confirm the need for a probationary period where modern buildings are concerned. If the review at the end of that period were to include an assessment of the building's overall performance, that would bring the treatment of modern buildings more into line with the way that buildings of all kinds have traditionally been assessed. It would allow the test of time to be part of the equation, as for most buildings it always has been.

However the introduction of such a system would leave a number of problems unresolved. First, many modern buildings would reach the need for a major overhaul before their 50 year review was due. How should they be treated? The implication of what has been said in this paper is that, apart from a few exceptional cases, such overhauls should be allowed to proceed including whatever changes and adaptations to the fabric are required. The meticulous conservation of the original fabric, including the precise replication of

components requiring renewal, should be reserved for a small number of outstanding buildings. The rest should be left to follow the path that buildings of previous generations have generally experienced.

That leaves a second question to be addressed, which concerns the recording of buildings that have been singled out for alteration or demolition. There has always been a strong historical argument for keeping good records of what happens to buildings. There is also a practical argument which says that unless we learn from the way buildings have behaved in the past we will go on repeating our mistakes. It is extraordinary how little effort is put into studying what occurs once buildings have been completed, or into recording their fabric when major changes have to be made. The importance of maintaining records of modern buildings has been recognized in the establishment of DoCoMoMo, but that is only the beginning of what ought to be a much wider debate about how our collective knowledge of buildings is maintained and passed on.

What is being suggested here is that conservationists have a wider responsibility than the protection of buildings and artefacts that have been classified as outstanding. The conservation of modern buildings raises issues about the way buildings are evaluated which until recently have been avoided or neglected. The debate about buildings assessment, which has arisen because of the difficulty of dealing with the problems of many modern buildings, gives conservationists an ideal chance to take on a much wider role as advocates of the way we learn from, and record, our building fabric.

References

1 Stamp, G. 'The Art of Keeping One Jump Ahead. Conservation Societies in the Twentieth Century', in Hunter, M. (ed.) (1996) *Preserving the Past*, Alan Sutton, Stroud, 98.

2 Samuel, R. (1994) *Theatres of Memory Vol. 1: Past and Present in Contemporary Culture*, Verso, London, 95, 197.

3 English Heritage, (1994) *Conservation Bulletin* **22**, 22.

4 The original instructions to investigators for listing (March 1946) are reproduced in Earl, J. (1996) *Building Conservation Philosophy*, College of Estate Management, Reading. Age and rarity are emphasized as factors in listing in Planning Policy Guidance 15, (1994) *Planning and the Historic Environment*, Dept. of the Environment, para. 6.11.

5 Duffy, F. (1990) 'Measuring Building Performance', *Facilities*, **8**, 17-20; Brand, S. (1994) *How Buildings Learn What Happens After They're Built*, Viking, London, 13-17.

6 Currie, C.R.J. (1988) 'Time and Chance: Modelling the Attrition of Old Houses', *Vernacular Architecture*, **19**, 4.

7 Jones, E.L., Porter, S. and Turner, M. (1984) 'A Gazetteer of English Urban Fire Disasters 1500-1900', *Historical Geography Research Series*, **13**.

8 Perry, V. (1994) *Built for a Better Future: The Brynmawr Rubber Factory*, White Cockade Publishing, Oxford, 54-62.

9 Cowan, P. (1962-3) 'Studies in the Growth, Change and Ageing of Buildings', *Transactions of the Bartlett Society*, **1**, 70.

10 Sutherland, R.J.M. (1985) 'Durability and Design Life – the Breadth of the Subject', in Institution of Civil Engineers, *Design Life of Buildings*, London, 9.

11 O'Brien, T. (1970) 'The Changing Face of Concrete', *Arup Journal*, **5**, 20-23.

12 Mills, H.E. (1967) 'Government Offices, Horseferry Road, London SW1', *Structural Engineer*, **45**, 1-13.

13 (1970) 'Cake House, St James's Park', *Building*, 79-80.

14 Department of National Heritage and Welsh Office, (1996) *Protecting our Heritage*, London, paragraphs 2.46-2.50.

Susan Macdonald

Conserving 'carbuncles'

Dilemmas of conservation in practice: an overview of current English Heritage research and advice

Introduction

In addition to protecting significant buildings through the listing process, English Heritage is involved in a wide range of activities concerned with the care and conservation of our twentieth century heritage, providing technical advice, research, training, and published guidelines. The listing of post-war buildings has introduced a huge number of new technical issues and materials into the conservation repertoire, which need to be dealt with if we are to fulfil our role as principal advisors to the government on heritage issues. We cannot hope to deal with all the new issues that are emerging immediately, and it will take some time before research and investigation into the plethora of materials and systems can provide conservation solutions. It is important to know where to access information and to share experience with others to help us in this task. Therefore we liaise closely with other organizations involved with similar work in Britain and abroad, in an attempt to keep abreast of current knowledge.

This paper is presented in three parts. Firstly, although there has already been some discussion of philosophical issues, further attention is given to principles and theories of conservation in relation to the specific problems of twentieth century buildings. Principally the focus will be on practical issues relating to reconciling authenticity and repair. These issues will be examined with reference to case-studies which we have been involved with from different periods of the twentieth century, so presenting some of our current research work. Secondly, drawing from our past experience, we are currently developing approaches to the most common problems, and an outline of the types of information we at English Heritage may be expecting from those seeking Listed Building Consent or grant aid is included. Lastly, in an attempt to draw some conclusions, the paper briefly examines where we need to go next in terms of investigation and research.

The case-studies have been chosen to cover a variety of periods and building types but there is a common thread – the use of concrete. A tremendous number

PHILOSOPHICAL / PHYSICAL PROBLEM	CAUSE OF CONFLICT
Material failure	• use of new materials with unproven performance records. • use of new materials without knowledge of best practice methods for use. • use of traditional materials in new ways, or in a combination with new materials. • poor workmanship and quality control (new materials chosen for reasons of economy.
Detailing failure	• lack of knowledge for best methods of detailing new materials to ensure long-term survival. • adaptation of traditional materials to new detailing to maintain original aesthetic.
Outmoded production	• rapid development of materials and equally rapid supersession of materials. • use of environmentally unfriendly materials now banned. • lack of established salvage industry for modern buildings.
Maintenance failure	• naivety regarding maintenance requirements for new materials and building systems. • failure to implement maintenance recommendations.
Patina of age	• comparative accelerated aging of modern aechitecture. • short-term performance of modern materials. • unrecognized nostalgia for aging modern buildings. • material problems for deteriorating modern buildings.
Design and functionalism	• adaptation for new spatial and planning requirements (open plan and glazing expanses). • upgrading for modern environmental performance requirements (energy conservation). • health and safety requirements.
Life span	• 'throwaway architecture' – intentionally designed for short lifespan. • poor technical performance of materials and systems. • economic viability. • conservation versus recording.
The unknown	• lack of experience. • lack of knowledge of modern materials and their performance over time. • lack of knowledge of repair systems in the longer term. • undeveloped repair methods to meet conservation aims. • availability of resources (salvage). • presence of the original architect (wish to restore and improve).

Fig. 11.1 Reconciling authenticity with repair: philosophical difficulties for modern buildings.

of new materials and building systems have been introduced over the past century. However, of all of these reinforced concrete is by far the most dominant material, and as a result is causing the most urgent, the most common and the largest scale problems in conservation terms, in a similar way that stone has for previous centuries. This said, it is very important that we start to think about the other materials used this century – metals, plastics, glass, and so on – and begin to tackle issues relating to their conservation. In addition, it is the manner in which materials were increasingly used in combination, in building systems such as the curtain wall, which also requires urgent attention.

Increased research into the many technical issues and the development of economically viable repair techniques will clarify some of the controversial philosophical issues that have been discussed in many of the chapters in this book. Investigating solutions to some of the key deterioration problems can also inform current building practice and assist us in achieving aims of sustainable development in the future. The fact that we have not yet challenged standard building practice, in order to approach repairs in a way which accommodates conservation aims, is an important factor. Coupled with this is the increasing trend in the building industry to carry out repairs and refurbishment based on guaranteed systems, relying on proprietary products designed for general use. Conservation usually demands an individual response to the specific problems at hand, and such a standardized approach is likely to be problematic.

Theories and principles

In principle, the philosophy and methodology adopted in the conservation of twentieth century heritage should be no different from that utilized for buildings from our more distant past. The material and structural innovations of the twentieth century, whether they belong to the vanguard of the modernism or not, have, however, introduced new problems, and the solutions may need reconciling with generally adopted principles of conservation. These problems follow from the fundamental characteristics of both modern and mainstream architecture of this century (summarized in Fig. 11.1), in essence:

• the utilization of new technology/new construction techniques.
• the use of new materials/prefabrication.
• new disciplines of planning and new forms of aesthetic expression.

Twentieth century architecture encompasses a rich diversity of architectural styles and languages. It is acknowledged that to generalize is to oversimplify the achievements of the last century. However, many of the problems can be categorized and related to the characteristics listed.

The misapprehension that buildings constructed with the new wonder materials such as steel and concrete would be low maintenance ignores many of the material and construction problems, such as corroding fixings, ungalvanized windows, inadequate internal drainage, and thin concrete walling with its minimal cover to reinforcement and poor thermal quality. Many twentieth century buildings have not stood the test of time well and their perceived inability to age gracefully or perform technically on a long-term basis has put into question some of the most fundamental conservation principles (see Peter Burman, Chapter 2) such as: minimal intervention, maximum retention of original fabric, 'conserve as found', reversibility and retention of authenticity.

It is where we begin to attempt to ensure authenticity in the conservation process that we sometimes find the material nature of the buildings causes a conflict with general conservation principles.[1] Authenticity in conservation terms is generally taken to mean the aim to conserve truth to the materials or fabric in which the building was constructed, truth to the original design concept and resulting architectural integrity, and acknowledgement of the building's passage through time.

It is the material versus aesthetic or design authenticity which is most problematic. To put it another way, should we preserve or prolong the life of the building at the expense of original fabric and/or the design or architectural integrity? With traditional buildings such as stone or timber we have established, over the last 100 years or more, repair methods which enable the maximum amount of building fabric to be retained, whilst extending the life of that building. When we are dealing with twentieth century architecture built of materials such as concrete we have not yet established methods which fulfil such aims, and there are particular material characteristics or use parameters which make this most difficult. In order to identify where authenticity becomes problematic it is simplest to examine some of the principal deterioration problems of twentieth century architecture, to draw out the key conflicts.

Material failures

A vast array of new man-made materials have been introduced over the last century. Most were not fully understood, when first introduced, in terms of best practice methods nor how they would perform over time. Traditional materials have been used in new ways to create new forms of expression, and have not always proved to be technically successful. Traditional detailing methods such as fixed weathering mouldings were abandoned first by the modernists and then in most post-war construction. New combination systems of construction which involve complex arrangements of materials and rely on connections and joints, such as curtain walling systems, have their own problems which also relate to the use and quality of the materials. Many new materials were erroneously believed to be low maintenance or maintenance free and this, combined with a lack of understanding of the projected performance of the materials, inevitably caused failure. Concrete for instance was thought to last indefinitely – there were Roman precedents to prove it! All these factors contribute to our pressing conservation problems.

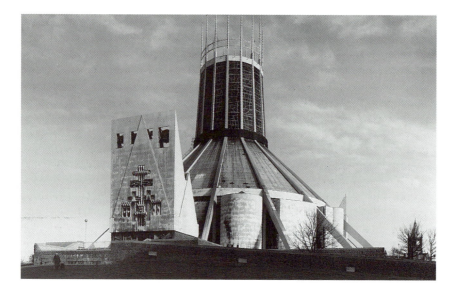

Fig. 11.2
The Metropolitan Cathedral of Christ the King, Liverpool completed in 1967 by Sir Frederick Gibberd. The Cathedral was built to last 500 years, but there are a number of problems with the fabric of the building which relate to the choice and use of the materials.

Many of the new materials and prefabrication systems were conceived as solutions to providing quick, cheap construction; all too often poor workmanship and quality control are important contributors to early failures. The Metropolitan Cathedral of Christ the King, Liverpool, completed in 1967, was built to last 500 years, and is a good example. It is at present being overclad where the original glass mosaic surface treatment has failed. This is a short-term solution to ensure the deterioration is abated while answers are found as how to deal with the material failure. At present there are no economically viable means by which the architect's intention of smooth glistening ribs can be salvaged, and the result is not only a loss of original fabric (material authenticity) but loss of the design intention and aesthetic integrity (design authenticity). The authenticity in material and design terms is thus reduced significantly by the lack of available knowledge to deal with the material failures. This is the subject of a current English Heritage research project to identify and define suitable repair options in order to retain and conserve the extensive mosaic cladding.

The use of mosaic as a cladding for concrete was increasingly seen by architects of the post-war era as a means of providing a durable, maintenance-free, weatherproof and notionally seamless skin to their bold, monumental structures. Mosaic relieved the visual monotony of reinforced concrete and was thought to be a solution to the weathering, colour and jointing problems of fair-faced concrete. Buildings such as Liverpool Cathedral are now suffering from loss of original fabric and there are no viable means of repairing or retaining the existing skin. Current methods of repair involve whole-scale removal, replacement, or overcladding.

Triggered by the problems with the mosaic cladding at the Metropolitan Cathedral of Christ the King, English Heritage initiated a programme of research into the repair of mosaic clad concrete. Our research seeks to understand the architectural use of mosaic, the methods of application, and to investigate why and how it deteriorates, and lastly to identify suitable economic and practical methods of repair.[2] Our work over the last year commenced with an international literature review which examined the manufacture, construction, decay and treatment of mosaic on concrete. Case-studies from Britain and abroad were identified and analysed. The work also included identification of appropriate survey and assessment protocols and techniques, and a review and investigation of techniques and treatments appropriate for the conservation of large scale mosaic clad concrete. The intention was to review conservation techniques used in the conservation of ancient and Victorian mosaic and identify where these methods might be appropriate for, or adapted to, modern construction. Any traditional methods which have such potential then need to be reconciled with the economic realities of large scale works to concrete buildings, and the likely skill base available for such projects. A detailed study of the decay and deterioration of the mosaic cladding to the Metropolitan Cathedral at Liverpool was undertaken, which included scientific analysis by University College, London. The research was carried out by our consultants Bickerdike Allen Partners along with mosaic specialists from the Victoria and Albert Museum.

The typical method of application of mosaic to *in situ* concrete was to apply a thick – average 1 in (25 mm) – layer of cementitious backing mortar to the

Fig. 11.3 Delamination of the mosaic to the ribs of the Cathedral through failure at the interface of the backing render and the concrete structure. The delamination of individual tesserae can also be seen. (Bickerdike Allen Partners)

concrete, onto which the sheets of mosaic were bonded using a thin cementitious grout. Sometimes in pre-cast work, the mosaic was laid in the mould and the concrete poured over the mosaic. Thus there are four layers of material making up the construction: concrete substrate, cement backing mortar, grout or adhesive, and mosaic. One of the difficulties with this type of study, that is one which involves combination construction systems, is reconciling the multiplicity of materials. This, as previously mentioned is a common problem in twentieth century construction which is rarely a simple masonry wall made up of stone or bricks and mortar.

A number of failure mechanisms were identified including:

- Substrate problems. This was the most common cause of mosaic failure, and is a result of the typical concrete deterioration mechanisms explained by Peter Ross in Chapter 8.
- Lack of movement joints to the rigid structure and the equally rigid thin skin. Movement in the substrate cannot be accommodated in the mosaic surface resulting in a delamination of the mosaics.
- The homogeneity of the impervious skin also traps any moisture entering the system, through failure of sealants, as a result of poor weathering details or interstitial condensation. Frost action behind the mosaics combined with the splayed edge profile of the individual tesserae tend to force the mosaic off the backing mortar. This often occurs in combination with substrate failure.
- Bonding failure of the backing mortar to the substrate is another cause of problems. Inadequate pre-wetting of the concrete, lack of key, or residual formwork oil may be contributors to the weakness of bond between these layers.[3] 'Freeze thaw' action can exacerbate the problem.

- Alkali–silica reaction between glass and backing mortar has been identified in some cases as a cause of failure. Here the silicates in the glass react with the alkali hydroxides in the cement of the backing mortar or grout to form an expansive gel.
- Disintegration of the individual tesserae.[4]
- Dubbing out of the irregularities of the structure using backing mortar, which exacerbates bonding problems and increases the weight of backing.[5]
- Loss of grout is a frequent cause of water ingress, exacerbated by 'freeze thaw' action.
- In most of these mechanisms poor workmanship plays a major role, according to many of the case-studies examined.

The research concluded that despite the number of high profile failures, mosaic cladding has generally fared well. This was fortunate as the project has not been able to identify any tremendously positive outcomes. Our understanding of decay mechanisms has improved considerably, but we are no closer to developing conservation minded repairs, and it seems at the moment that removal and replacement is the only option. This is due to the fact that the principal decay phenomena are associated with problems in the underlying structure or the method of application. What the research did highlight is the need for careful analysis of the problem in order to pinpoint causes of decay, as is standard good practice in any conservation project.

Over the research period we have been involved in a couple of other advisory cases where mosaic cladding was causing problems such as the Trade Union Club in London, designed by David Du R. Aberdeen, 1957, and the Centre Point apartment block, designed by Richard Seifert and Partners, 1971. Both examples exhibited problems at the interface of the backing mortar and the reinforced concrete substrate, through poor keying and poor detailing leading to water ingress, exacerbated by lack of movement joints.

The Trade Union Club mosaic is being repaired by reinstating the mosaic on an EML (expanded metal lath) reinforced backing mortar which is mechanically

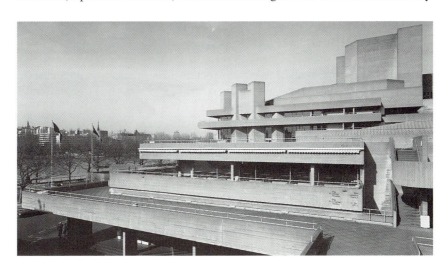

Fig. 11.4 Denys Lasdun's National Theatre of 1967-76, develops the Corbusian interest in the nature of concrete. The extremely high quality concrete finish, which is board-marked provides a richly textured surface which emphasizes the massiveness of the building and the strength of the material.

fixed to the substrate and which can accommodate some movement in the system. Centre Point is more difficult in that the unusually shaped and striped ceramic mosaics are no longer available.

Concrete deterioration is one of the most common problems faced by anyone involved in the care of twentieth century buildings. There are difficulties enough in matching patch repairs to cement render (including the precursors of modern concrete in the form of Roman Cement and stucco) or originally painted concrete, but these pale in comparison to those faced when we are dealing with structural fair-faced concrete.

It was not until the second half of the century that concrete began to be used in a manner which expressed the inherent nature of the material on a wider scale. Auguste Perret struggled valiantly to determine an honest concrete aesthetic and there are many buildings from the first half of the century which did use exposed concrete. For the most part, these were low status industrial or utilitarian buildings where, by virtue of their status or reasons of economy, they were left unclad. It was Le Corbusier at the Unité d'Habitation, who really established an architecturally recognized concrete aesthetic which was to gain increasing acceptance in the decades which followed.

Le Corbusier's rough, board-marked concrete, richly textured and patterned, focused attention to the surfaces of buildings and the aesthetic potential of the material. At this time a new monumental concrete architecture emerged which has created major conservation problems for the guardians of their legacy today.

This issue is a cause of concern not only for post-war buildings but for a smaller number of unassuming buildings from the first half of the century. The church of St John and St Mary Magdalene, Goldthorpe in South Yorkshire is a good example. The church and its clergy house were designed in 1914 by Arthur Nutt, for Rt Hon Viscount Halifax. The concrete contractors for the building were Messrs Hodgkin and Jones of Sheffield.[6] The church is unremarkable stylistically, built in a Renaissance style, but is innovative in its expressive use of material. It is entirely built in reinforced concrete down to the altar, the statues and even the perimeter fence. The aggregate was a carefully selected Belgian sand and the concrete was proudly exposed externally. The building was featured in *Concrete and Construction Engineering* in the year of its completion – a full feature, so it may be presumed to have been noteworthy at the time.

The church was set on a monolithic beam raft to accommodate the possibility of subsidence due to its close proximity to a disused coal mine. The walls are constructed of monolithic *in situ* reinforced concrete generally $6^1/_2$ in (160 mm) thick with regularly spaced rectangular columns which increase the thickness to approximately 10 in (250 mm). The walls sit on a plinth equal in thickness to the columns and terminate at the top in a band of the plinth thickness.

A sample taken revealed that the special aggregate finish was used in the outer layer of the concrete only. Construction photographs revealed the reinforcement to be a grid type mesh to the main walls. The column reinforcement is clearly visible now as a result of spalling of the concrete. In this case it seems as if the usual clips or wires (commonly annealed wire) connecting the vertical reinforcement were omitted. The concrete was built using the pise method of the time, bay by bay in 6–12 in (150–300 mm) lifts. The imprint of the formwork

Fig. 11.5 (left) St. John and St Mary Magdalene, Goldthorpe, 1914–16.

Fig. 11.6 (right) The deterioration to the concrete has progressed to the stage where there are areas where the reinforcement has completely disappeared.

can be clearly seen. Characteristic of concrete of this period, the compaction or punning, which was done by hand, was variable, with aggregate collecting to the base of each pour.

The building is suffering, but is well loved. The structural condition of the tower needs attention as the 1950s repairs did not address the cause of the concrete problems and this work is now likely to be contributing to further deterioration.[7] All the columns have suffered spalling at the corners to varying degrees. The rear of the apse is in the worst condition, the reinforcement having corroded completely. Carbonation, as explained in Chapter 8 by Peter Ross, is the most likely cause of reinforcement corrosion, aided by the fact that the concrete is variable in quality, quite porous and poorly compacted. The columns with their increased surface area are especially vulnerable to decay, and the lack of restraint usually provided by horizontal reinforcement wires has contributed further by allowing the vertical reinforcement rods to bow outwards and crack the concrete.

Cracking on the walling, particularly the south wall, is evident and in limited areas reinforcement has been exposed. The concrete at parapet level, particularly near the corners, also exhibits increased spalling, probably as a result of faulty rainwater goods and insufficient guttering which has allowed moisture into the structure.

The options for repairing this building are very difficult to reconcile with usual conservation aims. At present we are trying to assist the church through providing access to expert advice. The deterioration has gone unchecked for a long time, which for concrete can make the problems much more difficult to deal with.

Despite the fact that a number of the columns have suffered extensive reinforcement damage and the loss of cover, the rebars in other areas are still essentially sound. Obviously it will be necessary to carry out large scale traditional repairs – cutting back to reinforcement, treatment of rebars and then patch repairs or recasting. The scale of the deterioration will mean in some

instances virtually the whole column will need rebuilding. We do not yet know the extent of the damage to the walls, but one could assume there may be areas of considerable decay.

The building needs an appropriate investigation to determine the cause and extent of decay by a concrete specialist and structural engineer. The cost of the repair options needs to be balanced against the required life span of the structure, future maintenance, and of course, the resources of the church. In the case of a parish church it is unlikely that the full costs of repair will be able to be met, and the congregation will need to consider appeals and lottery applications.

The Good Shepherd Church in Nottingham, which is presently being considered for listing, suffers similar problems in terms of how to conserve the aesthetic authenticity of the building. Designed by Gerard Goalen in 1962-4 the church used *in situ* pre-cast concrete to provide the soaring vertical ribs which flank wonderful glasswork by Patrick Reyntiens. These ribs are causing the main problem. The pre-cast work seems to have been cast in two pours to provide the white crisp finish to the concrete. Typically of its time, calcium chloride has been added to the mix to aid rapid curing. Chlorides unfortunately affect the passivating film which forms naturally on reinforcement steel, so creating one of the most difficult concrete deterioration problems to solve. In addition the concrete is quite porous and not well compacted. There are not many options for repair – replacement of the affected members at huge cost and complete loss of material authenticity, or patch repairs that do not solve the problem. Unfortunately patch repairs of chloride damaged concrete often only serve to displace the corrosion to an adjacent area. Diagnosing chloride presence and assessing future decay is quite a difficult and complex process and requires expert assistance.

The church had already carried out some testing and enlisted the assistance of a local contractor, who had not done a bad job in matching the mix in his patch repairs. With a little more work and using a palette of concrete mixes rather than a single mix it may be possible to tackle the most urgent failures.[8]

Since the production of proprietary bagged, polymer modified, patch repair mortars in the early 1980s, concrete repairs rarely achieve a good visual match. Proprietary products do not usually look anything like the original mix, and have little similarity to the original material in composition terms. Most systems come with guarantees, but therefore they come as part of a repair system which usually includes a coating. Such mixes are unlikely to be suitable in the conservation of fair-faced concrete buildings, and although they provide a consistent quality are unlikely to match the existing colour or texture of the concrete. Site batched mixes, which will be cheaper than pre-bagged products, require close supervision by a contractor fully conversant in this method of repair.[9]

A number of different types of coatings have been developed with the aim of extending the lifespan of concrete structures. Anti-carbonation coatings operate on the principle that carbonation is abated by excluding carbon dioxide or moisture ingress. They are available in clear or pigmented versions. The opaque versions are usually preferred as the anti-carbonation properties are aided by the pigments. Where movement and/or shrinkage cracks are present, opaque elastomeric coatings are used which exclude oxygen and moisture. Water

repellents (silicones, silanes and siloxanes), which are usually clear, penetrate the pores of the concrete and exclude moisture. The new corrosion inhibitor coatings claim to penetrate the concrete and bond to the steel providing a protective coating, without altering the appearance of the concrete. Anti-carbonation coatings often recommend a fairing coat first, which fills the small holes and cracks to ensure better cover of the coating, but can change the texture of the concrete.

Both the buildings mentioned above will probably be recommended for some type of coating to the concrete. The unwillingness to attempt patch repairs which match the concrete, or the difficulty of achieving good patch repairs, means opaque coatings are often applied to cover the repairs. Clear coatings can change the colour slightly and appear shiny when wet, but at least retain most of the aesthetic authenticity of the building. Coatings need to be maintained, and thus it must be recognized that the repair will only be successful if it is thought of as the beginning of a longer-term maintenance programme.

Detailing failures

Lack of knowledge regarding the best means of detailing new materials is another cause of many of the problems we are tackling today. The abandonment of traditional weathering details initiated by the early modernists, became the norm in post-war construction. Even those buildings which did pay homage to the traditions of the past often used new materials in the execution of the details. For instance, the use of cement mortars with brick and stonework ensured that many of the early twentieth century mainstream building share these difficulties.

The decision to alter or improve poor detailing will be dependent on the severity of the problem and the required performance criteria, as well as budgeting constraints. Sometimes it is possible to carry out such improvements with minimal alteration to the fabric without destroying the aesthetic or material authenticity unduly.

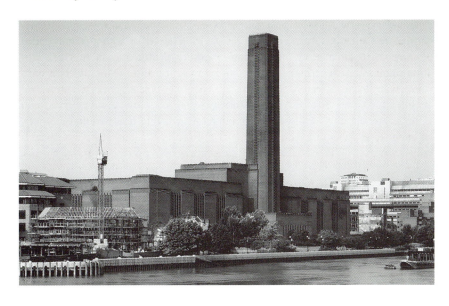

Fig. 11.7 Bankside Power Station suffers from sulphate reaction between the tri-calcium aluminate in the cement of the mortar and the sulphates in the bricks, in areas prone to water ingress or prolonged wetting. This causes the mortar to expand and break down, and has also jacked the brickwork in some areas of the parapet.

217

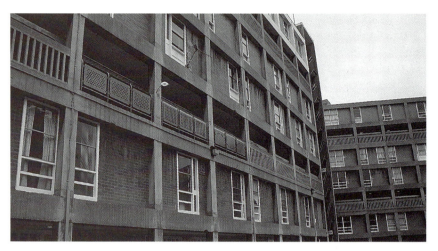

*Fig. 11.8 Park Hill
Housing, Sheffield , by
Lewis Womersley of the
Corporation's Architects'
Department, 1960,
showing the proposed
prefabricated balcony
replacements. An
alternative approach
which repairs only the
damaged sections may
prove a cheaper, and less
intrusive, alternative.*

At Park Hill flats in Sheffield a careful examination of the fabric provides a possible solution to the deterioration of the concrete railings to the walkways. The concrete rails and balusters are very large and heavy and were cast *in situ*. Many of these have suffered corrosion to the reinforcement and subsequent spalling of the concrete and are now considered dangerous. For the sake of economy the initial repair solution was a replacement in prefabricated metal which could be installed without scaffolding. As the building is now being considered for listing we were asked to comment on the possibilities of achieving a more authentic replacement.

On examining the balconies in detail it was obvious that they could be considered as a series of components. It was not usually the case that all the elements of each balcony needed replacement. Often the top rail suffered from reinforcement corrosion to isolated sections and could be repaired *in situ*. The upright balusters are not all in a state which necessitates complete replacement. We are presently, with the help of The University of Sheffield, designing pre-cast components using light-weight, high tensile steel which can be fitted without scaffolding from the 'streets in the sky'. Once we have a suitable design we will be attempting a mock up and preparing costings. It is hoped that repair to damaged areas, rather than wholesale replacement, may in the long run prove to be a more cost effective alternative, and one which accords with our conservation aims.

Burleigh School in Hertfordshire is another example of how detailed solutions based on an analysis of specific problems and an understanding of the materials can be achieved. The school was designed in 1947 by the Hertfordshire County Council Architects' Department. Here the thin concrete cladding panels with their minimal cover to reinforcement have spalled around the fixings causing them to pop off. It is difficult to replace the panels at a thickness suitable to prevent future problems. Increasing the thickness would necessitate either replacing the windows or finding a way of accommodating the junction detail. In this case, by using stainless steel mesh and good quality concrete, the panel thickness could be matched to the existing profile and the building's aesthetic authenticity retained.

218

Outmoded production

Proliferation of new building materials this century has meant that many products had short-lived production runs and are no longer available. The development of modern materials such as plastics, various metals, and new paints has moved so rapidly that many materials were superseded relatively quickly. To replace a damaged section may thus require hand crafting at considerable expense what was intended to be a mass produced item. Salvage is the alternative, although a comprehensive salvage industry is not yet established for twentieth century building materials as for other periods of architectural history.

The flooring at Lubetkin's Plumstead housing highlights this issue. Speculatively built, originally all the terraces had composite flooring. Magnesium chloride or jointless flooring was widely used in the inter-war and post-war period as a cheap, serviceable finish to many building types including housing. Now only one of the houses retains this flooring, and the new owner is interested in preserving the striking patterned floor of the entrance hall.

The floors are made of calcined magnesite and magnesium chloride compound with various other ingredients including pigments, sawdust, wood dust, talc and sometimes asbestos to make a seamless hard flooring. In this instance there is no asbestos in the mix. At present we are unsure how to reinstate the damaged sections. It seems these floors are still made in some form or another and it may be possible to patch in. Alternately it may be possible to use a lime-based mix. The floors were typically polished with floor wax or treated with linseed oils up to three times a year. This problem of outmoded production is not unique to buildings from this century but is exacerbated by the importance of the idea of mass production in the architectural concept of many buildings, and is primarily an ethical issue.

Maintenance failures

A lack of maintenance inevitably exacerbates deterioration. We often find that regular maintenance programmes were originally designed as part of the architect's brief, but it is often the failure to take on board such recommendations

Fig. 11.9 Plumstead Houses, London, by Lubetkin and Pilichowski, 1934. Magnesium chloride flooring survives in one of the houses.

which has substantially contributed to decay. The architect for the National Theatre in London (1965), Sir Denys Lasdun included a five-year cleaning cycle for the concrete in his maintenance plan for the building (Fig.11.3). This was never carried out and recent consultations regarding the cleaning of the concrete examined the possibilities of protective coatings. However it is still uncertain whether such coatings would have any long-term detrimental effect to the extremely high quality finish of the concrete, which is one of the important characteristics of the building. In any case the application of such a coating with its 12-year guarantee introduces a further maintenance cost.

Twentieth century buildings do require the same levels of care as buildings from any other historic period and it is only by incorporating maintenance programmes into post-conservation care that we can ensure their continued survival. The importance of maintenance in order to retain the aesthetic and material authenticity of these structures must not be underestimated.

The patina of age

The perceived inability of modern buildings to age gracefully is a weapon that has been wielded in arguments against conservation and in favour of conjectural restorations of modern buildings. Ungainly and accelerated aging is brought about principally by the materials and details adopted which simply do not equate with the expected lifespan. The patina of age we so often attempt to save, and see as an important part of a traditional building is not recognized with the same romanticism for modern buildings. In this case the patina is likely to be seen as an ugly blot on what is intended to be a pristine image, and as detracting from the original aesthetic. Did modernity, which advocated the new, and a clean streamlined expression, leave room for a patina of age? And is the problem any easier for those mainstream, non-modernist buildings of the same period?

Concrete is a material which it is difficult to reconcile with romantic deterioration. The nature of the material also denies the possibility of a gentle mellowing. Deteriorated concrete and exposed reinforcement, as seen in Langham Training Dome or Goldthorpe church simply encourage decay

Fig. 11.10 Langham Airfield Training Dome, 1941. The incipient decay associated with this structure has now become part of its character. There may be possibilities for repair using systems such as cathodic protection which may be developed in a manner which would retain its patina.

mechanisms and leave the fabric open to further deterioration. In both these cases we might feel comfortable in accepting the decaying image of these buildings. But none of the repair methods can accommodate this incipient decay, and in order to arrest the deterioration, the repair reworks the surface. This intervention may have to be accepted as being no different to rerendering a building and repainting to ensure that it is weatherproof and continues to perform its function as a shelter adequately.

New problems – new solutions

The recent nature of concrete technology is an important cause of our present difficulties. Lack of specific guidelines, lack of knowledge of materials and their performance over time, lack of knowledge of repair systems in the longer term, undeveloped repair methods for conservation aims and a lack of understanding of the value of many twentieth century buildings all compound together.

Another factor is the availability of resources. Conservation of more traditional architecture has built up a network in terms of professional knowledge, craftsmen, antique dealers, suppliers of materials and so on. No such network yet exists for buildings of this century.

Despite the enormous differences stylistically across different decades, many of the material problems affecting concrete buildings are similar. It is possible to identify the key issues particular to specific phases of development. However the analysis of problems and development of a rational approach based on that identification, is the same process for buildings of any period or type.

A methodology for concrete repair – dealing with conservation problems[10]

Unlike other forms of material degradation, concrete and other modern materials do not yet have a developed, universally accepted methodology for investigation, or for approaching repair. All too often the repairs are based on a cursory investigation, often done as a free quote, and with little information supplied as to the nature or even the extent of the repair work.

Until recently we have been in a difficult situation as our own knowledge was limited by the fact that we do not have a statutory role until buildings become listed. As more buildings from the twentieth century are listed we have been required to define our own approach to their conservation. Our starting point has to be that concrete buildings are no different from those made of other materials and therefore we should adopt the accepted investigation, testing and repair methodology required for other building types.

It is now generally acknowledged that the architect is very much a coordinator of specialists and it is often necessary to seek specialist advice for certain aspects of a project, be it new build or conservation work. Repairs to modern buildings are no different. Concrete repair is just one of many specialist activities. In fact reinforced concrete has always been the realm of specialist contractors, ever since it became used on a regular basis at the end of the nineteenth century. In the same way that the first specialist contractors of reinforced concrete in this country were holders of one or other of the patented systems, such as Hennebique, Considère, or Coignet, concrete repair is today in a similar situation. Specialist contractors are usually committed to, or holders of, licenses

for the various repair methods available, such as desalination, realkalization, and cathodic protection. Their patch repairs or traditional repair methods virtually always use a proprietary bagged product bought off-the-shelf with various standard requirements of use which form part of a guaranteed system.

Such an approach, that is one which uses a standard repair method, is a misnomer in conservation terms. We rarely use standard off-the-peg products in conservation work and argue that every building must be assessed on its own specific problems, and the response will be an individual one. This ensures that the specific causes of the problem are addressed which, in turn, ensures the most economical approach in the long term.

Our principal criticism is that there is often such a poor analysis of the underlying problem, which does not fully identify the cause of the decay. Hence any action addresses the symptom and not the cause. This can often lead to inadequate repairs. For any building adequate physical investigation will include a visual inspection. Non-destructive investigations may in some cases be required. An assessment of the damage, available resources and lifespan requirements will influence the repair programme.

There are various causes of concrete deterioration and to determine the most appropriate treatment in each case there are a number of issues which need to be covered in the investigative process. The methodology is the same as that for any other historic building investigation and includes broadly:

1. Selection of the appropriate specialist consultant
A concrete specialist should be independent, which ensures that there is not a conflict of interest between conservation aims and choosing the best repair method or system for the job. It is not considered appropriate for representatives from companies which manufacture and market insecticides to inspect and specify the repairs to a timber building (although this unfortunately does occur), so why should this be acceptable for a concrete building? This said there are a few companies which offer a complete range of repair systems which may under certain circumstances be suitable to be considered as consultants during the investigative stages, just as sometimes the specialist conservator/contractor may be brought in to assist with determining plaster repair methods.

2. Information gathering (historical)
It will be important to determine changes to the concrete, its environment and its functions over its history. Most importantly changes in chloride levels, levels of carbonation and any changes in its chemical and physical characteristics will be useful in understanding patterns of deterioration.

3. Physical inspection and examination
A thorough physical investigation will be required to quantify the physical damage to the concrete. Mapping of defects such as spalling, delamination, cracking and depth of friable surface layers will offer information about the nature and extent of the problem. An experienced consultant can determine much from the patterns of damage – reinforcement corrosion, alkali silica reaction and structural damage.

4. Diagnostic investigation

In order to determine the cause of the problem and the nature of the materials' resistance to decay, non-destructive and sometimes destructive testing will need to be carried out. The types of tests which may be required are likely to include:

- estimate of compressive strength (core or dust samples).
- chloride ion concentration levels and profiling of these (core samples).
- depth of cover to steel reinforcement (calibrated cover metre survey).
- depth of carbonation (simple on-site chemical test).
- petrographic examination of core samples for determination of 'freeze thaw' and alkali silica reaction.

5. Interpretation of results

The importance of the experienced consultant in interpreting these results is paramount. Tests should obviously be implemented in a manner which causes least disruption to the fabric. The decision to take core samples should be agreed with the architect.

6. Selection of repair strategy

As with any conservation project there will be a number of different repair options available, each with advantages and disadvantages, and the choice will be determined by the results of the investigation works, the severity of the deterioration, the risk of future deterioration, required life expectancy, practicality of applying the repair option, aesthetics and suitability to a listed building and finally, but almost always most importantly, cost. A useful exercise is to list all the repair alternatives from no action to the most long-term solution and then set these against their respective anticipated service lives and the advantages and disadvantages of each option. This summary proves the best means of focusing attention on the short- and long-term aims of the works in relation to current financial resources.

Future options

The conservation of our twentieth century architectural heritage offers the opportunity to reassess approaches used in the past and rethink some of the ways we deal with buildings generally. At the same time we need to determine whether these buildings are so different. We have not yet developed sympathetic repair methods which are economically justifiable. There are still conflicts and uncertainties in contemporary philosophy for conserving historic buildings and it should be remembered that these are not a set of rules, merely guiding principles.

The extent to which we intervene to conserve a structure is dependent on the extent of decay and how the decay is likely to continue, the future role of the building, and the finance and knowledge available to carry out the intervention. Generally, in contemporary conservation we subscribe to the idea that the less intervention the better for the structure. However when dealing with modern buildings and their particular material problems, which have a limited lifespan without intervention, we may need to reconsider. Characteristics of modernism such as functionalism should be recognized as being both negative and positive in conservation terms and the balance related to other issues under consideration.

Arguments concerning authenticity will subside as less intrusive repair methods are developed, and if we accept that loss of material authenticity may in some instances be warranted. The principle of approaching a project by careful analysis of the historical and physical evidence in order to evaluate the building's significance and then develop the appropriate conservation strategy is still valid.

As yet there is little written information that specifically deals with the technical problems. We need to push forward technical barriers, which limit what is achievable in conservation terms, to permit the aims of minimum intervention and retention of authenticity to be reconciled. We need to appeal to industry to work with us to achieve these aims and develop financially viable solutions if we are going to secure the future of many of our important buildings.

The establishment of knowledge networks will enable us to learn from each other. We need to carry out further research into the history of twentieth century architecture, develop our understanding of the materials and their deterioration mechanisms and experiment with repair methods.

Lastly, we must accept the adage that conservation is a process not a finite act. If we are confronted with a problem which appears insurmountable today, it must be remembered that a solution may be found in the future. Where possible the principle of reversibility should be observed.

Notes

1 The Venice Charter states as one of its aims the 'handing down of our cultural heritage to future generations' in... 'the full richness of their authenticity.' ICOMOS (1964) *The International Charter for the Conservation and Restoration of Monuments and Sites*. (The Venice Charter), Venice.

2 A paper of this research project will be published in English Heritage Research Transactions.

3 An approach particular to that used in Liverpool Cathedral was the casting of a wire mesh imprint in the *in situ* concrete to provide a bond between the backing mortar and the substrate. Usual practice was to roughen the surface through bush hammering or scabbling, and this economy seems to have proven to be unsuccessful.

4 In the case of Liverpool Cathedral the tesserae themselves have disintegrated. The mosaic used in this case was not manufactured in a traditional manner, but was made of sintered glass, probably by pressing blanks of finely milled or powdered material including recycled and raw materials. The material is then heated until the particles fuse together but do not melt, thus leaving tiny pores between them. The widespread failure of individual tesserae at Liverpool may be due to poor mixing of the original ingredients, inappropriate constituents and low firing temperature. The discolouration of the tesserae however was due to superficial dirt deposits.

5 At Liverpool, as is often the case, up to three layers of backing mortar have been used to even up the irregularities of the structure. The top coat in this case is the strongest of the mixes, 1:1 cement to sand, contrary to traditional practice of decreasing strength and porosity of the mix towards the outer face of the building.

6 Souter, E. A. (1916) 'Reinforced concrete church and clergy house at Goldthorpe', *Concrete and Construction Engineering*, **11**, No.12, 655-666.

7 The bell tower was extensively repaired in the 1950s by the addition of layers of concrete over the original structure using a fine mix with a smooth trowelled finish, which increases the concrete thickness by some 3/5 in (15 mm).

8 The use of surface coatings cannot slow down the process due to the inherent material problem.

9 Currie, R. and Robery, P. (1994) *Repair and Maintenance of Reinforced Concrete*, BRE Publications, Watford. See also Pullar-Strecker, P. (1987) *Corrosion Damaged Concrete: Assessment and Repair*, CIRIA/Butterworth Heinman, Oxford.

10 This section was written in conjunction with Kevin Davies of Rowan Technologies.

Index

Note: page numbers in **bold** refer to Figures